LEONARDO DA VINCI

LEONARDO DA VINCI

YALE UNIVERSITY PRESS IN ASSOCIATION
WITH THE SOUTH BANK CENTRE

Set in Monophoto Bembo by Tameside Filmsetting Ltd, Ashton-under-Lyne
and printed in Italy by Amilcare Pizzi SpA, Milan

Designed, produced and distributed by Yale University Press on behalf of the South Bank Centre

Library of Congress Cataloging-in-Publication Data

Leonardo, da Vinci, 1452–1519.
 Leonardo da Vinci, artist, scientist, inventor.

 Catalogue of an exhibition held at the Hayward Gallery,
 by the South Bank Centre, London.
 Bibliography: p.
 1. Leonardo, da Vinci, 1452–1519—Exhibitions.
2. Research—Exhibitions. 3. Inventions—Exhibitions.
I. Hayward Gallery. II. Arts Council of Great Britain.
South Bank Board. III. Title.
Q143.L5A3 1989 609.2′ 88-37855
ISBN 0-300-04508-5
ISBN 0-300-04509-3 (pbk.)

Contents

Catalogue entries by Martin Kemp except section 1 by
Jane Roberts and section 10 by Philip Steadman

Advisory Committee

Professor Sir Ernst Gombrich, CBE
(Chairman)
HE Signor Boris Biancheri, Italian
Ambassador to the Court of St James's
Sir Derek Thomas, KCMG, British
Ambassador to Rome
Signor Bruno Bottai, former Italian
Ambassador to the Court of St James's
The Lord Bridges, KCMG, former
British Ambassador to Rome
Professor André Chastel, Institut de
France, Paris
Mr Oliver Everett, LVO, Librarian,
Windsor Castle and Assistant Keeper of
The Queen's Archives
On. Professor Luigi Firpo, MP, Presidente,
Commissione Nazionale Vinciana, Turin
Professor Paolo Galluzzi, Direttore,
Museo di Storia della Scienza, Florence
Dottor Pietro C Marani, Sovrintendenza
per i Beni Artistici e Storici, Milan
Professor Augusto Marinoni, Università
Cattolica del Sacro Cuore, Milan
Monsignor Angelo Paredi, Direttore,
Pinacoteca Ambrosiana, Milan
Professor Carlo Pedretti, Director, The
Armand Hammer Center for Leonardo
Studies at the University of California,
Los Angeles
Professor Francesco Valcanover, Venice

Exhibition Committee

Martin Kemp, Professor of Fine Arts,
University of St Andrews
Jane Roberts, Curator of the Print
Room, Royal Library, Windsor Castle
Dr Philip Steadman, Director, Centre
for Configurational Studies, The Open
University
Paul Williams, exhibition designer
Olivia Winterton, researcher to the
exhibition
Andrew Dempsey, Assistant Director,
Hayward Gallery
Julia Peyton-Jones, Exhibition Organiser

Exhibition selected by Martin Kemp and
Jane Roberts

Foreword

Almost five centuries after his death the genius of Leonardo continues to astonish. This exhibition explores his work as artist, inventor, scientist and engineer. Its display of drawings and manuscripts and its use of recent technology is an attempt to get closer to the mind of Leonardo and to show the underlying unity of his vision of the world.

At the heart of the exhibition is what we believe to be the greatest display of original material across all fields of Leonardo's activity ever to be seen in this country. Such a display has only been possible through the generosity of our lenders, both public and private, who appear on the page following this foreword.

We are profoundly grateful to Her Majesty The Queen who has graciously lent eighty-eight drawings from the unrivalled collection at the Royal Library, Windsor Castle. This magnificent loan is the core of the exhibition.

The exhibition has benefited crucially from the encouragement of Professor Sir Ernst Gombrich and the collaboration of the members of the international advisory committee who are listed on page vi. It has been devised and selected by Professor Martin Kemp of the University of St Andrews and Jane Roberts, Curator of the Print Room of the Royal Library. Their work has brought to fruition a proposal first made to us in 1983 by the art historian Rosa Maria Letts.

Our selectors have been assisted by a small working committee which included Olivia Winterton who undertook much of the research, Dr Philip Steadman of the Open University who devised the computer sequences, and the exhibition's designer Mr Paul Williams of Stanton · Williams.

This is the second Hayward exhibition, the first being *Renoir* in 1985, which has received support from IBM United Kingdom Limited. In this case they have not only given substantial assistance with the costs of a very ambitious project but they have also generously made available the resources of their research centre in Winchester without which the computer sequences could not have been realised. We are extremely grateful to IBM UK's Chief Executive, Mr Tony Cleaver, to the Sponsorship Programme Manager, Mr Peter Wilkinson, and to Dr Peter Quarendon and his research team at the IBM UK Scientific Centre at Winchester.

Leonardo's fascination with mechanics and engineering is wonderfully demonstrated in the exhibition by James Wink's full-scale model of his flying machine and the impressive models lent by the Montreal Museum of Fine Arts, the Museo Nazionale della Scienza e della Tecnica 'Leonardo da Vinci' in Milan, and from the studio of Dr Roberto A. Guatelli in New York. Our thanks also go to THORN EMI Business Communications who have lent video players and monitors to the exhibition.

An exhibition of this scale and complexity involves the commitment and help of many people among whom we would like to mention the following: Caroline

Armitage; Christian Bailey; Hendrik Ball; Roberto Borrani; Dr Mauro Broggi; Bill Duff; Julian Clare; Dr Giorgio Colombo; Orazio Curti; Les Dangerfield; Vered Dinour; Lynne Green; Geoff Harrison; Sue Key; Sabine Leuerer; Professor Enzo O. Macagno; Joseph Mirabella; Theresa-Mary Morton; Dr Franz Netta; Doug Pidduck; Marc Pitre; Anna Sixsmith; Pierre Thèberge; Professor Alessandro Vaciago; Dr Paolo Viti; Dawn Waddell; Michael Warnes.

Joanna Drew
Director, Hayward and Regional Exhibitions
South Bank Centre

Lenders to the Exhibition

Her Majesty The Queen, Royal Library, Windsor Castle, cat. 1, 4, 5, 8, 9, 10, 11, 12, 15, 16, 17, 18, 19, 20, 21, 22, 23, 24, 25, 26, 27, 28, 29, 30, 31, 32, 33, 36, 38, 40, 41, 42, 43, 44, 45, 46, 47, 48, 49, 50, 51, 52, 53, 54, 55, 56, 57, 58, 61, 62, 63, 64, 65, 66, 69, 70, 71, 72, 73, 74, 78, 79, 82, 84, 85, 86, 87, 88, 89, 90, 91, 92, 93, 94, 95, 96, 97, 98, 99, 105, 106, 107, 108, 109, 110, 111, 113, 119

Bakewell, Derbyshire
The Duke of Devonshire and the Trustees of the Chatsworth Settlement, cat. 75

Cologne
Wallraf-Richartz-Museum, Graphische Sammlung, cat. 7

Florence
Gabinetto Disegni e Stampe degli Uffizi, cat. 35

London
The British Library Board, cat. 101
Trustees of the British Museum, cat. 2, 6, 13, 68, 76, 77
The Board of Trustees of the Victoria and Albert Museum, cat. 59, 60, 112

Madrid
Biblioteca Nacional, cat. 115, 116

Milan
Museo Nazionale della Scienza e della Tecnica 'Leonardo da Vinci', cat. 129, 131, 132

Montreal
The Montreal Museum of Fine Arts, cat. 121, 122, 123, 124, 126, 127, 128, 133, 134

New York
The Pierpont Morgan Library, cat. 114
Dr Roberto A. Guatelli Associates, Inc., cat. 130

Oxford
The Visitors of the Ashmolean Museum, cat. 80, 81
The Governing Body, Christ Church, cat. 34, 83, 103

Paris
Bibliothèque de l'Institut de France, cat. 100, 102, 118
Musée du Louvre, Département des Arts Graphiques, cat. 3, 67, 117

Rotterdam
Museum Boymans van-Beuningen, cat. 14

St Andrews
University of St Andrews Library, cat. 104

and a private collection, cat. 37, 39

Exhibition Acknowledgements

Assistance has been received from THORN EMI Business Communications for the loan of video players and monitors to the exhibition.
Laser discs have been supplied by Telemedia.

Exhibition Organiser : Julia Peyton-Jones
Exhibition Assistant : Rosalie Cass
Research Assistant : Olivia Winterton

Exhibition Design Stanton · Williams
Exhibition Graphics : Crispin Rose-Innes Limited
Exhibition Contractor: Carlton Beck Limited

MODELLING LEONARDO'S IDEAS BY COMPUTER

Computer sequences directed by Dr Philip Steadman
Consultant: Paul Williams
Art direction: Roy Reed, Triangle Two Limited
Produced by IBM UK Scientific Centre, Winchester; Dr Peter Quarendon, Christopher Denham, Stephen Glennon, Stephen Gray, Jeremy Holland, Glenys Jones, Andy McNamara, David May, Andrew Walter, Steven Woodman
Assistance with drawing the centralised churches: Frank Brown
Assistance with the description of branching forms: Kevin White
Information about the morphology of the human lung: Norman MacDonald

THE MODELS

The model of the flying machine has been commissioned by the South Bank Centre and made by James Wink, Tetra Associates, London.
The engineering and architectural models lent by the Montreal Museum of Fine Arts represent a portion of an exhibition organised by them in collaboration with the Engineering Centennial Board. They are toured by the Extension Services of the Montreal Museum of Fine Arts with the financial support of the Government of Canada, Ministry of Communications, and the Conseil des Arts de la Communauté Urbaine de Montréal.
Additional models have been lent by the Museo Nazionale della Scienza e della Tecnica 'Leonardo da Vinci', Milan, and Dr Roberto A. Guatelli Associates, Inc., New York.
The slide programme on Leonardo's paintings and relevant drawings has been produced by Triangle Two Limited.

E. H. Gombrich PREFACE

The colossal outlines of Leonardo's nature will never be more than dimly divined from afar.

Jacob Burckhardt (1860)

As a famous artist Leonardo da Vinci shares the summit of High Renaissance achievement with masters such as Michelangelo, Raphael and Titian, all somewhat younger than he was. As an engineer his rational efforts to construct a flying machine are commemorated in the designation of the Roman airport, 'Leonardo da Vinci'. The creator of two of the best known paintings in the whole history of art, the *Mona Lisa* and the *Last Supper* was equally in demand, in his lifetime as a sculptor, an architect, a master of revels, a military engineer and as a builder of waterways. It is true that he was also notorious, since his early days, as what we curiously call a 'perfectionist', ever reluctant to let a work go out of his hands. Moreover it was rumoured among his contemporaries that this strange man of doubtful religious orthodoxy had unhappily dissipated his energies on all kinds of abstruse pursuits, though little was known of the range and originality of his researches. The true magnitude of his achievements outside the field of art was not perceived before copies of his manuscripts and later also the original notebooks were published one by one and revealed the miraculous versatility of this intellectual giant. There appeared to be no field of knowledge to which he had not made a contribution: anatomy, physiology, mechanics, hydraulics, botany, optics were all transformed by his magic touch. No wonder that he was hailed as a genius who had transcended all the limitations to which human nature is prone, a prophet who had been so far ahead of his time that he seemed to have swept away all the errors that had clouded earlier centuries. But Leonardo was not a mythical figure, he was a real man of flesh and blood and wedded as he was to the pursuit of truth we owe it to his memory to disregard the legend and to speak of him in terms he would have understood and accepted.

Thus when we hear him praised (and in a way quite justly) as a man who had uniquely combined the two disparate branches of human creativity which we call 'art' and 'science', we might do well to reflect that he would scarcely have understood this form of adulation; indeed it could not have been expressed in the language of his time. To his contemporaries 'art', *arte*, meant skill, much as we still use the concept in 'the art of war' or 'the art of love', while 'science', *scientia*, meant knowledge. Leonardo emphasised again and again in his writings that the art of painting had to rest on knowledge. To him the widespread ignorance of the fundamental truth, that there was no art without science, was responsible for the low esteem in which his chosen profession was too often held. Far from being a mere craft, painting should be classified with the so-called Liberal Arts, the disciplines based on knowledge. Maybe there is hardly another aspect of

Leonardo's outlook more remote from the preconceptions of our age than this insistence on the rationality of artistic procedures. Without a profound understanding of the laws of nature the artist could never become the very rival of the Creator as Leonardo wished him to be.

The demand Leonardo often made in pursuit of that aim, that the painter must become 'universal', that is to say infinitely versatile in his researches and interests has attracted another cliché that often turns up when his name is mentioned – the formula of the 'universal man', the real or alleged ideal of that period which was celebrated in Jacob Burckhardt's classic, *The Civilization of the Italian Renaissance*. It is a moot point whether it was in fact possible for the men of the Renaissance to know everything they wished to know, notably the writings of the ancients, the Bible, the Church Fathers, not to forget the Seven Liberal Arts. What matters is only that their own definition of 'universality' would have excluded Leonardo's achievements. To be largely ignorant of Latin, the language of the classics and of the Church, was of course incompatible with a claim to culture. Leonardo was poignantly aware of this fact. It is true that he made attempts to teach himself Latin when studying a treatise on the art of war, but however successful he may have become in coping with certain scientific texts he would never have aspired to turn an elegant Latin phrase as was, after all, still expected in this country a few generations ago of an educated gentleman. When Leonardo described himself as an 'unlettered man', we must thus not take him to mean that he could not or did not make use of books. We have several lists of the many books he owned at various points in time, and those he did not possess he often borrowed. The image of Leonardo as an inspired autodidact who relied entirely on his own observations has long been shown to be wholly false. When he contrasted the kind of knowledge to which he aspired with that of the humanists and *letterati*, he wished to pillory the type of scholar who relied on authority rather than on critical reason. He had no more patience with theological or metaphysical disputations than he had with popular superstitions such as belief in ghosts or in astrology. The ultimate arbiter could only be experience.

Even reading his defiant utterances we must be wary of certain linguistic traps. Leonardo did not make as clear a distinction as does the modern scientist between 'experience' and 'experiment', by which is now meant a carefully controlled method of putting theory to a test. That Leonardo postulated such controlled experiments, there can be no doubt, but there is room for argument about the way he actually set them up to decide between rivalling hypotheses. Just as his notion of 'art' differed widely from ours, so, we gradually begin to see, did his notion of 'science'.

This exhibition would fail in its purpose if it did not cause the visitor to reflect on these matters. It should find us ever ready to revise our preconceptions when trying to engage with Leonardo's multifarious and multi-layered thoughts. Most of all, as has been indicated, it should disabuse us of simplifications and catchwords that would stand in the way of confronting the life-work of a man who, after all, lived as many as five hundred years ago, at an age and in a society very different from our own. Leonardo himself would have emphatically endorsed this reminder. There is a violent outburst among his notes against those he called 'abbreviators' who published summaries or digests of important authors. These 'abbreviators', he writes, 'harm both knowledge and love'. 'Love' he explains must be based on true knowledge, summaries are merely 'pandering to

impatience, the mother of stupidity'. Leonardo likens their authors to a man who strips a fine tree of its branches, leaves, blossoms and fruit merely to turn it into wooden boards. He, if anybody, demanded detail and more detail so as not to falsify the facts.

Reading Leonardo's notes or admiring his drawings we can only marvel at the master's voracious appetite for details. His range of activities and his insatiable thirst for knowledge seems never to have come in conflict with that awe-inspiring power of concentration that made him study one plant, one muscle, one sleeve or indeed one geometrical problem as if nothing else would ever concern him. Ultimately it may have been this relentless quest for the last detail that thwarted so many of his artistic or scientific projects. Even for him the day had only twenty-four hours, and though one may legitimately wonder whether he ever slept, his standards of perfection were indeed such that his life-work was bound to remain a torso.

Admittedly we cannot be reminded too often of the fact that what has survived is no more than a torso of that torso. His artistic *œuvre* has been dogged by misfortunes and many of his drawings and of his notes have disappeared. We must be all the more grateful for what has remained – much more, indeed, than can be documented in this exhibition. It cannot aim at doing more than giving the visitor a glimpse of the master's inexhaustible creativity.

To supplement it, the visitor should, if possible, seek out those excellent anthologies which, shunning 'abbreviations', offer large selections from Leonardo's writings. The best introductions to Leonardo's thoughts are J. P. Richter's two bilingual volumes entitled *The Literary Works of Leonardo da Vinci* (supplemented by Carlo Pedretti's invaluable commentary), and Edward MacCurdy's more easily accessible translation entitled *The Notebooks of Leonardo da Vinci*. They also teach us to appreciate Leonardo as a writer, the poetic fervour of some of his reflections no less than his caustic wit and his polemical skill. But even the perusal of these indispensable collections is not without its dangers. The first of them is inseparable from their principal asset. The master's notes are here arranged according to their subject matter, a helpful procedure which he himself had in mind and instructed his pupil Melzi to continue. But invaluable as it is to find a conspectus of all Leonardo wrote about a given matter, it is in the nature of these anthologies that they must ignore chronology; notes and jottings, perhaps separated by three decades are here printed side by side without much regard for the development of Leonardo's thought. It was his habit to return to the same problem again and again, correcting, reformulating and sometimes even contradicting his first idea. It is this heroic struggle with his material that we inevitably tend to miss in using these anthologies.

But maybe there is another danger, even less easily overcome: Leonardo wrote these notes for himself and he freely mixed excerpts of his readings and results of his observations with mere projects and plans. His intellectual ambition was boundless. He sometimes wrote as if he hoped and intended to encompass all knowledge and to fathom all the secrets of nature, though if that was ever his dream he soon realised the utopian character of such an enterprise which has even further receded with every advance of our knowledge. In any case it is obvious that most of the instruments and intellectual tools of science were not available to Leonardo. In particular we know today that for all his praise of the certainties of mathematics, he himself was not as good a mathematician as he was an

observer. Historians who have gone over his calculations have found him guilty of many errors.

As one might expect of an iconoclastic age such as ours, attempts have therefore not been lacking to 'cut him down to size'. We are confident that the exhibition will demonstrate the futility of such efforts. He was not omniscient, he was not even a 'universal man', but then he never made such a claim. What he thought of his enterprise near the beginning of his career is beautifully reflected in a passage of deep humility and wisdom that he drafted as part of a Preface, *proemio*, in his first Milanese period:

> Seeing that I can find no matter of much use or delight, because the men born before me have appropriated to themselves all the useful and necessary subjects, I shall do what the poor man does who comes last to the fair: since he cannot provide himself with any other stock he picks up all the things which the others had seen but rejected as of little value. These despised and rejected goods which were left behind by many buyers I shall load on my feeble donkey and shall carry them not to big cities but to poor villages and distribute them, taking such a price as the wares I offer may be worth.

Visitors to the Hayward Gallery will be able to find out what it was the learned men who came before Leonardo had rejected and what he left for us on the stalls of the fair.

Martin Kemp LEONARDO THEN AND NOW

Animals will be seen on the earth who will always be fighting amongst themselves with the greatest damage and frequent deaths on each side. There will be no limit to their malignity; we shall see great areas of trees in the wide forests throughout the universe felled by their proud limbs, and when they are satiated with food, the nourishment of their desires will be to deal death and grief and toil and wars and fury to every living thing. And through their undaunted pride they will desire to ascend towards heaven, but the excessive weight of their limbs will keep them below. Nothing will remain on the earth or under the earth and water that will not be persecuted, relocated or ruined, and those of one country expelled to another. And their bodies will become the tombs and conduits for the already dead bodies of living things. O earth, why do you not open, and throw them into the steep fissures of thy great abysses and caverns, and display no more to heaven such cruel and hateful monsters.

The answer to Leonardo's 'prophecy', cast in the form of a riddle, is 'man' – or rather 'the cruelty of man'. Yet we know that he worked with intense inventiveness on designs for machines of war, envisaging devices of fiendish efficacy and multiplying the effects of guns and mortars in such a way as to create a new destructive potential.

Understanding a mind as various, subtle and complex as Leonardo's is no easy task. We have a larger legacy of manuscripts from Leonardo's own hand than for any figure of his or earlier eras, yet his writings contain little that can safely be regarded as genuinely personal in an unguarded or emotional sense. We would be unwise to assume automatically that his savage 'prophecy' about man's cruelty is a personal statement, any more than his gruesomely humorous 'prophecy' about flying creatures full of sucked blood – mosquitoes – is an expression of his social attitudes. There is certainly nothing in his writings to compare with the rough-hewn excavation of inner thoughts that characterises Michelangelo's poetry. However elusive Leonardo's personality has proved to be, he has nevertheless intrigued succeeding generations and has become the very stuff of myth.

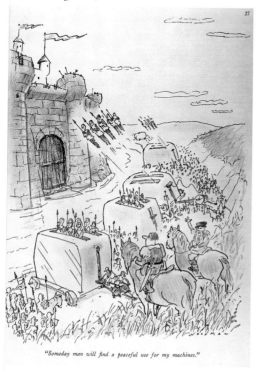

Fig. 1 *'Someday man will find a peaceful use for my machines'*. Drawing by Woodman, © 1987, the *New Yorker* Magazine, Inc.

"*Someday man will find a peaceful use for my machines.*"

Woodman's intelligently witty cartoon for the *New Yorker* (fig. 1) draws upon the myth as it exists in our own period. He has felt no need to label the speaker as Leonardo. Within the context established by Woodman – though the castle owes more to Walt Disney than to Renaissance fortifications – the barest indication of the inventor's stock image suffices to make the identification. It matters not for this purpose that the image used by the cartoonist, Leonardo's drawing in Turin of a majestic, long-bearded 'seer' (fig. 34), may not be a self-portrait. The drawing is so established as a self-image of Leonardo – at what might be called a 'spiritual' level – that its status is virtually unassailable. It has to be admitted that Woodman is drawing for a literate and visually-aware audience, but the hold of Leonardo extends far beyond the circles of those who profess an educated interest in art and history.

At one level, the spell is such that some of his images have become infused into popular culture on a world-wide basis in stereotyped and commercialised forms. The *Mona Lisa* (fig. 4) has been used to sell almost anything, from hair-dye to alcoholic beverages, and has adorned a vast range of products, including tin trays and tea-towels. This situation has itself become a matter for ironic comment in art, as in Mike Mycock's painting of a faceless beach beauty (fig. 2), which plays upon the shared vacuity of the beautiful products – animate and inanimate. At another level, Leonardo has become the very image of the universal genius, a mind unconstrained by convention or limits of time or place or field of intellectual endeavour. It is this Leonardo that shares the cover of a children's book on great inventors (fig. 3) with such prophets of modern technology as Frank Whittle of the jet engine, Benjamin Franklin of electricity and Thomas Eddison of the telephone. Leonardo, portrayed again from the Turin drawing, is accompanied by his spiral 'helicopter', implying strongly that he should be regarded as the true pioneer of human flight.

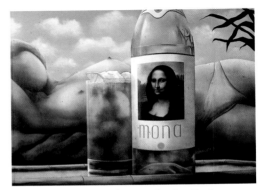

Fig. 2 Mike Mycock, *Just Another Product*, 1974, acrylic on canvas, 91 × 122 cm; Courtesy: Nicholas Treadwell Gallery, Bradford

This second Leonardo, the butt of Woodman's humour, is a relatively recent one, built ultimately upon the studies of scholars who have revealed the contents of Leonardo's unpublished manuscripts. The pages of designs, teeming with an apparently endless stream of inventions, seem to present Leonardo as a prophet of the modern world, propagating astonishing visions of the aeroplane and the submarine, the bicycle and the horseless carriage, the tank and (if Woodman is to be believed) the pop-up toaster.

The image of Leonardo in his own day and in the immediately following generation was rather different, though the inherent fascination of his personality cast its spell from the first. In Castiglione's famous treatise, *The Courtier*, largely written during the artist's lifetime, we find an early expression of the typical note of Renaissance impatience with Leonardo's varied dabbling in different fields, to the detriment of his career as an artist: 'one of the foremost painters of the world, neglecting that art in which he was most singular, set himself to learn philosophy, in which he produced such strange concepts and new chimeras that, with all his paintings, he did not know how to paint them'.

The author of the first extended biography of Leonardo, Giorgio Vasari (1550 and 1568), provides a compelling picture of the man who laid the foundations for what Vasari regarded as the third and ultimate period of artistic achievement, but he writes about Leonardo's non-artistic activities with a mixture of admiration and irritation: 'he was truly marvellous and celestial ... and he would have made great advances in knowledge and in the foundations of learning had he not been of such a various and changeable nature. For this reason he set himself to learn many things, and, having commenced them, abandoned them.' However, at least one of Leonardo's patrons, Francis I, King of France, appears to have regarded the universality of Leonardo's mind with positive favour, supporting the artist towards the end of his career as an ornament of his court. The sculptor Cellini reports Francis as saying that 'he did not believe that a man had ever been born who knew as much as Leonardo, not only in the spheres of painting, sculpture and architecture, but that he was a very great philosopher'.

Within a generation of his death it was virtually impossible to gain a clear picture of his achievement as an artist – to say nothing of his less public activities. The *Last Supper* (fig. 25) the single large-scale work that could stand beside Michelangelo's frescoes in the Sistine Chapel and Raphael's Vatican wall-

Fig. 3 *Famous Names in Invention* by Martyn Hamer, cover of a children's book, Wayland Publishers, Hove (1980)

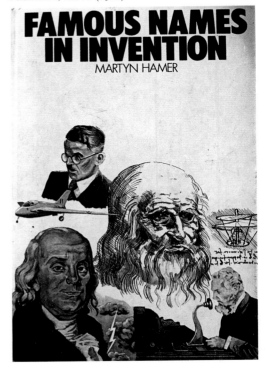

FAMOUS NAMES IN INVENTION
MARTYN HAMER

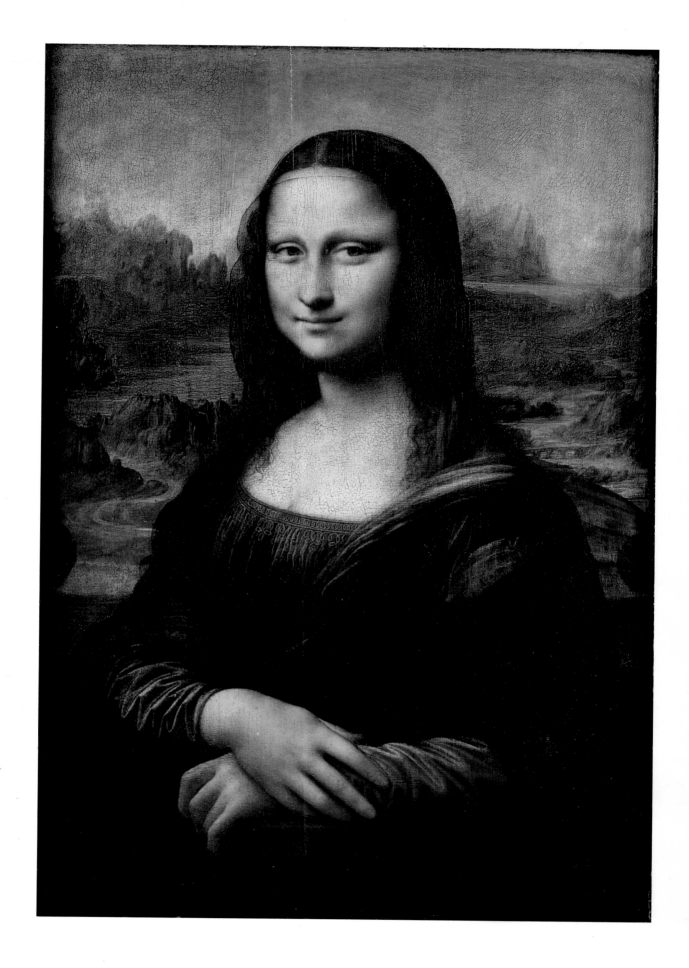

Fig. 4 *Mona Lisa*,
c.1505–14, 77 × 53 cm,
Musée du Louvre, Paris

paintings, was already in a sadly advanced state of deterioration. His artistic legacy came to be dominated by the virtually endless versions and pastiches by his followers, particularly in Milan, where the mannerisms of his style were faithfully imitated but without the substance – to adapt Kenneth Clark's characterisation (in turn referring to Lewis Carroll), the smile without the Cheshire cat. The full extent of his written legacy was even less apparent. However, some of his writings on art were transcribed in a form that ensured their accessibility. His immediate heir, Francesco Melzi, the young Milanese nobleman who had been his pupil and faithful companion, was responsible for a pious yet repetitive and disorderly anthology of some of his master's notes on painting, gleaned from scattered drafts in the manuscripts he had inherited. This anthology in the Codex Urbinas in the Vatican, which came to be known as the *Trattato della pittura*, was widely copied in manuscript form in the sixteenth century, often without the *paragone* (his comparison of the arts), which occupies a large section at the beginning of Melzi's selection. It was in its shorter form that the *Trattato* was finally published in France in 1651 in Italian and French editions.

Fig. 5 Rembrandt van Rijn, *Last Supper* after Leonardo, *c*.1635, red chalk; Courtesy: Robert Lehman Collection, The Metropolitan Museum of Art, New York

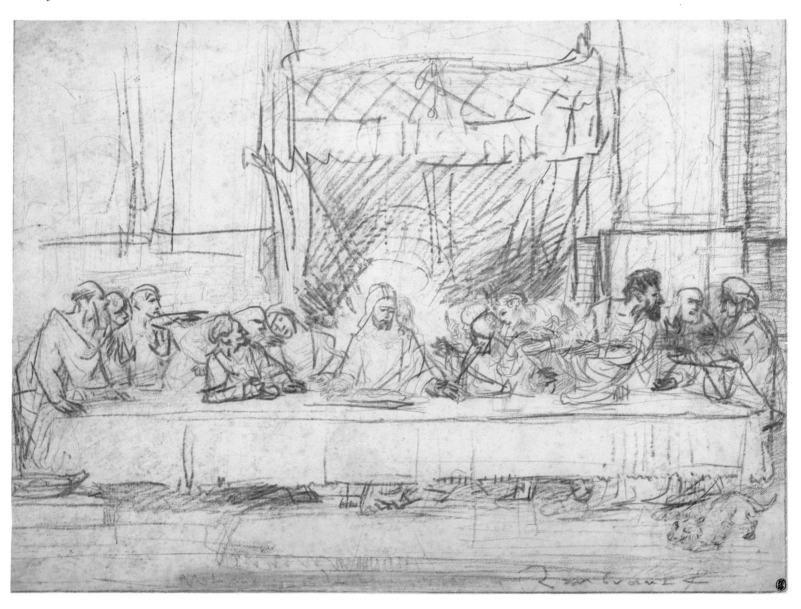

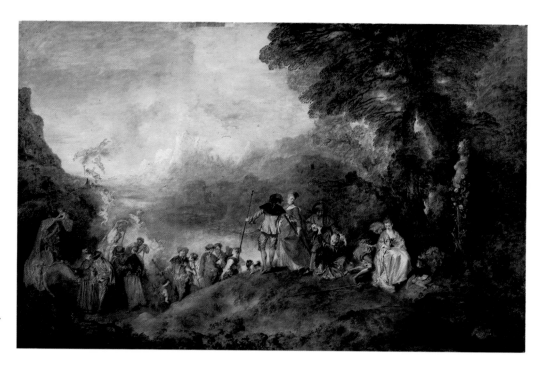

Fig. 6 Antoine Watteau, *Preparations for the Departure from the Isle of Cythera*, 1717, 128 × 193 cm, Musée du Louvre, Paris

The impetus for the publication had come from that leading patron and arbiter of taste in Baroque Rome, Cassiano del Pozzo, and it was through Cassiano that the *Trattato* acquired its illustrations by Poussin. Cassiano, in partnership with Count Galeazzo Arconati in Milan, had also set in train a grander project to bring Leonardo's scientific writings into the public domain, which, had it been accomplished, would have radically altered his century's view of Leonardo. However, it was not until the late nineteenth century that Cassiano's goal began to be realised.

The muddy picture of Leonardo's real achievements did not affect the ability of a few truly perceptive artists to penetrate to the heart of his inventions, whether or not they had access to his original works. Perhaps the most remarkable example is Rembrandt's large-scale sketch reworking the *Last Supper* (fig. 5), which was based upon one of the dispiritingly stiff engravings after Leonardo's painting yet exhibits a special kind of insight into the expressive core of his predecessor's conception. In a very different vein, we find that great eighteenth-century master of eloquent motion, Antoine Watteau, drawing his own lessons from the autograph painting of the *Virgin, Child, St Anne and a Lamb* (fig. 29) in the Louvre. Watteau not only recalled the eternally suggestive mountainscape in the far background of Leonardo's masterpiece when he came to paint his *Preparations for the Departure from the Isle of Cythera* (fig. 6) but also adopted Leonardo's techniques for the fluent formal and emotional interplay of the actors in his romantic drama.

The late eighteenth century saw the first substantial moves to bring the private Leonardo before the public. Fresh attention was devoted to the great cache of drawings in the collection of George III, and various proposals were made to bring them into the public domain, though without immediate success. In 1797 Giambattista Venturi published the first transcriptions from Leonardo's scientific notes, including some of those concerned with water. And in 1810 Giuseppe Bossi's monograph on the *Last Supper* may be seen as marking the beginning of

historical scholarship on Leonardo's career and work. It was in response to Bossi's book that Goethe painted his famous word-picture of the narrative of the *Last Supper* conveying, at the same time, a very real insight into the tenor of the artist's intellectual quest: 'he did not rely upon the inward impulse of his innate and inestimable talents; no arbitrary, random stroke was admitted; everything was meditated and reflected upon. From the pure and tried proportion to the strangest and most contradictory forms or monstrosities, everything was to rest on the principles of nature and reason.'

As the full extent of Leonardo's written and drawn legacy became apparent, culminating in the great series of facsimiles and transcriptions from the nineteenth century onwards, so each different generation, and each varied cast of mind, has seen a different figure behind the mask, and different aspects of his work have come to assume different degrees of relative prominence.

The age of Romanticism gave us the melancholic seer of Stendhal and the 'sinister' *Mona Lisa*; the aesthetic movement provided the setting for Pater's elegant evocations of Leonardo's visual incense; the world of the Symbolists, at the end of the century, provided the flavour for Valéry's intuitive if self-indulgent penetration to the universal meaning at the heart of Leonardo's diversity; and Freudian psychology has aspired to delve into the motivations behind Leonardo's creation of such a strange race of beings. More recently, professional scholarship and criticism has given us Clark's epoch-making catalogue of the Windsor drawings and his beautifully scripted monograph. And the dedicated researches of such scholars as Augusto Marinoni and Carlo Pedretti has ensured that we have no excuse for remaining ignorant about Leonardo's manuscripts. Can we now claim to be close to a vision of the real Leonardo?

I think we can, in the sense in which the nature of his achievement is now more clearly delineated both in itself and with respect to its historical context. The general outlines of his artistic career and the attribution and dating of his works are reasonably stable and convincing. His seminal position in the forging of what is called the High Renaissance is indisputable, even if much of the detail of his relationships with his contemporaries and successors remains to be clarified. By contrast, the status and role of his writings on art remain surprisingly elusive, both with respect to his own practice and that of succeeding generations.

In terms of his scientific work, historians have revealed the extent and quality of scientific thought in the Middle Ages and established the theoretical framework on which Leonardo's own beliefs and practice were based. It has become clear that he is neither to be exalted as an isolated harbinger of the 'scientific revolution' nor dismissed as a derivative dabbler in Aristotelian commonplaces. Although he nowhere made a clear conceptual break with the characterisation of natural law in Mediaeval science, his persistent questioning did reveal the strains in the old order and suggest where new possibilities might lie. His position in the history of technology is harder to discern, not least because our knowledge of Mediaeval and Renaissance engineering is inevitably patchy. His mastery of contemporary techniques, particularly for the transmission of power, is fully apparent, as is his restless inventiveness, but the extent to which he played a fruitful role in Renaissance technology has not been satisfactorily elucidated. However, we do know that the more visionary aspects of his striving to master the forces of nature, particularly through flight, belong to a long tradition of fantastic inventions, which acquired renewed vigour in the Renaissance. Where Leonardo stands out

in his technology, as in other areas of his science, is in the astounding complexity of his powers of spatial visualisation, in his unprecedented conception of the potential of different types of visual representation, in his insistence on using direct 'experience' to relate even the smallest technological procedure or minutest functional detail to the basic laws of nature, and in his all-embracing vision of form and function in the inventions of man and nature.

In such respects, we are now in a position to gain a clearer view of the whole man, at least in terms of the evidence selectively preserved for posterity. What we would be unwise to claim is that we can see the 'true' Leonardo. Any complex body of historical material, particularly if one of its central features is a group of works of art, remains continuously responsive to different enquiries made of it by different enquirers with different values and priorities. We, no less than students of earlier eras, construct our own Leonardo.

However, I do not believe that the Leonardos of the various eras are incommensurable. It seems to me that there is a core to his achievement, however imperfectly transmitted and received by different generations, that remains intuitively accessible. What has been sensed is that his artistic productions are more than art – that they are part of a vision embracing a profound sense of the interrelatedness of things. The full complexity of life in the context of the world is somehow implied when he characterises any of its constituent parts. Leonardo's man, as artist-scientist-inventor, strives for an ever more complete mastery of nature, achieving almost god-like powers, but must necessarily remain aware that nature is not to be abused – that we are an integral and subject part of the natural system of the world. I believe that his vision of the totality of the world as a kind of single organism does speak to us with particular relevance today, now that our technological potential has become so awesome. This vision, I suggest, can lay the foundation for 'our' Leonardo. It is a Leonardo in which the totality of his own remaining work triumphs over the scarcity of finished parts. It is intended to be the Leonardo of this exhibition, and I hope it would have been recognisable to Leonardo himself.

'DISCIPLE OF EXPERIENCE' *Martin Kemp*

Dimmi se mai fu fatto alcuna cosa?

'Tell me if anything was ever done?' This question, sometimes in abbreviated forms such as *dimmi se mai*, echoes across Leonardo's manuscripts like a pessimistic refrain. It became his stock verbal doodle, apparently springing readily to mind when he wished to try out a new pen. To some extent the question is a matter of rhetoric and routine, but it clearly also had some special appeal for Leonardo. It is difficult not to feel that it directly expresses the frustration of a man who could unfailingly envisage limitless potentialities in all his fields of endeavour and yet was aware of the all too finite constraints which left him powerless to realise these potentialities in a finalised form.

If we ask the question directly of Leonardo, in relation to the agenda he set himself, the answer must be 'no'. Indeed the question could stand as his personal motto – a *divisa* in the Renaissance sense – alluding to the unfinished nature of his quest, in its whole and in so many of its parts. However, given the visual and intellectual glories of his work as it has come down to us, *dimmi se mai fu fatto alcuna cosa* is too melancholy in tone to be a fitting *divisa* for his achievement. Rather I should like to suggest that the emblem of the plough (fig. 7) at Windsor (12701), which was probably devised for a client, provides a more appropriate symbol for his heroic quest. The plough is accompanied by the motto *hostinato rigore* ('obstinate rigour', or, more figuratively, 'unswerving exactitude'). Elsewhere he provides alternative glosses for the emblem: 'obstacles do not bend me'; 'every obstacle is destroyed through rigour'; and 'I do not depart from my furrow'. The idea is clearly one of unswerving purpose, guided by principles in the face of which every impediment must ultimately yield.

There is no doubt which principle Leonardo considered as defining the true direction for the furrow he wished to plough. That principle was what he termed 'experience':

> Many believe that they can reasonably reproach me, alleging that my proofs go against the authority of those men held in greatest reverence by those of inexpert judgement, not considering that my works are born of simple and pure experience, which is the true mistress. This gives rules by which you are able to distinguish the true from the false, and enable men to strive towards what is possible with more discrimination and not to wrap themselves up in ignorance. If the rules are not put into effect, you will in despair give yourself up to melancholy.
>
> They say that knowledge born of experience is mechanical but that knowledge born and ending in the mind is scientific, and that knowledge born in science and ending in manual operations is semi-mechanical, but to me it appears that those sciences are vain and full of error that have not been born of

Fig. 7 *Emblem of a Plough*, c.1508, pen and ink and brown wash with blue chalk (Windsor 12701, detail)

experience, mother of every certainty, and which do not likewise end in experience; that is to say those that have neither at their beginning, middle nor end passed through any of the five senses.

These and other rigorous assertions of the primacy of experience and the necessity of sensory knowledge align Leonardo's thought with prominent aspects of the Aristotelian tradition in Mediaeval science, and give him what he considered an infallible way of overcoming the bookish obstacles placed in his path by humanist pedants, who looked to the authority of the written word rather than use their own eyes. Leonardo was acutely aware that 'not being a man of letters, it will appear to some presumptuous people that they can reasonably belabour me with the accusation that I am a man without learning'.

Relatively speaking, Leonardo must be considered as a 'man without learning' when he is set beside other thinkers in preceding, contemporary and later generations who aspired to make progress in the highest realms of natural philosophy. His familiarity with the existing Latin literature on the sciences was very limited compared, say, to Galileo or Kepler, and he never acquired the facility in handling the Aristotelian corpus of knowledge that would have been expected of a teacher in a late Mediaeval university. Although it has been claimed that this relative ignorance was a positive advantage for Leonardo, there is every indication that he did not regard it in this light himself – whatever his rhetorical stance in public as a man hostile to book learning – and that he worked strenuously to master the framework of natural law in ancient and Mediaeval philosophy. His revered 'experience' could in reality only gain articulate shape under the shaping hand of traditional wisdom. The form of traditional wisdom which provided him with the ultimate means for the structuring of experience was mathematics:

> True sciences are those which have penetrated through the senses as a result of experience and thus silencing the tongues of disputants, not feeding investigators on dreams but always proceeding successively from primary truths and established principles, in a proper order towards the conclusion. This may be witnessed in the principles of mathematics, that is to say number and measure – termed arithmetic and geometry – which deal with discontinuous and continuous quantities with the utmost truth. Here no one hazards guesses as to whether two threes make more or less than six, or whether the areas of a triangle are less than two right angles. Here all guesswork remains destroyed in eternal silence, and these sciences are enjoyed by their devotees in peace, which is not possible with delusory sciences of a wholly cerebral kind.

Leonardo's notebooks bear witness to his search amongst traditional texts for the principles of nature – the mathematicising laws – which could provide him with criteria for the analysis of experience. Occasionally he refers directly to the authorities or texts he consulted, while at other times his analysis gives a clear impression of the sources for the ideas he is exploiting. The internal evidence of the notes themselves is supplemented by a number of booklists, the fullest of which is on the second and third folios of Codex Madrid II. This list contains some one hundred and sixteen named items, of which more than forty are concerned with natural philosophy. Of particular importance in the various branches of his study were Johannes de Ketham's *Fasciculus di medicinae* (for his anatomy),

Euclid's *Elements* (for his geometry), John Pecham's *Prospettiva communis* (for his optics), Albertus Magnus's *Opus philosophie naturalis* (for a range of natural laws), and Ptolemy's *Cosmography* (for the mapping of the heavens and earth).

It is clear that his aim was to construct a 'universal science', rather in the manner of Roger Bacon but without Bacon's sustained exposition of theological truths. This science was to be founded on the shared principles behind the diverse phenomena of nature. But the principles themselves were never enough for Leonardo. Only when he had explained with the utmost rigour all the multitudinous varieties of observed effects could he rest content. Every tiny detail of anatomical structure must be explained in terms of its perfectly functioning design. Every vortex in turbulent water must be characterised in terms of the principles of impetus, percussion and revolving motion. Every light effect must be understood in terms of strength, distance, angle, reflection, colour, atmosphere etc. Only when the investigator of nature had investigated these and all other natural phenomena, achieving a perfect match between causes and effects in every conceivable case, could he consider his quest accomplished. And only when the painter had achieved a complete understanding of natural form and function could a 'second world of nature' be constructed for any imagined situation in a way that matched Leonardo's ideals of perfection.

Such ideals of total understanding, which ultimately demanded the ability to forecast any conceivable effect, inevitably condemned Leonardo's quest to incompletion. There is every indication that he recognised this himself – *dimmi se mai fu fatto alcuna cosa* – but found himself powerless to reach the kind of workable compromise that must be made if any investigation is to be brought to a practical conclusion. Nowhere does this inability to compromise on a practical base emerge more clearly than in his written agendas for the depiction of battles and deluges (nos. 22, 64, 66 and 87). Every visual factor, from the shape of the grandest mass to the minutest optical nuance, every aspect of natural law, from the greatest surges of flood waters to the behaviour of particles of dust, and every aspect of human behaviour, from general locomotion to the clenching of teeth, must be characterised in remorseless perfection according to the infallible law of 'necessity', which constrains all effects to obey their causes with absolute directness.

Leonardo's inability to compromise on a workable base was a product of a creative imagination which always provided him with an endlessly extended series of insights into what should or might be possible. The restless fertility of his imagination – what he called *fantasia* – was both a blessing and a curse, but, either way, it demanded nourishment no less insistently than the more analytical faculties of his *intelletto*. His booklists bear vivid witness to the way in which he sought such nourishment. Works of literary imagination (accepting for the moment a somewhat anachronistic classification) figure as prominently as treatises in natural philosophy. He owned books of chivalric romances, amatory and burlesque poetry, didactic poetry and collections of tales, fables and jests. Leonardo himself tried his hand at many of these literary genres in his notebooks, and the arguments against poetry in his *paragone* knowingly challenge almost all the established forms of poetic expression. The almost obsessive vigour with which he attempts to secure painting's triumph over literature reflects his awareness of the powerful achievements of the great Italian writers. This is true above all of Dante, whose great edifice of elevated fantasy was constructed upon

secure foundations in natural philosophy and theology. Dante provided Leonardo with an important vernacular education in the nature of the physical world and with a supreme challenge as an imaginative inventor. The difference was that Dante could make his knowledge serve his chosen art, whereas every aspect of Leonardo's knowledge tried to serve every other.

Presenting Leonardo's unified yet multifarious vision in a way which matches his own ideals is an impossible task within the scope of a single exhibition or within the covers of a single book. This impossibility is not simply a question of the unfinished and fragmentary state of his surviving legacy, but it is more profoundly concerned with the problems of classification. Any orderly presentation requires classification, as Leonardo well realised as a student of scholastic science. As he wrote on what is now the first folio of the Codex Arundel: 'This will be a collection without order drawn from many pages which I have copied here, hoping then to put them in order in their places, according to the subjects with which they will deal, and I believe that before I am at an end of this, I will have to repeat the same thing many times.'

Leonardo has left various guides as to what he considered the 'subjects', *materie*, under which he was to classify his knowledge. There are titles of books on some of the folios – 'On the Human Figure', 'On Water', 'The Elements of Machines', 'The Book of Beneficial Inventions', 'On the Flight of Birds', etc. – and he occasionally tabulated subdivisions for a particular treatise. Not infrequently he makes a cross-reference to one of his own treatises, mentioning, say, the fifth (proposition) of the second (book) on a particular subject. However, the indications are that none of the projected treatises reached a definitive point of organisation and completion. The classifications of knowledge which he used were broadly in line with those in late Mediaeval natural philosophy, and the texts in his completed treatises would probably have been presented somewhat in the manner of John Pecham's Mediaeval text-book on optics, the *Perspectiva communis* – divided into a number of 'books', each of which would contain a systematic series of propositions in the form of subheadings which would subsequently be expounded in sections of varying length. Clearly, the modern student of Leonardo's works stands no realistic chance of assembling the surviving fragments of his incomplete works according to such an elaborate model.

However, the drawings and texts can and have been presented effectively under a series of broad headings, such as 'Anatomy', 'Mechanics', 'Mathematics', 'Optics' and 'Art', which may in some cases bear a resemblance to Leonardo's own categories. Why has that obvious option not been followed here? One answer is that we should not accord a privileged position to the late Mediaeval and Renaissance categories that served Leonardo so inadequately – and we certainly should not assume that our modern systems of classification will work any better, on the grounds that Leonardo was a 'modern' before his time. Rather, the present manner of presenting his legacy is based upon the characteristic patterns of his thought which emerge from a close study of the drawings and manuscripts as a whole. It is a matter of exploiting the benefits of historical hindsight with sensitivity and discrimination to reveal the underlying structures of his vision. The strength and beauty of these structures are responsible for the compelling quality of his drawn and written legacy, and they are responsible to no less a degree for the failure of his thought to sit comfortably within conventional frames of reference. The grouping of his works under the thematic divisions

which follow in this catalogue should not be regarded as the definitive way to provide access to his thought. Different divisions would give different relative weights to other qualities of his mind. But I believe that the present system does allow the central characteristics of his vision in all its fluidity, subtlety and universality to emerge through a series of visual analogies, concordances and conjunctions.

Leonardo wished to be regarded as a 'disciple of experience'. The works assembled here show that no one has ever presented us with a greater range of the human experience of man and nature as what in modern parlance would be called interactive systems. In the face of this vision, the question as to whether 'anything was ever done' becomes irrelevant and trivial.

Jane Roberts THE DRAWINGS AND MANUSCRIPTS

History

Leonardo was extraordinarily prolific both as a writer and as a draughtsman. It should therefore come as no surprise to learn that we have more drawings by him than by any other major artist of his time. We are thus able to examine in detail Leonardo's activities and interests at different stages of his long life. However, it is also clear that what has survived (particularly in Milan, Paris and Windsor) is only a fraction of Leonardo's total output. In the artist's will, written in France on 23 April 1519 (nine days before his death), he bequeathed all the books which he had with him to his friend and pupil Francesco Melzi. Two years earlier Antonio de'Beatis had reported seeing 'an infinite number of volumes' during his visit to Leonardo in France. Melzi's inheritance evidently included the majority of the artist's drawings and notes, and specifically the anatomical studies which were at the time bound into a series of notebooks of various small dimensions. Vasari visited Melzi in Milan in 1566 and saw his Leonardo collection which, incidentally, included a number of drawings, particularly 'replacement copies' of drawings by Leonardo, in Melzi's own hand: there are notes by Melzi on the verso of no. 26, for instance, and the red chalk study on no. 97 may also be by him. Vasari's Life of Leonardo also mentions several drawings of heads of men and women, in pen and ink and in chalk, which were in the writer's own collection. An early sixteenth-century source (the 'Anonimo Gaddiano') refers to the drawings which were left at the hospital of Sta Maria Nuova in Florence, on Leonardo's departure for France in 1516. It is worth noting that the main repositories of Leonardo's work (in Milan, Paris and Windsor) contain very little that can be dated before 1480, by which time Leonardo was an established artist in his late twenties. The little that has survived from his early years is elsewhere, but clearly much has perished. Some indication of the amount of material that has gone emerged as a result of Carlo Pedretti's reconstruction of the lost *Libro A*: 'there must have been enough additional material to form another volume of the same bulk as the Codex Atlanticus' (Pedretti, *Libro A*, p. 255).

Following Melzi's death (*c.*1570) his collection passed to his son Orazio, who had sold the majority to the sculptor Pompeo Leoni by 1590. Leoni is known to have owned at least ten Leonardo manuscripts as well as a number of loose drawings. These he sorted and arranged into a number of volumes, or rather albums, grouping together studies with related subject matter (e.g. mechanical drawings, anatomical studies, plants, etc.). This sorting operation involved a certain amount of trimming of the original sheets. In some cases a fragment was cut out of a larger sheet and the two parts were mounted in different albums, which are today divided between Milan and Windsor (see Pedretti, *Windsor*

Fragments). During his time in Italy in the period 1600–6 Rubens had access to the anatomical drawings. However, towards the end of Leoni's life, he took the main part of his collection to Spain, where he was employed as court sculptor. Following his death in Madrid in 1608, inventories mention four volumes of Leonardo manuscripts and drawings, made up respectively of 174, 206, 234 and 268 folios. Meanwhile, part of Leoni's collection appears to have remained in Milan where, in 1625, the great corpus of Leonardo drawings called (from the large dimensions of its binding) the 'Codice Atlantico' (fig. 11) was purchased by Galeazzo Arconati from Leoni's son-in-law, Polidoro Calchi. With ten other Leonardo notebooks the Codex was presented by Arconati to the Biblioteca Ambrosiana in 1637. Leoni's Spanish estate was dispersed rather earlier, in a series of auctions of which the outcome is largely the subject of conjecture. Of the four Leonardo volumes only that made up of 234 folios can now be identified with any degree of certainty: a volume with precisely that number of pages was noted in the late eighteenth century in the British Royal Collection, where it is known to have been for almost a hundred years and where it still remains.

The 'Windsor Leoni volume' (fig. 9) (as it will hereafter be referred to) was almost certainly purchased in Spain by agents acting for Thomas Howard, Earl of Arundel, and brought to England where copies demonstrate its presence by 1627. Hollar's etched versions of a selection of the Windsor drawings were presumably made during the years that he was in Arundel's service in England (1636–41); indeed two (Parthey 1609 and 1771; fig. 8) are inscribed *Ex Collectione Arundeliana*. However, the dates on Hollar's etchings of the Windsor Leonardos (1645–66) indicate that Arundel (who died in 1646) could not have been directly involved in their publication. Hollar also etched a few Leonardo (and School) studies which are not included in the Windsor series. In addition to the Windsor Leoni volume and the manuscript now in the British Library (the Codex Arundel, no. 101), Arundel evidently had other miscellaneous Leonardo drawings in his collection. These were presumably obtained for him by agents in Italy (particularly in Milan) or Spain.

It is far from clear how and when the Windsor Leoni volume entered the Royal Collection. Count Arconati noted that drawings by Leonardo concerning anatomy, nature and colour were 'in the hands of the King of England' before 1640. Such information is difficult to equate with the inscriptions on Hollar's etchings, for Arundel left England for ever in 1641 and died five years later. The political climate of the 1640s ensured that Charles I was not in a position to purchase works of art from Arundel's estate. The Leonardo volume does not appear in any of the inventories of the collections of the earlier Stuart monarchs. However, in his diary entry for 22 January 1690 King William III's secretary Constantine Huygens noted a visit to the queen's closet (at Kensington) where he was shown four or five albums of drawings, in addition to those containing works by Holbein and Leonardo. This reference occurs only one year after the joint accession to the English throne of William and Mary. If the drawings had been in their possession in Holland it is unlikely that Huygens would have commented on them in such a way. It is also highly unlikely that King James II acquired them. We must therefore conclude that the Windsor Leoni volume was an acquisition of either Charles I or Charles II. By 1690 it was certainly in royal ownership, and nearly three hundred years later remains one of the greatest treasures of the British Royal Collection. Its six hundred or so individual drawings have gradually been

Fig. 8 Wenceslaus Hollar, etching after Leonardo, *c*.1646, (see cat. 90), Royal Library, Windsor Castle (Parthey 1609)

Fig. 9 *The Leoni binding*, Royal Library, Windsor Castle

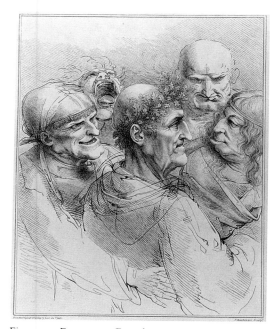

Fig. 10 Francesco Bartolozzi, engraving after Leonardo, published by John Chamberlaine, 1812, Royal Library, Windsor Castle

Fig. 11 *The Leoni binding*, Biblioteca Ambrosiana, Milan

removed from the original binding and are now all independently mounted and thus able to be exhibited.

Conversely, the 1,750 or so sheets that make up the Codex Atlanticus have recently been inserted into the pages of a number of new albums, in a way which virtually precludes their travelling for an exhibition. Although many of Leonardo's ideas in the scientific and technical fields, including statics, dynamics and engineering, are illustrated in these pages, it was not feasible to include any part of the Codex in the present exhibition.

Before leaving the Windsor and Milan volumes it is worth recalling the uniformity (of style and lettering) of the two bindings which originally housed the two collections (and which both survive, emptied of their contents, in their respective libraries), and the fact that both sets of drawings were long ago inscribed (perhaps by Leoni himself) with figures which are neither consecutive nor comprehensible. The absence of similar numbering on other 'stray' Leonardo drawings suggests that they may never have formed part of Leoni's collection. The sixteenth-century provenance of these other drawings is unknown, but collectors' marks indicate that by the seventeenth and eighteenth centuries a number had entered the collections of Peter Lely, Jonathan Richardson the Elder, General Guise, Thomas Lawrence and others.

In addition to the two albums in Milan and Windsor (into which individual drawings were pasted) there is the series of independent Leonardo manuscripts (including some still in the form of the notebooks actually used by Leonardo) of which nine are included in the present exhibition (nos. 59, 60, 100, 101, 102, 112, 115, 116 and 118). All but two of the thirteen books of varying sizes in Paris, named by letter from A to M, share the same provenance as the Codex Atlanticus, with which, in 1796, they travelled from Milan by order of Napoleon. However, unlike the Codex they remained in Paris and are still to be found in the Library of the Institut de France. It is possible that the two recently rediscovered Madrid Codices (see nos. 115 and 116) also once belonged to Leoni, who may have transported them to Spain. Other Leonardo manuscripts include a set of small notebooks (collectively the Codex Forster; see nos. 59, 60, and 112) in the Library of the Victoria and Albert Museum, the Codex Hammer (formerly the Codex Leicester, now disbound in Los Angeles) and the Codex Trivulzianus (in Milan). (The complete history of these volumes is given in clear tabular form in Pedretti, *Libro A*, pp. 256–7. See also Pedretti, *Richter Commentary I*, pp. 92–7).

The availability of Leonardo's notes and drawings to scholars and artists at different times is a subject of study in itself. In Leonardo's lifetime a small group of his drawings of geometrical bodies were reproduced as woodcut illustrations in Luca Pacioli's *De divina proportione* (1509; no. 104). But although there is a strong possibility that Leonardo himself intended to publish the results of his anatomical research (see note on no. 109), it was four hundred years before these particular drawings and writings were made available to a wider public. Hollar's etchings had disseminated on a small scale a number of key images (both anatomical and non-anatomical) in the mid-seventeenth century, and during George III's reign engravings of seventeen of the Windsor drawings were included in John Chamberlaine's *Imitations of Original Designs by Leonardo da Vinci* (1812; fig. 10). The scholarship of Venturi, Bossi and others during that period was only followed up around sixty years later with the great generation of scholars such as Milanesi, Uzielli, Piumati, Richter and Müller-Walde, who for the first

time applied scientific techniques and scholarship to Leonardo's manuscripts and drawings. The labours of these men have proved to be the foundation of modern Leonardo scholarship, which is now served by an increasing number of facsimile editions, accompanied by transcriptions and translations of Leonardo's notes.

Rationale and technique

Even a casual observer will notice that this exhibition (and catalogue) includes a variety of different types of drawings: there are small explanatory diagrams on sheets of paper covered with notes and memoranda; there are studies of natural phenomena, drawn from life; and then there are pages of pure draughtsmanship, thoroughly-worked preparatory studies for one of Leonardo's projects in painting, architecture and technology. Finally, there are 'presentation drawings' such as the lost *Neptune* for Antonio Segni (see no. 71), and the *Allegory with a Wolf and Eagle* (no. 82); the 'Deluge Drawings' should also very possibly be included in this category. The artist expounded the advantages of drawing over verbal description on a number of occasions. Around 1510 he added a note to the beautiful page of studies of the human spine (no. 109) explaining that by drawing the various interlocking parts (of the spine) 'you will give true knowledge of their shapes, knowledge which is impossible for either ancient or modern writers . . . without an immense, tedious and confused length of writing and time'. This was particularly the case with a draughtsman of the calibre of Leonardo.

Yet, in spite of the quantities of drawings and notes by Leonardo which have come down to us, we are continually reminded of the fact that what we have is only a fragment of what once existed. The few botanical studies that have survived are a case in point. Leonardo must have made many hundreds of other studies of plants and flowers, to enable him to paint the 'floral carpets' of the *Annunciation*, the *Virgin of the Rocks*, the (lost) *Leda*, or to have conceived the complex foliage interlace for the vault of the Sala delle Asse in the Castello Sforzesco in Milan. Likewise, for a great mural painting such as the *Battle of Anghiari* he would probably have made detailed studies for every figure, or even for every detail of every figure, in addition to careful compositional studies showing how the various parts would connect with one another. Of these we only have around eight small compositional studies (eg. nos. 13 and 87), the merest sketches, a number of small-scale studies associated with different horses or figures, and three large heads for horsemen.

Leonardo's manuscripts would often contain lists (fig. 12), whether of food bought or consumed, books read or in store or of his own works (eg: Codex Atlanticus ff.210ra/559r and 324/888r). The following selection from such a list, probably made in the early 1480s, may give some indication of the contents of Leonardo's studio, as he was embarking on what was to be the most fruitful period of his working career:

> many flowers copied from nature
> measurements of a figure
> designs of furnaces
> many designs of knots
> 4 drawings for the picture of the Holy Angel

Fig. 12 Works listed in Leonardo's collection (C.A. f.324r/888r)

a head of Christ done in pen
many compositions of angels
certain forms in perspective
many necks of old women
many heads of old men
many complete nudes
many arms, legs, feet and postures

Although we may be able to identify one or two items on this list, the repetition of 'many', particularly when related to drawings at this comparatively early stage of Leonardo's career, reminds one of the quantity of that which has not survived.

All the drawing media available in Italy during the Renaissance period were employed by Leonardo at different stages of his life. He used paper of Italian (and later also of French) manufacture, and almost invariably of such high quality that it seems as strong today as it was in Leonardo's day, 500 years ago. His earliest dated drawing (the Uffizi landscape of 1473) was unfortunately considered to be in too poor a state to be lent to the exhibition, not because of the intrinsic quality of the paper, but because the corrosive nature of the ink has in parts burned holes through the support. The elaborate spidery gothic manuscript added by the artist to this page, the very obvious recessional lines and the curiously idiosyncratic shorthand method of drawing trees, gradually developed into the more ordered, regular and 'classical' style of his pen drawings such as the skull studies of 1489 (e.g. nos. 9 and 93), in which both the handwriting and the draughtsmanship have assumed an almost obsessive clarity and neatness. The skulls are completed in ink over very faint preparatory underdrawing in black chalk (or black lead). Other pen and ink drawings are more free-hand, using the expressive qualities of the calligraphic sweep of the pen to the full. Sheets such as nos. 5 and 6, with the central figures of the Virgin and Child apparently still moving in front of our eyes, show how many different touches of pen and ink, and how many different styles of pen drawing, were in use by Leonardo at the same time. These pages are normally dated in the period 1478–81, during his first Florentine period. By the time of his return to Florence around twenty years later, Leonardo's use of the drawn line had changed in one very significant respect: whereas the early drawings are shaded and modelled in diagonal strokes, from top left to bottom right (typically for a left-handed artist), the later studies are drawn and shaded by lines following the three-dimensional shape of the object depicted. Thus, the convexity of a cylinder will be shown by a series of parallel curved lines passing around the surface of the form rather than by a group of straight lines running diagonally across the form. It may be no coincidence that Leonardo and Michelangelo were working alongside each other in Florence during the years in which this new, more sculptural style was being evolved.

Another refinement, namely the delicate application of wash in place of hatching or shading lines, is apparent from Leonardo's earliest drawings such as *A Lily* (no. 42). On slightly later drawings of a more technical nature the wash is applied in quite a different way, suggesting that its use is there derived from the convention found in engineering treatises known to Leonardo. This technique, which often passes unnoticed, is seen on studies of a file maker (*c*.1480), and of weapons (e.g. nos. 68 and 69), but continued in use to the series of anatomical studies (including that of the spine, no. 109) of *c*.1510, and the *Foetus in the Womb* (no. 26) of shortly thereafter. By this time the handwriting is less ordered, and the

drawn page apparently crammed with a random series of images. Leonardo's late handwriting style is blunt and rapid, particularly so on the rougher and more absorbent surface of the French paper that he latterly employed. And like the ink used in the 1473 landscape, the ink used by Leonardo in his last years was very corrosive.

Pen and ink was the most popular of the drawing media used by Leonardo, and the one that would most readily be used for the quick sketches and diagrams that accompanied his notes. Metalpoint (or silverpoint, as it tends somewhat inaccurately to be described), the favourite drawing technique of the Early Renaissance, was used by Leonardo for many of his finest and most finished drawings, until the early 1490s. The head *Bust of a Warrior* (no. 2), the *Study of Arms and Hands* (no. 4), and the Sforza horses (nos. 8 and 40), are all drawn in metalpoint on the tinted chalky coating of the paper. When Leonardo advised the artist to make notes (*brevi segni*) in 'the little notebook which you must always carry with you', he added that the paper should be tinted (i.e. coated) 'so that it cannot be erased': the sketches were evidently to be in metalpoint. There is at once a delicacy and precision to metalpoint drawing which likens it to miniature painting. It is therefore no surprise to discover that for large-scale paintings such as the *Last Supper* (fig. 25) and the *Battle of Anghiari* Leonardo abandoned metalpoint for a new drawing material, chalk, which allowed for an effect of greater breadth and an easier means of modelling in three dimensions, and with the lighter and more rapid touch of the drawing point enabled the artist to depict movement with extraordinary vigour (e.g. no. 73). Kenneth Clark described the *Last Supper* as the first High Renaissance composition and the drawings for it are the first important Italian drawings in red chalk. But just as Leonardo could adjust his use of pen and ink to his requirements at a given moment, so could he vary the touch and effect of his red chalk drawings. *A Copse of Trees* (no. 12) was drawn in the same period as *A Rearing Horse* (no. 73), but to what different effect. Shortly afterwards Leonardo experimented with the textural possibilities afforded by the use of red chalk on red coated paper, a combination which might have proved more successful had the coating been lighter in tone and the actual drawing thus more easily legible. According to Gianpaolo, writing at the end of the sixteenth century, Leonardo should also be credited with the invention of the pastel drawing (or painting) technique. With the exception of the Louvre portrait of Isabella d'Este (fig. 27) (which could not be lent to this exhibition), no pastel by Leonardo has come down to us. The luminosity, the colouristic possibilities, and the *sfumato* effects of pastel would surely have appealed to him. The use of the technique by his followers, by Michelangelo (in the *Virgin and Child* in the Casa Buonarroti), by artists in the circle of Correggio, and by Barocci, all lend support to Lomazzo's statement.

By the end of Leonardo's life black chalk had become his preferred drawing medium. In it he found the means to express the swirling destructiveness of wind and water in the 'Deluge Drawings' (nos. 22, 63 and 66), the elegantly clad masquerade figures, and the *Pointing Lady in a Landscape* (no. 79) in which 'the touch is as broken and evasive as the latest Titian, and has the same unity of effect. We cannot imagine the drawing being done part by part. A puff of wind has blown away the mist, and revealed this goddess, as stately as an elm, as subtle as a gothic Virgin.' (Kenneth Clark)

Jane Roberts THE LIFE OF LEONARDO

For a figure of such universally acknowledged importance, who has left behind so many manuscripts and drawings, it comes as some surprise to discover how little we have in the way of secure biographical information concerning Leonardo. Few documents, contemporary sources or letters (either to or from Leonardo) have survived. A limited number of drawings or notes are actually dated, but for the rest a great deal of detective work is necessary. As Leonardo's fame was already established in his own lifetime, brief references to particular works appeared in topographical or chronological accounts (such as Albertini's *Memoriale* of 1510). Shortly before the artist's death the *Libro di Antonio Billi*, the important early biographical manuscript, lists eight works by Leonardo and mentions his various talents and consistent failure to complete his 'inventions'. Around a decade later Paolo Giovio included Leonardo among the famous men and women of whom he wrote eulogies. The most extensive early biography is that by the so-called 'Anonimo Gaddiano' (or Magliabecchiano), written *c*.1542. The previous lists of works are greatly amplified, and further details are provided concerning his early life, his appearance, and the various techniques he employed. Vasari's Life (particularly in the 1568 edition) draws heavily on all the earlier accounts and amplifies the technical and biographical information and the *œuvre*.

The scarcity of biographical information is particularly noticeable in the crucial years before Leonardo's first visit to Milan in the early 1480s. The artist's birth on 15 April 1452, at the tiny village of Anchiano, near Vinci in the hills to the west of Florence, was recorded by his paternal grandfather. Leonardo was the illegitimate son of a local peasant girl Caterina (who married a lime-burner five years later) and Piero, the son of a professional Florentine family with a house in Vinci, which was Leonardo's first home. Leonardo's father, Ser Piero, is recorded as having married four times, and having fathered a further eleven children. Like other members of his family, Piero became a successful notary and following the death of his grandfather in 1468, and from 1469 at least, it is likely that Leonardo joined his father in Florence, where the latter had been appointed notary to the Signoria, the governing body in Florence. In 1469 Leonardo appears to have entered the workshop of the artist Andrea Verrocchio, whose other apprentices included Domenico Ghirlandaio, Pietro Perugino and Sandro Botticelli. We know nothing of Leonardo's early education, either general or artistic. Vasari describes his first years in the Tuscan hills drawing flowers and animals or modelling women and children in clay, and fashioning fantastic creatures such as dragons. He records that the young Leonardo was also talented both as a musician and as a mathematician, indications which help confirm that he was far from an 'unlettered man'.

In 1472 Leonardo's name was inscribed on the roll of the Florentine 'Company

Fig. 13 *Studies of Heads and Machines*, 1478, pen and ink, Galleria degli Uffizi, Florence (446E)

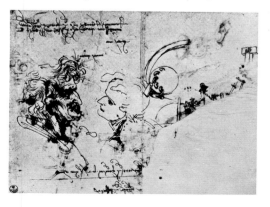

of St Luke', the painters' Confraternity. At the age of twenty he had achieved the status of an independent artist. However, we know (from the records associated with two accusations of sodomy made against Leonardo) that four years later he was still residing in the house of his master Verrocchio. According to the Anonimo Gaddiano, Leonardo belonged to the 'Academy' set up by Lorenzo the Magnificent to enable talented youths to work among the Medici collection of antique sculpture in Florence. The artist's first dated work, the landscape drawing in the Uffizi (fig. 14), is inscribed with the date 2 August 1473. Another drawing shows the hanging body of Bernardo di Bandino Baroncelli (fig. 15), who was hung on 29 December 1479 for the murder of Giuliano de Medici. Leonardo's chief activity in these years would have been the production of religious paintings, particularly altarpieces and small-scale devotional works. His first recorded independent commission was placed by the Florentine government and concerned the altarpiece of the Chapel of St Bernard in the seat of government, the Palazzo Vecchio. The initial payment for this was made in March 1478, but the project was inexplicably abandoned, and the altarpiece later provided by Filippino Lippi. In the same year, 1478, in a note on a sheet of pen drawings in the Uffizi (fig. 13), Leonardo recorded having begun work on 'two Virgin Marys'. His training in Verrocchio's workshop would doubtless have included some sculptural activity and although we assume that these two works were paintings, they could equally well have been free-standing sculptures or reliefs. Then in March 1481 Leonardo received a commission for a painting of the adoration of the Magi (fig. 16) for the high altar of the monastic church of S. Donato a Scopeto outside Florence. The last payment for this project, which he left unfinished, was made to Leonardo in September of the same year. It is likely that his departure from Milan also accounts for his abandonment of the *St Jerome* (fig. 17) in the Vatican which shares many technical and stylistic characteristics with the *Adoration*.

The picture commissioned in March 1481 for S. Donato is the only properly

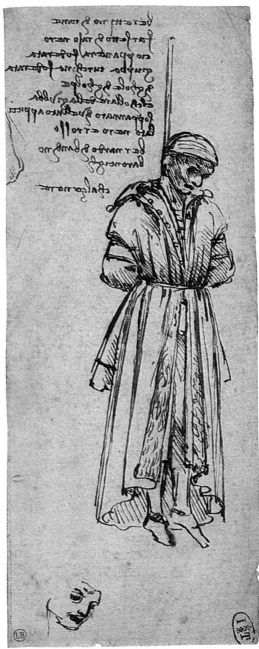

Fig. 15 *Hanging Body of Bernardo di Bandino Baroncelli*, 1479, pen and ink, Musée Bonnat, Bayonne (659)

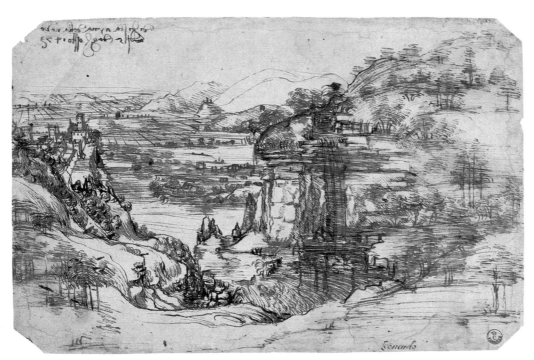

Fig. 14 *Study of a Tuscan Landscape*, 1473, pen and ink, Galleria degli Uffizi, Florence (8.P)

documented work from Leonardo's first Florentine period. But as it remains unfinished, with only the brown underpaint and no colour added, it can be used only with difficulty as a touchstone for the artist's early style and to provide some idea of his early artistic development. Nevertheless, as Kenneth Clark rightly observed, the *Adoration* is 'an overture to all Leonardo's work, full of themes which will recur', and it constitutes the first mature and independent statement of his genius. Surrounding the perfectly balanced central pyramidal group of the Virgin and Child, with the kneeling kings to either side, Leonardo has sketched

Fig. 16 *Adoration of the Magi, c.*1481, 246 × 243 cm, Galleria degli Uffizi, Florence

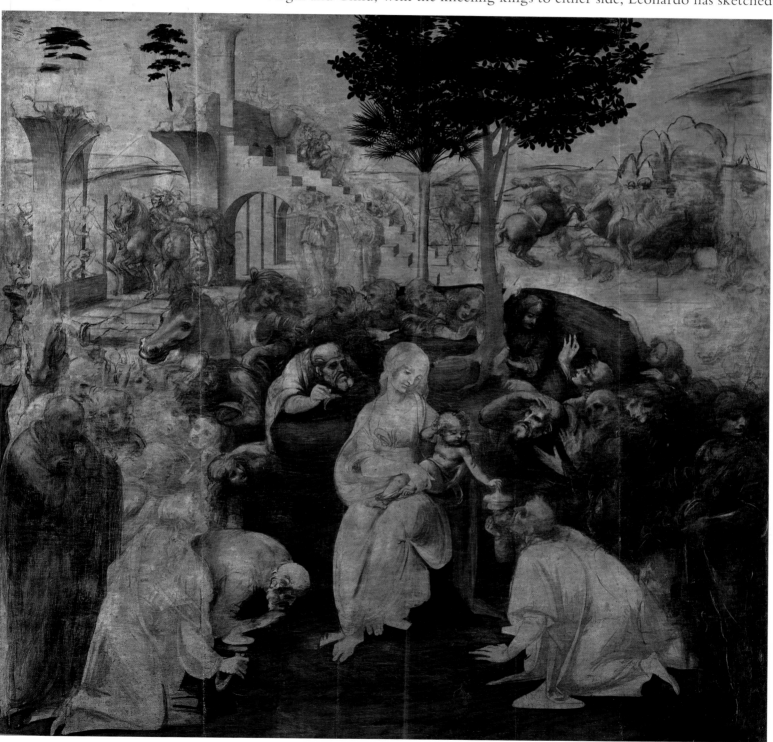

figures with a variety of gesture and emotion that is quite new to Italian art. Although Leonardo (like his master Verrocchio) was naturally aware of the vocabulary of pose and facial type to be found in antique art, the *Adoration* has very little to do with this and instead depends on Leonardo's control of living forms drawn from life. The principal figures are not ranged in some carefully contrived classical architectural setting, but are rather crowded into the near and middle distance, where the massing of forms achieves a structural effect in its own right.

A number of other paintings are traditionally dated to Leonardo's first Florentine period. The *Benois Madonna* (fig. 18) in the Hermitage and *Virgin with Flowers* (fig. 19) in Munich and may be related to the reference to the two 'Virgin Marys' begun in 1478, although the Munich picture is probably a little earlier as it is obviously related to Verrocchio's studio, where Leonardo is documented as residing until 1476. During this period Verrocchio's work included the (unfinished) Uffizi *Baptism* (fig. 20) for the monastic church of S. Salvi outside Florence. According to Albertini's *Memoriale* of 1510, this painting includes 'an angel by Leonardo', a statement amplified by Vasari as follows: 'Leonardo did an angel holding some clothes and, although quite young, he made it far better than

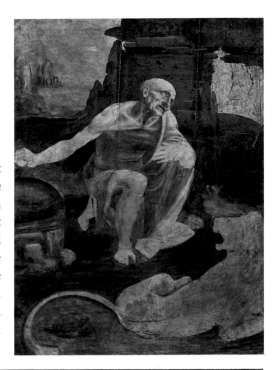

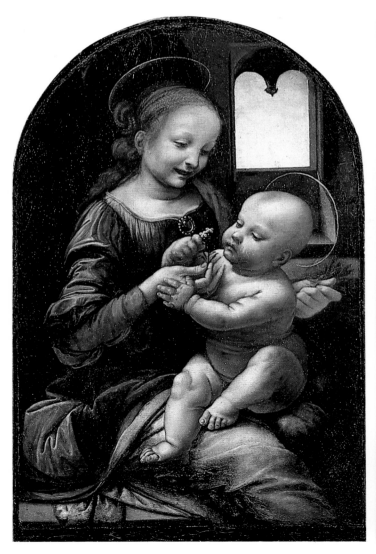

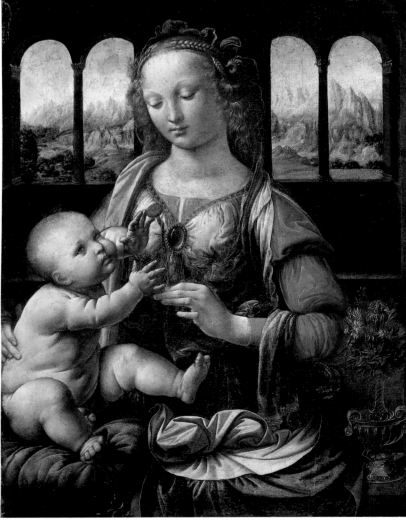

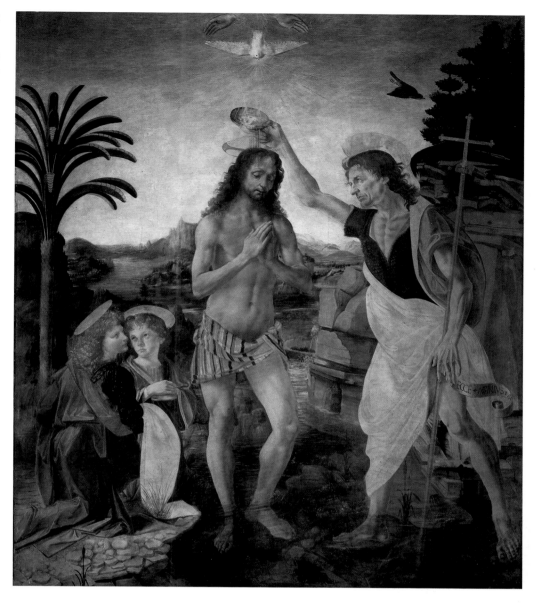

the figures of Andrea [Verrocchio]. The latter would never afterwards touch colours, chagrined that a child [aged 20?] should know more than he.' It does indeed appear that Verrocchio concentrated on sculpture after 1472, relying upon senior assistants in the workshop to produce painted works.

Two further early works are the Uffizi *Annunciation* (fig. 21) from the convent of Monte Oliveto outside Florence and the portrait of the lady called *Ginevra de' Benci* (fig. 22) (National Gallery of Art, Washington). Leonardo's portrait of Ginevra, the talented daughter of the Florentine banker Amerigo de' Benci, was first mentioned in 1518, and was later noted by Vasari and others. It is reasonable to assume both that it was painted at around the time of her marriage (in 1474, at the age of 16), and also that the Washington painting, showing the sitter in front of a juniper bush (for which the Italian word is *ginepro*), is the picture described. Both works can be attributed with ease to an artist working in the context of Verrocchio's studio, while demonstrating unusual qualities in the subtle modelling of the face and neck (particularly of the portrait), and in the depiction of

highlights of the hair. The characterisation of 'melancholy beauty' is one which often recurs in Leonardo's work, even as late as the *Pointing Lady* of *c*.1512 (no. 79). So far as these first works are concerned we must conclude, following Kenneth Clark once again, 'that the early pictures are less good than we should expect them to be. Only one of them [*Ginevra*] is wholly successful as a work of art. The others must be enjoyed in detail or "read backwards" in the light of his later work.'

Leonardo's move from Florence to Milan probably took place at the end of 1481 or the start of 1482. In Florence he had been active chiefly as a painter, but in Milan he appears to have been expected to fill a wider role. According to the Anonimo Gaddiano – and later Vasari – Leonardo was sent to Milan by Lorenzo the Magnificent as a sort of musical ambassador, to present a lyre to the Duke of Milan. However, in the artist's undated letter to Ludovico Sforza (which was possibly drafted after his arrival in Milan) he offered his services principally as a designer of military (and naval) weaponry and secondly (in peacetime) as an architect, painter, drainage engineer, and as the sculptor who could model and cast 'the bronze horse' planned to commemorate Ludovico's father, Duke Francesco (Codex Atlanticus, f.391r/1082r). Leonardo remained in Milan as the faithful servant of the Sforza court for the next seventeen years and he was indeed called upon to work in a very large number of different roles, from costume designer to hydraulic engineer.

In April 1483 Leonardo and the brothers Ambrogio and Evangelista de Predis received a commission from the Confraternity of the Immaculate Conception for the painted components in an altarpiece in the chapel of the Confraternity in the Milanese church of S. Francesco Grande. The resulting picture, the *Virgin of the Rocks*, is known in two versions: in the Louvre, Paris (fig. 23) and in the National Gallery, London (fig. 24). Both paintings appear to be substantially the work of Leonardo, although for stylistic reasons the Paris version must be earlier than that

Fig. 22 *Ginevra de' Benci*, possibly 1474, 42 × 37 cm, National Gallery of Art, Washington DC

Fig. 21 *The Annunciation*, *c*.1473, 104 × 217 cm, Galleria degli Uffizi, Florence

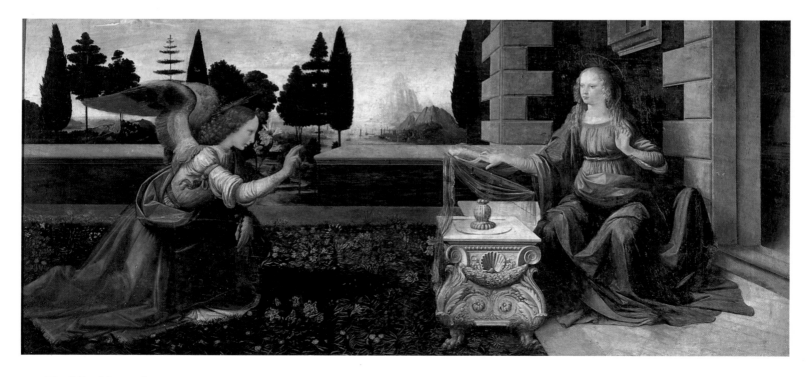

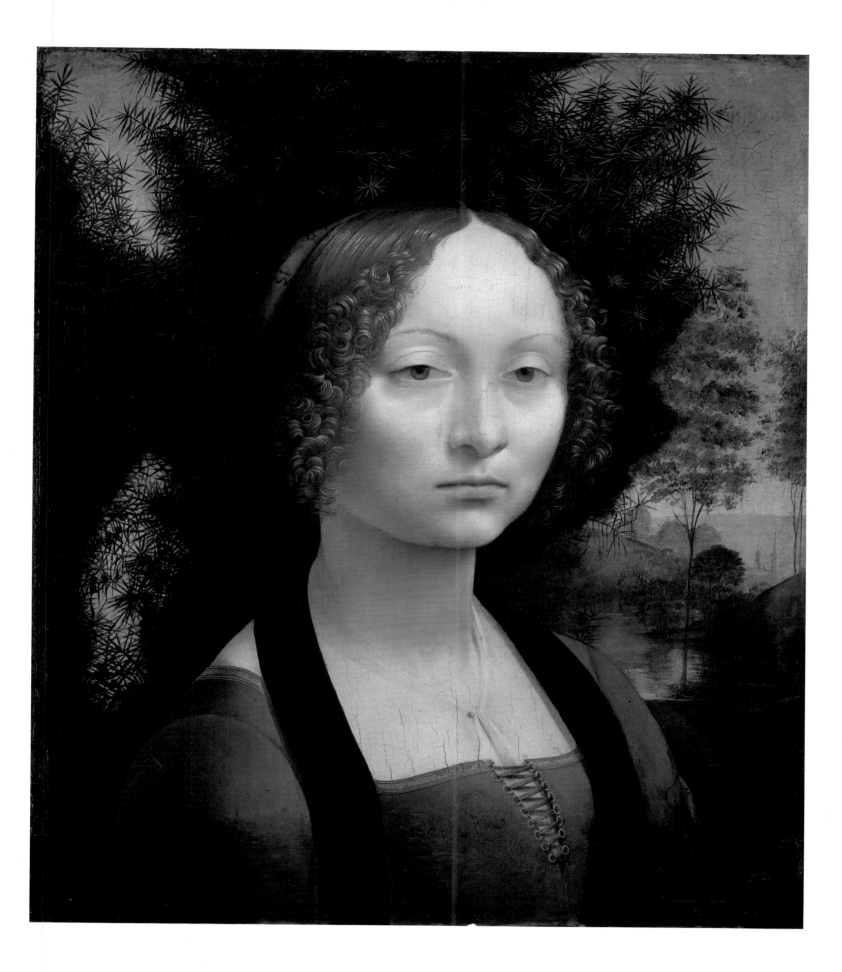

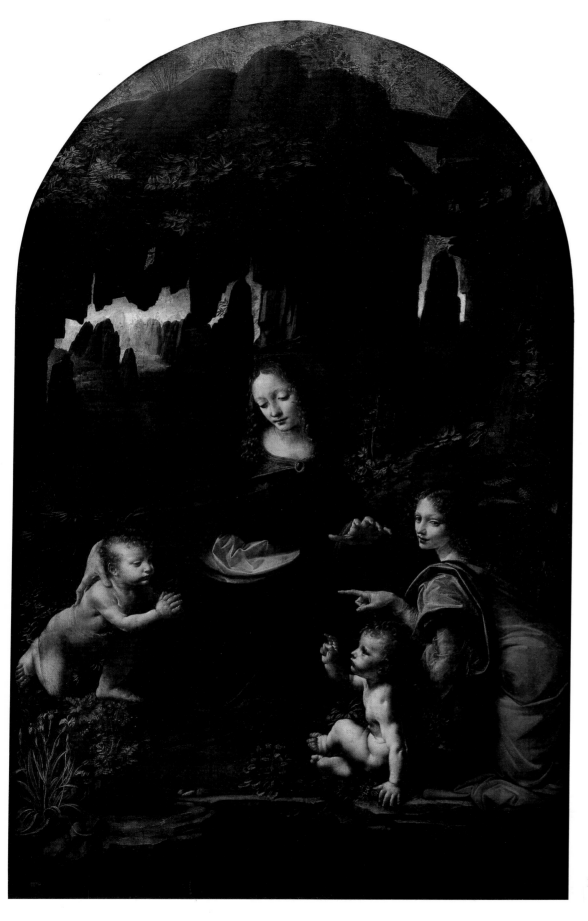

Fig. 23 *Virgin of the Rocks*, c.1483–6,
198 × 123 cm, Musée du Louvre, Paris

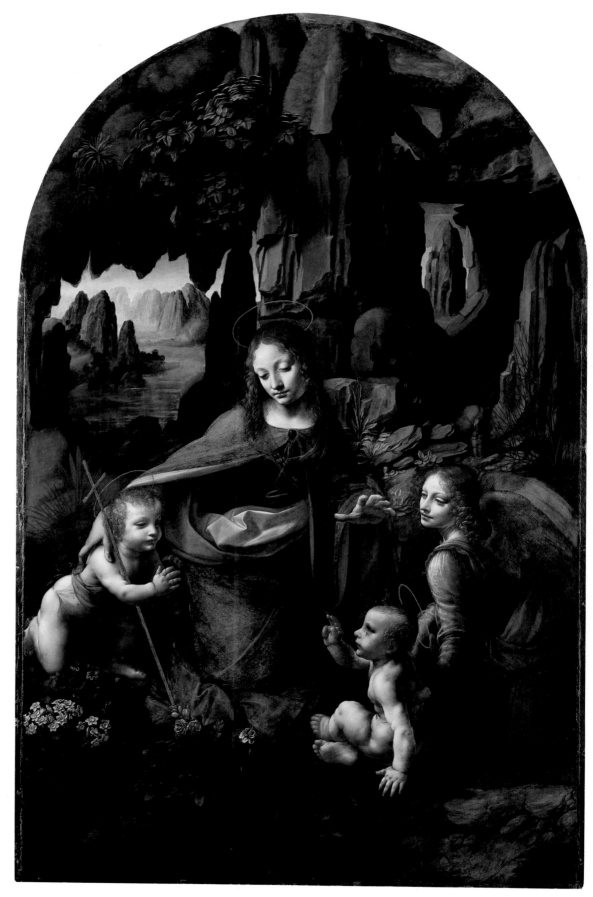

Fig. 24 *Virgin of the Rocks*, c.1495–1508, 189.5 × 120 cm, The National Gallery, London

in London and the numerous differences between the two prove that one cartoon could not have served for both paintings. It has even been suggested that the Paris picture antedates the 1483 commission and was painted in Florence, although the coincidence of size and subject seem virtually to exclude this possibility. The Early Renaissance 'prettiness' and clarity of modelling of the Paris picture had made way for a new unity of colour and shading and a more reflective gravity of mood by the time that the London painting was completed, probably *c*.1506–8. The documentary evidence concerning this commission is far from straightforward.

Leonardo's main activity in Milan was centred on the Sforza court. The commission to portray Cecilia Gallerani, the mistress of Ludovico Sforza ('Il Moro'), was probably received before *c*.1485 and resulted in the picture of the *Lady with an Ermine* in Cracow (fig. 26). In 1487–8 Leonardo received payments for a model of the *tiburio* (crossing-dome) of Milan Cathedral, and in 1489 he inscribed one of a series of pen drawings of the human skull. In January 1490 his work included designs for the pageant of 'Il Paradiso' at the Castello Sforzesco to celebrate the marriage of Duke Gian Galeazzo Sforza and Isabella of Aragon. Similar festivities, also to Leonardo's designs, were held in January 1491 to commemorate the marriage of Ludovico Sforza and Beatrice d'Este.

On 23 April 1490 Leonardo inscribed the date at the start of a new notebook (Ms.C; see no. 100) in which the discussion concerns light and shade, and stated that he had 'recommenced the horse', that is the grandiose (but ultimately abortive) scheme for an equestrian monument to Duke Francesco Sforza (see nos. 8 and 40). The artist was also involved in decoration and building work in Milan at the Castello Sforzesco (the Sala delle Asse, 1498), and at the Lombard town of Vigevano, where Ludovico was reshaping the castle and main square, and building a country villa, 'La Sforzesca'.

Fig. 26 *Lady with an Ermine (Cecilia Gallerani)*, *c*.1485, 54 × 39 cm, Czartoryski Museum, Cracow

Fig. 25 *Last Supper*, *c*.1495–7, 460 × 880 cm, Convent Sta Maria delle Grazie (Refectory), Milan

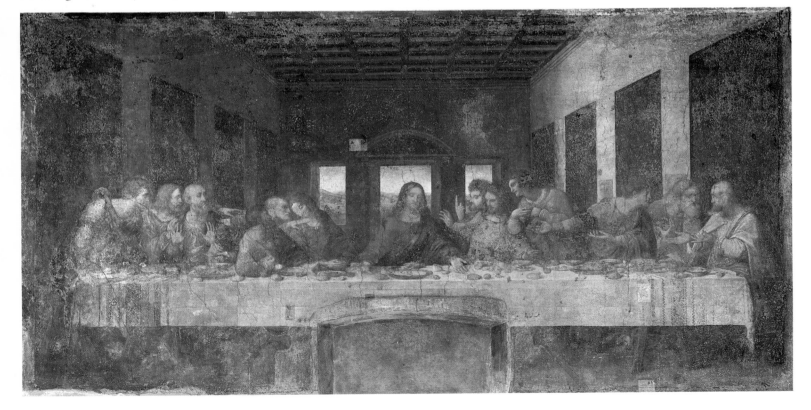

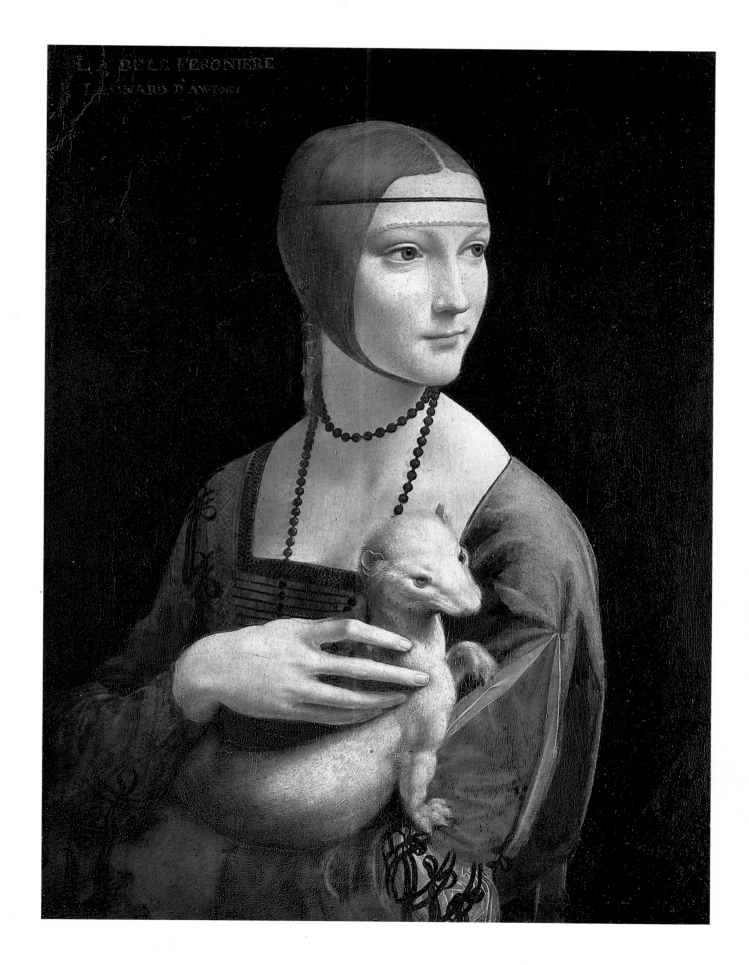

In around 1495 he had begun work on the painting for which he is now best known, the *Last Supper* (fig. 25), in the monastic church of Sta Maria delle Grazie in Milan (which was under the special protection of the Sforza family). The painting, in an experimental (and sadly unsuccessful) technique on the end wall of the Refectory, was described as being almost complete in June 1497. Even in its present state it shows Leonardo as the master of the depiction of controlled emotion, by observed facial variations and gesture. The organisation of the figures within the space and the skilfully controlled lighting of this space are both new. The *Last Supper* is generally considered the first painting of the High Renaissance.

During this first period in Milan Leonardo travelled extensively both within the Milanese territories and beyond, probably making brief visits to Rome in 1492 and Florence in 1495. Towards the end of the 1490s the threat posed by the French in northern Italy had become so great that the bronze set aside for the casting of the Sforza monument had instead to be made into cannon, and Ludovico's role as patron of the arts virtually ceased. In October 1499 the French entered Milan. In December of the same year both Leonardo and the court mathematician, Luca Pacioli, left the city, bound for Venice via Mantua, where Leonardo portrayed the Duchess, Isabella d'Este (fig. 27). During his brief visit to Venice Leonardo appears to have made a profound impression on Giorgione, with respect to the depiction of types of beauty and ugliness, and in such technical matters as chiaroscuro modelling and the effects of light on colour. It is likely that Leonardo's work in Venice included a (lost) half-length painting of Christ carrying the cross.

By 24 April 1500 Leonardo was back in Florence, an established artist in his late forties, whose many-sided talents were now well known. Just under a year later it was reported (by Fra Pietro da Novellara) that Leonardo's 'mathematical experiments have so distracted him from painting that he cannot even bear the brush'. The writer added that since his return to Florence Leonardo had been concentrating on a single composition showing life-size figures of the Virgin and Child with St Anne and a lamb. The cartoon (for what was presumably to be an altarpiece) was at that stage still unfinished. Although the 1501 composition does not appear to have survived, Leonardo's evolution of the Virgin and Child and St Anne theme can be traced through the National Gallery cartoon of *c*.1505 (fig. 28) to the Louvre painting of a few years later (fig. 29). Another work mentioned as being complete in 1501 is 'the little picture that he is doing for one Robertet, a favourite of the King of France . . . of a Madonna seated, as if she were about to spin yarn . . . The Child . . . has grasped the yarnwinder and gazes attentively at the four spokes that are in the form of a cross.' The *Virgin and Child with a Yarnwinder* is now known only from copies or studio versions (fig. 30).

During much of the period from 1502 to 1503 Leonardo was employed as military architect for Cesare Borgia in Romagna. At this time he made a number of maps, including the famous *Map of Imola* (no. 98). Following his return to Tuscany in March 1503 he was involved in various schemes of canalisation, including the plan to divert the Arno around Pisa, the city with which Florence was then at war (nos. 48, 49 and 62). Excavation work commenced the following summer but was soon abandoned.

At some date before October 1503 Leonardo received the commission for what should have been his most important work in Florence, the mural painting of the *Battle of Anghiari*, which was to decorate part of the vast new Council Chamber in

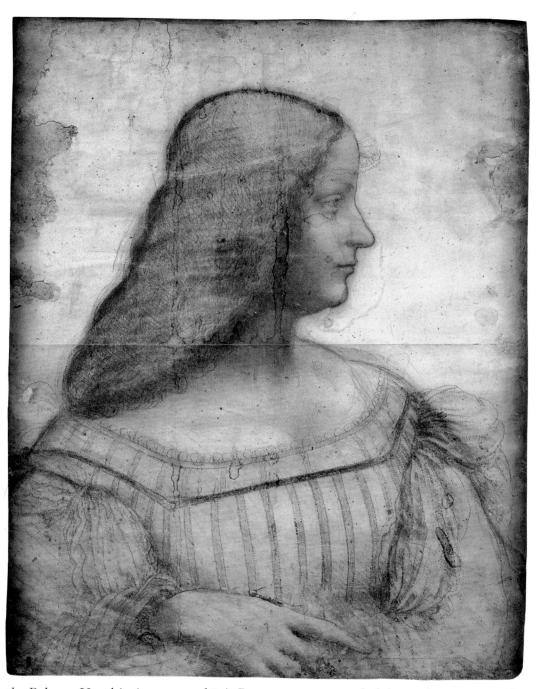

Fig. 27 *Isabella d'Este*, *c*.1500, pastel, Musée du Louvre, Paris (MI 753)

the Palazzo Vecchio (nos. 13 and 87). Payments are recorded throughout 1504 and 1505, and in June 1505 the artist noted that he 'commenced colouring in the palace', a reference which is usually taken to mark the start of his painting on the wall following completion of all the preparatory stages. From the summer of 1504 he was competing directly with Michelangelo, who had been commissioned to paint the companion piece, the *Battle of Cascina*. The only part of the *Battle of Anghiari* to be painted by Leonardo was that showing the 'Fight for the Standard', and this was covered over by Vasari's mural painting in the 1560s. Like the *Last Supper*, there is evidence that the technique in which the *Battle* was painted was experimental. The reason for Leonardo's breaking off work on the project is not known, but may be connected with technical problems.

There are contemporary references to a number of other works during this

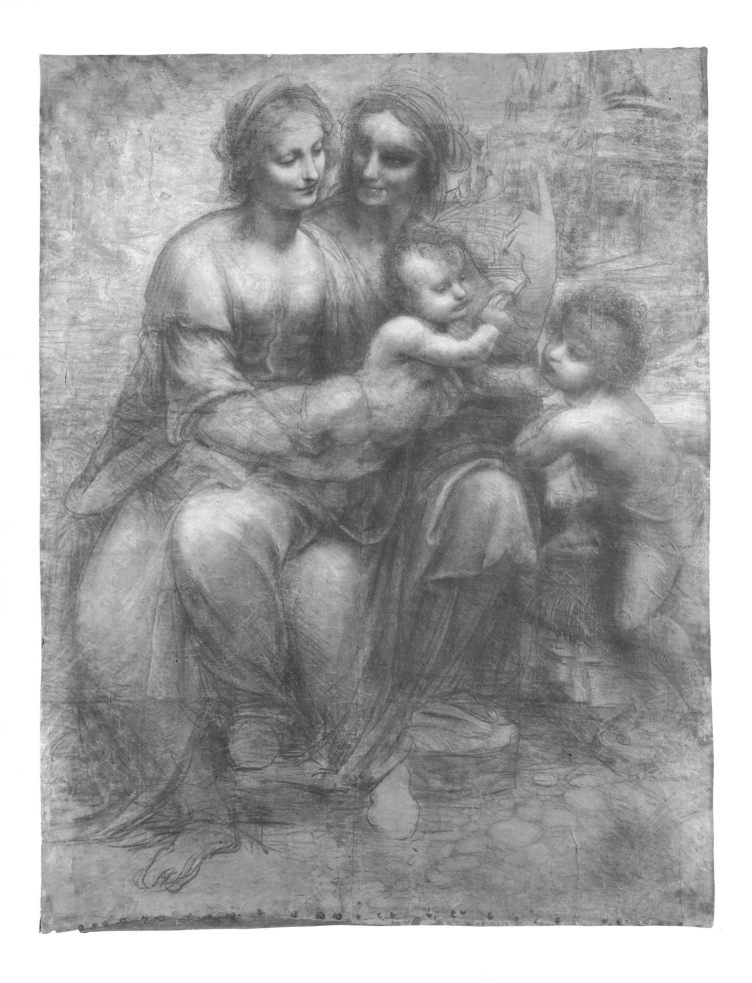

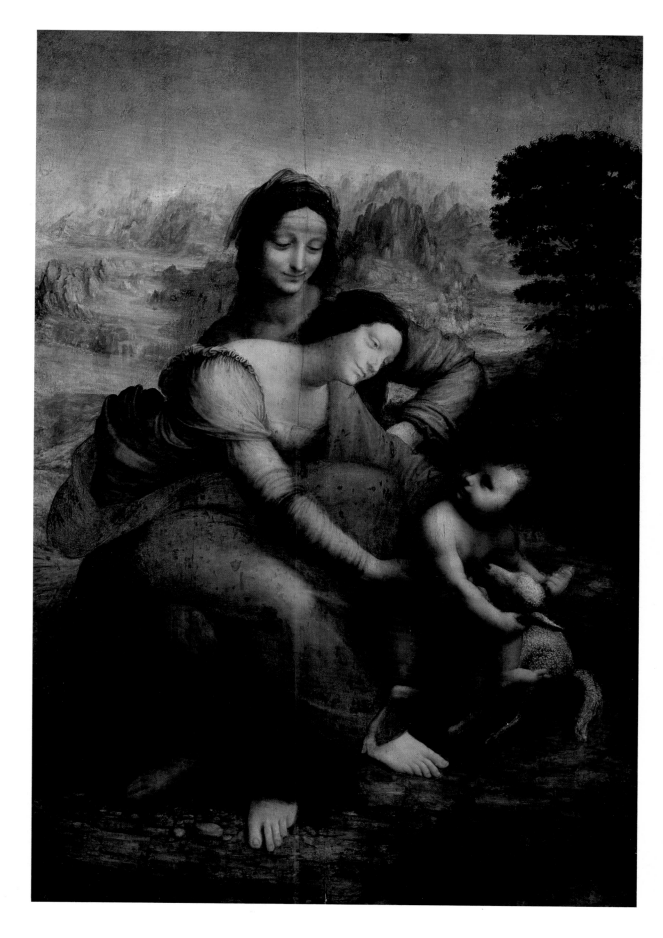

Fig. 28 *Cartoon for the Virgin, Child, St Anne and St John*, c.1505–7, black chalk, The National Gallery, London

Fig. 29 *Virgin, Child, St Anne and a Lamb*, c.1508 onwards, 168 × 112 cm, Musée du Louvre, Paris

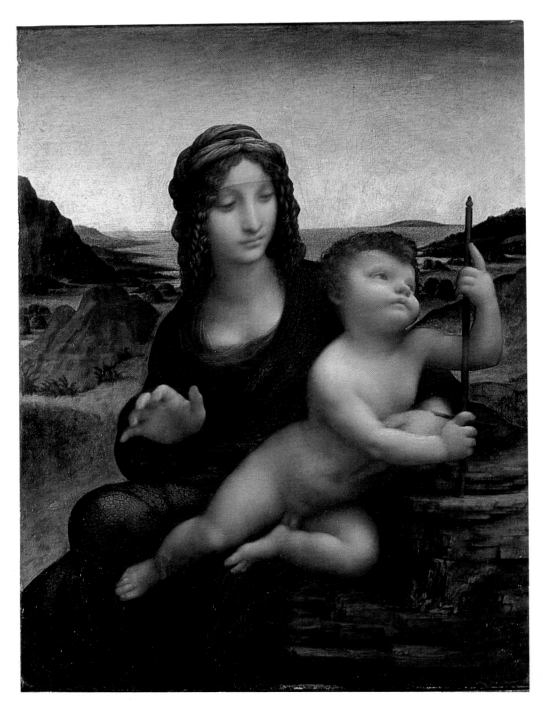

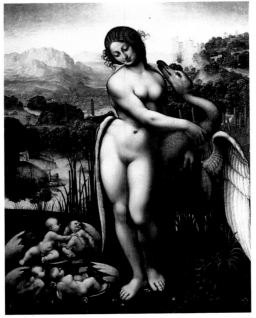

Fig. 30 Leonardo and studio, *Virgin and Child with a Yarnwinder*, c.1501, 46.4 × 36.2 cm; Collection: The Duke of Buccleuch and Queensberry KT

Fig. 31 *Leda and the Swan* after Leonardo, 96.5 × 73.7 cm; Collection: The Earl of Pembroke, Wilton House Trust, Salisbury

second Florentine period: a young Christ planned for Isabella d'Este (May 1504), the finished drawing of Neptune and his chariot (see no. 71) for Antonio Segni (who left Florence for Rome in 1504), the *Mona Lisa* portrait (fig. 4) in the Louvre, and the lost picture *Leda and the Swan* (see nos. 14, 58, 74 and 75). There is also a large amount of evidence for Leonardo's scientific studies on bird flight, stereometry and other topics at this time.

During Leonardo's first Milanese period (1482–99) he had worked almost exclusively for the Sforza court. His departure followed the occupation of Milan by the invading French forces. It is somewhat disconcerting therefore to find the artist returning to Milan (in May 1506) at the invitation of the French Governor,

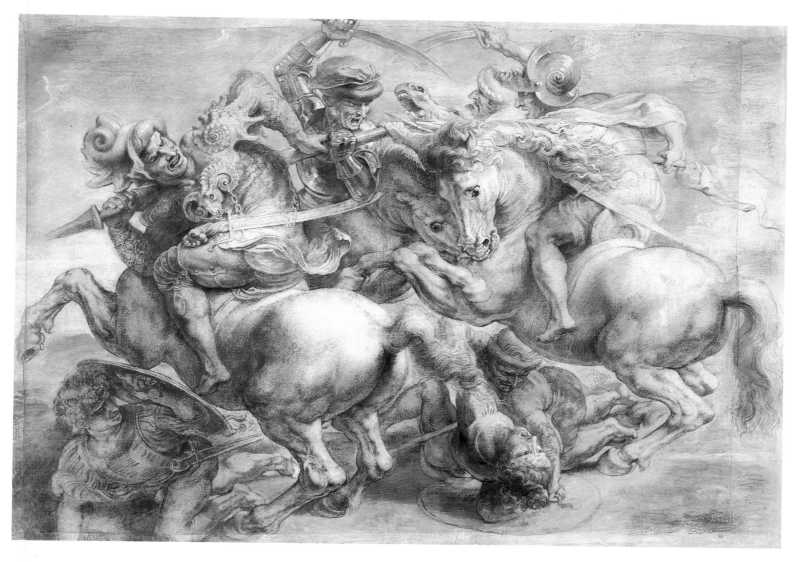

Fig. 32 Peter Paul Rubens, *Copy of Leonardo's Battle of Anghiari*, c.1603, chalk worked over with pen and bodycolour, Musée du Louvre, Paris

Charles d'Amboise, and to discover that (after a number of trips back to Florence in 1507 and 1508) Leonardo spent much of the following seven years, and the period from late 1516 to his death in May 1519, working for the French court either in Milan or in France. Leonardo's return to Milan in 1506 may have been related to the dispute concerning the *Virgin of the Rocks*. He received payments from the Confraternity in 1507 and 1508, and presumably delivered the London version of the picture at that time.

Under the rule of the new French government of Milan Leonardo was expected to serve both the king (Louis XII) and the local governors (Charles d'Amboise until 1511, and then Gaston de Foix and Gian Giacomo Trivulzio). The king made it known that he would like a number of paintings by Leonardo, specifically of the Virgin and Child, and some portraits. The *Virgin of Cherries* (known only from Flemish copies) and the Louvre *Virgin, Child, St Anne and a Lamb* (fig. 29), may have been among Leonardo's works for Louis XII. As was the case during his first Milanese period, Leonardo was expected to carry out a multiplicity of different tasks for the new rulers: he was architect, engineer, theatrical designer and court painter. Specifically, in a letter to the Florentine Signoria dated 26 July 1507, the king made reference to 'our dear and well

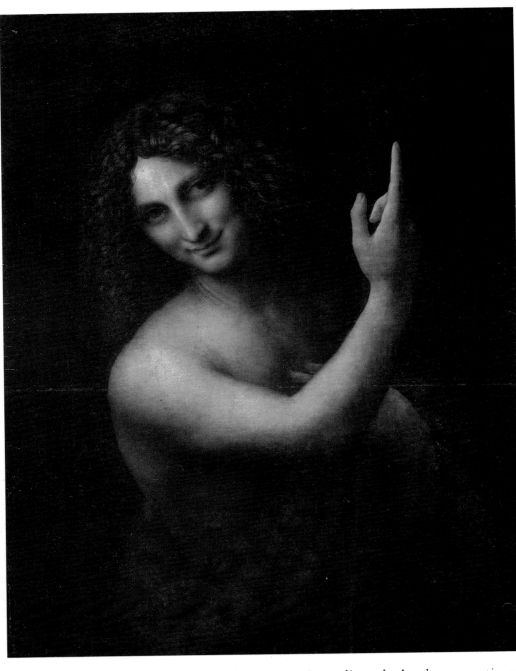

Fig. 33 *St John the Baptist*, *c.*1509, 69 × 57 cm, Musée du Louvre, Paris

beloved Leonardo, our painter and engineer in ordinary'. At the same time Leonardo's studies of mechanics, geometry, hydraulics, anatomy and the theory of painting also thrived. In Milan in mid-September 1508 we find him 'writing up' the dissection of the body of the 'centenarian', whose death he had recently witnessed in the hospital of Sta Maria Nuova, Florence (see no. 51). The majority of Leonardo's anatomical studies, including the great series in Folio A (see nos. 95, 96, 106, 108, 109 and 110), and the drawings concerning cardiology and embryology, were carried out during his second Milanese period. The second project for an equestrian monument (for Trivulzio) is largely undocumented, but the style of the drawings suggests a dating *c.*1508–12.

Political factors were again responsible for Leonardo's departure from Milan, for in June 1512 the combined forces of Spain, the papacy and Venice took over

the Milanese state from the French. Before moving away entirely, the artist spent a short time at the Villa Melzi on the Adda river near Milan, home of his pupil (and eventual heir) Francesco Melzi. There he produced a series of exquisite small-scale topographical drawings of the area surrounding the Villa, which fall chronologically between the landscape studies in red chalk on red coated paper of 1511, and the final 'Deluge Drawings' (nos. 22, 63, 64 and 66) of Leonardo's very last years.

By December 1513 the artist had settled in Rome, and was given lodgings in the Belvedere of the Vatican Palace by Giuliano de' Medici, since September 1512 head of the Florentine state and brother of Giovanni de' Medici who had been elected Pope (as Leo X) in March 1513. Although Leonardo was in Rome for much of the following two years, he remained closely in touch both with Florence and with the French court and apart from a few architectural projects he seems to have completed very little while in Rome. The notebooks show Leonardo working on mirrors, mechanics and geometrical puzzles. A possible product of these years could be the painting of St John (fig. 33) in the Louvre, in which the *sfumato* effect (seen at its best in pictures such as the *Mona Lisa* and the London *Virgin of the Rocks*) has become excessive, and the human form almost lifeless.

The death of Giuliano de' Medici in March 1516 may have enabled Leonardo to accept the French king's offer of the Château of Cloux (near Amboise). According to Benvenuto Cellini the king 'did not believe that a man had been born who knew as much as Leonardo, not only in the spheres of painting, sculpture and architecture, but also that he was a very great philosopher'. The artist's only securely documented works undertaken in France do not involve paintings but are concerned with a variety of other pursuits, including theatrical designs and geometrical investigations. The drawings from the French period show that he also worked on projects for a royal residence at Romorantin and on schemes to canalise the river Loire.

The most vivid evidence concerning Leonardo's time in France is provided by the report by Antonio de'Beatis (the secretary to the Cardinal of Aragon) following the cardinal's visit to Leonardo at Amboise in October 1517. Leonardo

> showed His Eminence three pictures, one of a certain Florentine lady from life [*Mona Lisa?*] for the late Magnificent Giuliano de'Medici, another a young John the Baptist, and a third the Madonna and Child seated on the lap of St Anne, all perfect. Nothing more that is fine can be expected of him, however, owing to the paralysis, which has attacked his right hand. A Milanese [Melzi], who was educated by him and paints excellently, lives with him. Although Leonardo can no longer paint with his former sweetness he can still draw and teach others. . .

As the artist is known to have written and drawn with his left (rather than his right) hand, it is difficult to know what if anything to make of de'Beatis' report of Leonardo's paralysis. A sheet of the Codex Atlanticus is dated 24 June 1518, in as clear a hand as those immediately preceding it. It is possible that a stroke prevented him from painting but that he regained his ability to draw. Ten months later the artist made his will, naming Melzi as his chief heir and executor, and on 2 May 1519, at the age of 67, he died at Cloux. Soon afterwards Melzi reported the death to Leonardo's brothers and added: 'To me he was like the best of fathers, for whose death it would be impossible for me to express the grief I have felt. . . It is a hurt to anyone to lose such a man, for nature cannot again produce the like.'

CATALOGUE

Catalogue Note

The arrangement of the catalogue is designed to reflect the thematic nature of the exhibition. The sequence and grouping of illustrations is intended to reveal the series of visual resonances within and across Leonardo's various fields of endeavour. The introductory essays for each section explore the themes, and the individual entries concentrate on the role of each item in these contexts, while giving some general guidance on matters of technique, dating etc.

Given the vast quantity of literature on Leonardo, it would have been easy to burden the catalogue with a cumbersome apparatus of references, but such an apparatus would be inimical to the spirit of the present enterprise. Each catalogue entry contains, therefore, the minimum of citations to reference material (mainly to the standard facsimiles, transcriptions and catalogues) through which the reader may gain access to the body of Leonardo literature. The bibliography is also limited to some standard points of reference, in English wherever possible, including all those works cited in abbreviated form in the catalogue. The provenances have been summarised to indicate the main points of interest, and can be found in fuller form in the standard sources.

Leonardo's own words have been extensively quoted, so that his voice will underscore the visual themes. In section 7, 'Art and Imagination', each entry is introduced by a quotation, and this section assumes something of the guise of an illuminated treatise on various aspects of artistic creation. The quotations have generally been retranslated, and many of those concerned specifically with painting have been taken from the newly edited anthology by Martin Kemp and Margaret Walker, *Leonardo on Painting*.

<div style="text-align: right">MK</div>

All illustrations are of works by Leonardo da Vinci unless described otherwise.
Unless otherwise stated, all loans come from the Royal Library, Windsor Castle and are reproduced by gracious permission of Her Majesty The Queen.
Works which are identified by a figure number are comparative illustrations and are not part of the exhibition.
The drawings are on white paper unless described otherwise.
The recto of each drawing is exhibited unless otherwise indicated.
Dimensions are given in millimetres, height × width × depth, except for the measurements of the paintings and the models which are in centimetres.
The measurement of both folios of codices is given when a double opening is shown.
Codex Atlanticus reference numbers give the old system of numbering before the new.
References are listed in full in the bibliography.
References to manuscripts and catalogues of collections are given in abbreviated form. A full list of abbreviations is provided in the bibliography.

I
BIOGRAPHY

Painter, sculptor, architect, engineer, stage designer, musician, writer, student of the physical sciences, mathematician, geologist, anatomist, natural historian . . .

In spite of the great range of his activities, it was Leonardo's work as an artist that shaped his career. Yet while the Leonardo of the *Last Supper* and the *Mona Lisa* is familiar, our knowledge of him as an artist is incomplete – a few finished masterpieces, a tragically deteriorated mural, a series of unrealised projects and a number of lost works. In total there are no more than thirteen paintings generally accepted as coming from Leonardo's own hand and all of these are illustrated in the chapter on the life of Leonardo on pages 23 to 41.

The surviving drawings and manuscripts, though only a fraction of Leonardo's output, represent the core of his legacy and the diversity of this legacy is the key to an understanding of his life. This opening section therefore offers an outline of his career mainly through drawings associated with important artistic projects.

I

SCHOOL OF LEONARDO DA VINCI: PORTRAIT
OF LEONARDO DA VINCI, *c.*1519
Red chalk. 274 × 190 mm
Prov.: Windsor Leoni volume (12726)
Ref.: C&P; Pedretti *L.S.* 20; Pedretti III
383

Fig. 34 *Drawing of a Bearded Man*, possibly self-portrait, *c.*1513, red chalk, Biblioteca Reale, Turin (15571, B229)

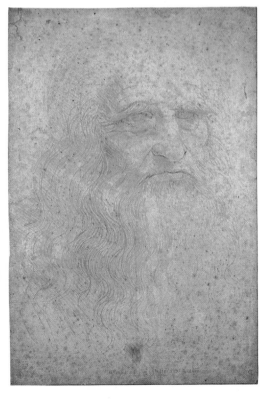

Leonardo's physical appearance is known to us from a number of sixteenth-century descriptions. In the decade after the artist's death, Paolo Giovio wrote that 'his charm of disposition, his brilliancy and generosity were not less than the beauty of his appearance'. The Anonimo Gaddiano added that Leonardo was 'well-proportioned and graceful', and that 'his hair came to the middle of his chest and was well-dressed and curled'.

The bold title added below the portrait appears to use the same chalk as the main drawing. This image served as the basis for the paintings of Leonardo in the Giovio Museum at Como (1536), and in the gallery of Cosimo de'Medici in Florence (1566–8). It was then used to illustrate the published version of Giovio's eulogy on Leonardo in his *Imagines Clarorum Virorum Graeciae & Italiae* (1589). For this purpose the original drawing had presumably been studied in Melzi's collection, where Vasari also recorded seeing a portrait of Leonardo. (A copy of this drawing, probably by Melzi, is in the Biblioteca Ambrosiana.) Vasari used this image for the painted figure of Leonardo in the room of Leo X in the Palazzo Vecchio, and in the woodcut portrait accompanying Leonardo's Life in the *Vite*. There is little doubt therefore as to the authenticity of this drawing as a portrait of the artist: it can indeed be used to suggest that the man with similar features shown in a pupil's drawing at Windsor (12300v) is also Leonardo.

The matter of attribution is more complex, however. The profile presentation and the right-handed shading alone argue against it being a self-portrait. However, the depiction of the waves of the hair (particularly lower right) is very close to the configurations of turbulence (in black, rather than red chalk) in the 'Deluge Drawings' of Leonardo's last years (see particularly nos. 22, 63, 64 and 66). When Antonio de'Beatis visited Leonardo at Amboise in 1517 he calculated the artist's age to be over 70, whereas in fact he was only 65. This suggests that Leonardo looked older rather than younger than his years. Could this drawing therefore perhaps be

an idealised likeness made by a pupil at around the time of Leonardo's death, showing a somewhat rejuvenated image of the Master, much as he had looked some years earlier? For a drawing of old age from Leonardo's last years, see no. 36. However, the figure there appears to be considerably older than 67, the artist's age at the time of his death in 1519.

The famous Turin '*Self-Portrait*' occupies an uncertain position within Leonardo's iconography (fig. 34). Whereas the style of no. 1 is akin to Leonardo's of *c.*1515, but shows a man of 40 or 50, the Turin drawing (which is also in red chalk) is in an earlier style (perhaps as early as the late 1480s), but shows a very aged man. The present drawing must be preferred as an authentic image of Leonardo.

It was reported at the time that Raphael's figures of Plato and King David, respectively in the Vatican *School of Athens* and the *Disputà*, were personifications of Leonardo. Both show an aged, long-haired, bearded sage, conforming to Lomazzo's description of Leonardo's 'druidic' appearance.

The stock image of Aristotle produced in various media in the early and later sixteenth century, which was based upon a type known from antique medals, bears an uncanny resemblance to the authorised image of Leonardo. The characterisations fused to such a degree that the philosopher's portrait in Giovio's *Icones* was no more than the portrait of Leonardo in reverse.

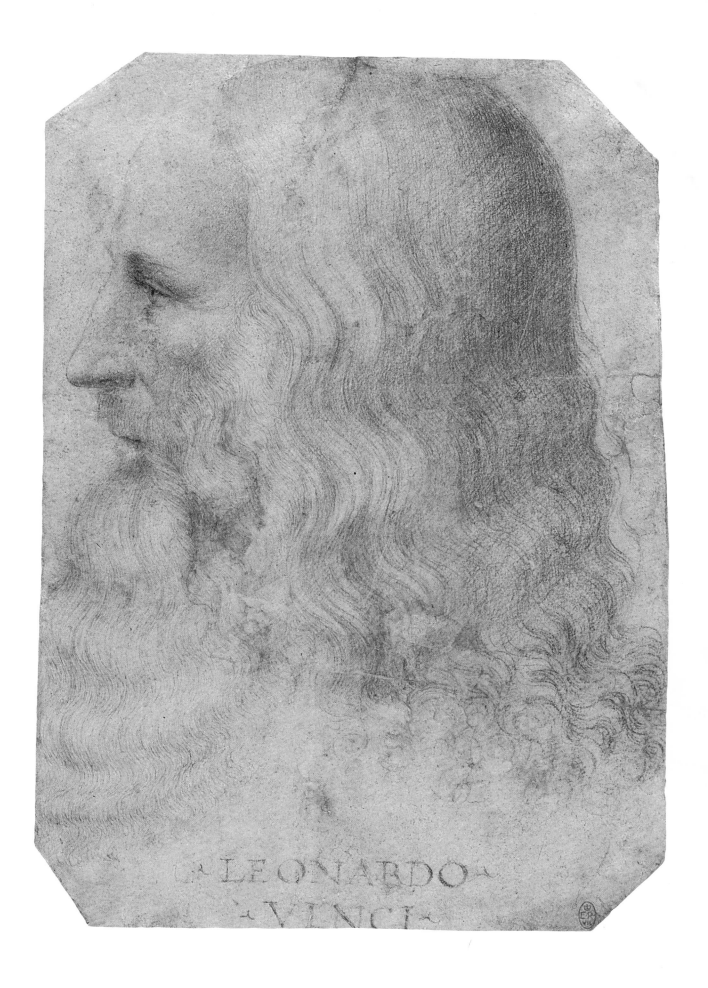

LEONARDO
VINCI

2

BUST OF A WARRIOR, *c*.1472
Metalpoint heightened with white on
 paper coated with a cream-coloured
 preparation. 285 × 208 mm
Trustees of the British Museum, London
Prov.: W. Y. Ottley; Thomas Lawrence;
 J. C. Robinson; John Malcolm; British
 Museum (1895-9-15-474)
Ref.: Popham 129; Popham & Pouncey
 96

Metalpoint was the medium favoured by artists of the Early Renaissance, but rarely has a sheet on the scale (or of the quality) of this drawing survived in such comparatively good condition. On one level it is a typical product of Andrea Verrocchio's studio, which appears to have included Leonardo from 1469 to 1476 at least. The workshop handled commissions for both oil paintings and three-dimensional objects, from small-scale metalwork to large-scale sculptural monuments. Verrocchio's style may be described as classicising in a decorative and sometimes fantastic manner. The forms are normally crisp and metallic, but demonstrate (particularly in the sculpture) a mastery of the depiction of movement through subtly balanced contrasting axes. Vasari specifically mentions a group of drawings by Verrocchio in his collection: 'made with much patience and very great judgement; among which are certain heads of women, beautiful in expression and in the adornment of the hair which, for their beauty, Leonardo always imitated'. In this drawing the extraordinary naturalistic 'wing' on the helmet, and the lion's head on the breastplate, but particularly the 'nutcracker' profile of this *all'antica* warrior, all point to an attribution to Leonardo. Similar profiles, which ultimately depend on classical prototypes through Verrocchio's example, are found throughout the artist's *œuvre*, from the 1478 Uffizi drawing (fig. 15) and no. 6, through to the *Last Supper* sequence (e.g. no. 89), to the contemplative old man (no. 21), and the late aged heads in black chalk (e.g. no. 36).

There is an evident (if somewhat complex) relationship between this drawing and a pair of metal (bronze?) half-reliefs by Verrocchio described by Vasari. The reliefs, which depicted Alexander the Great and Darius, were apparently sent by Lorenzo the Magnificent to Hungary as a gift for Matthias Corvinus. The originals do not appear to have survived, but may be known through versions in a variety of media. No. 2 comes closest to the polychrome terra-cotta relief of Darius in Berlin, a late product of the Della Robbia workshop. There exists the possibility that Leonardo might himself have been responsible for the design and execution of reliefs of this type. That Leonardo's drawing (no. 2) may have been a study for or even from a sculptural relief is suggested by the purely decorative elements (particularly the ribbons) which fill the area to the right at the back of the half-figure.

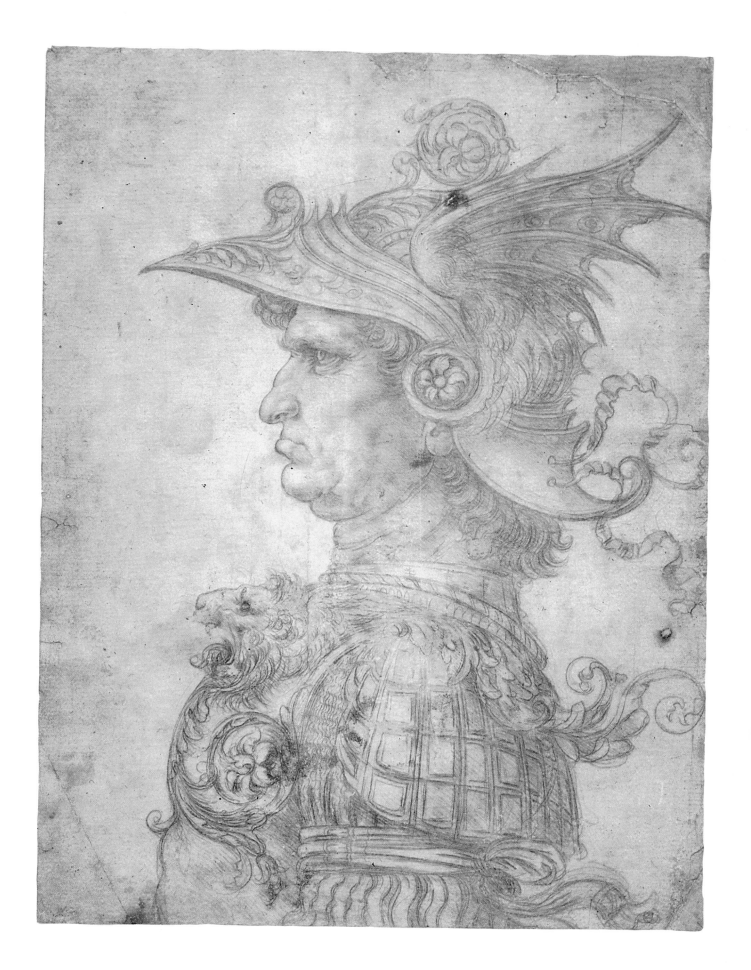

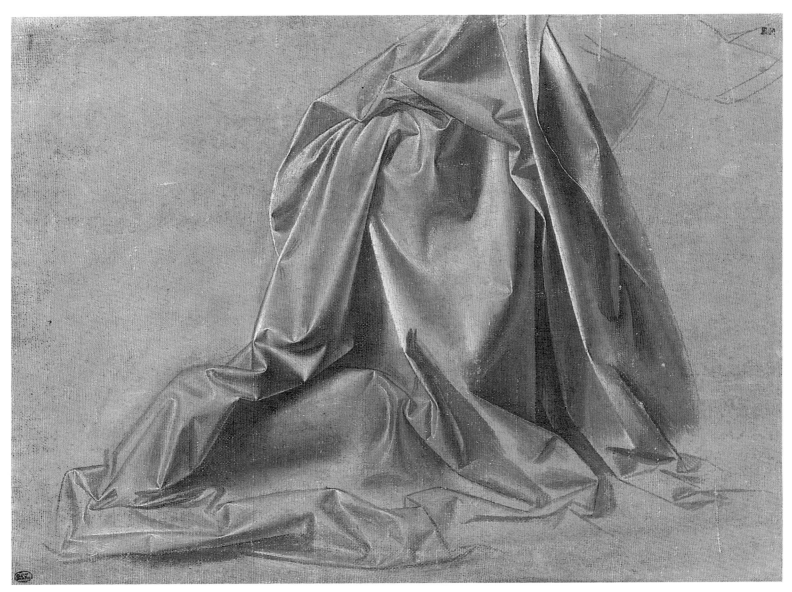

3

CAST OF DRAPERY FOR A FIGURE KNEELING
 TO THE RIGHT, *c.*1472
Bodycolour with white heightening,
 applied with brush over traces of
 black chalk, on linen coated with grey
 bodycolour. 180 × 234 mm
Musée du Louvre, Département des Arts
 Graphiques, Paris
Prov.: Nourri Sale, Paris, 1785 (as
 Dürer); M. de Saint-Morys; Museum
 National/Musée du Louvre, 1793
 (2256)
Ref.: Popham 3

According to Vasari, when Leonardo
was first studying art

 he often made figures in clay which
he covered with a soft worn linen
dipped in clay, and then set himself to
draw them with great patience on a
particular kind of fine Rheims cloth
or prepared linen; and he executed
some of them in black and white with
the point of a brush to a marvel, as
some of those which we have in our
book of drawings still bear witness.

A number of drapery studies on linen
have survived: five are in the collection
of the Comtesse de Béhague, three
(including this one) are in the Louvre,
three in the Uffizi, and one in the
British Museum. The draperies are cast
as the clothing of a seated, kneeling or
standing figure, and can be generically
related to such early Leonardo works as
the kneeling angel in Verrocchio's
Baptism (who has his feet covered as
here; fig. 20), the Uffizi *Annunciation*,
and the *Adoration of the Magi*. In these
pictures the drapery falls in stiff and
angular folds, very obviously dependent
on preparatory studies such as this.

 Apart from observing the shape of the
folds formed by the drapery, Leonardo
is also at pains to observe the fall of
light on the static, clay-soaked cloth.
The method was not peculiar to him.
Other drapery studies on linen survive
from the hand of Lorenzo di Credi
(another member of Verrocchio's
workshop), and Fra Bartolommeo. The
latter continued to use the technique
until *c.*1500. It is likely that the present
drawing is from almost thirty years earlier.

4

STUDY OF ARMS AND HANDS, *c.*1474
Metalpoint heightened with white, over
 black chalk, on paper coated with a
 buff-coloured preparation.
 214 × 150 mm
Prov.: Windsor Leoni volume (12558)
Ref.: Popham 18; C&P; Pedretti III 165

This drawing has been related to the
female portrait in the National Gallery
of Art, Washington, which is normally
identified (with reason) as the portrait of
Ginevra de'Benci by Leonardo, noted by
the Anonimo Gaddiano *c.*1518 and later
by Vasari and others (see pp. 27–8 and
fig. 22). It is probable that Leonardo's
painting was done at the time of
Ginevra's marriage, in 1474. The
Washington painting has evidently been
cut down at the base. Some indication
of the original position occupied by the
arms and hands may be found in a
portrait of an unknown lady by Lorenzo
di Credi (Metropolitan Museum of Art,
New York). The sitter in that portrait,
as in the Washington picture, is painted
in front of a juniper bush (*ginepro*), and
may therefore be another Ginevra. In
the New York portrait the hands are
crossed at waist level. The sitter's left
hand is raised to hold a ring, in the same
way that the right hand is raised to hold
the edge of the bodice in Leonardo's
drawing: the gesture is merely reversed.

 The small grotesque profile top left is
typical of Leonardo's apparently absent-
minded additions to his drawings,
although the context of the addition is
seldom more inappropriate than here.

 To date this drawing so early in
Leonardo's career (1474) presents us with
some difficulties, for the technique is
almost identical to that in studies for the
Sforza monument of around twenty
years later (e.g. no. 40). On the other
hand it appears to be drawn with
considerably more fluency and
confidence than the London warrior (no.
2). The long, thin hands and fingers are
similar to those found in the sculpture of
Verrocchio, and in Leonardo's Uffizi
Annunciation (fig. 21).

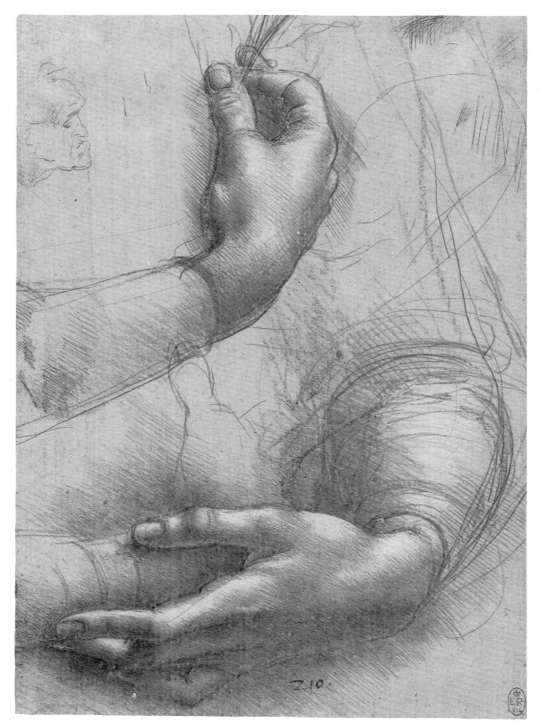

5

SHEET OF STUDIES WITH THE VIRGIN AND
CHILD AND ST JOHN, *c*.1478–80
Pen and ink. 404 × 291 mm
Prov.: Windsor Leoni volume (12276)
Ref.: Popham 23; C&P; Pedretti III 162r

Leonardo's work on paintings (or sculptures) of the Virgin and Child during the 1470s and 1480s is reflected in a number of preparatory studies, of which those on the recto and verso of no. 6 and on the present sheet are among the best preserved. The ever-inventive Leonardo has covered both sides of this large sheet of paper with studies in pen and ink. The main drawing shows the half-kneeling figure of the Virgin, with the Christ Child seated on her raised right knee and turning to feed from her breast, while the infant St John looks on from the right. The Virgin's head is shown in two positions, the first more intimately looking at the Christ Child, the second more assertively gazing towards the Baptist. In the first position the Virgin's features are close to types depicted by Leonardo's master, Verrocchio. The drawing incorporates what may be the first statement of the typical triangular (or pyramidal) grouping of the Virgin and Child so much favoured by the High Renaissance artists, including Leonardo himself. There are also analogies between the Virgin and Child in this drawing and in several of Raphael's paintings (in particular the *Belle Jardinière*), dating from the first decade of the sixteenth century. The suggestion of mountain peaks to the right of the main group possibly anticipates the cavernous background of Leonardo's *Virgin of the Rocks* (figs. 23 and 24).

The numerous profiles of various types are often no more than doodles. That of the man centre left on the verso and of the lion at the lower edge of the recto recall features in the early metalpoint warrior (no. 2). The delicately shaded head of the youth, lower left of centre on the recto, can be seen as Leonardo's ideal type of male beauty: it is clearly dependent on his master's bronze figure of *David* in the Bargello, and recurs in Leonardo's work as late as 1513 (Windsor 19093).

The pen and ink drawing technique, combining very fine diagonal hatching in the lower profiles with a free sweep of the pen in the main figures, and the style of handwriting on the verso, suggest a date betwen 1478 and 1480.

However, dating based on stylistic considerations is not without its problems in Leonardo's *œuvre*:

> It is worth noting that while the Virgin is drawn with an almost reckless breadth, some of the profiles are tame and flat. Leonardo's style was so little of a flourish, so dependent on his observation, that it varied from hour to hour, and no theory of its evolution can give more than the general drift. (Kenneth Clark)

The repaired vertical cut parallel to the right edge suggests that the sheet may once have narrowly escaped a radical trimming operation. The horizontal line across the centre of the page is an old fold.

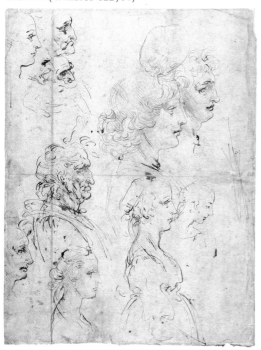

Fig. 35 *Male and Female Head Studies, c.*1480, pen and ink (Windsor 12276v)

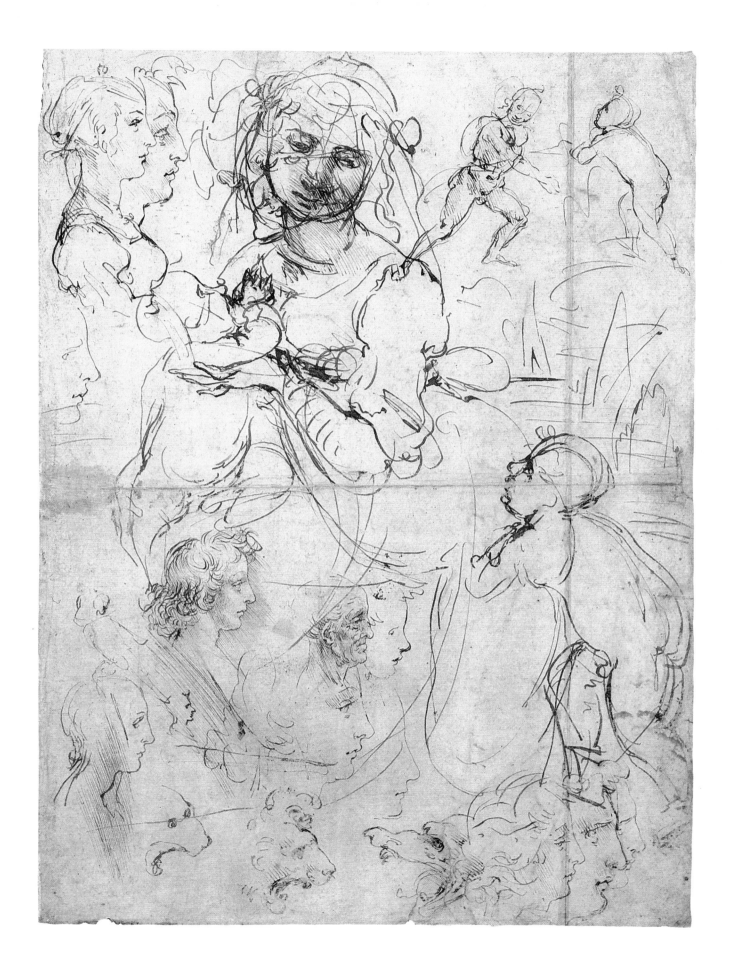

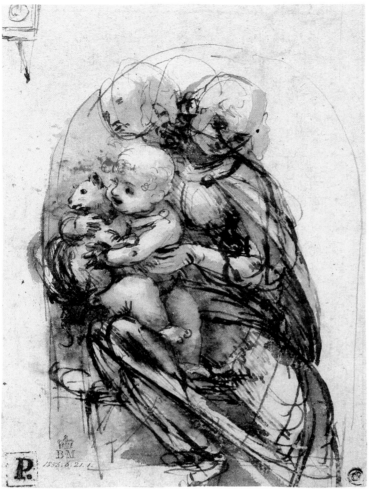

6

VIRGIN, CHILD AND CAT, *c.*1478–81
Pen and ink with wash. 132 × 95 mm
Trustees of the British Museum, London
Prov.: A. C. Poggi; Prince N. Esterhazy;
 G. B. Cavalcaselle; British Museum
 (1856-6-21-1)
Ref.: Popham 9B; Popham & Pouncey
 97

This sheet incorporates one of the first uses of the transparency of paper to transfer an image on one side of the page to the other, by tracing the outlines while holding the paper up to the light (see also no. 16). On the verso of this drawing (fig. 36) Leonardo has experimented in pen and ink with the composition of a group consisting of the half-length figures of the Virgin, seated towards the right, with the Christ Child perched on her lap, and a cat attempting to escape His grasp. When traced through to the recto, Leonardo appears quickly to have decided to abandon the original (upright) position of the Virgin's head in favour of one either looking down to the right or out to the left, in the direction of the cat. The position of the Child remains relatively unchanged (though naturally reversed), His body facing in, but His head turning towards the cat. The Virgin's drapery and legs are subtly changed, but using the same framework of outlines, to

suggest a half-standing position, partly supported by a ledge to the left, rather than seated on a low bench as on the verso.

Leonardo's drawings of the Virgin, Child and cat appear to date from the late 1470s. The central figure in this one is clearly related to that in no. 5: in both, the position and expression of the head develops from one of Verrocchiesque simplicity to something less conventional, creating its own directional counterpoint. In the drawing on the recto of no. 6, Leonardo appears almost to be moving away from the solution finally arrived at in the painted *Benois Madonna* (Hermitage Museum, Leningrad; fig. 18), to which the verso drawing is quite closely related. In the painting the young smiling Madonna holds a flower for her somewhat oversized Child to examine, whereas in the drawings on this sheet the Child holds a cat. In all three versions the figures are contained within an arched framework, but the addition (of a wall clock?) top left of no. 6 might suggest that a more extended composition was also considered.

This drawing represents a very early instance of Leonardo's use of wash over an ink drawing.

Fig. 36 *Virgin, Child and Cat, c.*1478–81, pen and ink, The British Museum, London (1856-6-21-1v)

7

FIGURE STUDIES FOR THE ADORATION OF
 THE MAGI, c.1481–2
Pen and ink. 274 × 180 mm
Graphische Sammlung, Wallraf-
 Richartz-Museum, Cologne
Prov.: probably from the Wallraf
 Collection, Cologne (Z2003)
Ref.: Popham 47

Leonardo's great unfinished painting of
the *Adoration of the Magi* (Uffizi,
Florence; fig. 16), was commissioned for
the high altar of the monastery of S.
Donato a Scopeto (outside Florence) in
March 1481. The last recorded payment
was made to Leonardo on 28 September
1481. At some date thereafter, but
before 25 April 1483 (at which time he
was in Milan, and received the
commission for the *Virgin of the Rocks*),
Leonardo moved to Milan leaving the
altarpiece unfinished. The commission
was subsequently transferred to Filippino
Lippi, whose altarpiece (of the same
subject) is now also in the Uffizi,
following the destruction of the
monastery during the siege of Florence
in 1529.

 Three years before receiving the
S. Donato commission, on 10 January
1478, Leonardo had contracted to paint
an altarpiece for the Chapel of St
Bernard in the Palazzo Vecchio,
Florence, and likewise never completed
the picture. It has been suggested that
the subject of the earlier altarpiece was
the *Adoration of the Shepherds*, though the
painting supplied some years later (again
by Filippino) showed the Virgin and
Saints, including St Bernard. In any
event, Leonardo's *Adoration of the Magi*
develops seamlessly from studies for an
Adoration of the Shepherds. It is likely that
the present sheet (and a related one in
the Louvre, Popham 43) are preliminary
studies for the *Adoration* in its later guise,
although (typically for Leonardo) the
poses of all the figures were subtly
adjusted before the Uffizi picture.

 The studies on this drawing appear to
have been taken from life. Particular
attention is paid to gesture (especially of
the hands) and facial expression.
Although the *Last Supper* is considered
the *locus classicus* of Leonardo's interest
in and use of these dramatic devices, he
was already using them over ten years
earlier in the Uffizi *Adoration*.

 The rather summary technique, in
which the outlines alone indicate the
form and very little modelling is
included, is paralleled in other studies for
the *Adoration*: see particularly the Louvre
compositional drawing and figure studies
(Popham 42).

8

STUDY FOR THE SFORZA MONUMENT,
*c.*1488
Metalpoint on paper coated with a blue-coloured preparation. 152 × 188 mm
Prov.: Windsor Leoni volume (12358)
Ref.: Popham 68; C&P; Pedretti II 106

When Leonardo offered his services to Ludovico Sforza in *c.*1482, he specifically mentioned that 'work could be undertaken on the bronze horse, which will be to the immortal glory to eternal honour of the auspicious memory of His Lordship your father and of the illustrious house of Sforza'. The project to commemorate Francesco Sforza (1401–66), the first Sforza ruler of the Milanese state, had been under discussion since the 1460s. It is not known when Leonardo received the commission, but in 1489 Lorenzo de'Medici was provided with information concerning the progress of the horse. Ludovico was evidently hoping for 'something quite outstanding'. Leonardo was at the time preparing a model for the monument, which would show Francesco Sforza armed, riding a colossal horse. But 'although the Duke has entrusted this matter to Leonardo, it does not seem . . . that he is fully confident that Leonardo understands how to complete it', so Ludovico was enquiring after other sculptors who might undertake the work. Designs for a Sforza equestrian monument by Antonio Pollaiuolo may relate to this episode; alternatively they may pre-date Leonardo's involvement.

Among the relatively small number of secure biographical details in Leonardo's life are two dates which appear specifically to concern the Sforza horse: on 23 April 1490 Leonardo noted that he 'recommenced work on the horse', and two months later, on 21 June, we know that he was in Pavia, where he recorded having seen the classical equestrian monument known as the *Regisole*. This appears to have inspired Leonardo to show the horse walking (as on Windsor 12345; fig. 37), rather than rearing (as in no. 8). The vast clay model for the monument (which was to be well over life-size) was ready for casting in December 1493, but nothing was done and in November 1494 the bronze intended for the horse was supplied to Ludovico's father-in-law, Ercole d'Este, for the making of cannon. Leonardo's model seems to have been destroyed by the invading French troops in 1499, but the moulds were apparently still extant in 1501. They were never used.

This study shows Leonardo working through some of the possible positions of horse, rider and fallen foe, for the first version of the Sforza monument. He had already studied horses in some detail in Florence, in connection with the Uffizi *Adoration* where various groups of horsemen are shown in the background. There are classical prototypes for both the rearing and the walking horseman. It is likely that Leonardo finally adopted the latter alternative because of the problems inherent in supporting the great mass of bronze above. In this drawing these were presumably to be overcome by inserting a metal rod through the arm of the fallen figure and along the horse's leg. A date of *c.*1488, or a little earlier, is consistent with the style and technique of this drawing.

Fig. 37 *A Horse walking in Profile*, *c.*1490, pen and ink (Windsor 12345)

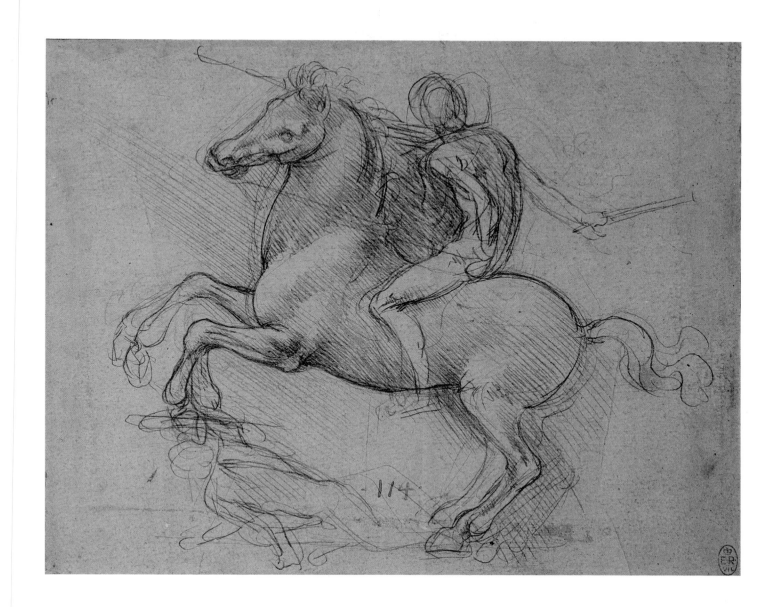

9

THE SKULL BISECTED AND SECTIONED, 1489
Pen and ink. 189 × 139 mm
Prov.: Windsor Leoni volume (19058v)
Ref.: B 41v; Popham 219; C&P; K/P
 42v

Leonardo's first sustained programme of anatomical work appears to have been concerned with the human skull, of which he made a series of careful drawings. This research was carried out at least partly to satisfy his curiosity as to the precise location of the *sensus communis*, the meeting place of all the senses and the seat of the soul (see the verso of this page and no. 93 and figs. 38 and 39). The skull series can be dated very specifically (because of the inscription on Windsor 19059) to 2 April 1489. At the time Leonardo was residing in Milan as court artist to Ludovico Sforza. He was (or should have been) at work on the *Virgin of the Rocks* and the Sforza horse (see no. 8), but had not yet received the commission for the *Last Supper*, in which the brilliant characterisation of facial types owes so much to his knowledge of the underlying anatomical structure.

 The artist has prepared and presented his model with customary care and attention to detail. The main and subsidiary drawings, with accompanying notes (concerning the different facial cavities and types of teeth) are here set out in the manner of the printed page of a textbook. The shape and surface texture of the skull are suggested by a series of extraordinarily fine parallel hatching lines. The refined control of pen and ink is akin to that found in manuscript illumination or miniature painting.

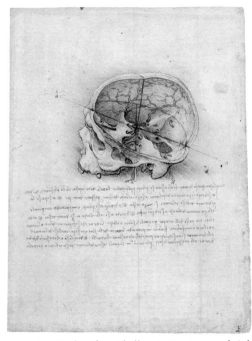

Fig. 38 *Study of a Skull*, c.1489, pen and ink (Windsor 19058)

Fig. 39 *Two Drawings of the Cranium*, 1489, pen and ink (Windsor 19059)

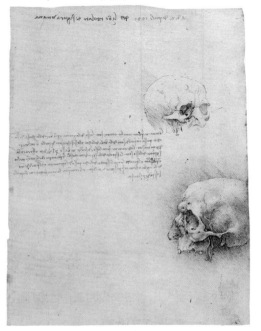

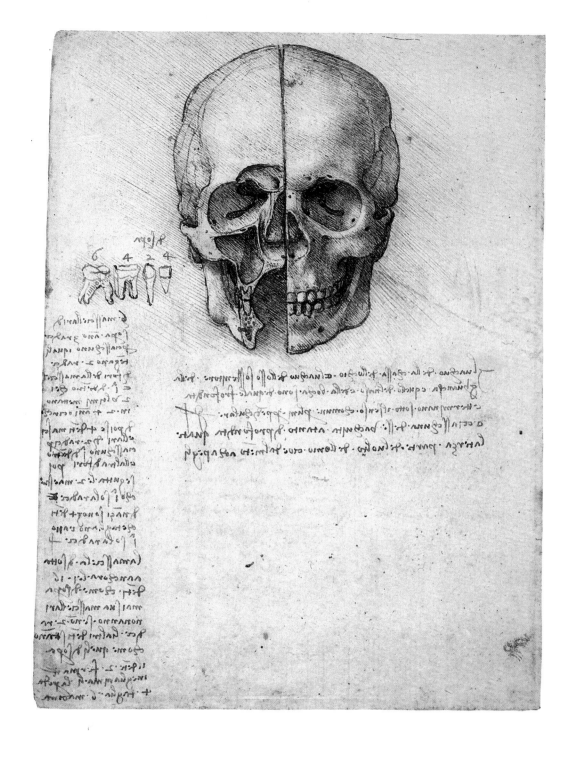

10

PRELIMINARY SKETCH FOR THE LAST
 SUPPER, AND OTHER STUDIES, *c*.1495–6
Pen and ink. 266 × 215 mm
Prov.: Windsor Leoni volume (12542)
Ref.: Popham 161; C&P; Pedretti III
 195r; Pedretti *L.S.* 3

Leonardo's best-known composition, the
Last Supper (fig. 25), was painted on the
end wall of the Refectory attached to
the church of Sta Maria delle Grazie,
Milan. The experimental medium
employed in the painting was
responsible for its deterioration: it was
already said to be decaying in 1517. The
current restoration campaign will
remove dirt and repaint but cannot
replace the modelling in the many areas
in which it has disappeared. This
notwithstanding, we have a clear
enough image of the *Last Supper* – an
image derived from the original, from
the many copies, and from the various
preparatory studies (which include nos.
10, 31, 88 and 89).

The precise date of Leonardo's
commission for the mural is not known,
but it was part of the larger Sforza
programme for the church and monastic
complex of Sta Maria delle Grazie
which from 1492 involved Bramante in
the transformation of the church into a
Sforza mausoleum. In 1497, after the
death of Ludovico's daughter (Bianca)
and of his wife (Beatrice d'Este),
Leonardo was urged to complete work
on the *Last Supper* and to proceed with
the other wall of the Refectory. At
around this date Raymond Pérault,
Cardinal of Gurk, visited the monastery
and observed Leonardo at work: this
visit was later recounted by Bandello.
Luca Pacioli implies that work on the
painting was complete by February
1498.

This drawing is one of two
'compositional' studies for the *Last
Supper*, which have been dated *c*.1495–6.
It is the only one to indicate an
architectural setting. If the arches top left
are read as part of the actual
architecture, we must assume that the
Last Supper was not always to have been
on the end wall of the Refectory.
However, the arches are more easily
explicable as Leonardo's first thoughts
for the fictive architectural background.

The placing of figures both in this
study and in the rather crude sketch in
Venice (Popham 162) employs the
traditional (and somewhat obvious)
device of placing Judas on the opposite
side of the table to the remainder of the
group, and showing St John asleep at

the side of Christ. The present sheet
appears to have been trimmed at top left
for only ten of the twelve Apostles are
visible. In the upper drawing Christ is
shown third from the left, a sage with
long hair and beard. His figure is
repeated (with alterations) in the group
to the right. In the finished painting the
main changes relate to the placing of
Judas, and the disposition of the Apostles
into four groups of three, ranged at
either side of the central, serene and
clean-shaven figure of Christ. The
architectural background is also quite
different.

The note and drawing occupying the
lower half of the page may have been
the first to be inscribed on this sheet.
These relate to the construction of an
octagon from a given line, using a
standard geometrical method.

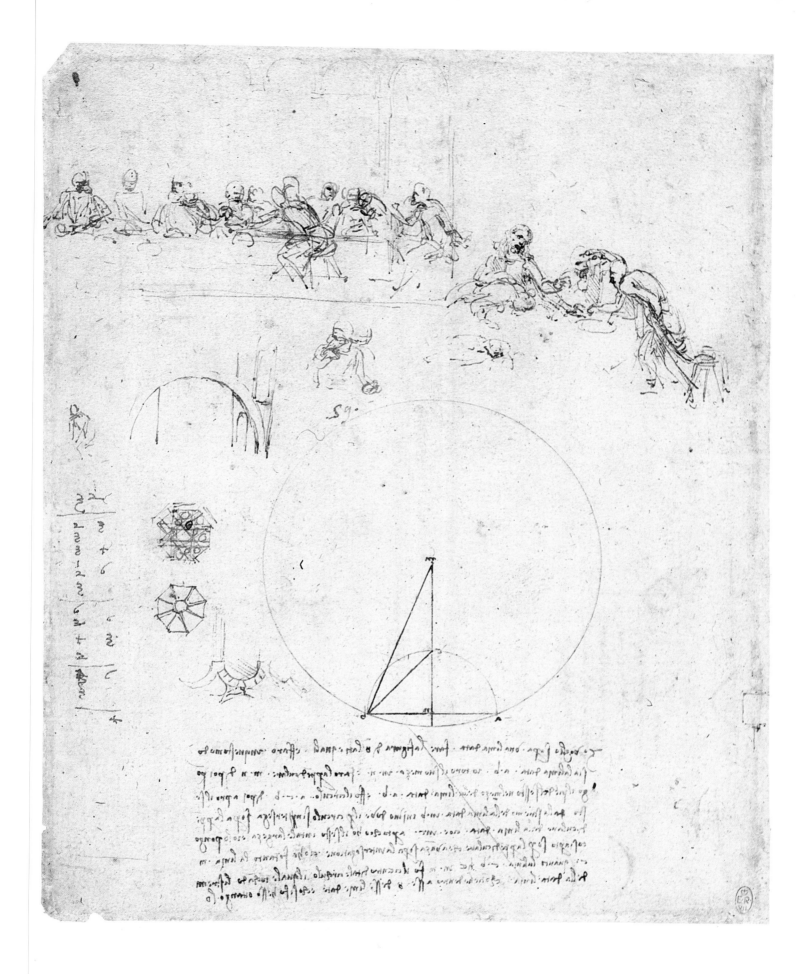

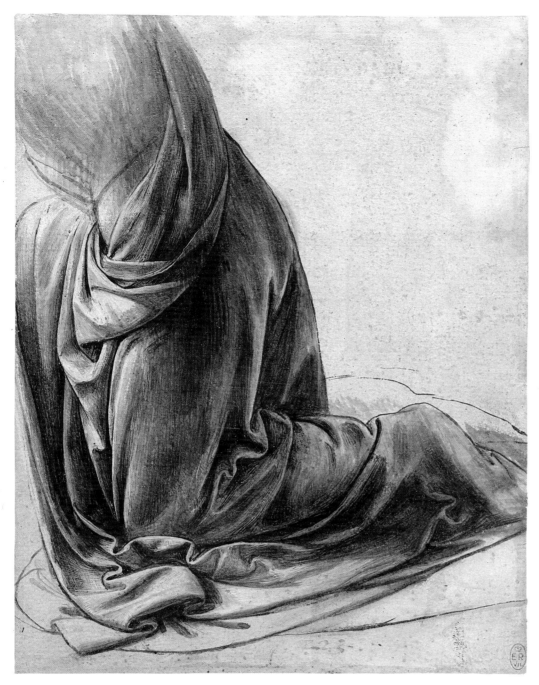

II

DRAPERY STUDY FOR THE VIRGIN OF THE
ROCKS, *c.*1496
Black wash, heightened with white, on
paper coated with a pale blue
preparation. 212 × 159 mm
Prov.: Windsor Leoni volume (12521)
Ref.: Popham 158; C&P; Pedretti III
176r

On 25 April 1483 Leonardo received a
commission, from the Confraternity of
the Immaculate Conception, for an
altarpiece. The resulting picture, the
Virgin of the Rocks, is known in two
versions: in the Louvre, Paris and in the
National Gallery, London (figs. 23 and
24). Both appear to be largely
autograph, but the Paris picture is
normally dated *c.*1483–6, while it is
generally thought that the London
version was not completed until
*c.*1506–8, though it may have been
commenced before 1500. No. 11 is
clearly a drapery study for a kneeling
figure seen in approximately the position
of the angel in the *Virgin of the Rocks*.
The angel's drapery is shown billowing
out towards the right in the Louvre
version. In the London picture it is more
controlled and sufficiently close to the
pattern in the present drawing to suggest
a direct connection between the two.

The technique, which is ultimately
dependent on the early studies on linen
(e.g. no. 3), is not apparently paralleled
in Leonardo's surviving work. However,
the monochrome modelling, black
outline and treatment of the drapery in
general is comparable to that in the
study for St Peter's arm in the *Last
Supper* (Windsor 12546) of *c.*1496. The
incomplete and extraordinarily complex
documentation of the *Virgin of the Rocks*
allows for the possibility that work on
the altarpiece continued during the
1490s. Therefore this study could also
date from *c.*1496.

12

A COPSE OF TREES, *c.*1500
Red chalk. 194 × 153 mm
Prov.: Windsor Leoni volume (12431)
Ref.: Popham 262A; C&P; Pedretti I 8

The many references to trees in
Leonardo's manuscripts show that he
was as interested in their changing
appearance under different light
conditions as in their intrinsic make-up
or growth. On the verso of the present
sheet, in a note accompanying a drawing
of a single tree, he states:

> The part of a tree which has shadow
> for background is all of one tone, and
> wherever the trees or branches are
> thickest they will be darkest, because
> there are no little intervals of air. But
> where the boughs lie against a
> background of other boughs, the
> brighter parts are seen lightest and the
> leaves lustrous from the sunlight
> falling on them.

This drawing may indeed have been
made as a possible illustration to
Leonardo's *Treatise on Painting*.
 Red chalk was first used by Leonardo
in the 1480s, and had been fully
mastered by the time of such drawings
as the *Study for St James* for the *Last
Supper* (no. 89). In no. 12 the chalk is
put to very different effect. By subtle
variations of touch diverse foliage types
are suggested, as is the depth and
thickness of the copse, and the quality of
lighting.
 A number of different dates have been
suggested for this drawing, from *c.*1495
to *c.*1510. The relationship with a page
(f.81) in Paris Ms. L of *c.*1498–1502
would indicate the earlier date, as would
the similarity of technique between this
drawing and the *Storm over a Valley* (no.
47). However, both the handwriting and
the arrangement of text and illustration
on the verso of no. 12 are close to a
drawing such as no. 41, which is
normally related to the Trivulzio
monument of *c.*1508–12.

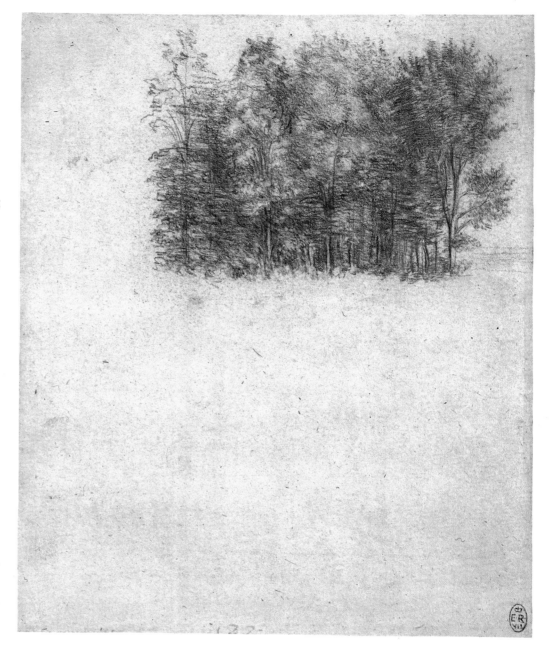

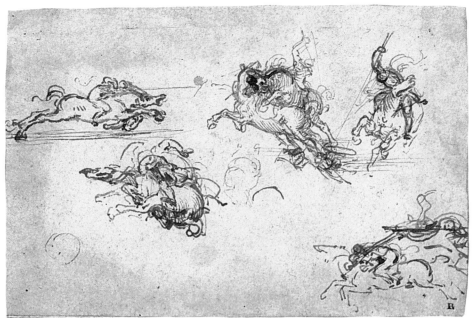

13

STUDIES OF BATTLING HORSEMEN, *c*.1503
Pen and ink. 83 × 120 mm
Trustees of the British Museum, London
Prov.: Jonathon Richardson the Younger;
Uvedale Price; British Museum
(1854-5-13-17)
Ref.: Popham 193A; Popham & Pouncey
109

Leonardo's principal commission during his second period of residence in Florence (1500–6) was for a large mural painting in the new Salone del Cinquecento of the Palazzo Vecchio (see also nos. 73, 74 and 87). The subject (ironically, considering Leonardo's dual allegiance to Florence and Milan) was to be the victory of the Florentine forces over the Milanese at Anghiari in 1440. The description of the battle provided for Leonardo's use is preserved among his drawings and notes in the Codex Atlanticus, though he also consulted other accounts of the conflict, including that by Capponi.

In October 1503 Leonardo began work on the cartoon for the battle piece, for which he received payments throughout 1504 and from April to August 1505. On 6 June 1505 he inscribed a page of Madrid Ms. II: *cominciai a colorire in palazzo*, which is normally taken to indicate the start of his actual painting on the wall. From the middle of 1506 Leonardo was chiefly active again in Milan, and although he returned to Florence on numerous occasions he did not complete more than a relatively small section of the battle piece. His painting was later covered over by Vasari's grandiose decorative scheme, but is known from copies, such as that by Rubens in the Louvre (which was based on an engraving or drawing; fig. 32).

Leonardo's painting of the *Battle of Anghiari* appears to have been conceived as a tripartite composition. The area actually painted onto the wall was within the central episode, 'The Fight for the Standard'. This drawing is associated with the scene to the left of the Standard group. The power and speed which Leonardo has suggested in a few pen lines is extraordinary. Horses are shown dashing from side to side, their riders attacking with lances held at various angles. In the group to right of centre of this sheet one horse appears to be biting another, an action typical of the *pazzia bestialissima* (most beastly madness) which according to Leonardo is the inevitable result of warfare. Many of the incidents shown in this and other preparatory studies for the *Battle* (aptly described by Kenneth Clark as 'fiery little scribbles') had been included by Leonardo in his verbal description of 'How to represent a battle', which occurs in the Codex Ashburnham (see p. 132 and no. 87).

14

LEDA AND THE SWAN, c.1505–7
Black chalk, pen and ink.
125 × 110 mm
Museum Boymans-van Beuningen,
 Rotterdam
Prov.: Thomas Lawrence; King
 William II of Holland; Grand Duke
 Karl Alexander of Saxe-Weimar;
 J. W. Boehlar; F. Koenigs; Museum
 Boymans-van Beuningen (I 466)
Ref.: Popham 208

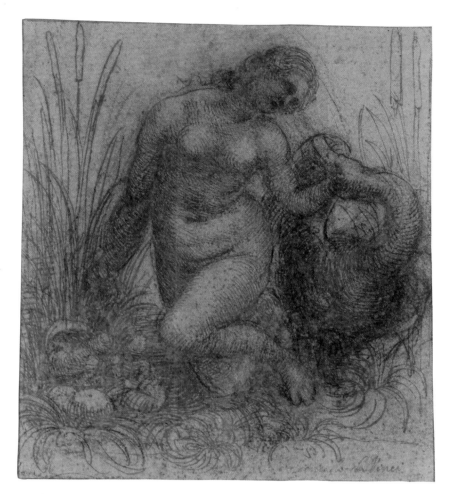

This drawing represents the main participants in the legend of Leda, the Aetolian princess who was loved by Jupiter disguised as a swan. It was variously claimed that out of the eggs resulting from this union there emerged the infants Castor and Polydeuces (the Dioscuri), and Helen and Clytemnestra. Antique representations of the story were known in the Renaissance and inspired Michelangelo's lost picture of the same subject. The pose of Leda in Leonardo's painting (which is also lost) was instead inspired by figures of Venus Anadyomene and Venus Pudica.

Our knowledge of Leonardo's picture of *Leda and the Swan* is derived from his surviving preparatory studies (see also nos. 58, 74 and 75), copies by other artists of his cartoon and painting, and from verbal descriptions. Of these the fullest is that by Cassiano dal Pozzo, who saw the picture at Fontainebleau in 1625:

> a standing figure of Leda almost entirely naked, with the swan at her feet and two eggs, from whose broken shells come forth four babies. This piece, though somewhat dry in style, is exquisitely finished, especially in the woman's breast; and for the rest the landscape and the plant life are rendered with the greatest diligence. Unfortunately, the picture is in a bad state because it is done on three long panels which have split apart and broken off a certain amount of paint.

The origin and style of the contemporary copies suggests that the picture was painted in Milan c.1507–10, on the basis of a cartoon drawn in Florence. The most Leonardesque of the surviving copies is that attributed to Cesare da Sesto at Wilton House (fig. 31).

This drawing and that at Chatsworth (no. 75) indicate that Leonardo had first envisaged that Leda would be shown kneeling. The evolution of this pose is seen in the two 'framed' studies in no. 74, in which the position finally occupied by the swan is taken by the children hatching from their egg (or eggs). The elaborate working of both no. 14 and no. 75 may indicate that they were intended as presentation pieces in their own right or as the basis for such pieces, like Antonio Segni's *Neptune* drawing (see no. 71). The elaborate hairstyle which is so much a hallmark of the standing *Leda* (e.g. no. 58) is already hinted at in this drawing, as are the plants which were eventually to occupy the foreground of the painting (e.g. nos. 44 and 57).

15

A COMPARISON BETWEEN THE LEGS OF MAN
AND HORSE, c.1506–7
Pen and ink over red chalk on paper
coated with a red preparation.
281 × 205 mm
Prov.: Windsor Leoni volume (12625)
Ref.: C V 22r; Popham 230; C&P; K/P
95r

Around twenty years after the remarkable drawings of the head and skull (see nos. 9 and 93) Leonardo returned to his anatomical studies with an extraordinary burst of activity. At this time he was chiefly resident in Milan: the inscription along the top of this sheet mentions an address in the Cordusio, the old market-place of that city.

Although Leonardo's chief interest was human anatomy, some of his earliest drawings record dissections of animals, whose corpses were more freely available than those of humans. The Sforza monument had involved the artist in much specialised study of the horse, carried out (also in Milan) in the 1480s and 1490s. According to Vasari, Leonardo's treatise on the anatomy of the horse was lost during the French invasion of Milan in 1499. The present sheet includes a clear illustration of comparative anatomy. Alongside the two drawings lower centre Leonardo has written: 'To compare the structure of the bones of the horse to that of man you shall represent the man on tiptoe in figuring the legs.' In both drawings the muscles are represented by chords to clarify their relative positions and actions. Leonardo used the same technique in drawings such as nos. 106 and 108.

The curious 'red on red' technique was used first in the 1490s for drawings for the *Last Supper* (e.g. no. 88), and then to great effect in the series of plant studies connected with the painting of *Leda* (e.g. nos. 28 and 44). Leonardo's use of the technique in no. 15 suggests a link between his work at this time 'on the origin of both vegetable and human life – a theme symbolised by the *Leda*' (Kenneth Clark).

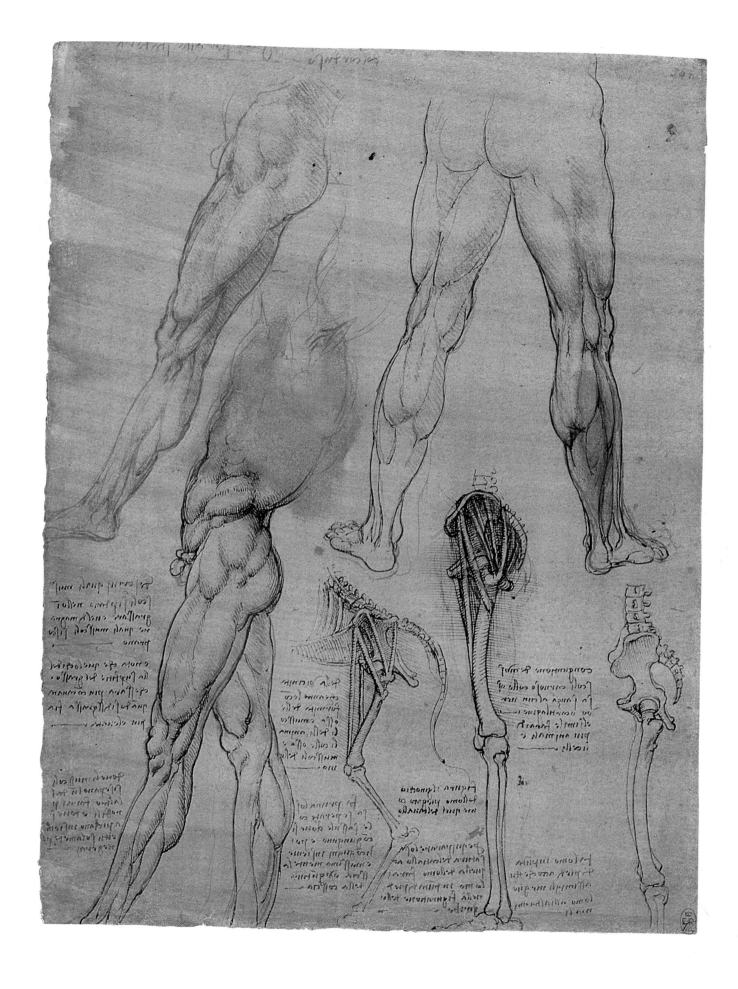

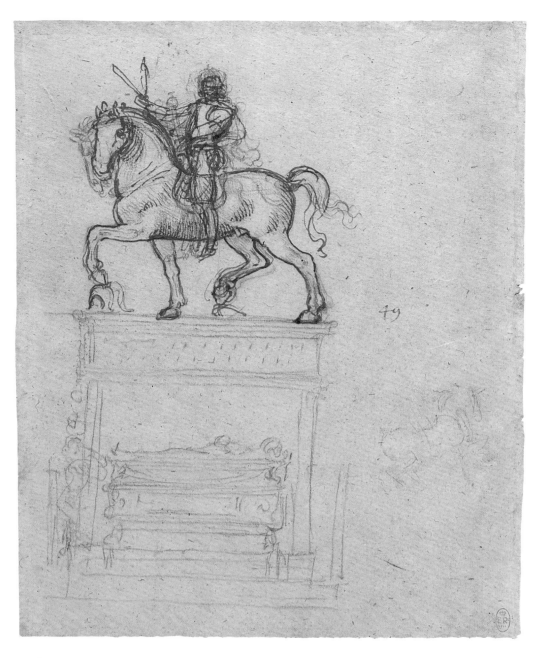

16

STUDY FOR THE TRIVULZIO MONUMENT,
 c.1509–10

Pen and ink over red chalk, with traces
 of black lead. 225 × 176 mm
Prov.: Windsor Leoni volume (12356)
Ref.: Popham 93; C&P; Pedretti II 135r

Among the Leonardo drawings at
Windsor it is possible to distinguish two
series of preparatory studies for
equestrian monuments. The first group
evidently relates to the Sforza
monument of c.1483–93 (see no. 8 etc.).
The second group, which includes this
drawing, is stylistically considerably
later. A detailed and costed (but
undated) specification for 'The
Monument to Messer Giovanni
Giacomo Trivulzio' survives, in
Leonardo's handwriting, in the Codex
Atlanticus (f.179va/429r). Although no
other documents appear to refer to this

commission, and none of Leonardo's
biographers mention it, we may assume
that this later group of drawings is
preparatory for the Trivulzio
monument. The date of these studies is
thought (from the drawing style and the
paper employed) to be c.1508–12.

Giovanni Giacomo Trivulzio, a
successful *condottiere*, was appointed by
the French to serve as joint Governor of
Milan (with Gaston de Foix) following
the death of Charles d'Amboise in 1511.
In the same year work appears to have
begun on the Trivulzio Chapel in
S. Nazaro, Milan, to designs by
Bramantino: this was presumably to be
the architectural setting for Leonardo's
monument. The specifications indicate
that the horse and its rider were to be
'*grande al naturale*', that is life-sized. The
equestrian group was to be made of
bronze, while the platform and its
supporting columns below would be
largely of marble. The recumbent effigy
of the deceased was to be of stone
(*pietra*) rather than marble (*marmo*). At
the four corners of the base there were
to be chained 'captives', possibly inspired
by Michelangelo's first project for the
Julius Tomb.

As with the Sforza monument, some
of Leonardo's ideas for the Trivulzio
monument (e.g. Windsor 12353, 12355
and 12360) show a rearing rather than a
walking horse. The verso of this
drawing includes further studies on the
ideal pose for both horse and rider. The
same basic form is retained by the
simple technique of holding the sheet up
to the light and tracing through the
outlines of one side onto the other. In
either case the poses are very close to
those finally arrived at for the Sforza
monument (see no. 8). Kenneth Clark
noted:

> that in the red chalk under-drawing
> of the recto the horse in profile and
> the rider with a cloak are in the
> classical convention . . . but when
> drawing it over in ink Leonardo
> turned to the Renaissance convention
> with the figure in armour as in
> [Donatello's] Gattamelata.

17

STUDY FOR THE HEAD OF ST ANNE, *c.*1510
Black chalk and some ink applied with a
 brush (?), with red chalk off-setting.
 187 × 129 mm
Prov.: Windsor Leoni volume (12533)
Ref.: Popham 182; C&P; Pedretti III
 295r

Although there are records that
Leonardo worked on various
compositions including the Virgin and
Child with St Anne, together with St
John the Baptist or a lamb, the picture
in the Louvre (fig. 29) is the only
finished painting of this subject to
survive. This drawing is a preparatory
study for the head of St Anne in that
painting. (No. 56 is a drapery study for
the Virgin's sleeve.)

In April 1501 Fra Pietro da Novellara
reported to Isabella d'Este that

Since [Leonardo] has been in Florence,
he has worked on one cartoon, which
represents an infant Christ of about
one year, freeing himself almost out
of his mother's arms and seizing a
lamb and apparently about to
embrace it. The mother half-rising
from the lap of St Anne is catching
the Christ to draw it away from the
lamb . . . St Anne, just rising from
her seat, as if she would wish to
hinder her daughter from parting the
Christ from the lamb. . . The figures
are life-size, but they fill only a small
cartoon, because all are seated or bent,
and each one is placed before the
other, to the left. The sketch is not
yet complete.

This cartoon appears to have been
undertaken when Leonardo was
(supposedly) working on a picture for
the high altar in SS. Annunziata,
Florence. Its appearance may be
recorded in a drawing in a private
collection in Geneva (see Pedretti in
Leonardo dopo Milano, p. 18 and no. 21).
The National Gallery cartoon shows the
Virgin and Child and St Anne (or,
possibly, St Elizabeth), with the young
St John the Baptist in the place of the
lamb. The London cartoon is datable to
*c.*1505–7 on the grounds of style (see
also no. 77). Whereas the figures in the
1501 cartoon were apparently grouped

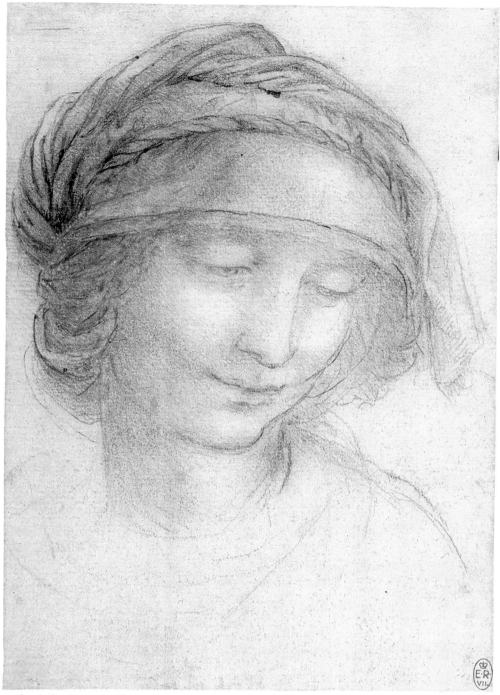

to the left, those in the London
composition are grouped to the right.
The same is the case with the final
variation of this theme, the Louvre
painting of the *Virgin, Child, St Anne
and a Lamb*. The picture is not
documented but appears to date at the
earliest from Leonardo's second Milanese
period and may have been completed as
late as *c.*1515.

The final arrangement of figures in
the picture allows for a compact if

highly artificial assemblage of forms
within a pyramidal grouping at the apex
of which is the head of St Anne.
Kenneth Clark notes that a comparison
between the drawing and the painting
'shows how much Leonardo regularised
features in his pictures to attain his ideal
of beauty and perfection, losing thereby
something of freshness and humanity.
The drawing has human mystery, the
painting artificial.'

18

FIVE VIEWS OF A FOETUS IN THE WOMB,
*c.*1510–12
Pen and ink with red and black chalk.
304 × 213 mm (irregular)
Prov.: Windsor Leoni volume (19101)
Ref.: C III 7r; C&P; K/P 197v

At the start of the last decade of his life Leonardo's anatomical studies were concentrated on two fundamental areas: the heart (see no. 19) and embryology. At the same time he was completing the series of studies of the musculature and skeleton of the shoulder, arms and legs, known as Folio A (e.g. nos. 95, 106 and 109). This anatomical work was chiefly carried out in Milan.

Both nos. 18 and 19 demonstrate how Leonardo's mastery of pen and ink drawing could be used to illustrate the results of his anatomical dissections, and to demonstrate his theories. In no. 18 there is a further addition of red chalk modelling. The present sheet is closely related to the famous study of *The Foetus in the Womb* (no. 26) and must have been made on the same occasion as that drawing, and from the same model. On the verso of no. 18 Leonardo wrote 'the child was less than half a *braccio* long, and nearly four months old', although its developmental stage suggests that it is at least a month older. The artist was well aware of the usefulness of drawing each part of a structure (particularly each anatomical element) from a number of different viewpoints. The slight variations in the positions of the infant's feet both on this page and on no. 26 might suggest that the artist was drawing a live infant, but this is extremely unlikely. Instead he was illustrating his ingenious (but erroneous) belief, stated in the note to left of centre, that the tucked-in heel of the foetus prevents the passage of urine into the uterus.

Elsewhere in the notes on this page (both recto and verso) Leonardo discusses the length and position of the umbilical cord and states (mistakenly) that 'the length of the umbilical cord is equal to the length of the foetus at every stage of its growth'. He also concludes that the child does not respire in the body of its mother 'because it lies in water and he who breathes in water is immediately drowned . . . and where there is no respiration there is no voice'. The drawings across the top and the notes down the left side of the page relate to the female genitalia.

In the note bottom right Leonardo digresses to make one of his frequent observations about the relative roles of the painter and the artist: when the poet depicts reality 'he would make himself equal to the painter if he could satisfy the eye with words in the same way that a painter with brush and colour makes a harmony to the eye in an instant, like music does to the ear'.

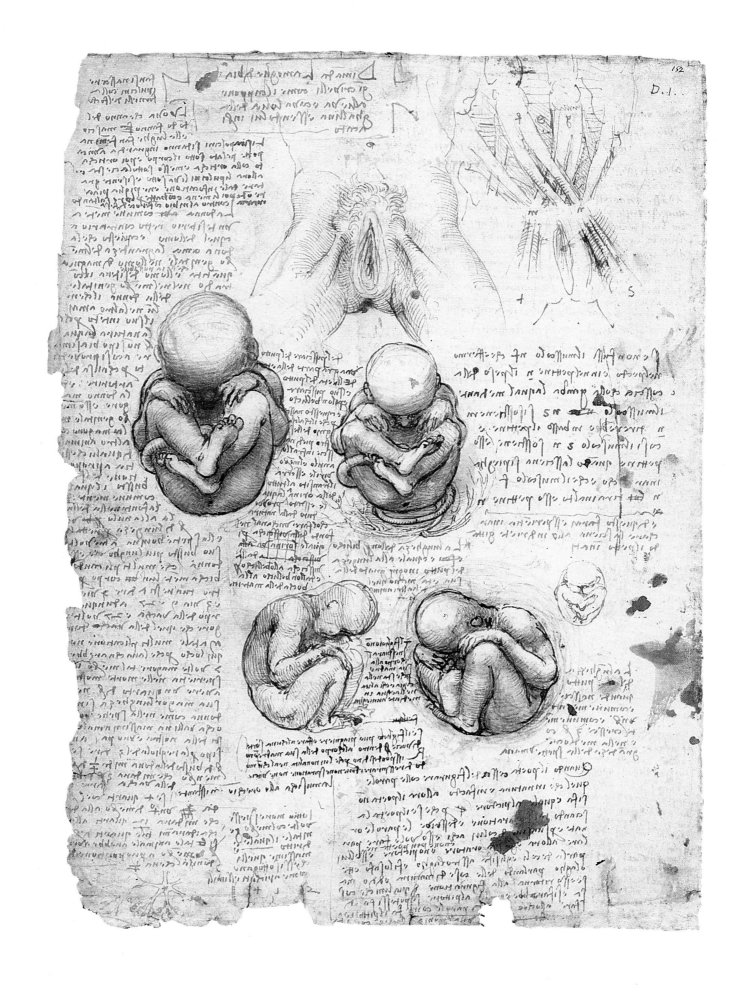

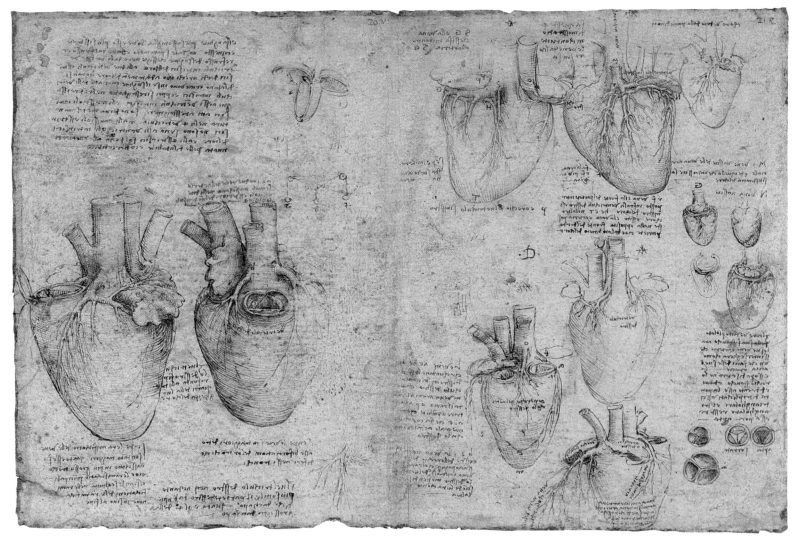

19

THE HEART OF AN OX, *c*.1513
Pen and ink on blue paper.
　290 × 412 mm
Prov.: Windsor Leoni volume (19073-74v)
Ref.: C II 3v and C II 4r; Popham 249;
　C&P; K/P 166v

No. 19 belongs to a series of drawings in pen and ink on blue paper, which can be dated with reference to the inscription on one of the series (Windsor 19077v). Although the drawings (which include nos. 55 and 119) are chiefly concerned with the appearance and workings of the heart, the dated sheet shows the diaphragm and thorax of an ox, and a fortress at the bend of a river. It is inscribed 9 January 1513, four days after the fortress (at Trezzo, near Vaprio d'Adda, to the east of Milan) was overcome by the Venetian forces.

This page is double the usual size of paper used for Leonardo's drawings, but indicates the original sheet size. Until recently it was kept folded in two, hence the two inventory numbers. The heart shown here from various viewpoints is that of an ox. On the left-hand page the root of the pulmonary artery is drawn (severed) at the left of the left-hand diagram, and in the forefront of the right-hand one.

Above these are diagrams of the interventricular septum of the heart, with the lateral walls of the ventricles displaced. The septum was of great importance in the Galenical system since it was through its pores that some of the blood which ebbed and flowed in the right ventricle passed in refined or subtilised form to the left ventricle, from where the warmed blood distributed the vital spirits to the regions of the body.

The drawings over the right-hand side of the sheet show the heart from other viewpoints, and with other vessels severed for greater clarity. The small figures in the middle of the right-hand margin show the ring of blood vessels surrounding the top of the heart like a crown, illustrating well the origin of their name, 'coronary' arteries. Beneath them near the right margin Leonardo writes: 'The heart seen from the left side will have its veins and arteries crossing like somebody crossing his arms; and they will have above them the left auricle and inside them the gateway of triplicate triangular [i.e. aortic] valves; and this gate remains triangular when open.' Below these words Leonardo draws two aortic valves, that on the right with the caption *ap*[*er*]*ta* (open), and that on the left *serrata* (closed).

20

BIRD'S-EYE VIEW OF A FERRY SWINGING
 ACROSS A RIVER, c.1513
Pen and ink. 100 × 130 mm
Prov.: Windsor Leoni volume (12400)
Ref.: Popham 268B; C&P; Pedretti I 51r

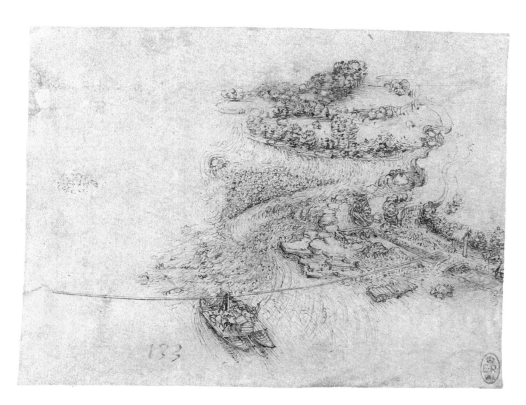

Leonardo's interest in water movement
and turbulence in general (which is
discussed in further detail elsewhere, in
the section devoted to the Vortex) was a
particular feature of the period from
c.1500 (together with the Arno
canalisation projects), and especially
from c.1508. It is very difficult to arrive
at a precise date for this drawing and for
other studies in a similarly miniaturistic
technique (e.g. Windsor 12398, 12399
and 12402). There are no other drawings
that are both comparable and securely
datable. However, it has recently been
shown that the majority of these
drawings represent identifiable places.
No. 20 is a bird's-eye view of a stretch
of the river Adda between Canonica and
Vaprio d'Adda. The two small bridges
lower right are still extant, over 450
years on (fig. 40). Although the *traghetto*
has now been replaced by a bridge, the
steps which once led to the ferry are still
in place.

 Vaprio d'Adda was the home of the
Melzi family, and thus of Leonardo's
favourite pupil (from c.1508) and
ultimate heir, Francesco Melzi. The view
shown here is immediately in front of
the Villa Melzi. The dated drawing on
blue paper in the 'heart' series suggests
that Leonardo was in the vicinity of
Vaprio d'Adda in January 1513 (see no.
19). He may also have stayed with the
Melzi family later in the year, prior to
leaving Milan for Rome.

 This drawing repays lengthy
examination. Observe particularly the ox
on the banks of the river (below the
traghetto cable to the right), which
appears to be calling to the animals on
the ferry. And study the bubbles above
the turbulent water, referred to
repeatedly by Leonardo as *sonagli*, thus
attaching a musical connotation to the
image of bubbling water.

Fig. 40 Photograph of present-day topography of
the river Adda between Canonica and Vaprio
d'Adda, © 1982 Lucilla Malara

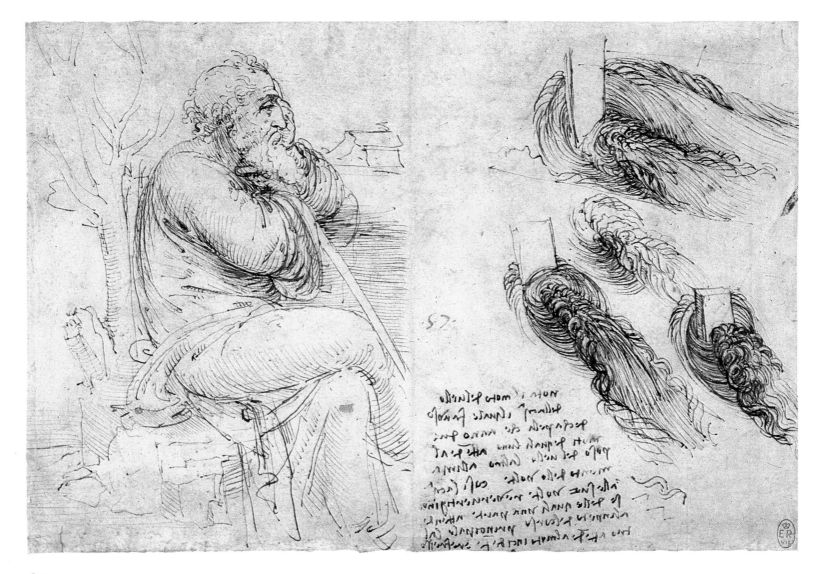

21

A SEATED OLD MAN WITH WATER STUDIES,
 c.1513
Pen and ink. 154 × 216 mm
Prov.: Windsor Leoni volume (12579)
Ref.: Popham 282; C&P; Pedretti I 48r

The powerful image on this small sheet of an aged seer contemplating the flow of water may be fortuitous. The sheet was probably originally folded down the middle, hence the rather abrupt termination of the shading lines in the left-hand drawing.

No. 21 has been dated *c*.1513, both from the drawing style and from the possible association of the architectural studies on the verso to Leonardo's designs for the Villa Melzi at Vaprio d'Adda, which are thought to have been produced shortly before his departure for Rome in the autumn of 1513.

The seated figure has often been described as a self-portrait of the artist, but surely represents a man much older than 61, Leonardo's age in 1513. Kenneth Clark's description is typically apt:

It shows an old bearded man seated in profile, his head in his hand gazing into the distance, with an air of profound melancholy. His nutcracker nose and sharply turned-down mouth remind us of the old men in Leonardo's unconscious scribbles, but his curling beard and large deep-set eye recall the likeness of Leonardo himself. Even if this is not strictly a self-portrait we may call it a self-caricature, using the word to mean a simplified expression of essential character.

The note accompanying the drawing of water-flow around obstacles compares the growth of hair to the flow of water, and is translated in the entry for no. 58.

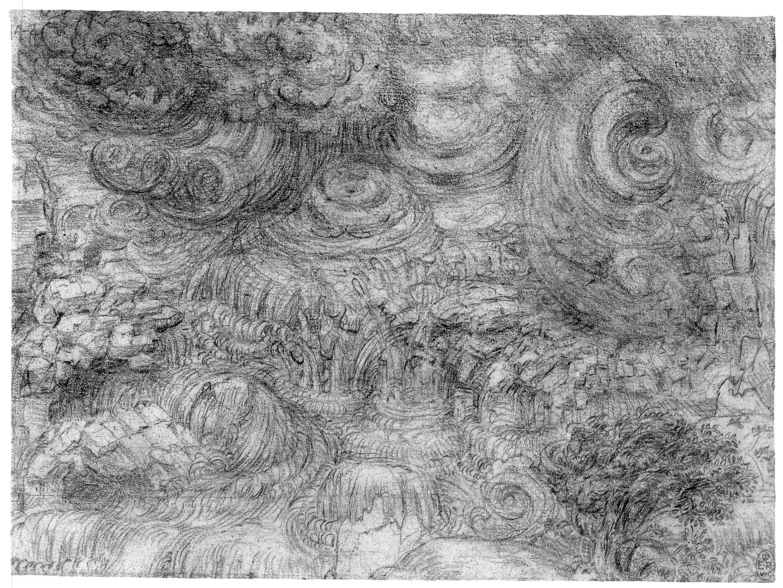

22

DELUGE OVER A ROCKY LANDSCAPE,
 *c.*1513–15
Black chalk on white paper.
 157 × 203 mm
Prov.: Windsor Leoni volume (12377)
Ref.: Popham 292; C&P; Pedretti I 58r

The extraordinary group of ten studies at Windsor known as the 'Deluge Drawings' are among the most original and perplexing in Leonardo's *œuvre*. They appear to illustrate an apocalyptic vision of the destruction of the Earth, as indeed is suggested in Leonardo's note 'How to represent a storm' on Windsor 12665. The gradual annihilation of animal and plant life, of towns, houses and then whole mountains, is shown in finished chalk drawings, which appear to have been made as works of art in their own right.

The drawings are normally dated to the years around 1514, during Leonardo's time in Rome. Their purpose has yet to be satisfactorily explained. They could have been intended as illustrations to the *Trattato della pittura* They may also be associated with a natural disaster such as those recorded in the Alps near Bellinzona in 1513 and again in 1515, when a major landslip led to the collapse of walls and the destruction of whole villages under the joint impact of falling rocks and water. Leonardo himself made a note of the extraordinarily violent storm in Florence in 1505 (which damaged his *Battle* cartoon); another Florentine storm of great force is recorded in 1514.

The 'Deluge Drawings' provided a perfect opportunity for Leonardo to demonstrate his knowledge of the movement of water and other natural forms. 'But although the drawings have a scientific background, they are fundamentally excuses for the release of Leonardo's sense of form, and for the expression of an overwhelming feeling of horror and tragedy.' (Kenneth Clark)

2
THE AGES OF MAN

How the ages of man should be depicted; that is to say, infancy, childhood, youth, manhood, old age, decrepitude.

The theme of the ages of man was conventional enough in the Middle Ages and the Renaissance, and the corrosive effects of time were well represented in a variety of writings, most notably in the Early Renaissance by Petrarch's *Triumph of Time*. The designated number of the ages of man varied from three to seven, and Leonardo himself favoured six. These well-worn subjects were transformed in his hands into a compelling series of visual meditations, characterised in equal measure by intellectual urgency and emotional potency.

Leonardo's fascination with the process of procreation and the sowing of the seeds of life was apparent about 1490 in the earliest phases of his anatomical investigations, most vividly in the famous coition study (no. 24). Subsequently, the secret life of the embryo in the womb provides one of the most remarkable sequences of drawings in his late anatomical researches in the period around 1513 (no. 26), while those aspects of ageing that lead naturally to death were the focus of attention in his only fully-documented dissection of a complete corpse, the dissection of the so-called 'centenarian' in the winter of 1507–8 (no. 51). His projected treatises on anatomy and proportions were intended to include full treatments of the human figure in all its stages of life – from conception to maturity and beyond.

Leonardo's interests embraced what we would now regard as standard concerns in the anatomy and physiology of reproduction and embryology, including the question of the nourishment of the foetus in the womb. They also extended to what would now be regarded as more metaphysical questions about the infusion of the soul into the foetus and the relationship between the foetal soul and those of its parents. In relation to the soul of the mother, he asks at one point 'why one soul governs two bodies?', while the accompanying drawing shows a direct conduit for the passage of the life of the father's soul from the spinal chord to his penis during coition, in keeping with traditional concepts (no. 24).

Drawings made in connection with works of art from the earliest phase of his career in Florence show a keen response to the features of different human types and ages, a response inherited from his master, Verrocchio. Two motifs in particular, the androgenous youth and 'nutcracker' man, became recurrent images, either separately or in combination (e.g. nos. 5, 31, 35, 90), symbolising at the deepest level the diverse temperaments, forms, potencies and ages of man. While the youth remains relatively invariant – if becoming somewhat more heavily sensual in his later manifestations – the choleric man appears in a variety of incarnations, from mature virility, through obstinately belligerent middle age (no. 33), to toothless decrepitude (no. 35). Towards the end of Leonardo's own

career, the sense of caricature that pervades some of the images disappears in the face of moving and personally-felt evocations of old age (no. 36).

The transitory nature of human life and of the beauty he so cherished are familiar subjects in his notebooks. On occasion the expression is thoroughly literary in tone:

O time, consumer of all things, o envious age. You destroy all things and consume all things with the hard teeth of old age, little by little in a slow death. Helen, looking at her reflection, observing the withered wrinkles made in her face by old age, wept and contemplated why it was that she had twice been abducted.

And, setting the theme in a universal context:

now see that the hope and desire of returning to the first chaos seems like the moth to the light, and that the man who, with constant desire, always awaits with joy the new spring, always the new summer, always the months – the things he desires seemingly coming too late – does not realise that he is willing his own destruction; but this desire is the very quintessence of the elements, which, finding itself trapped within the soul of the human body, always desires to return to its giver. And you should know that this same desire is that quintessence, the companion of nature, and the man is a model of this world.

In the *paragone*, in which Leonardo debates the relative merits of the various arts, he places great emphasis on the way in which a painting can preserve transitory beauty: 'O marvellous science, you keep alive the transient beauty of mortals and you have given it greater permanence than in the works of nature, which continuously change over a period of time, leading remorselessly to old age.' In his actual practice of painting, most brilliantly in the *Last Supper*, he played with a conscious and virtuoso hand on the diverse types and ages of man. The expressive subtleties in his visual expressions of the theme, particularly in his drawings, testify that a deep personal resonance lies behind the rhetoric of his written accounts.

While it is unsurprising to discuss Leonardo's artistic compositions in terms of expression, it is more unexpected – and, on the face of it, more dangerous – to talk of emotional responses with respect to his anatomical work. However, it is difficult to avoid some measure of emotional response when confronted by individual drawings, such as the woman's genitalia (no. 23), the image of coition (no. 24), or his vision of the foetus in the womb (no. 26). The notes accompanying the drawings reinforce this subjective response. He not only exhibits a sense of awe in the face of the mysteries of the origins of life, but also a more troubled reaction to the procedures and organs concerned with procreation. His remarks on various aspects of bodily functions, such as ingestion and egestion, suggest a distaste for man's 'animal powers', and his comments on the absurd and repellent aspects of the act of copulation (see no. 24), indicate a response far from devoid of emotional tensions.

What evidence there is to indicate his own sexual inclinations points away from a straightforward heterosexual orientation, and his few forays into the field of female anatomy provide some of his most discomforting images of the human figure. His art breathes an air of absorption with woman simultaneously as an ideal beauty – remote and conceptualised in a somewhat Ruskinian manner – and

as the embodiment of the universal principle of life in the body of the world. There may be an element of what might be described as fear in his awe, and his uncompromisingly frontal depiction of the female genitalia has something of the character of a confrontation. Perhaps it is not too remote in spirit from his reaction to a mysterious feature in the Earth's body: 'I came to the entrance of a great cavern, in front of which I remained for a while, amazed and uncomprehending such a thing . . . There immediately arose in me two feelings – fear and desire – fear of the menacing, dark cavity, and desire to see if there was anything miraculous within.'

23

THE EXTERNAL GENITALIA AND VAGINA,
WITH DIAGRAMS OF THE ANAL
SPHINCTER, c.1508–9
Pen and ink over black chalk.
192 × 138 mm
Prov.: Windsor Leoni volume (19095)
Ref.: C III 1r; C&P; K/P 54r

The main drawing depicts the vulva of
an apparently multiparous woman after
childbirth, with some degree of
exaggeration of the major features and
omission of lesser ones. It is the most
emphatic of a series of drawings of the
female urino-genital system, dating from
the same time as his exploration of the
theme of generation in his *Leda and the
Swan* compositions (nos. 14, 58 and 75).
Drawings of females are comparatively
rare in Leonardo's anatomical studies,
and models for study may not have
been readily available. His own
metaphorical terminology reinforces the
dramatic impact of the characterisation:
'the wrinkles or ridges in the folds of
the vulva have indicated to us the
location of the gatekeeper of the castle'.

The smaller drawings show him
attempting to understand the complex
structure of the anal sphincter. He
concludes that it is operated by five
rather than seven muscles. His attempt
to determine the number of muscles
through visual and verbal reasoning is
entirely characteristic, as is his concern
during this mature phase of his
anatomical work to explain the
principles of the operation of bodily
components on mathematical principles.
He has written 'false' beside the central
diagram, on the grounds that it did not
satisfy his criteria of design and function.

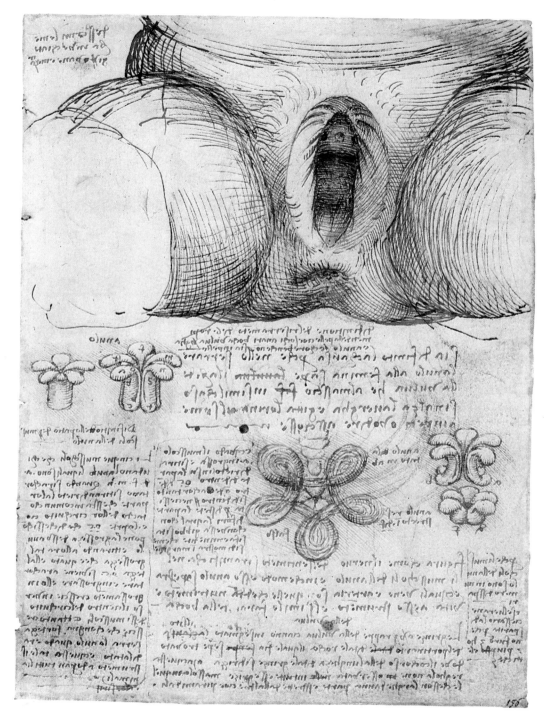

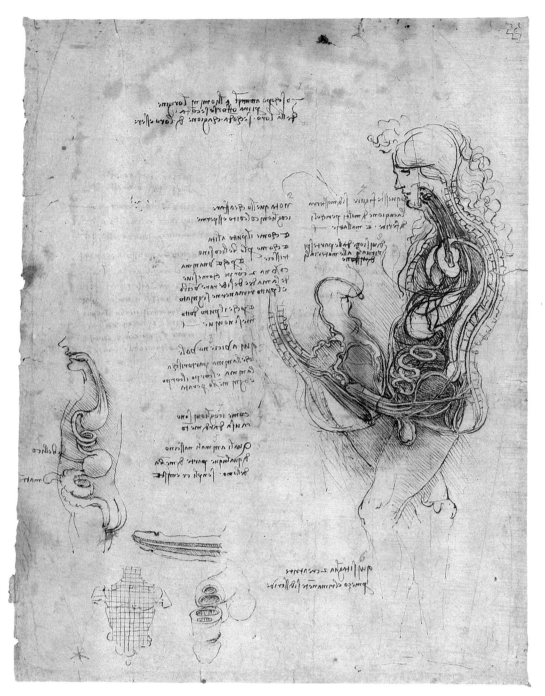

24

COITION OF HEMISECTED MAN AND
 WOMAN, c.1492–4
Pen and ink with black lead numbering
 of manuscript passages added in a
 nineteenth-century hand.
 273 × 202 mm
Prov.: Windsor Leoni volume (19007v)
Ref.: C III 3v; C&P; K/P 35r

This is one of comparatively few early
sheets of anatomical drawings, and
displays the schematic quality typical of
Leonardo's earliest accounts of internal
anatomy. The main drawing illustrates
traditional notions of the generative act,
showing the male seed of life as
originating in the lumbar region of the
spinal chord and proceeding to the penis
through a piece of fictitious plumbing.
In later years, he revised many of the
notions recorded in this drawing.

The figure at bottom left displays a
comparably schematic view of the
human alimentary tract, incorporating
knowledge of animal anatomy, most
conspicuously in the two 'stomachs'.

At the bottom of the sheet he notes:
'here two creatures are cut through the
middle, and the remains are described'.
Later he was to write (on the drawing
exhibited here as no. 109), 'the act of
coitus and the parts employed in it are
so repulsive that if it were not for the
beauty of the faces and adornments of
the participants and their frenetic
disposition, nature would lose the
human species'.

25

THE FOETAL CALF IN UTERO, *c.*1506–8
Pen and ink over traces of black chalk.
192 × 142 mm
Prov.: Windsor Leoni volume (19055)
Ref.: B 38r; C&P; K/P 52r

The upper drawing illustrates the
double-horned uterus of the cow from
the outside. In the lower drawing
Leonardo uses his 'transparency'
technique of demonstration to show the
placental cotyledons, through which the
mother's blood reaches the foetus. The
foetal calf lies upside down, its head to
the left and its forelegs bent. The overt
portrayal of animal anatomy stands in
contrast to his automatic incorporation
of animal findings into the human body
in his earlier work (no. 24), though, as
the following drawing shows, he
continued to resort to animal
morphology where he lacked detailed
knowledge of human features.

The subsidiary diagrams demonstrate
(bottom right) how the 'fingers' of the
maternal and foetal cotyledons 'are
interwoven like burrs'; and (upper left)
his speculation on the geometrical
configuration of the cotyledons after
birth, as they become compressed
together. Both demonstrations are
characteristic of his search for the
universal formal principles that govern
the behaviour of organic components.

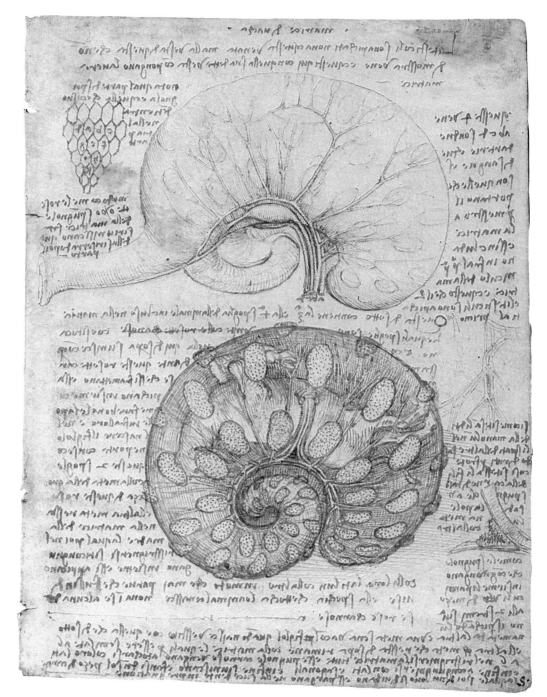

26

THE FOETUS IN THE WOMB, *c.*1510–12
Pen and ink with wash over traces of
 black chalk and red chalk.
 305 × 220 mm
Prov.: Windsor Leoni volume (19102)
Ref.: C III 8r; Popham 248; C&P; K/P
 198r

This page and its companion (no. 18),
belong to a series of embryological
studies which can be dated either to
Leonardo's last years in Milan or early
years in Rome.

Although Leonardo records that the
foetus used in these studies was 'almost
four months old', it appears to be
somewhat more developed. It is shown
in the breach position, and is beautifully
characterised directly from a model
which must have become available to
him through some unfortunate
circumstance. However, the womb and
placenta are compiled synthetically from
his knowledge of animal anatomy
(compare no. 25). Thus the placenta is
formed from a series of separate
cotyledons, in contrast to the single
fleshy pad in humans. Four of the
subsidiary diagrams explore the
interdigitating processes of the
cotyledonous placenta and the wall of
the womb.

The line-diagram to the right of the
main drawing explains how a sphere
with an extra weight placed eccentrically
at *n* will roll slightly up the incline and
remain there in a stable position. The
presence on this page of this note on
statics may well have been occasioned
by his considering how the weight of
the head of the foetus might cause it to
rotate in the womb and thus to adopt
the normal head-down position for
birth.

This series of drawings is as rich in
emotionally potent images as it is in
scientific content and diagrammatic
ingenuity. In exploring the 'great
mystery' of the foetus within the waters
of the mother's womb, he reveals its
secrets as if the outer layers of a seed are
being peeled and cut away. His
perception of this ultimate state of
anatomical intimacy between two beings
is emphasised by the interpenetrating
'fingers' of the cotyledons of the
placenta. In one of the notes he indicates
that:

> The same soul governs these two
> bodies, and the desires and fears and
> sorrows are common to this creature
> as to all the other animal parts, and
> from this it arises that something
> desired by the mother is often found

imprinted on the limbs of the infant
. . . and a sudden terror kills the
mother and child.

The graphic technique of curved
cross-hatching underlines the interplay of
convexity and concavity, and,
accordingly, the all-important sense of
enclosure. It is ironic that this sheet, on
which he has obtained such a
compellingly three-dimensional image,
should also contain a note and diagram
(bottom right) explaining 'why a picture
seen with one eye will not demonstrate
such relief as the relief seen with both
eyes'.

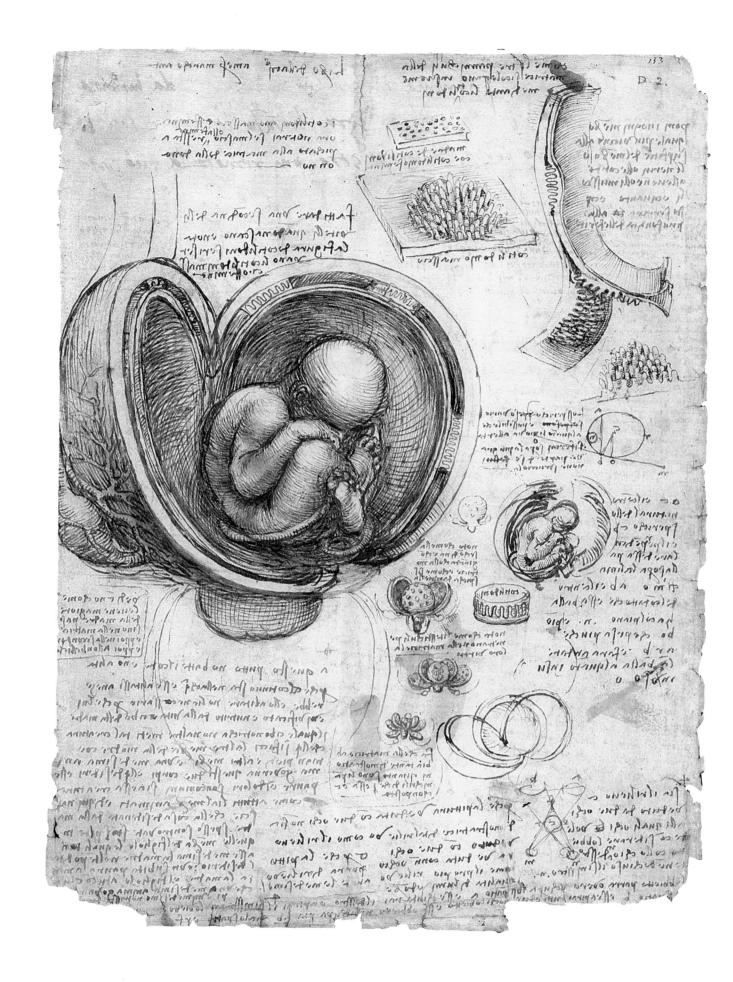

27

A LONG STEMMED PLANT (*Coix lachryma-
 jobi*), *c.*1515
Pen and ink over faint black chalk.
 212 × 230 mm
Prov.: Windsor Leoni volume (12429)
Ref.: Popham 270; C&P; Pedretti I 25r

Leonardo was no less fascinated by the
fecundity of nature than by the
procreative process in humans. His
major series of drawings of flowering
and seeding plants (from *c.*1506–9) is
closely associated in time and theme
with his studies of the female
reproductive system (e.g. no. 52) and
with his designs for *Leda and the Swan*
(nos. 14, 15, 74 and 75). This particular
drawing may be rather later than the

majority of his plant studies, but clearly
explores the same quality of fruitfulness,
and may be compared at this later date
with his spherical image of the womb
opened like a seed (no. 26).

28

A SMALL OAK BRANCH (*Quercus robur*)
WITH A SPRAY OF DYER'S GREENWEED
(*Genista tinctoria*), *c.*1508
Red chalk with touches of white
heightening on paper coated with an
orange preparation. 188 × 153 mm
Prov.: Windsor Leoni volume (12422)
Ref.: Popham 277; C&P; Pedretti I 18r

This study of two fruiting plants comes
from the group of botanical studies in
the Royal Collection related to the lost
painting *Leda and the Swan*. The
technique, red chalk on reddish paper, is
used for the other drawings in this
series, and the vertical fold line and
stitching holes on the present sheet
suggest that these botanical drawings
may once have formed part of a
notebook in which flowering and
seeding plants were presented in strongly
modelled relief (compare no. 44). There
is a possibility in this case that the
outlines have been reinforced by a hand
other than Leonardo's.

In his fables Leonardo expresses his
sense of the generative potential encased
within a seed, as when a wall is 'moved
by compassion' to shelter a nut fallen
from the beak of a crow: 'after a short
time the nut began to prize open and
put roots between the cracks of the
stones, and to enlarge them, and to
thrust out branches from its hiding place
. . . Then the wall, late and in vain,
bewailed the cause of its downfall.'

In his optical researches he cited 'a
great oak that has a modest start in a
little acorn' as an example of 'things
arising from a small beginning that
become greatly enlarged over a period
of time'.

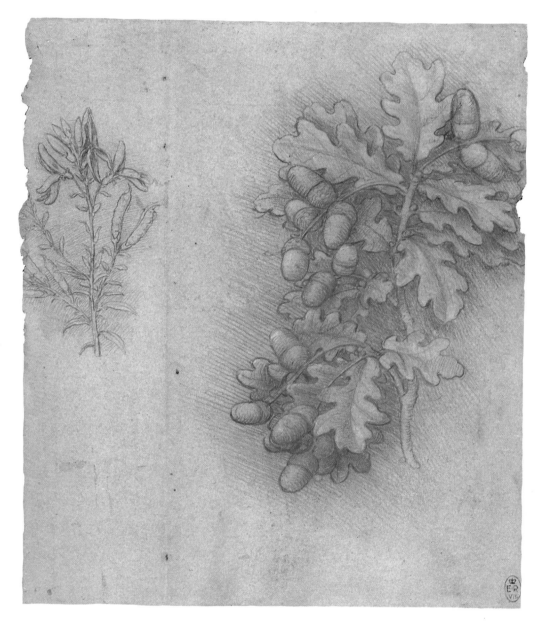

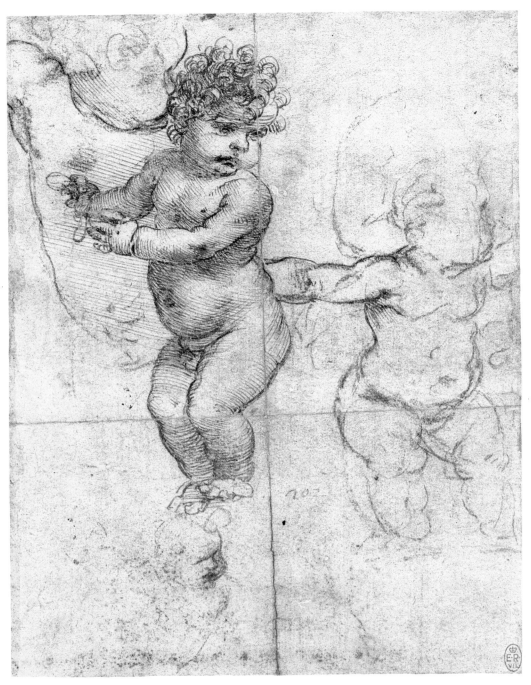

29

STUDIES OF THE HEAD AND BODY OF A
NAKED CHILD, *c.*1506–8
Black chalk traced over in parts with
pen and ink. 205 × 152 mm
Prov.: Windsor Leoni volume (12562)
Ref.: Popham 181; C&P; Pedretti III
291r

These are probably studies for one of
the compositions of the *Virgin, Child and
St Anne* (with or without St John or a
lamb) on which Leonardo was working
during the unsettled period of his career
between 1506 and 1508, when he was
involved with a series of commitments
in Florence and Milan. The cartoon in
the National Gallery, London, and the
Louvre painting (probably executed
later) represent the outcome of his
experiments. The energetically curved
hatching, emphasising the plump
roundness of the limbs, aligns this pen
study with the *Leda* drawings (nos. 14,
75).

He recorded that the relative
proportions of the parts of a child's
body vary significantly from those of a
mature individual: 'babies are thin at
their joints and fat between the joints, as
may be seen in the joints of the fingers,
arms and shoulders, which are slender
and have concave dimples . . . Where
babies have dimples, men have
prominences.' The proportionately
larger head of babies shows that 'nature
first composes in us the mass of the
house of the intellect and then that of
the vital spirits [i.e. the other bodily
parts]'.

30

HEAD AND SHOULDERS OF A NAKED CHILD,
 c.1497
Red chalk. 100 × 100 mm
Prov.: Windsor Leoni volume (12519)
Ref.: Popham 171A; C&P; Pedretti III
 189r

This is closely related to the Christ in
the National Gallery's version of the
Virgin of the Rocks (fig. 24). Both this
drawing and the drapery study (no. 11)
help confirm that the London version is
the result of Leonardo's own deliberate
revisions of the Louvre painting, in
keeping with his later ideas.

However, the immediate purpose of
this drawing appears to have been an
independent bust of a child, such as is
described in one of his notes which was
recorded by Gianpaolo Lomazzo in the
later sixteenth century: 'modelling . . .
has always given me much pleasure and
delight, as can be seen in the various
complete horses, limbs and heads, also
human heads representing Our Lady,
and complete youthful Christs and
fragments, and heads of old men in
good number'. A study for the back and
front of the child's bust is also at
Windsor (12567). Busts of the holy
children, Christ and St John, were
placed in aristocratic nurseries in
Florence as exemplary images, 'in which
your child when still in his swaddling
clothes may delight as being like
himself' (Cardinal Dominici).

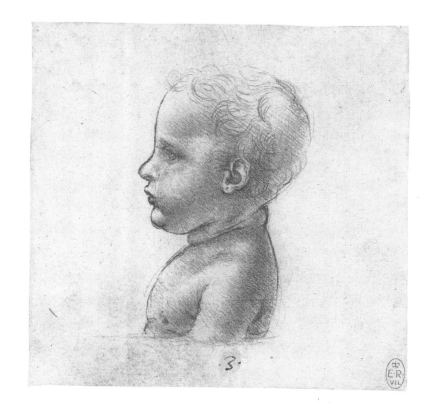

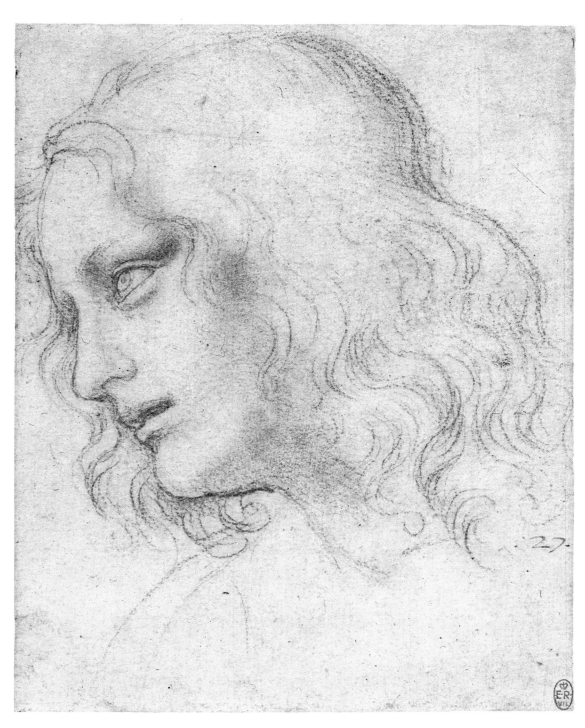

31

STUDY FOR THE APOSTLE PHILIP, *c.*1495–7
Black chalk. 190 × 149 mm
Prov.: Windsor Leoni volume (12551)
Ref.: Popham 165; C&P; Pedretti III
 198r; Pedretti *L.S.* 11

The study for St Philip is one of several highly evocative studies, apparently taken from life, for the apostles in the *Last Supper* (see nos. 10, 88 and 89). It represents one of his earliest uses of black chalk to achieve effects of soft modelling, known as *sfumato*.

Not the least important aspect of the ways in which the complex and deeply-pondered narrative of the *Last Supper* made its effect was through the striking individualisation of the disciples. As he writes: 'in narrative paintings there ought to be people of varied temperaments, ages, flesh colours, attitudes, fatness, leaness – heavy and thin, great, small, corpulent, lean, fierce, meek, old, young, strongly muscled, weak and with small muscles.' The youthful and meltingly beautiful St Philip – of a type to be adopted by Raphael – is consistent with his observation that 'in the young the parts will be lightly muscled and veined, with delicate and rounded contours and of agreeable colour'.

32

MALE NUDE SEEN FROM BEHIND, *c.*1503–7
Red chalk. 270 × 160 mm
Prov.: Windsor Leoni volume (12596)
Ref.: Popham 233; C&P; K/P 84r

This powerful nude figure is not
apparently connected to any known
project, though it is of the type used in
the *Battle of Anghiari*. It epitomises
Leonardo's vision of the male body in
prime condition at a time in the early
sixteenth century when both he and
Michelangelo were exploiting the
expressive potential of the kind of
heavily-muscled figures which were to
become so ubiquitous in Italian painting
and sculpture during and after the High
Renaissance.

The subtle surface modelling does
much to justify his conviction that 'the
infinite contours of . . . a figure can be
reduced to two half figures, that is to
say, one half from the middle backwards
and the other half from the middle
forewards . . . which combine to make a
figure in the round'.

He explained that:

every part of the whole should be in
proportion to the whole. Thus if a
man has a thick and short figure he
will be the same in all his limbs, that
is to say, with short and thick arms,
wide and thick hands, and short
fingers with joints in the prescribed
manner, and so on with the rest of
the parts. I intend to say the same
about plants and animals universally.

And, 'muscular men have thick bones
and are short, thick and have a dearth of
fat, because the muscles, through their
growth, are compressed together, and
the fat that would otherwise be
interposed between them cannot find
any room.'

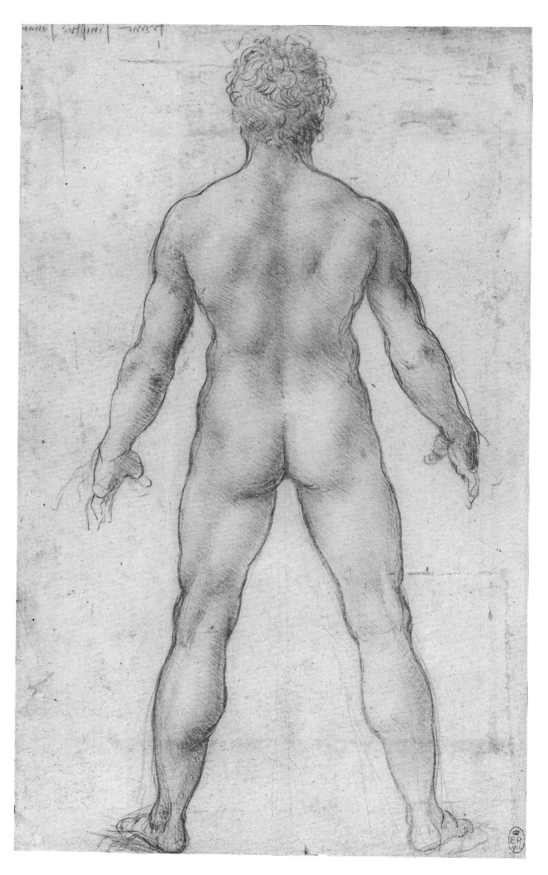

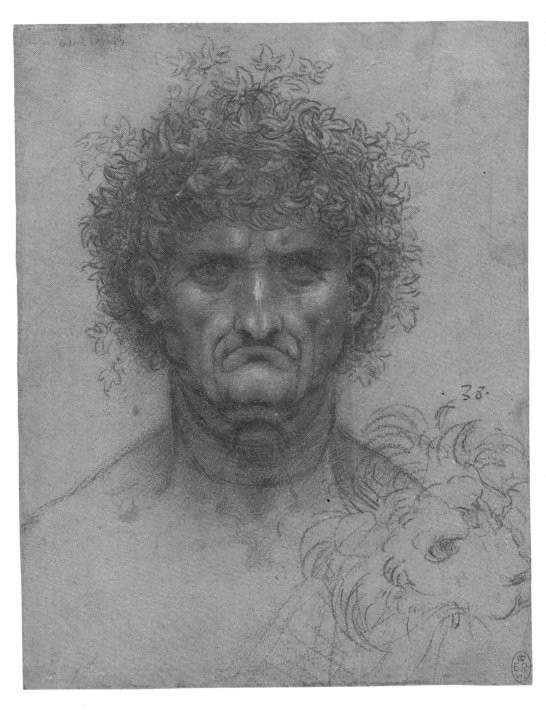

33

HEAD OF A MAN AND OF A LION,
 c.1503–5
Red chalk heightened with white.
 183 × 136 mm
Prov.: Windsor Leoni volume (12502)
Ref.: Popham 142; C&P; Pedretti III
 360r

The familiar physiognomic type of a
'belligerent warrior' appears recurrently
in Leonardo's work, varying in age and
expression. Here he is exaggeratedly
choleric in appearance.

Leonardo frequently commented on
the living, mobile quality of hair, which
has been amplified in this drawing with
sprigs of freely interwoven ivy. He cited
ivy as a symbol of longevity, and it has
probably been added in this instance as
an ironic counterpoint to the inescapable
signs of the warrior's advancing years,
rather than as an attribute of Bacchus.

His interest in the classical theory of
the four temperaments did not lead him
to adopt the more rigid prescriptions of
the earlier theorists of physiognomy, but
he did subscribe generally to the view
that 'the signs of the face show us in
part the nature of men, their vices and
temperaments . . . and those who have
facial features of great relief and depth
are bestial and wrathful men, with little
reason, and those who have strongly
pronounced lines located between the
eyebrows are wrathful'. Also, 'an angry
person has raised hair, lowered and
tensed eyebrows, and clenched teeth,
and the two edges of the sides of the
mouth are arched downwards'.

In other studies (nos. 5 and 87) he sets
human heads besides those of animals,
and the juxtaposition of the lion and
human heads on this page is unlikely to
be casual. Rather than carrying the
suggestion that the man is Hercules, it is
probably intended to underline the
characterisation of the warrior as choleric
in temperament and correspondingly
leonine in physiognomy.

34

A GROTESQUE HEAD, *c.*1504–7
Black chalk with contours pricked for
transfer. 382 × 275 mm
The Governing Body, Christ Church,
Oxford
Prov.: Giorgio Vasari (?); General
J. Guise; Christ Church (0033)
Ref.: Popham 146; Byam Shaw 19

This almost life-size caricature is the
culmination of the grotesque heads
which Leonardo produced in such
numbers between 1490 and 1505. Its
exceptional size, degree of finish and
pricking for transfer suggest that it was
not intended as a purely private exercise.
One such head, depicting 'Scaramuccia,
chief of the gypsies', was owned by
Giorgio Vasari, sixteenth-century
biographer of the artist. Leonardo's
uncompromising depiction of human
oddities proved exceptionally popular in
the Renaissance, and conformed to the
robust taste for grotesquerie that found
expression in Italian *novelle* from the
tradition of Boccaccio and in burlesque
poetry.

The grotesque provided for Leonardo
an intellectual and emotional counterpart
to the beautiful, and he paid particular
attention to the greater prominence of
idiosyncratic features in mature and
older individuals. His memoranda
confirm that he sought out people with
'fantastic' features, and many of the
heads are probably based directly on life,
with varying degrees of exaggeration.

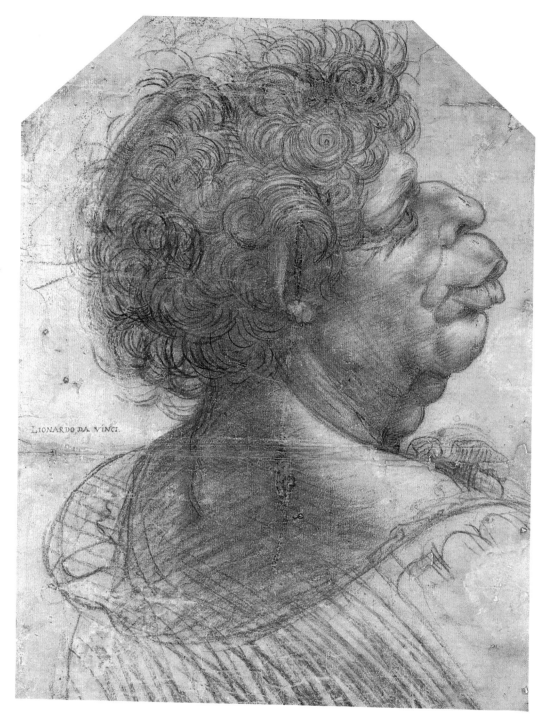

LEONARDO DA VINCI.

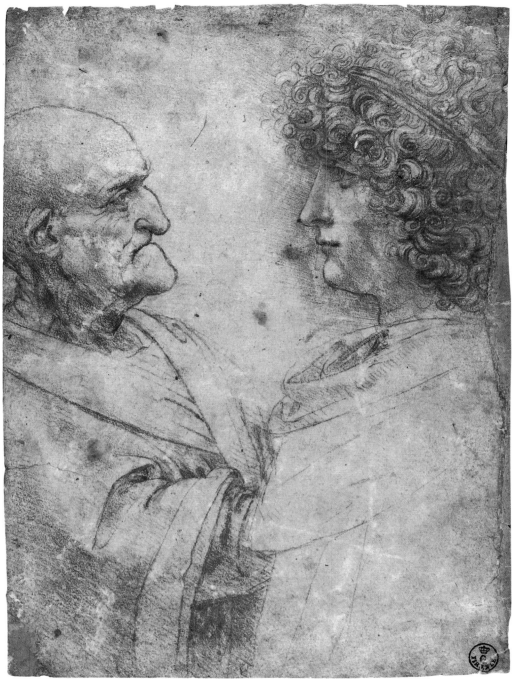

assume the character of personal creations. The Verrocchio types, which originally possessed an uncomplicated directness of expression, have been progressively manipulated to produce, in this mature example, images which are both more exaggerated and more ambiguous in their emotional resonances. The youth has developed what may be described as a 'late Roman' air of incipient decadence, as his beauty has become more fleshily sensual, while the 'nutcracker' man has become a toothless travesty of his virile persona.

35

PROFILES OF AN OLD MAN AND A YOUTH, c.1495

Red chalk. 208 × 150 mm

Gabinetto Disegni e Stampe degli Uffizi, Florence

Prov.: Reale Galleria di Firenze by 1793; Lorenzo Medici, Uffizi (423 E)

Ref.: Popham 141; Tofani, 1986; Uffizi, 1985, IIr, pp. 189–90.

Familiar types are directly juxtaposed in old age and youth, both 'idealised' to distill the essence of the contrast, and to highlight his often-expressed theme of the transient nature of human beauty: 'a mortal thing of beauty passes and does not endure'.

Neither type was Leonardo's own invention, having been familiar motifs in Verrocchio's sculpture, but they became so deeply embedded in his vision of the types and ages of man that they came to

36

HEAD OF AN OLD MAN, c.1514–15

Black chalk. 253 × 182 mm

Prov.: Windsor Leoni volume (12500)

Ref.: Popham 155; C&P; Pedretti III 379r

The use of black chalk on coarse grey paper achieves a rough finish that is characteristic of some though not all of Leonardo's late drawings. The depiction of turbulent flow in the old man's beard shares much in common with the 'Deluge Drawings' (particularly nos. 64 and 66). By comparison, the famous red chalk '*Self-Portrait*' in Turin (fig. 34) looks considerably earlier in style and conception, and may well therefore not be a self-portrait at all. (See also no. 1.)

This image of an aged man from the final phase of Leonardo's own career – he was himself into his 60s – appears to be less a virtuoso variation on his well-worn theme of ageing than a moving depiction of a particular individual which conveys genuine insight into old age itself. The comparison with the late Titian, made by Kenneth Clark, remains compelling as the only real parallel in Renaissance art.

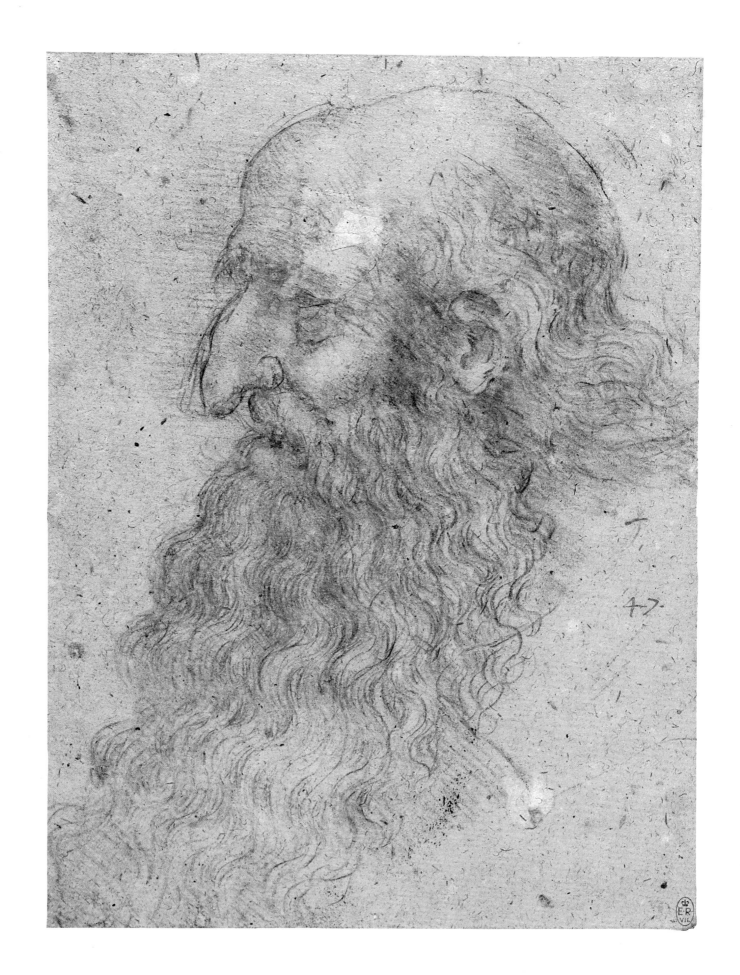

3
THE NATURAL WORLD

Certain peoples known as Guzzarati do not feed upon anything which contains blood, nor will they permit each other to harm any animate thing, like our Leonardo da Vinci.

Andrea Corsali in his first letter to Giuliano de'Medici

Contemporaries attest to Leonardo's tender concern for living creatures, and one of the recurrent themes of his prophetic riddles is man's brutality to the products of nature. Viewed in this light, his sympathetic studies of animals and plants appear to be some of the least complicated products of his genius. At the earliest and latest stages of his career (nos. 6 and 38) he drew cats in action and in repose with what we cannot but feel is an unaffected delight in their svelte motions and feline personalities. His studies of horses – functional though these were in relation to his works of art – also bespeak a responsiveness to the special beauty and nervous energy of the animal in its own right. And the plant studies, undertaken in the final dozen years of his career, indicate that nature retained its freshness of delight for him in the face of his remorseless desire to codify natural causes and effects.

This vein of direct naturalism had found expression in his native Florence in what is unhelpfully termed 'late Gothic naturalism', which had been inspired not least by manuscript illuminations and tapestries from northern Europe. The supreme representatives of this naturalism in Florence were the sculptor, Lorenzo Ghiberti, who adorned his Baptistry doors with an abundant array of natural delights; the influential visitor, Gentile da Fabriano, whose Strozzi altarpiece was in its own way as novel as Masaccio's *Trinity*; and Benozzo Gozzoli, whose Medici chapel frescoes contained a wealth of directly-studied flora and fauna. Outside Florence, Pisanello was the exemplary draughtsman of animals, both familiar and exotic. Later in the century the increased number of imports in Netherlandish oil paintings gave fresh stimulus to the challenge of depicting nature with such veracity that – as Pliny might have said – a bee would try to draw nectar from the lily in an *Annunciation*. Or as Leonardo did say, 'I have seen dogs trying to bite painted dogs, and a monkey did an infinite number of stupid things in front of a painted monkey'.

However, we would be wrong to assume that this tradition of imitation was simply for delight in naturalism *per se*. The late Mediaeval world, of which Leonardo was an heir, saw meaning in the book of nature. Real and fabulous animals and plants were viewed in such a way that their characteristics – actual and imagined – were part of the symbolic and moral constitution of God's creation. Leonardo was fully conversant with this tendency, transcribing sections from such 'encyclopaedias' as the *Physiologus* (the Bestiary) into his own notebooks. The bear (no. 37), for example, exemplifies *ira* (rage) in that it indulges in futile and ineffective rage against the bees swarming around it rather than concentrating

upon retrieving the honey. The ermine which appears in the portrait of Cecilia Gallerani (fig. 26) is taken as epitomising 'moderation' because it 'does not eat other than once a day, and it will rather be taken by hunters than wish to escape into a dirty lair, in order not to besmirch its perfection'. Plants and trees also play their role in nature's story-telling. Leonardo recounts how the pear tree overcomes the taunts of the laurel and the myrtle when its wood is carved into a worshipped statue of Jupiter. Although much of this story-telling is a traditional form of literary entertainment, it is all of a piece with his belief that nature embodied significance as well as science.

Not that science, of course, was ever absent when Leonardo looked at anything. With the possible exception of the early study of a lily (no. 42), every drawing in this section is part of his quest to understand systematically the forms of natural things. The wonderfully observed horse (no. 40) is one of a series in which he sought to codify the proportional harmonics governing the beauty of horses, and his notes testify to his searches in the Milanese stables for superb specimens from which to take his measurements. The bear's head (no. 37) probably belongs to a series which includes detailed dissections of a bear's foot, and in his later anatomical studies of the human foot (no. 105) he reminds himself to draw a bear's foot for comparison. We know that the motion of animals was to be the subject of one of his many projected treatises, and two of the drawings in this section (nos. 38 and 41) would have been fitting illustrations of this theme. The highly-finished botanical drawings (nos. 43 and 44) are presented on the sheet in such a way as to suggest that they were part of his campaign to write on plants, and the drawing of two types of rush (no. 43) appears to be an essay in taxonomy, in which varieties of the same plant were to be systematically distinguished through selected morphological characteristics. The questions 'how?' and 'why?' never failed to complicate the simple 'what?' of observation when Leonardo turned his attention to the natural world.

37

HEAD OF A BEAR, *c*.1490–5
Metalpoint on paper coated with a
 pinkish preparation.
 70 × 70 mm
Private collection
Prov.: Thomas Lawrence
Ref.: Popham 78A

The demanding and somewhat inflexible
metalpoint medium, particularly
favoured by fifteenth-century
draughtsmen when precision and
delicacy were required, does not appear
to have been used by Leonardo after the
1490s. A date for this drawing of *c*.1485
seems likely when it is compared with
the Sforza horse study (no. 40) and the
ermine in the portrait of Cecilia
Gallerani (fig. 26), but the touch is more
varied than in his early metalpoint
drawings – perhaps as a result of his
experiments with red chalk – and it may
have been executed as late as *c*.1495.
 A drawing of what is probably the
same bear, also in metalpoint on pink
paper, is in the Metropolitan Museum of
Art, New York (formerly in the
Rosenthal Collection), and the set of
drawings depicting the dissection of a
bear's foot at Windsor (12372–5) may
have been made at the same time.
Leonardo mentions a bear hunt in the
Chiavenna valley in one of his notes
from the early 1490s, and this hunt may
have provided his specimen – in which
case the Metropolitan drawing may
represent a dead bear imaginatively
'animated'.
 Pattern-book drawings of domestic,
wild and exotic animals were popular in
a number of fifteenth-century studios,
and some Italian artists, most notably
Pisanello, had preceded Leonardo in
direct studies from nature. Leonardo
yields nothing to his predecessors in
evoking the presence of the animal, and
also succeeds in suggesting the shape and
structural qualities of the head in a
characteristically economical way.

38

CATS, LIONS (?) AND A DRAGON, *c*.1513–14
Pen and ink with touches of wash over
 black chalk with red offset.
 271 × 204 mm (irregular)
Prov.: Windsor Leoni volume (12363)
Ref.: Popham 87; C&P; Pedretti II 157

This elaborately worked sheet is closely
related in style, layout and theme to the
page depicting a cat, horses and St
George and the dragon (no. 72). Both
drawings appear to be amongst his latest
explorations of the theme of animal
motion.
 The inscription at the foot of the
sheet reads: 'On bending and extension.
This animal species, of which the lion is
the prince, because the joints of its spinal
chord are bendable.' The note suggests
that this drawing, with no. 72, was
envisaged as part of his projected treatise
on the nature of movement in men and
animals: 'on this important study . . .
write a separate treatise describing the
movements of animals with four feet,
among which is man, who likewise in
his infancy crawls on all fours'.
 His earliest studies of cats in various
poses were undertaken in connection
with his project for a painting of the
Virgin, Child and cat in the late 1470s
or early 1480s (no. 6). These latest
studies pay almost exaggerated attention
to serpentine and spiral motions as an
expression of the 'continuous quantity'
of the motion of forms in space (see no.
97).
 Leonardo's fascination with the cat's
sinuous grace – resulting from what he
called the 'compound' motions of the
components of the body – led him to
fill the sheet with a series of free
explorations of feline behaviour, in
which the cats sometimes assume the
guise of wrestlers (near the centre of the
sheet) while others are metamorphosed
into leonine creatures. These
improvisations have in turn given birth
to a curly-tailed dragon. He noted in his
'bestiary' that dragons 'accompany each
other and intertwine themselves in the
manner of roots'.

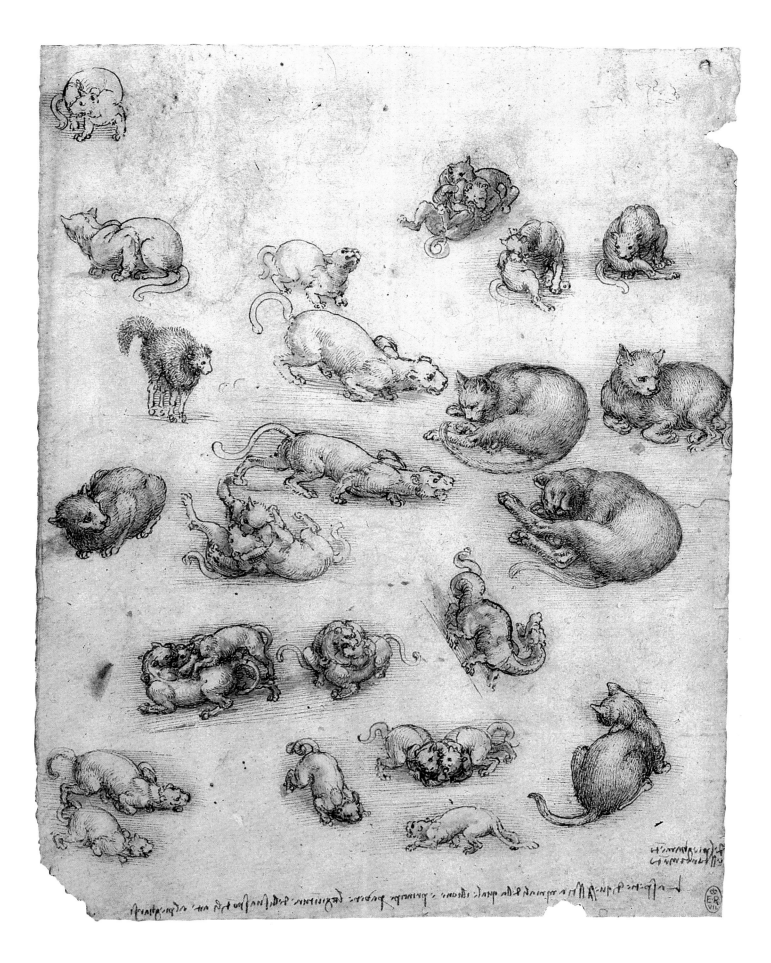

39

THREE STUDIES OF THE PAWS OF A WOLF (?)
*c.*1490–5
Metalpoint on paper coated with a
 pinkish preparation.
135 × 105 mm
Private collection
Prov.: Thomas Lawrence
Ref.: Popham 79B (verso)

In spite of their obvious similarities to
the foot of a bear studied in isolation or
the drawing of the whole bear in the
Metropolitan Museum, New York, the
studies on the recto and verso of this
sheet depict a canine foot of some kind.
However, we know that Leonardo
planned a comparative study of the feet
of man and various animals, and this
study may belong to the same campaign
of investigation as his dissections of
bear's foot. To an even greater degree
than his study of the bear's head (no. 37)
this metalpoint drawing exhibits marked
affinities with his red chalk technique of
the mid-1490s.

By representing the foot from
different angles, in what was to become
a characteristic technique in his
anatomical drawings, he is able to
convey a clear impression of the spatial
relationships between the claws, bony
joints, pads and fur, in a way which
takes him beyond simple surface
description.

40

RIGHT PROFILE OF A HORSE, c.1490
Metalpoint on paper coated with a blue
 preparation. 211 × 159 mm
Prov.: Windsor Leoni volume (12321)
Ref.: Popham 77; C&P; Pedretti II 92

This study was evidently made from
life, and is one of a series of studies of
carefully selected horses in Milanese
stables, made during the period 1490–3
when Leonardo was working most
intensively on the project for the
equestrian monument to Francesco
Sforza (nos. 8 and 115). In some
instances he noted the variety and
ownership of a particularly fine
specimen.

The inscription – '*a–b* is as long as the
foot' – and the lines overlaid on the
main figure reflect Leonardo's concern
to discover a system of proportions for
the horse, akin to the definitive yet
flexible system of harmonic
measurements he sought in the human
body. His attention to such a system
does not result in any diminution in the
fresh naturalism with which the nuances
of form are described. The immaculate
skill with which he has evoked the
vitality of the surfaces, at the same time
as controlling the overall shape, is at
least the equal of his most refined studies
of the male nude at this time (e.g.
Windsor 12637).

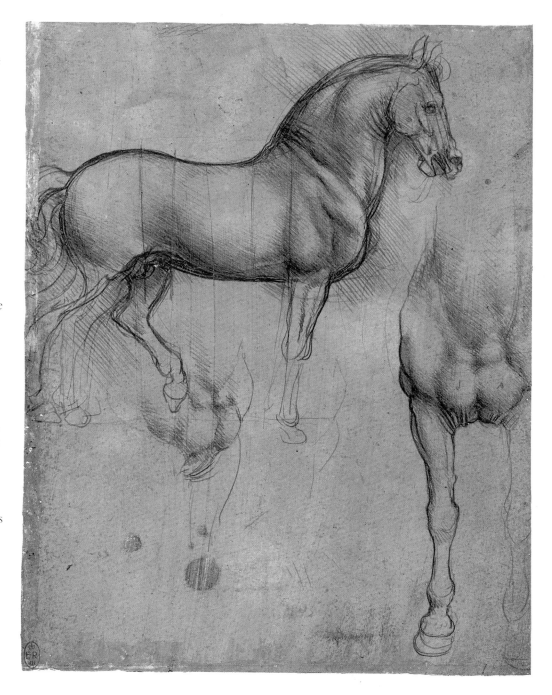

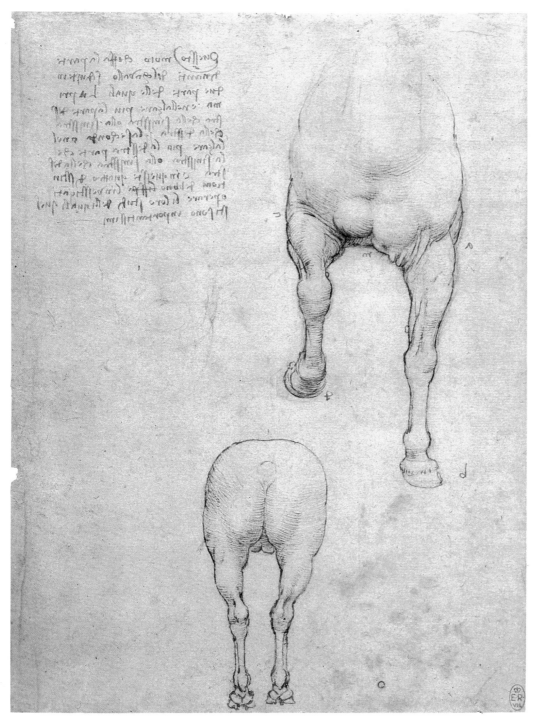

41

FOREQUARTERS OF A HORSE, *c.*1510–11
Black chalk drawn over with pen and
 ink. 233 × 164 mm
Prov.: Windsor Leoni volume (12303)
Ref.: Popham 95; C&P; Pedretti II 142

Together with no. 16 this drawing is
one of a number at Windsor associated
with the Trivulzio equestrian monument
which, like the Sforza project, was never
completed. This particular study is of a
type that could be incorporated equally
readily into his intended treatise on
animal motion or his book on the horse.
The notes describe the four principle
movements of two different gaits of the
horse, the amble and the walk.

 Two of Leonardo's major concerns in
discussing human and animal motion
were to understand the behaviour of the
skin in relation to the underlying
features and to define which muscles and
tendons gain prominence with different
actions. The bunching of the muscles
and wrinkling of the flesh in this
drawing precisely obey his own
instructions: 'remember, painter, that in
the movements you depict as being
made by your figures you disclose only
those muscles which are relevant to the
motion and the action of your figure,
and in each case make the muscle which
is most relevant most apparent and that
which is less relevant is less shown'; and
'the flesh which clothes the joints of the
bones and other adjacent parts increases
and decreases in thickness according to
bending or stretching . . . That is to say
increasing on the inside part of the angle
produced by the bending of the limbs
and becoming thinner and extended on
the part on the outside of the exterior
angle.'

42

A LILY (*Lilium candidum*), c.1472–5
Pen and ink and wash over black chalk,
 pricked for transfer. 314 × 177 mm
Prov.: Windsor Leoni volume (12418)
Ref.: Popham 254; C&P; Pedretti I 2r

This drawing, which is the earliest of
Leonardo's surviving plant studies,
cannot unfortunately be identified as the
direct model for the lily held by the
angel in the Uffizi *Annunciation*, from
which it differs in its arrangement of
flowers, buds and leaves, as well as
inclining in a different direction. The
pricked outlines do, however, indicate
that this study was to be used in the
preparation of a painting. The procedure
would have conformed to that used in
the Verrocchio workshop for natural
details in such paintings as the *Madonna
and Child with Angels* in the National
Gallery, London. The drawing's specific
function helps account for the difference
in scale and medium from his other
plant studies, which are preparatory for
paintings only in a more general sense.
The recording of 'many flowers copied
from nature' in his list of works from
c.1482 indicates that other early studies
have been lost.

The emphatic description of irregular
contours and the detailed attention to
light and shade on the flowers probably
reflect the influence of Netherlandish art,
particularly Hugo van der Goes's
Portinari Altarpiece, but the wiry outlines
also exhibit something of the quality of
metalwork by Verrocchio and Ghiberti.

The faint and incomplete geometrical
drawing may relate to a perspective
projection, such as that required in the
Uffizi *Annunciation*.

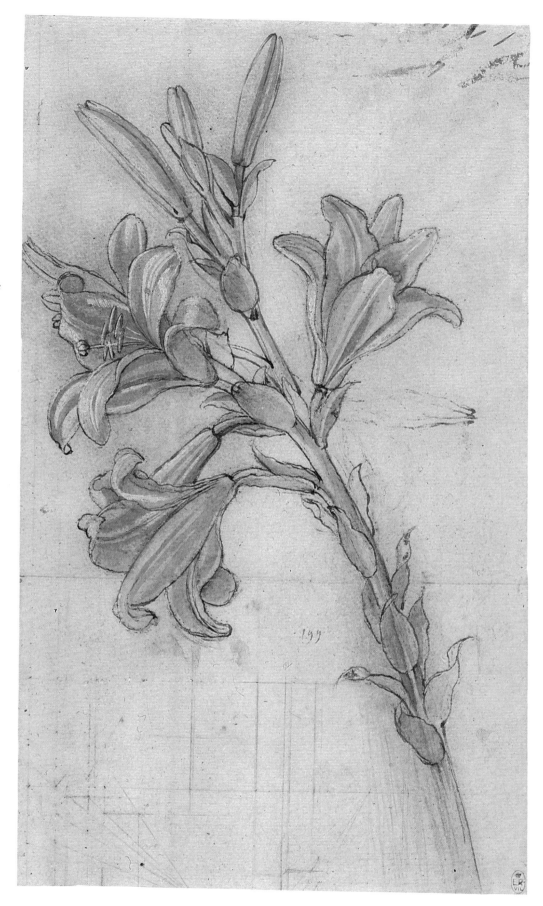

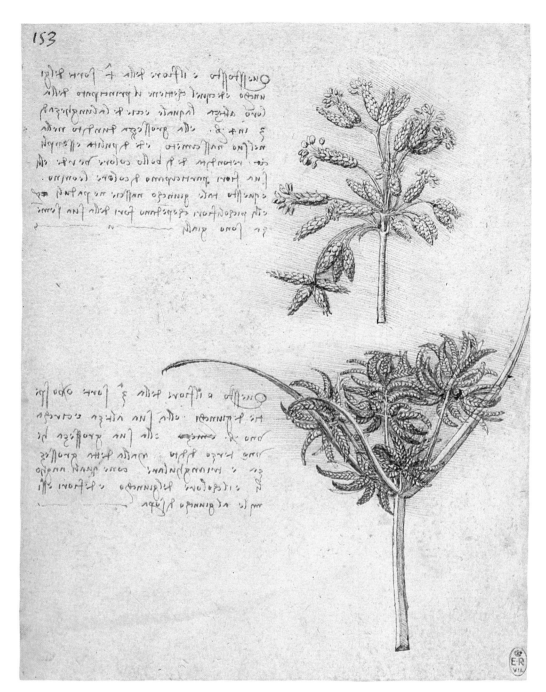

153

43

A RUSH AND A SEDGE (*Scirpus lacustris* AND *Cyperus monti*), *c.*1510
Pen and ink over traces of black chalk.
195 × 145 mm
Prov.: Windsor Leoni volume (12427)
Ref.: Popham 272; C&P; Pedretti I 24r

These studies are distinct in technique and style from the group of red chalk plant drawings associated with *Leda and the Swan* (nos. 28, 44 and 57), and probably date from a few years later. The layout, careful placement of the drawings and notes, systematic content and graphic technique – suitable for reproduction in engraving – suggest that this may be an illustration intended for his 'discourse on herbs', mentioned on a late anatomical drawing at Windsor (19121).

The inscriptions read:

(*Above*) This is the flower of the fourth type of rush and is the principal of them, growing three or four *braccia* high, and at its origin [from the ground] it is one finger thick. It is of clean and simple roundness and a beautiful green colour, and its flowers are somewhat fawn-coloured. Such a rush occurs in marshes etc. and the small flowers which hang out of its seeds are yellow.

(*Below*). This is the flower of the third type, or rather species of the rush, and its height is about one *braccio* and its thickness is one third of a finger. But the said thickness is triangular, with equal angles, and the colour of the rush and the flowers is the same as the rush above.

Leonardo is characteristically attracted by geometrical variations within the related morphologies of the rush and sedge, and appears to be working towards the definition of characteristics for a systematic classification.

44

SPRAY OF CRANBERRY (*Vibernum opulus*),
 *c.*1508
Red chalk touched with white on paper
 coated with a red preparation.
 143 × 143 mm
Prov.: Windsor Leoni volume (12421)
Ref.: Popham 276; C&P; Pedretti I 21

The medium, characterisation and
curved hatching of the fruits align this
with the group of *Leda* plant studies
(nos. 28 and 57). The outlines may in
places have been reinforced by another
hand (compare no. 28).

 The drawings in this series concentrate
upon flowers, fruits and seeds. Although
generically related to the preparations of
the painting and its theme of fecundity,
a study such as this should probably be
regarded as more directly intended for
one of Leonardo's many unrealised
projects to describe natural forms. The
careful presentation, as if in relief in
front of the surface of the page, tends to
confirm that he had a relatively formal
function in mind, as may also have been
the case with the study of acorns (no.
28).

 At first sight the note does not seem
to refer directly to this drawing – *acero
frutto di corallo* – but to the fruit of a
plant in the acer family. However if
acero is interpreted as 'bitter' (i.e. related
to *acerbo*), the note may be intended to
inform us that the cranberry has 'bitter,
coralline fruit'.

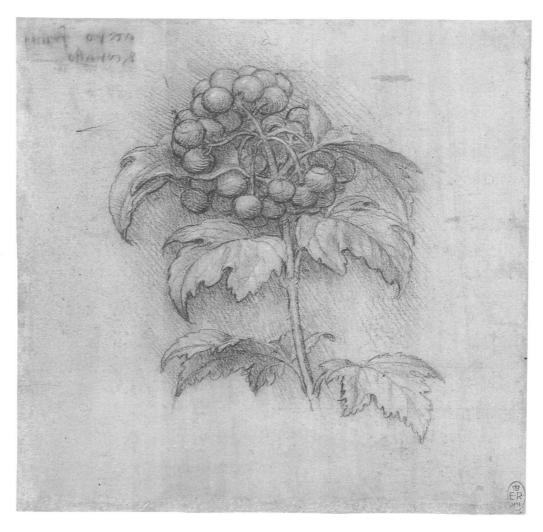

4
BODY OF EARTH AND BODY
OF MAN

Man has been called by the ancients a lesser world, and certainly the award of this name is well deserved, because, in as much as man is composed of earth, water, air and fire, the body of the earth is similar; if man has in himself bones, the supports and armature for the flesh, the world has the rocks, the supports of the earth; if man has in himself the lake of the blood, in which the lungs increase and decrease in breathing, the body of the earth has its oceanic sea, which likewise increases and decreases every six hours with the breathing of the world; if from the said lake veins arise, which proceed to ramify throughout the human body, the oceanic sea fills the body of the earth with infinite veins of water; the nerves are lacking in the body of the earth – they are not there because nerves are made for the purpose of movement, and the world, being perpetually immobile, does not need movement, and, not needing movement, the nerves are not necessary. But in all other respects they are very similar.

Leonardo's own account of the analogy between the body of the world and the body of man, written in the early 1490s in one of his earlier notebooks (Ms.A in the Institut de France) provides a fully developed definition of the theme explored in the group of drawings that follows in this section. His writings on both anatomy and physical geography contain regular references to the analogy. Phrases such as 'the breathing of this terrestrial machine', 'the veins of the waters', and 'the nourishment and vivification of this earth' occur as a matter of intellectual habit in his discussions of the role of water in the life of the world; while he states on one of his anatomical drawings (no. 50) that 'here shall be represented the tree of the vessels generally, as Ptolemy did with the universe in his *Cosmography*'.

There was, as Leonardo acknowledged, nothing new in this concept – expressed more technically by the terms 'microcosm' for man and 'macrocosm' for the body of the universe. He could have looked towards the 'ancients' such as Seneca, who had written:

> the idea appeals to me that the earth is governed by nature and is much like the system of our own bodies in which there are both veins (vessels for blood) and arteries (vessels for air). In the earth there are some routes through which water runs, some through which air passes. And nature fashions these routes so like the human body that our ancestors called them 'veins' of water.

Or he could have looked amongst his immediate Italian predecessors to Brunetto Latini: 'the inside of the earth is full of cavities from one place to another, and is full of veins and caverns, and furthermore the water which leaves the sea comes and goes throughout the earth and surges within and without, following the veins

that lead hither and thither, just as the blood of man is distributed throughout the veins, so it scours all the body from mountains to valleys.'

Although the idea of man as a microcosm may be regarded as something of a commonplace by Leonardo's time, it was certainly not a matter of routine or mere convention for him. Its reality lay at the very heart of his vision of the principles of life. No natural thing, man included, could depart from the 'necessity' of the universal laws of function and form which govern the design of the macrocosm. It was on this basis that argument by analogy from one constituent part of nature to another was fully justified as a scientific method, as was common in Mediaeval natural philosophy. The unique nature of Leonardo's achievement lies less with his expression of the theme in a notably dynamic manner in his writings than with its visual realisation in a series of images of man and nature which are suffused with a shared vitality of form and motion. No artist, before or since, has quite equalled the suggestive magic with which he insinuates his vision of the inner and outer oneness of created forms into drawings and paintings.

This vision reaches a climax towards the end of his second period in Florence, that is to say, about 1508. It was sustained by a coming together of a series of speculations which had in turn been triggered by his sustained involvement with first-hand investigations in physical geography and anatomy. The geographical activities related to various projects for canalisation in Tuscany, of both a civil and a military kind (nos. 48, 49 and 62). His studies of the topography and water courses around Florence gave him direct evidence of the vital role played by water as a shaping force in the body of the earth, and he became increasingly aware of vast changes in the distribution of water and land over long periods of time. His observations led to far-ranging speculations, particularly in the Codex Hammer (formerly Leicester), about such matters as the origins of springs high on mountain-sides, the cause of tides and the meaning of fossils. He concluded, with the utmost firmness, that the signs of change could not be taken as evidence for the Biblical flood, since they were clearly the result of a great series of major geological events.

His studies of anatomy centred on the dissection in Florence of an old man, the 'centenarian' (no. 51), which probably took place in the winter of 1507–8. He gained the conviction that the old man's gentle descent into death was the result of the failure of his blood vessels to maintain the supply of 'vivifying' humours to the parts of the body. The centenarian's internal channels had become tortuous and silted, resulting in loss of nourishment to the skin, peripheral regions, liver and ultimately to the heart itself. By contrast, a young person's body is irrigated by fluids vigorously coursing through channels of a straighter kind.

These intuitions were to find visual expression in his drawings, particularly of landscape, rocks and water, and ultimately in his lost painting of *Leda and the Swan* and above all in the *Mona Lisa*. Pater was right to sense that the *Mona Lisa* is profoundly concerned with time, but it is not the time of an unchanging eternity. Rather it is the time of motion, change, life, birth, growth, decay, death and renewal, in which everything is in continual flux. Leonardo was fully conscious that his art, by encapsulating the transitory, was able to provide something enduring beyond even the powers of nature herself.

His researches during the first decade of the century seemed to be leading to a

rich affirmation of the old analogy. However, the more searching his use of argument by analogy became, the more he became uneasily aware that problems were not far below the surface. There were technical problems. The 'veins' of the earth were being continually widened by the passage of their waters, whereas those in the body 'thicken so much in their walls that they become closed and allow no passage for the blood'. There were also broader problems which struck at the heart of the analogy: 'the origin of the sea is contrary to the origin of the blood, since the sea receives into itself all the veins which are caused solely by water vapours raised into the air; but the sea of blood is the cause of all the veins'. There is no indication that Leonardo, towards the end of his career, was able to take on the full implications of the serious erosion that was occurring to an idea he had so cherished – but there is something heroic in his willingness to countenance such erosion at all.

45

A RIVER RUNNING THROUGH A ROCKY RAVINE WITH BIRDS IN THE FOREGROUND, c.1483

Pen and ink. 220 × 158 mm
Prov.: Windsor Leoni volume (12395)
Ref.: Popham 255; C&P; Pedretti I 3r

This may be regarded as the earliest of Leonardo's surviving drawings concerned with rock formations, and aligned with the first version of the *Virgin of the Rocks* (fig. 23), commissioned in 1483. Such vertical clusters of rock pinnacles occur throughout Leonardo's career, but it is difficult to reconcile these particular structures with the more coherent and internally consistent rock formations in his later drawings. The pen-work recalls that of some of the Sforza allegories of the 1490s, but a date in the early 1480s is probably to be preferred.

This study exemplifies his characteristic conception of rocks as the armature for the life of the world. Water, as the 'vital humour of this arid earth', is perceived as a powerful agent for change, forging the deeply cut ravine, splitting the rocks into ever smaller parts and disclosing the inner anatomy of the world. This disclosure is particularly apparent in the curved strata at the entrance to the ravine on the right.

The overall sense of process relates closely to his discussions of 'the ruin of mountains falling down, their bases consumed by the continuous currents of rivers which gnaw at their feet with very swift waters', and 'the subterranean passage of waters, like those which exist between the earth and the air . . . which continually consume and deepen the beds of their passage'. The precarious trees on the undercut cliffs and sprightly water-birds underscore the impression of life, motion and flux in the body of the world.

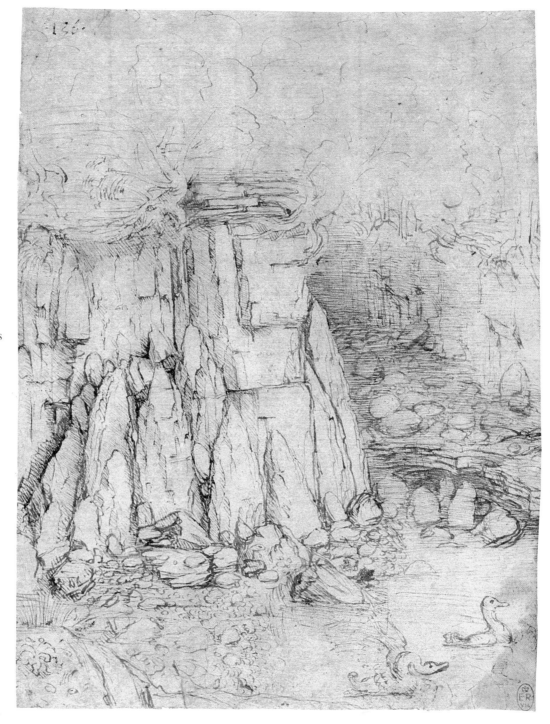

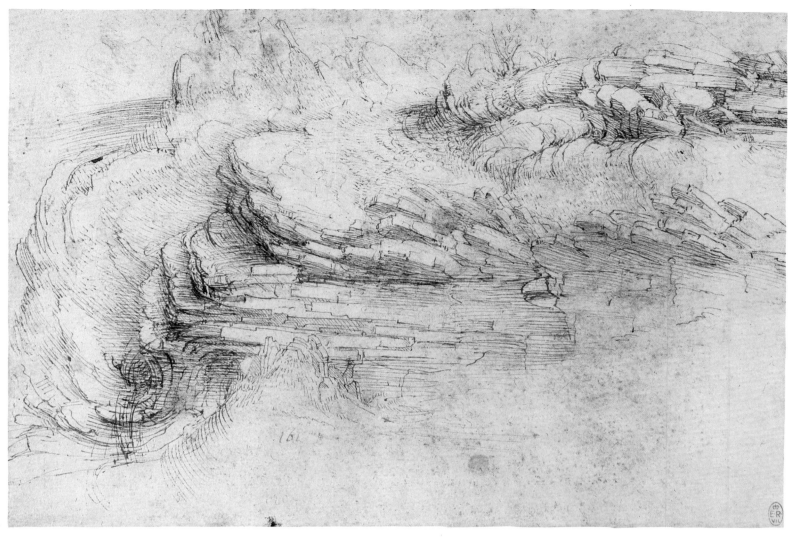

46

HORIZONTAL OUTCROP OF ROCK,
 *c.*1510–13
Pen and ink over black chalk.
 185 × 268 mm
Prov.: Windsor Leoni volume (12394)
Ref.: Popham 289; C&P; Pedretti I 53r

This is one of a series of late drawings of
geological structures in which the strata
assume a rhythmic configuration. As the
only such drawing in pen, it is not easy
to date precisely, but its approach to the
anatomy of the earth may be compared
to his anatomical studies of the human
body around 1510 (e.g. nos. 105 and
106). The complexity, detail and spatial
conviction provide a contrast to the
relatively schematic structures in the
previous drawing.

　His studies of physical geography,
undertaken with particular intensity in
the years immediately following his
work on the Arno canal projects (nos.
48, 49 and 62), had revealed the
awesome nature of the vast changes
undergone by the structures of the
world. He found evidence of major
redistributions of land and water masses,
great cataclysms and remorseless erosion,
as the destabilised elements sought to
find their natural levels. This drawing
clearly manifests the shaping hand of
time, and bears witness to the great
forces that have moulded the strata into
their contorted configurations. This
'bony' framework is then clothed with a
thin skin of soil, which in turn supports
the sparse vegetation.

47

STORM OVER A VALLEY IN THE FOOTHILLS
 OF THE ALPS, *c.*1506
Red chalk. 198 × 150 mm
Prov.: Windsor Leoni volume (12409)
Ref.: Popham 261; C&P; Pedretti I 5r

The convincingly characterised,
topographical and atmospheric effects
suggest that this was drawn from nature,
but no convincing location has been
proposed. It bears a general resemblance
to his description of 'Valtellina, as it is
called, a valley surrounded by high and
terrible mountains', and it is likely that
the present view was inspired by just
such a valley in the foothills of the Alps.
It is not easy to date with reference to
other landscape drawings. Popham
proposed *c.*1499, and this seems broadly
acceptable, though a date as late as
*c.*1507 should not be excluded. It is

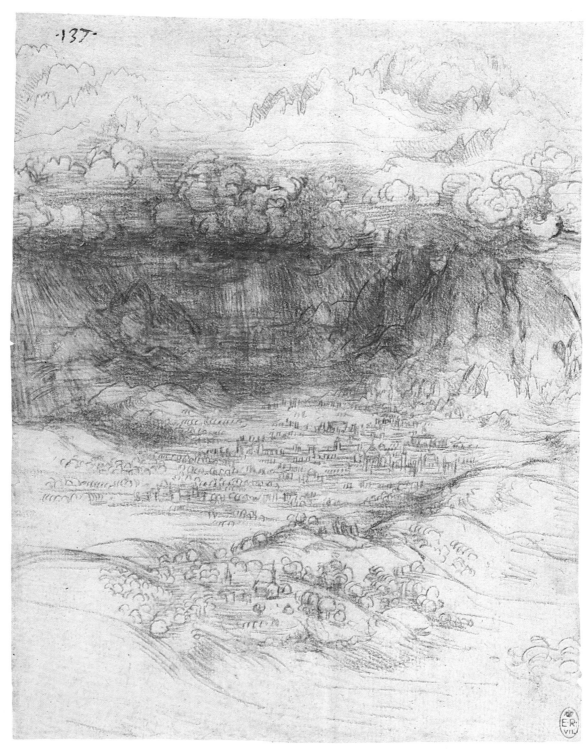

almost certainly earlier than the series of Adda landscapes from the second Milanese period (e.g. no. 20).

The formation of clouds and the precipitation of rain occupied Leonardo's attention around 1506–8 as he sought to understand the dynamics of the cyclical movement of fluids above, within and on the earth (particularly in the Codex Hammer, Armand Hammer Collection, Los Angeles).

The optical effects of rain were also of great interest: 'the rain as it falls from the clouds is the same colour as those clouds, that is to say on its shaded side, unless indeed the sun's rays should break through them'. The painter's mastery of such effects provided one of the grounds for his challenge to sculptors in his *paragone*: 'the painter shows you different distances and the variations of colour arising from the air interposed between the objects and eye; similarly the mists, through which the images of objects penetrate with difficulty; similarly rains, behind which can be discerned cloudy mountains and valleys'.

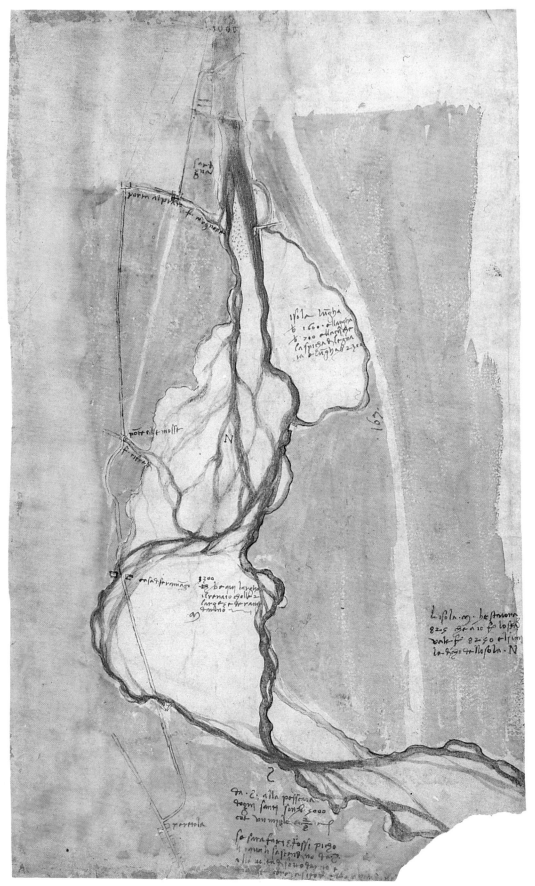

MAP OF THE ARNO AND MUGNONE, WEST
 OF FLORENCE, c.1504

Pen and ink washed with blue and
 green. 422 × 242 mm
Prov.: Windsor Leoni volume (12678)
Ref.: C&P; Pedretti IV 444r

Although the river is sketched with
vigour and apparent freedom, other
maps in this series carry precise scales
and are undoubtedly intended to serve as
measured surveys. The series, for which
preparatory studies are to be found in
the Codex Arundel, can be generally
associated with plans to link Florence to
the sea by a navigable waterway. The
most radical scheme was for a curved
canal to bypass the unavailable reaches
of the Arno, as in the following
drawing, but consideration was also
given to the possibility of altering the
bed of the Arno itself above and below
Florence. The potential rewards in terms
of tolls and irrigation rights were
considerable, as Leonardo recognised:
'straightening the Arno below and
above – a treasure will be found at
whatever rate per acre someone may
wish'.

 However, this particular drawing, on
which Leonardo states that 'three little
ditches are to be made extending from *S*
to the bend of the Arno below', may be
more directly concerned with the
detailed management of the existing
river, as is certainly the case in no. 62.
The notes, which record place names
and distances, are written left-to-right,
indicating that this map was not
produced purely for his private
purposes.

 It was during Leonardo's studies of
these water courses that he observed the
'solid rock of Mugnone, carved out by
powerful water in the form of vases,
appears to be handiwork, it is so
precise'.

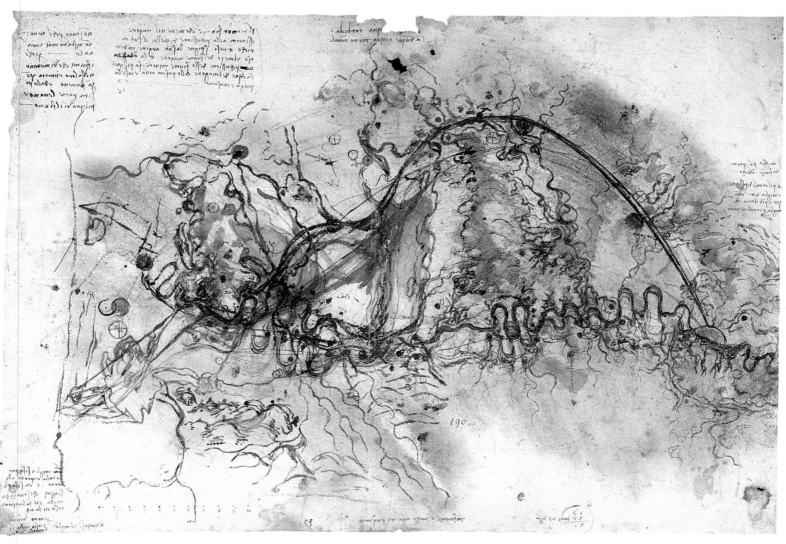

49

MAP OF THE RIVER ARNO AND PROPOSED
 CANAL, *c.*1503–4
Pen and ink over black chalk with
 washes, pricked for transfer.
 335 × 482 mm
Prov. Windsor Leoni volume (12279)
Ref.: C&P; Pedretti IV 441

Although this is the most turbulently
dynamic of all Leonardo's maps, it
contains a measured scale at the lower
left and is pricked for transfer. It is
closely related in content and date to
maps in Codex Madrid II, datable to
*c.*1503.

During the siege of Pisa in 1503 a
number of hydraulic engineers,
including Leonardo, were consulted on a
scheme favoured by Machiavelli to
divert the Arno around Pisa to the sea at
Livorno, and an unsuccessful start was

made. It may have been this experience
that prompted Leonardo to write on this
drawing that 'they do not know that the
Arno will never remain in a canal,
because the rivers that feed into it
deposit earth where they enter, and on
the opposite side erode and bend the
course of the river'. Elsewhere he
advised the engineer that 'the river,
which has to be diverted to another
place, must be tempted away and not
treated harshly with violence'. This sense
of working with something possessing a
life of its own reflects his view that 'the
ramifications of the veins of water are
all joined together in this earth, as are
those of the blood of other animals; they
are in continual revolution for its
vivification, always consuming the places
in which they move, both within the
earth and outside it'.

The scheme which Leonardo is

outlining in this drawing is not
specifically concerned with bypassing
Pisa for strategic purposes, but rather
with the long-standing desire of the
Florentines to bring boats from the sea
as far as Florence. The proposed canal
runs in a huge arc past Prato and Pistoia
and through a specially cut pass at
Serravalle before rejoining the Arno east
of Pisa. The distance would actually be
less than following the meandering
course of the river. This is the route
followed by the modern *autostrada*. He
had earlier suggested that the Arte della
Lana (the Wool Guild) as the sponsoring
body could draw large profits from
control over navigation and irrigation
with the new canal.

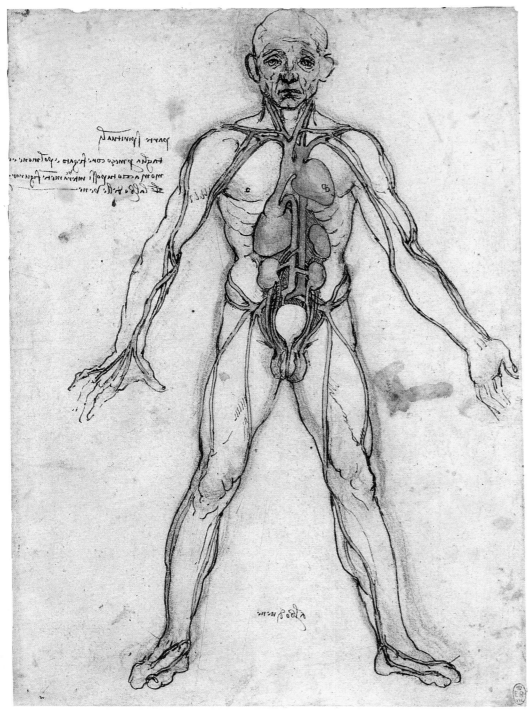

50

ANATOMICAL FIGURE SHOWING THE HEART,
LIVER AND MAIN BLOOD VESSELS,
*c.*1488–90
Pen and ink with coloured washes over
black chalk. 280 × 198 mm
Prov.: Windsor Leoni volume (12597)
Ref.: C V 1r; Popham 232; C&P; K/P
36r

This relatively crude drawing is the
earliest of Leonardo's surviving attempts
to represent the main conduits of the
vascular and urino-genital systems in a
complete figure. The style, anatomical
content and relatively ornamental
writing indicate an early date, perhaps
before 1490 and possibly earlier than the
coition drawing (no. 24), with which it
shares its rudimentary and schematic
treatment of internal anatomy.

Leonardo's intention is to show what
he calls (in the title between the legs of
the figure) the 'tree of the vessels' as the
means by which the humours are
transmitted throughout the body. He
explains that he intends to 'cut through
the middle of the heart, liver and lung
and kidneys so that the tree of the
vessels can be represented in its entirety'.
These 'spiritual parts' (as captioned at
upper left) are responsible for the
generation and flow of the 'natural
spirits', which arise from the liver, and
the 'vital spirits', which originate from
the heart. The conception of the
physiology and morphology of the
vascular system stands entirely within
the tradition of the great Greek
anatomist Galen. Leonardo's primary
source at this time was Ketham's
Fasciculus di medicinae, which contained
an illustrated version of the famous late
Mediaeval textbook by Mundinus.

The system of representation already
shows his interest in displaying structures
within a 'transparent' body, but the
relationships between surface features
and inner structures, displayed partly in
section and partly in three dimensions, is
unresolved, and contributes to the
graceless quality of the drawing.

51

THE SUPERFICIAL VEINS IN THE LEFT ARM,
 AND THE VESSELS OF THE YOUNG AND
 OLD, *c.*1507–8

Pen and ink. 191 × 140 mm
Prov.: Windsor Leoni volume (19027)
Ref.: B 10r; C&P; K/P 69r

This is a key sheet in the chronology of
Leonardo's anatomical studies, and a
landmark in his approach to anatomical
investigation. The notes on the verso
record the death of an old man in
Florence:

> This old man, a few hours before his
> death told me that he had exceeded
> one hundred years, and that he was
> conscious of no deficiency in his
> person other than feebleness. And thus
> sitting on a bed in the hospital of Sta
> Maria Nuova in Florence, without
> any movement or sign of distress, he
> passed from this life. And I made an
> anatomy to see the cause of a death so
> sweet.

This event can be assigned with some
confidence to the winter of 1507–8,
when Leonardo had returned
temporarily from Milan. He also
mentions his dissection of a 'child of
two years, in which I found everything
to be opposite to that of the old man'.
At the top of the recto he reminds
himself to 'represent the arm of
Francesco the miniaturist, which exhibits
many veins'.

Leonardo's investigations centred on
the vascular system of the 'centenarian'
and the failure of the aged vessels to
permit an adequate ebb and flow of the
life-giving blood to and from the heart.
His conclusions are recorded in the
diagrams and note to the left of the
main drawing, labelled 'old man' and
'youth', in which he argues that death
'proceeded from weakness through lack
of blood in the artery which feeds the
heart and lower members, which I
found to be very dry, thin and
withered. . . In addition to the
thickening of their walls, these vessels
grow in length and twist themselves in
the manner of a snake.' On the verso he
recorded that:

> the liver loses the humour of the

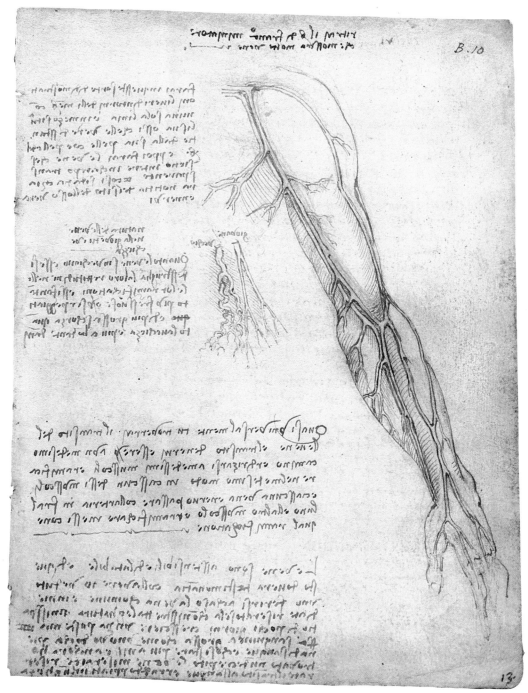

blood . . . and becomes dessicated like
congealed bran in colour and
substance . . . and those who are very
old have skin the colour of wood or
dried chestnut, because the skin is
almost completely deprived of
nourishment; and the covering of the
vessels behaves in man as in oranges,
in which as the peel becomes thicker
so the pulp diminishes, the older they
become.

His explanation of the centenarian's
death gained cogency for Leonardo
from his ability to characterise it in
terms of micro-macrocosmic parallels.
The botanical analogies, seen in the
preceding drawing, remain no less valid
in principle, as no. 53 confirms. Equally
apparent are the parallels with the
inefficient flow of tortuous rivers, such
as the Arno (nos. 48, 49 and 62), which
are continually silting up their channels
and altering their courses.

52

THE PRINCIPAL ORGANS AND VASCULAR
AND URINO-GENITAL SYSTEMS OF A
WOMAN, c.1507
Pen and ink and wash over black chalk
on washed paper, pricked for transfer.
478 × 333 mm
Prov.: Windsor Leoni volume (12281)
Ref.: C I 12r; Popham 247; C&P; K/P
122r

This drawing records the most
astonishing and heroic of Leonardo's
efforts to synthesise his investigations
into the systems of irrigation within the
human body. Although the relatively
formalised treatment of some of the
structures, such as the heart and womb,
have led to suggestions of a date around
1500, the approach seems sufficiently
close to that of the drawings in the
'centenarian' series from c.1507–9 (nos.
51 and 53) to justify a later dating.

The extensive pricking of the outlines
indicates the elaborate care with which
Leonardo planned this composite
demonstration, first folding the sheet
vertically to transfer the outlines from
the left to the right and then pricking
the completed drawing for transfer to
another sheet. On the verso the main
outlines of the figure and organs have
been traced in outline.

His greater sophistication of
anatomical knowledge and command of
representational techniques is vividly
apparent when contrasted to no. 50, but
the problem of mixing diagrammatic
conventions in one demonstration
remains. Some forms are sectioned,
some shown in transparency and some
described in three dimensions. He
realised that spatial clarity was being
sacrificed, and noted: 'make this
demonstration also seen from the side, so
that knowledge may be given how
much one part may be visible behind
the other, and then make one from
behind'.

His characterisation of many of the
blood vessels, the bronchial tubes, the
liver, kidney and spleen reflect the fruits
of his dissections in the years following
the previous drawing. The general
conception of the physiological functions
remains within the standard framework.
The heart, lacking atriums, and the
spherical womb, with prominent horns
and internal 'cells', are conceptualised
structures, blending inherited wisdom
with design according to functional
prescription.

The other notes mention Leonardo's
intention that his 'series shall begin with
the formation of the child in the
womb', and discuss questions of
digestion, the blood vessels, reproduction
– with a critical reference to Mundinus –
and cycles of death and rebirth within
the human body.

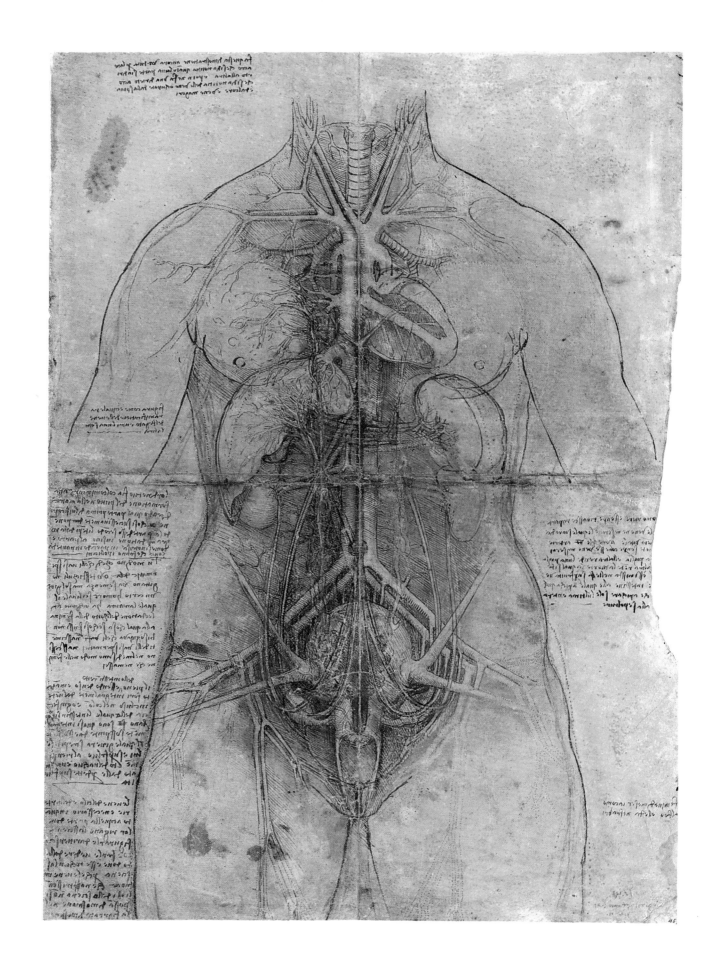

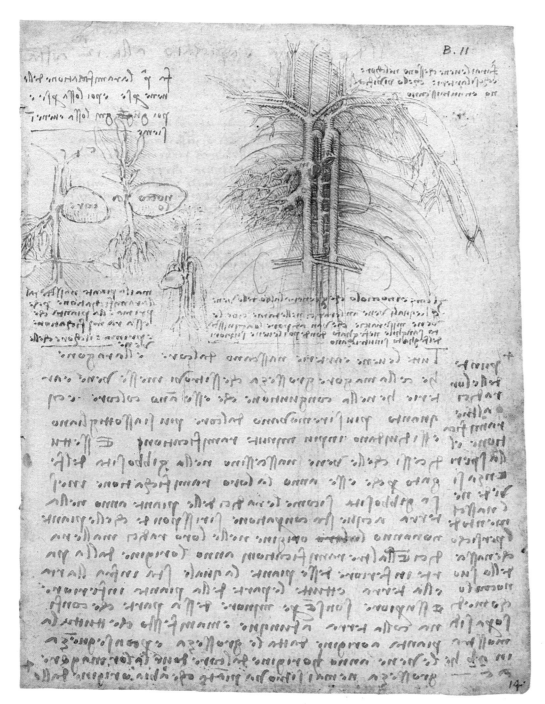

53

THE MAIN ARTERIES AND VEINS OF THE
THORAX (OF AN OX?) AND STUDIES OF
THE HEART AND BLOOD VESSELS
COMPARED WITH A PLANT SPROUTING
FROM A SEED, *c.*1508–9
Pen and ink. 191 × 140 mm
Prov.: Windsor Leoni volume (19028)
Ref.: B 11r; C&P; K/P 70r

This is one of the series of
demonstrations which take as their
starting-point the 'centenarian'
dissection, but characteristically contain
speculations on broader issues, in this
case the germination of the vascular
system from the heart or from the liver.
This topic had been much debated since
the time of Aristotle, against whom
Galen had argued that the liver was the
vital organ. Leonardo sided with
Aristotle, using a botanical analogy to
prove his point:

> if you should say that the vessels arise
> in the protruberances of the liver . . .
> just as the roots of the plants arise
> from the earth, the reply to this
> analogy is that plants do not have
> their origin in the roots but . . . the
> whole plant has its origin in its
> thickest part and in consequence the
> veins have their origin in the heart
> where it is of the greatest thickness
> . . . and this is to be seen through
> experience in the germination of a
> peach which arises from its stone.

A similar though less developed
botanical analogy had earlier been used
by Mundinus to make the same point.
Leonardo's diagrams to the left of a
germinating 'nut' (or peach-stone) beside
the rough outline of the heart and major
vessels shows that 'the tree of the vessels
. . . has its roots in the dung [of the
liver]', leading to the conclusion that
'the heart is the nut which generates the
tree of the vessels'.
In his optical researches he drew an
analogy between the strength of a tree
at its thickest part, i.e. at the base of its
trunk, and the greater strength of light
and shade closer to their origins, in
keeping with 'the nature of universal
things, which are more powerful at their
beginning and become enfeebled
towards their end'.

54

THE LUNGS AND UPPER ABDOMINAL
 ORGANS (PERHAPS OF A PIG), *c.*1508–9
Pen and ink. 194 × 143 mm
Prov.: Windsor Leoni volume (19054v)
Ref.: B 37r; C&P; K/P 53v

This drawing is one of Leonardo's most
developed and beautiful attempts to
synthesise results from the phase of his
anatomical research centred on the
'centenarian' dissection (no. 51), though
this particular demonstration may be
more directly related to his experiments
with a pig's lung, which he attempted
to inflate.

The conduits at the top of the right-
hand drawing are labelled:

a – trachea, whence the voice passes; *b*
– oesophagus, whence the food passes;
c – apoplectic [i.e. carotid] vessels,
whence passes the vital spirits; *d* –
dorsal spine, where the ribs arise; *e* –
vertebrae, where the muscles arise
which end in the neck and raise up
the face to the sky.

The organs below are labelled: lung
liver; stomach; diaphragm; spine.

The diagrammatic technique, which
strives to combine exterior description
with transparency, presents difficulties,
and Leonardo decides that he 'will first
make this lung complete, seen from four
aspects in its complete perfection; then
you will make it so it is seen fenestrated,
solely with the ramifications of the
trachea, from four other aspects'. By
'fenestrated' Leonardo meant showing
the substance of the lung as entirely
transparent, as if looking through a
window at a tree without leaves. Such
demonstration of branching systems in
three-dimensional isolation was to
become a key technique in Vesalius's
Fabrica (1543).

The principle upon which the
branching is designed is the same as that
he formulated for trees, namely that the
sums of the cross-sectional areas of the
branches at successive stages of
bifurcation must be equal to each other
and to the cross-section of the main tube
or trunk. This equality of area is
necessary if turbulent flow is to be
avoided, according to the hyrodynamic
law he had discovered in his studies of

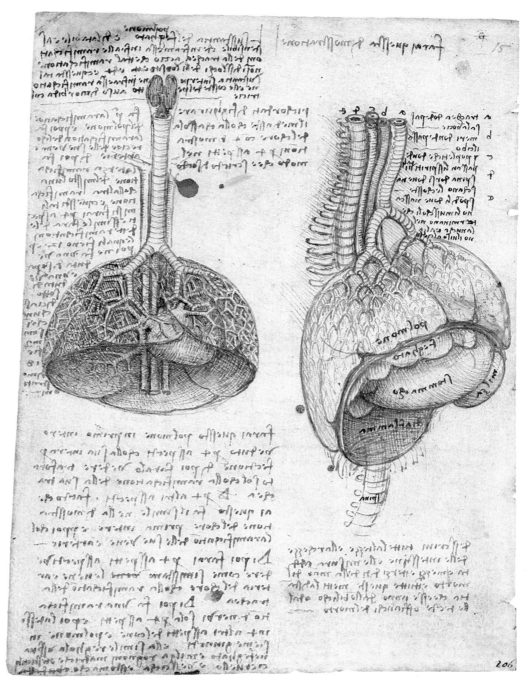

water in channels and conduits, which
indicated that the volume of water
passed at a constant velocity was directly
proportional to the cross-sectional area
of the channel.

5
THE VORTEX

At times water twists to the northern side, eating away the base of the bank; at times it overthrows the bank opposite on the south; at times it turns towards the centre of the earth consuming the base which supports it; at times it leaps up swirling and bubbling to the sky; at times revolving in a circle it confounds its course . . . Thus without any rest it is ever removing and consuming whatever borders upon it. Going thus with fury it is turbulent and destructive.

The vortex epitomises in tangible form Leonardo's passion for geometry, and the geometry of his passion for motion. His response to motion was at once intuitive and intellectual. No draughtsman ever exhibited a more pronounced ability to evoke the potential for motion in the products of nature, even when they are at rest, and no artist of his time was more sensitive to the expressive potential of motion. The vortex in particular becomes a ubiquitous sign of the life beneath the surface of nature (e.g. nos. 57 and 61). And in his intellectual scrutiny of the dynamics of nature he strove to achieve the most rigorously mathematical analysis of even the most intransigently complex of effects – and none was more intransigent than vortex motion in fluids.

The framework for Leonardo's dynamics was drawn from late Mediaeval natural philosophy, and ultimately from classical theory. The four elements – earth, with water, air and fire in concentric circles around it – all desired to find their own level in nature. It required some active agent, in the form of an 'accidental' force, to move one of them from its assigned position. An object above its natural level would exercise weight, striving to descend according to the rule of gravity, and one below, such as a submerged bubble (no. 61) would desire to ascend by the shortest route possible. Any object to which the force of lateral motion is actively imparted, such as a thrown stone, would desire to travel an assigned distance in a given time, according to the weight of the object and the size of the force. The quality impressed in a moving body by force was termed impetus in the late Mediaeval theory which Leonardo adopted from such authorities as Buridan and Oresme. He wrote in Codex Forster II (f.141v) that: 'Impetus transports a mobile body beyond its natural location. Every movement has terminated length, according to the power that moves it, and upon this one forms the rule.'

The concept of impetus in this sense is very different from the Newtonian law of the conservation of motion, in that impetus would 'drain' from an object, in accordance with the natural rule of the pyramidal diminution of power, rather than persisting until opposed by contrary forces. However, this did not mean that impetus was any less remorseless than Newtonian inertia. If a moving object encountered an obstruction, it would necessarily strive to complete its assigned motion. Thrown balls and rays of light would rebound, with angles of reflection equal to angles of incidence, while water and air would adopt patterns of eddies:

'Moving water strives to maintain its course in accordance with the power of its cause, and if it finds resistance opposing it, it completes the span of the course it has commenced by circular and twisting movement.' Thus, when water from a conduit falls into a pool (no. 61), it undergoes collisions of incredible complexity, in accordance with the conflicting desires of the weights and impetuses of the components involved. Each current of water percusses others, many rebounding from the walls of the container, while the submerged bubbles conduct their own battle to return to their natural position in the main body of air: 'the air submerged together with the water . . . returns to the air, penetrating the water in sinuous motions, changing its substance into a great number of shapes'. His intense studies of water, conducted virtually throughout his career, represent the perfect blend of mathematical theory and tireless observation in the service of a series of variables that ultimately lay beyond the reach of the techniques available to him.

In his practice as an engineer, water was of immense importance. It was necessary for irrigation, transport and as the chief source of sustained power for driving machinery. 'Masters of Water' were important specialists in early technologies. Much of the time of such masters was spent not in harnessing power but in managing the movement of water in such a way as to minimise its destructive potential. Leonardo was especially sensitive to the obstinate will of water to behave as it wished, and devoted particular attention to problems of erosion (no. 62).

The model for the engineer was the human body. Leonardo's late studies of the heart (nos. 19 and 55) revealed it as a superbly designed instrument, working with infallible necessity in harmony with the inexorable motion of the vortices within its cellular chambers and geometrically structured valves. 'The heat of the heart is generated by the swift and continuous motions made by the blood which make friction within itself by its revolvings.' In fact, there would be a grave danger of overheating, were it not 'for the help of the bellows called the lungs'.

It is easy to see why he considered at one point that it should be possible to harness such power to realise the age-old dream of perpetual motion. The invention of a mill which would work with 'dead' water (no. 59), and the contrivance of a 'perpetual wheel' (no. 60) were two of the most well-tried devices. In the late 1480s Leonardo hoped that he could raise water through a screw requiring relatively little power, then using the raised water to work a more powerful screw as it descends, in turn driving the ascending screw. By 1500 he had definitely abandoned the quest, realising that in any mechanical system increments of power would be lost at each stage:

I have found amongst the excessive and impossible beliefs of man the search for continuous motion, which is called by some the perpetual wheel, and has occupied the attention of many ages with long research and great experimentation. It has regularly employed almost all the men who take pleasure in mechanisms for water, war and other subtle contrivances. And always it finally transpired – as with the alchemists – that through a little part the whole is lost. Now it is my intention to offer this corollary to this sect of investigators, that is to say giving them benefit of respite in their search, for as long as my little work may endure.

Leonardo's intellectual fascination with the science of circular motion was

complemented by a highly-charged sense of awe at its destructive potency. Water was the key element in this respect. It was mobile, like air, and possessed weight, like earth. This combination made it the most feared of the natural elements for Leonardo. When the masses of mobile water were unleashed by nature, man remained powerless: 'against its fury no human defence avails'. The same mathematics of impetus that had worked with such controlled vitality in the heart acts as the agent of terrifying death in the 'Deluge Drawings' (nos. 63, 64 and 66). His depiction and literary descriptions of the raging vortices of water, air and debris represent the horrendously unregulated unwinding of the universal clock-work of motion.

In many respects Leonardo's visions of the deluge are highly conceptualised, but we should not miss the sense of reality behind them. His notebooks show him to have been a keen collector of references to natural disasters – the scale of which may have become exaggerated in the telling – and we know that hugely destructive earthquakes occurred in the Alps near Bellinzona in 1513 and 1515. Such terrible blows of 'Fortune', that ever perverse goddess of human affairs, made a deep impression on Leonardo, no less than on his contemporaries.

55

STUDIES OF THE VORTEX MOTION OF
BLOOD WITHIN THE HEART, *c.*1513
Pen and ink on blue paper.
283 × 207 mm
Prov.: Windsor Leoni volume (19083v)
Ref.: C II 13v; C&P; K/P 172v

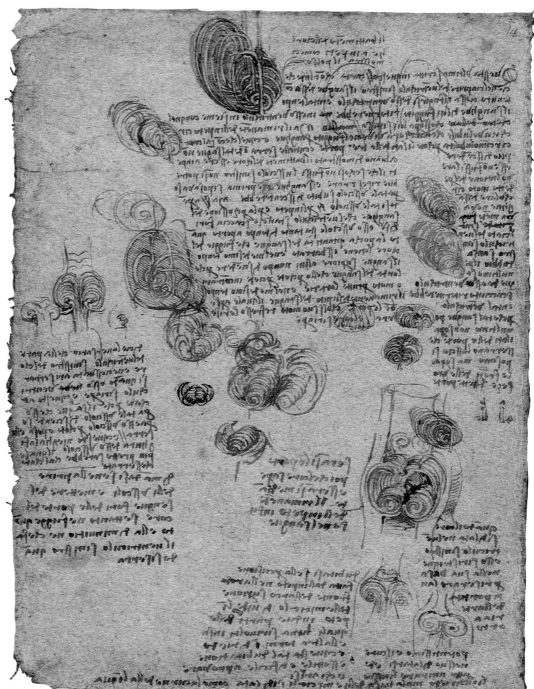

This page of elaborate notes with
supporting diagrams is characteristic of
Leonardo's researches into the heart
undertaken in 1513 (see no. 19). The
subtle structures of the heart, depicted in
such architectural terms on no. 119,
were designed to operate in harmony
with the hydrodynamic laws which
governed the motion of the blood. The
analysis on this and related pages of
heart studies is deeply informed by his
water researches (e.g. nos. 21 and 61), to
which he makes direct reference in the
notes.

The turbulence depicted in these
drawings is both inevitable and
necessary. It arose inevitably from the
pumping of the ventricles of the heart
and the resulting impacts of the streams
of blood on each other and on the
cellular walls of the heart. It is necessary
since it 'serves two purposes':

> The first of these is that this
> revolution, multiplied from many
> sides, causes great friction within
> itself, which heats and rarefies the
> blood and augments and vivifies the
> vital spirits which are always kept hot
> and humid. The second purpose of
> this revolution of blood is to shut
> again the opened gates of the heart,
> with its primary motion reflected to
> make a perfect closure.

This page and related sheets at
Windsor (19116v, 19118, 19045)
concentrate upon the patterns of the
eddies within the aortic valve. When the
blood is pumped through the valve it
encounters the progressively restricted
neck of the aorta, and Leonardo argues
that it is forced in part to turn back on
itself in a spiral motion. The revolving
of the resulting vortices within the
flexible cusps of the valve fills these
cusps, thus closing the valve until the
next body of the blood is forced
between them. However, as he
recognised, determining the precise
patterns of turbulence is extremely
difficult: 'It is doubtful if the percussion
made by the impetus . . . divides the
impetus into 2 parts, one of which
revolves upwards and the other turns
backwards. Such doubts are subtle and
difficult to prove and clarify.'

On one of the sheets in this series
(Windsor 19082) he planned to test his
theory by building a glass model of the
neck of the aorta, equipping it with
membranes in imitation of the cusps and
watching the action of liquid within his
apparatus – 'but first pour wax into the
gate of a bull's heart so that you may
see the true shape of this gate'.

Almost inevitably, engineering
analogies came to mind as he considered
the action of the various valves in the
heart: 'give names to the *chordae* which
open and shut the two sails [the cusps of
the tricuspid valve], that is to say the
chief one you shall name the bowline
and the topmast etc.'

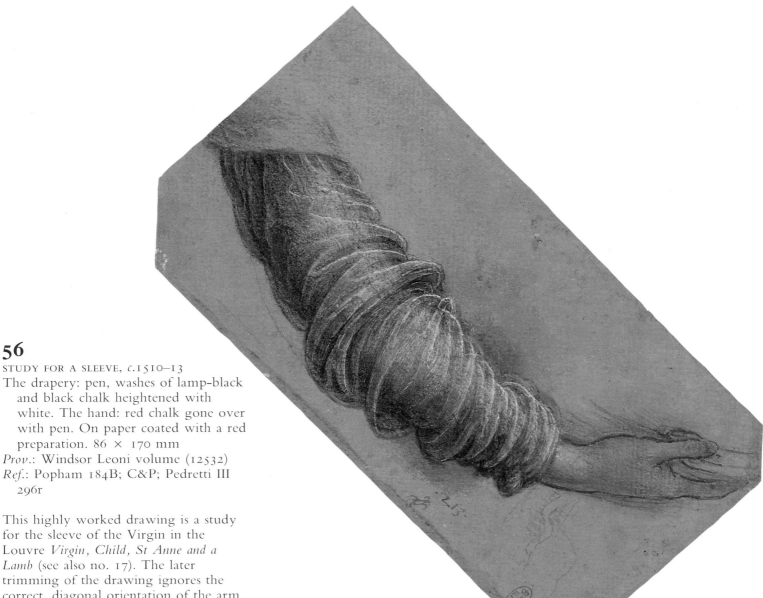

56

STUDY FOR A SLEEVE, *c.*1510–13

The drapery: pen, washes of lamp-black
 and black chalk heightened with
 white. The hand: red chalk gone over
 with pen. On paper coated with a red
 preparation. 86 × 170 mm
Prov.: Windsor Leoni volume (12532)
Ref.: Popham 184B; C&P; Pedretti III
 296r

This highly worked drawing is a study
for the sleeve of the Virgin in the
Louvre *Virgin, Child, St Anne and a
Lamb* (see also no. 17). The later
trimming of the drawing ignores the
correct, diagonal orientation of the arm,
which has been restored in the present
mounting of the sheet. The theme of the
Virgin, Child and St Anne had exercised
Leonardo at least from 1501, and the
Louvre painting may have been
completed as late as 1515–17. The
complex rhythms and subtle optical
effects of superimposed layers of
material suggest a date not before
*c.*1508, when he completed the second
version of the *Virgin of the Rocks*
(National Gallery, London), in which
the angel's sleeve demonstrates some of
these effects in less developed form. A
date after 1513 should not be excluded.
The awkwardly orientated and
gracelessly drawn hand was probably
either added later by someone else or

inked over a faint trace of Leonardo's
own drawing.

Leonardo's instructions on how to
portray draperies emphasise that cloths
of different kinds should display
different fold patterns, and that the
configurations of folds should respond to
the motion of the figures. As with all
other phenomena, natural law comes
into operation: 'by nature everything has
a desire to remain as it is. Drapery being
of equal density and thickness both on
its reverse and its right side strives to lie
flat. Wherefore when it is forced to
foresake this flatness by reason of some
pleat or fold, observe the effect of the
strain on that part of it which is most

bunched up.' In this particular case,
virtually every part of the sleeve is
subject to the force of bunching,
corresponding to Leonardo's description
of 'limbs surrounded by frequent folds
and swirling about these limbs'. The
response of the thin, mobile draperies of
this sleeve has been to assume
configurations of vortices analagous to
those of hair and water.

57

THE STAR OF BETHLEHEM (*Ornithogalum umbellatum*) AND OTHER PLANTS, *c*.1508
Red chalk, pen and ink. 198 × 160 mm
Prov.: Windsor Leoni volume (12424)
Ref.: Popham 273; C&P; Pedretti I 16r

This is the most spectacular of the plant studies undertaken in connection with the project for *Leda and the Swan* (nos. 14, 44, 74 and 75). The main and subsidiary drawings all breathe the air of direct studies from nature, though it is doubtful if the leaves of the Star of Bethlehem naturally adopt quite as emphatic a spiral arrangement as illustrated here. The procedure may be similar to that in some of Leonardo's anatomical studies, in which his method of observational analysis results in an emphasis upon the underlying organisational patterns. The act of observation openly fuses with the act of analytical demonstration.

The function of the plants in the painting was to underscore the theme of nature's fecundity represented by the fruitful union of Leda and the swan (Jupiter in one of his rapacious disguises). In the final version of the painting, known from copies, their four children tumble out of the broken shells on to a sumptuous bed of curling leaves. The whole composition was to be a symphony of serpentine curves, and Leonardo's hand in the drawings becomes a vehicle for the energies embodied in the spiral forms and motions of nature.

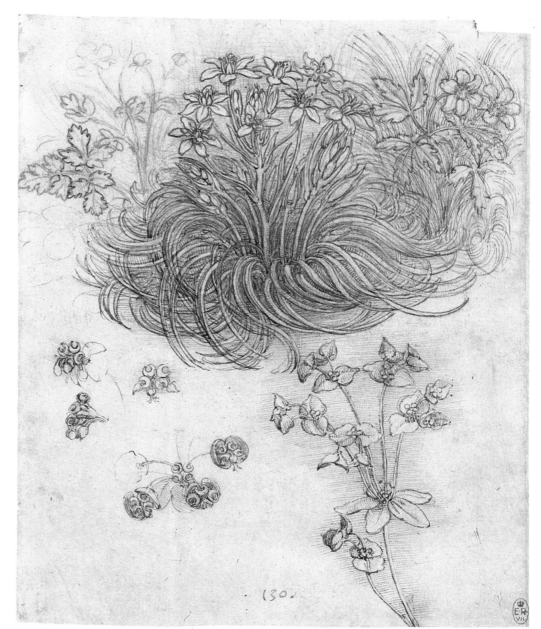

58

STUDY FOR THE HEAD OF LEDA, c.1505–7
Pen and ink over black chalk.
198 × 166 mm (irregular)
Prov.: Windsor Leoni volume (12516)
Ref.: Popham 210; C&P; Pedretti III 323

The main study on this page is for the head of Leda for his painting *Leda and the Swan*, which was housed in Francis I's *Appartements des Bains* at Fontainebleau – with apparently fatal consequences for the long-term survival of Leonardo's panel. The Leda composition appears to have originated around 1505, when he was working on the *Battle of Anghiari* (nos. 73, 74 and 87). The twisted, semi-kneeling pose in the early schemes (nos. 14 and 75) was abandoned in favour of the more gently serpentine motion of the version as painted, in which Leda stands beside the swan. This head corresponds to the later version, and may be dated with reasonable confidence to 1505–7, when Raphael made a sketch (in the Royal Collection) either of a developed study for the final painting, or of the cartoon, or from early work on the painting itself.

Leda's coiffure represents an extreme development of the interest in complex hair styles that Leonardo had inherited from Verrocchio. As Kenneth Clark observed, she is wearing a wig, and on another drawing at Windsor (12517) for an alternative configuration Leonardo noted that 'this kind can be taken off and put on again without damaging it'. It is characteristic of Leonardo that he should have felt the need to envisage the complete wig in his drawings, displaying the knotted braids at the rear as well as the front portion to be shown in the painting.

The elaborate plaiting of the wig may be regarded as an artificial elaboration of the propensities of hair in its natural state, which, as Leonardo explains on no. 21, provides a model for the spiral motion of water:

> Observe the motion of the surface of water, which resembles the behaviour of hair, which has two motions, of which one depends on the weight of the strands, the other on the line of its revolving; thus water makes revolving eddies, one part of which depends upon the impetus of the principle current, and the other depends on the incident and reflected motions.

This analogy could not be better expressed than by the spouts of Leda's own hair, surging through the apertures at the centre of the lateral whorls.

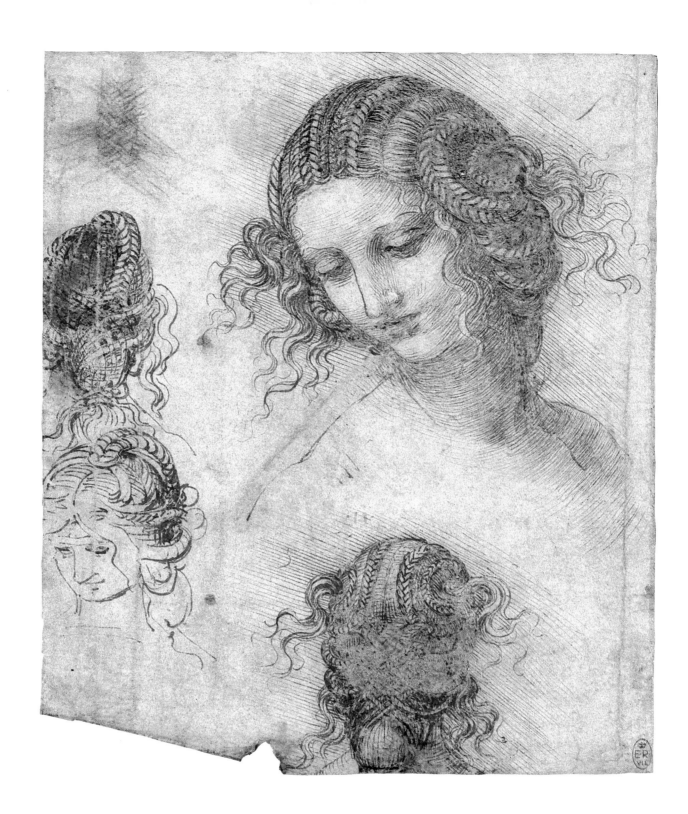

59

This Codex comprises two notebooks:
the first forty folios concentrate on
geometrical transformation and date
from 1505; folios 41–55 deal almost
exclusively with hydraulic engineering
and can be dated to the late 1480s. The
folios illustrated here demonstrate the
dominant concern of the earlier
notebook, the use of water screws and
pumps to create perpetual motion.

The Archimedean screw, a traditional
device of spiral pipes used to 'wind'
water uphill, was of continuing
fascination to Leonardo, and appeared in
his drawings as early as his first
Florentine period. The raising of water
to high tanks or reservoirs was of
considerable economic importance, both
as a source of power and for irrigation.

In the upper drawings on the left-
hand page and the central drawing on
the right he is investigating the
possibility that compound systems of
such screws might achieve the long-
sought goal of perpetual motion – a
particularly fashionable quest amongst
Renaissance inventors, including
Francesco di Giorgio, who recorded a
water-screw method in a manuscript
later annotated by Leonardo. In a
memorandum in Paris Ms. BN 2037 (see
no. 118) Leonardo reminds himself to
'ask maestro Lodovico about the
conduits of water and the small furnace',
adding that 'it stays in perpetual
motion'. Although, as we will see (no.
60), Leonardo was within a few years to
to be rudely scathing about this quest,
the pages of this Codex show him
irresistibly drawn towards the possibility
that a solution might exist.

He hoped that compound spirals of
varied curvature would provide the

answer. On the left he explains that
since the inner spiral is 'closer to the
central axis *mt*' the water will ascend
readily, before returning downwards in
the wider spiral *b*. On the grounds that
the wide spiral will exercise a more
powerful turning moment – with the
result that the water will be made to re-
ascend in the inner screw – he claims
that 'the double screw depicted above
will have continuous motion'.

On the right is one of a number of
schemes in which planar spirals, conical
spirals and V-shaped configurations of
tubes are combined to produce the same
effect. The water ascends to the centre
of the planar spiral *sp*, and then passes
into the 'pyramidal screw *nc*', running
from the point at *c* to *p* and acting as an
'equidistant lever' to turn the whole
apparatus. As the device revolves, so
further 'levers' would come into play –
though the precise arrangement and
operation is far from clear. It is easy to
understand why Leonardo was attracted
by the great prize of perpetual motion
and why he looked towards his beloved
vortex motion to achieve this end.

The lower drawing on the left is a
sketch of a perpetual pump. The water
passes from the spout of the pump into
a container-*b*, which descends to *c*,
levering the arm of the pump
downwards and raising more water in
its barrel. When the container releases

the water, the arm will be lightened and
a counterweight (the ball on top of the
pump?) will press the piston of the
pump downwards again. This device
proved no less chimerical than the
perpetual waterscrew.

(The thumb-nail sketch of the
bowman, and the notes at the top and
bottom of the page, added after the
compound screw, are discussed in the
introduction to the section on 'Art and
Imagination', pp. 142–3.)

60

STUDIES OF 'PERPETUAL WHEELS' c.1495–7
Pen and ink. Folio measurements:
 98 × 146 mm
The Board of Trustees of the Victoria
 and Albert Museum, London
Prov.: J. Forster; Victoria and Albert
 Museum (Codex Forster II,
 ff.90v–91r)
Ref.: Reale Commissione Vinciana, 1934,
 II, part 2, pp. 145–6

Forster II is composed from two *libretti* (folios 1–63 and 64–159) in their original bindings. They can both be dated to the second half of the 1490s, though there is a possibility (discussed below) that part of the second notebook dates from *c.*1500.

 Like the screw system in Forster I (no. 59) the topic of these folios is perpetual motion – in this case, 'the wheel which continually revolves' (f. 104v). By this later date, however, Leonardo's studies of mechanics, including his investigations of weights and balances elsewhere in this Codex, permit a more rigorous analysis of the proposed solutions and allow him to assert their impossibility. The left-hand page shows one of a series of wheels in which weights are arranged on hinged axes around the diameter in such a way as to tumble downwards on the descending side to enhance its turning impetus. The simple ratchet on the right prevents the wheel from turning in reverse. He argues that a calculation of the action of the weights on their axes will make the matter 'clear', though he does not give the promised measurements on this folio, merely indicating that he 'intends to define it precisely with its proofs in another place, where motion and percussion are treated'.

 On another page (f. 89v) Leonardo argues that each of the twelve weights will only generate one-twentieth of the necessary motion, resulting in the gradual slowing of the wheel. On f. 92v he asserts that 'whatever weight shall be fastened to the wheel, which weight might be the cause of the motion of the wheel, without any doubt the centre of such weight will remain under the centre of the axis. And no instrument

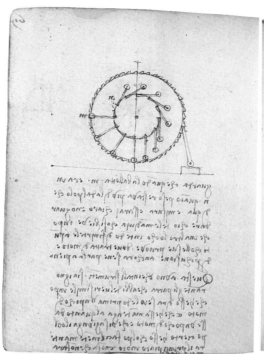

that turns on its axis can be constructed by human ingenuity so as it might avoid this result.' He concludes this latter note with a brief diatribe: 'O speculators on perpetual motion, how many vain designs you have created in the like quest! Go and join up with the seekers after gold!'

 The attractive device on the right consists of 'eight balls in twelve channels, of which four are on this side of the axis and four on the other'. The idea is that the balls will run downwards from the curved sections of the channels, causing 'percussion on the place at which they stop' (at the peripheral tips of the channels). This percussion will make the channels pivot around their central axis, creating sufficient impetus for the balls to run again into curved sections to repeat the process. Leonardo argues that the ball at the bottom will not contribute useful weight to the turning motion, and that in effect two balls will therefore be opposing five, with the result that the wheel will settle into a position of stability.

 The devices illustrated here with such compact intensity appear not to be of Leonardo's own contriving, but are probably inventions by other aspirants to the title of the creator of perpetual motion. On the flysheet of Codex Madrid I he records the congregation of such aspirants in Venice, which he visited in 1500: 'I remember having seen many men and from various countries brought by their infantile credulity to Venice with great hope of gain by making mills in dead water. Being unable, after much expense, to move such a machine, they were compelled by great fury to escape from this debacle.' On ff. 147v–148r of Madrid I he provides detailed analyses for the failure of the type of wheel on f. 80v of the Forster Codex, showing that 'such a wheel is sophistical'.

 The Madrid notes suggest that the folios in Forster II in which Leonardo discusses the wheels may have been written in direct response to devices he encountered in Venice, and should therefore be dated no earlier than 1500.

61

STUDIES OF WATER PASSING OBSTACLES
 AND FALLING INTO A POOL, *c.*1508–9
Pen and ink over traces of black chalk.
 298 × 207 mm
Prov.: Windsor Leoni volume (12660v)
Ref.: Popham 281; C&P; Pedretti I 42r

Extensive investigations of water appear in Leonardo's earlier manuscripts, including Ms.C and persist unabated into his late notes (e.g. Mss.E and G). The present drawing shares most in common with the studies in Ms.F, which is dated 1508. The main drawing is the most complex and ornamentally beautiful of all his water drawings and may be regarded as the hydrodynamic equivalent of the 'great lady' anatomy (no. 52). It represents a synthesis of phenomena investigated separately in other drawings (e.g. Windsor 12659–62). Leonardo's note carefully outlines the factors behind this synthesis:

> The motions of water which has fallen into a pool are of three kinds, and to these a fourth is added, which is that of the air being submerged in the water, and this is the first in action and it will be the first to be defined. The second will be that of the air which has been submerged, and the third is that of the reflected water as it returns the compressed air to the other air. Such water then emerges in the shape of large bubbles, acquiring weight in the air and on this account falls back through the surface of the water, penetrating as far as the bottom, and it percusses and consumes the bottom. The fourth is the eddying motion made on the surface [*pelle* = skin] of the pool by the water which returns directly to the location of its fall, as the lowest place interposed between the reflected water and the incident air. A fifth motion will be added, called the swelling motion, which is the motion made by the reflected water when it brings the air which is submerged within it to the surface of the water.

The obvious difficulty in tabulating the variables in a subject of this complexity is reflected in Leonardo's adding factors as he expounds his initial *tre spetie*. Although this is a synthetic drawing, deeply influenced by his theoretical framework of impetus and revolving motion, it does reflect many hours of patient scrutiny of water motions in natural, artificial and experimental situations, as recorded in such pocket-books as Ms.F. The note

squeezed on to the lower section of the page contains a typical observation and explanation, which begins, 'I have seen in the percussion of a boat that the water within the water more completely obeys the revolutions of its impacts than that of the water which borders on the air, and this arises because water within water has no weight, but it has weight within air.'

The drawings on the upper part of the page depict, with an obvious sense of formal pleasure, the curling tails of turbulence resulting from boards inserted at different angles into a rushing stream. They could serve as a perfect illustration of his famous parallel between the curling of hair and the spiral motion of water, quoted in the entry for no. 58. In a similar vein he had earlier written in Ms.A that 'all the motions of wind resemble those of water'. We might fairly add in the present context that they can also resemble the configurations of twisted drapery (no. 56) and patterns of growth in plants (no. 57).

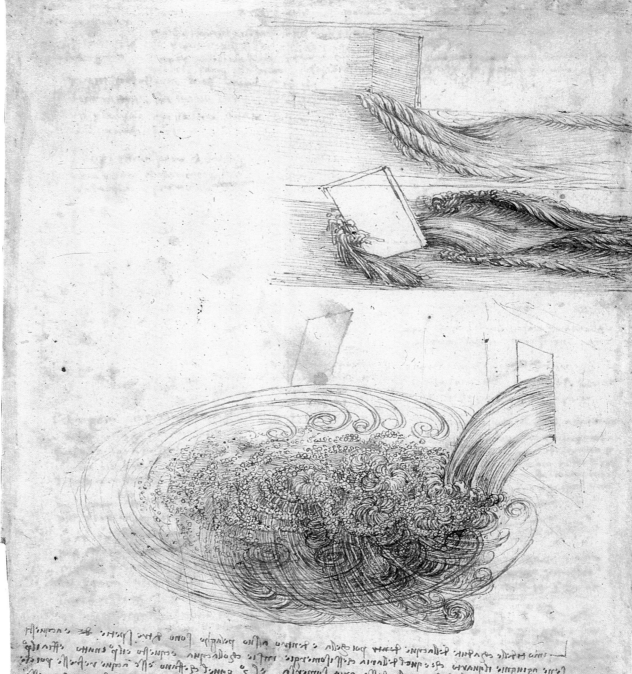

A mirror-written manuscript text in Leonardo da Vinci's hand appears at the bottom of the page, written right-to-left and not legible in standard transcription.

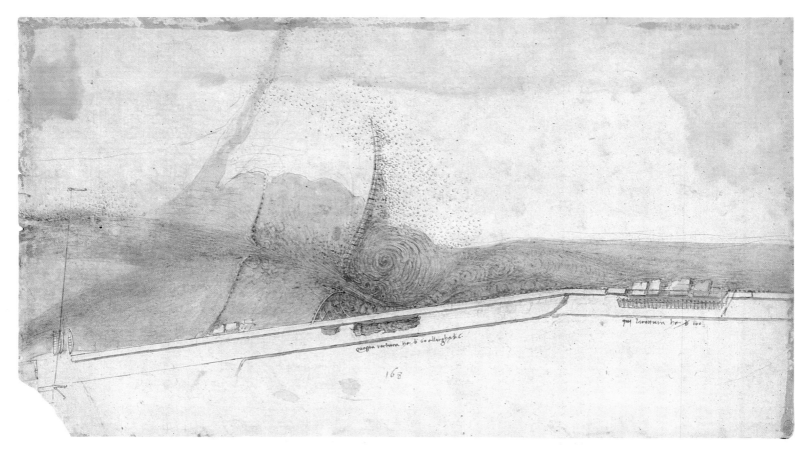

62

MAP OF BREAKWATERS AND ERODED
 EMBANKMENT ON THE RIVER ARNO,
 c.1504
Pen and ink and watercolour.
 236 × 416 mm
Prov.: Windsor Leoni volume (12680)
Ref.: Popham 267; C&P; Pedretti IV
 447r

This drawing relates to the studies he
was making during his second Florentine
period for various hydraulic projects on
the Arno (no. 49). In common with the
study of the Arno west of Florence
(no. 48) and a smaller-scale map of the
same area as illustrated here (Windsor
12679), this study does not directly relate
to the more grandiose schemes of
canalisation but to detailed questions of
the management of the river's flow. It
depicts a section of the river just
downstream from a chain ferry, visible
at the left. Highly finished and legibly
labelled left-to-right, this plan was
obviously designed for utility and may
have been specifically commissioned by
the Florentine authorities.

Its function has been consistently
misinterpreted as his own scheme for
two weirs to narrow the course of the
river. Rather, it records an existing
scheme and the trouble it was causing.
The drawing is a report on the way in
which the remorseless vortex behind the
opening in the second weir has scoured
a deep breach in the wall – 'this fracture
is 60 *braccia*, and 6 *braccia* wide' – while
the main stream is deflected in a sinuous
meander to strike the bank further
downstream, where it has prized blocks
out of the wall – 'here the fracture is
100 *braccia*'. There is no record of
Leonardo's solution, but it would have
been totally out of character for him not
to have proposed at least one.
 Like *The Map of Imola* (no. 98), even
this functional drawing retains his
characteristic sense of the interplay of
forces on and within the surface of the
earth. It recalls his powerful descriptions
of water in action, such as his
observation in Ms.A of 'hollows in
which the water, whirling around in
various eddies consumes and excavates
and enlarges these chasms . . .

consuming and devouring whatever
stands in its path, changing its course in
the midst of the ruin'.

63

DELUGE STUDY, *c*.1515
Black chalk, pen and ink.
 162 × 203 mm
Prov.: Windsor Leoni volume (12380)
Ref.: Popham 296; C&P; Pedretti I 59r

This study belongs to the series of
sixteen at Windsor, collectively known
as the 'Deluge Drawings', which depict
awesome cataclysms. The conventional
dating to the last years of Leonardo's life
seems convincing.
 The execution of this drawing in pen
with yellowish ink gives it a more
formalised and defined air than the
otherwise similar drawings in black
chalk (e.g. nos. 22 and 66). The
strangely objectified quality of this
terrible vision of destruction is
reinforced by the coolly observational
tone of the note: 'On rain: show the
degrees of rain falling at various

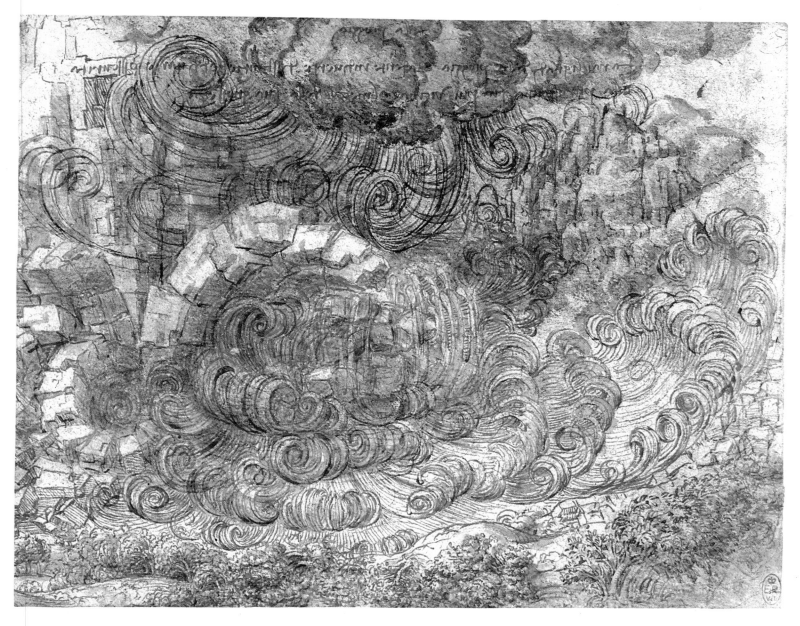

distances and of varied darkness; and the darker part will be closer to the middle of its thickness'. This note associates the drawing with his proposed treatise on painting, for which he lists a series of appropriate subject-headings: 'darkness, wind, tempest at sea, deluge of water, forests on fire, rain, bolts from heaven, earthquakes and the collapse of mountains, razing of cities'.

In his famous description of a deluge, the analytical tone is maintained:

And let some mountains collapse headlong into the depths of a valley and dam up the swollen waters of its river. But soon breached, the river bursts the dam and gushes out in high waves. Let the biggest of these strike and demolish the cities and country residences of that valley. And let the disintegration of the high buildings of the said cities raise much dust which will rise up like smoke or wreathed clouds through the descending rain. Let the pent-up water go coursing round the vast lake that encloses it with eddying whirlpools which strike against various objects and rebound into the air as muddied foam, which, as it falls, splashes the water that it strikes back up into the air. The waves that in concentric circles flee the point of impact are carried by their impetus across the path of the other circular waves moving out of step with them, and after the instant of percussion leap up into the air without breaking formation. . .

The language – impetus, percussion, circular waves – is unmistakably that of Leonardo's water researches (e.g. no. 61). However, the cumulative impact of the whole description generates a power which it is difficult to feel as other than expressive – albeit in a peculiarly intellectual manner. The emotional charge becomes explicit when he turns to the specifically human consequences (no. 64).

6
THE FORCES OF DESTRUCTION

In a crossbow which is not disposed for violence, the motion of the projectile will be short or nonexistent. Where there is no dispensation of violence, there is no motion, and where there is no violence there can be no destruction, and for this reason a bow which has no violence cannot generate motion if it does not acquire this violence.

Leonardo as a draughtsman of battles was a supreme master of the effects of violence, and as an inventor he was fascinated by the means of its propagation. Amongst his official duties was the devising of new means for the purveying of destruction on the enemies of his employers. 'When besieged by ambitious tyrants, I find a means of offence and defence to preserve the chief gift of nature, which is liberty.' This may sound like the worthy sentiment of a Florentine democrat, until we realise that it was written while he was working for Ludovico il Moro, usurper of absolute power in Milan, to whom Leonardo was committed to divulge his military secrets.

Leonardo undertook the illustration of military machines with inventive zest, and with no little sense of style in his conscious emulation of precedents from classical antiquity, which he keenly studied through the writings of Vitruvius and others (nos. 67 and 68). In one of the most spectacular of his later conceptions (no. 70), there is something chilling in the geometrical grace with which destruction is rained on to the enemy's defences. Something of this compound of relish and distanced objectivity emerges in his description of 'how to represent a battle':

> You should first paint the smoke from the artillery mingled in the air with the dust stirred up by the movement of the horses and the combattants. Realise the mingling thus: dust, being composed of the earth, has weight, and although on account of its fineness it will rise easily to mingle with the air it nonetheless is eager to resettle. The finest particles attain the highest reaches and consequently there it will be least visible and will seem to have almost the colour of the air . . . [There follows a careful account of the 'optics' of the mixture of dust, air and smoke.] . . . Show the foreground figures covered in dust – in their hair, on their brows and on other level surfaces suitable for dust to settle . . . And if you show one who has fallen, indicate the spot where he has slithered in the dust turned into bloodstained mire. All around in the semi-liquid earth show the imprints of men and horses who have trampled over it. Paint a horse dragging along its dead master, leaving behind it the tracks where the corpse has been hauled through the dust and mud. . .

We should not ignore the elements of both propaganda and entertainment in the effective depiction of violence, particularly in the contexts in which Leonardo worked. He indicates that his prophetic riddles, whether dealing with light-hearted matters or what he called 'philosophical things', were to be read out in 'a frenzied or berserk manner as in mental lunacy' – presumably as courtly

entertainment. His depiction of a vicious rain of tools (no. 65), with its evocation of 'human misery', may be a similarly virtuoso performance in the devising of a diverting image, in which we would be unwise to read a statement of personal beliefs. The context of assumption and convention within which Leonardo was communicating was very different from ours.

However, in the face of his most potent images, even the historian's scepticism is eroded, and it becomes impossible not to feel a genuine and direct communication of human feelings. This is above all true if we look at the 'Deluge Drawings' (nos. 22, 63, 64 and 66) with Leonardo's own words ringing in our ears:

How many capsized boats there were with people atop, both these still sound and those in pieces, toiling for means of escape with painful actions and sad gestures that presaged awful death. Others with gestures of hopelessness, were taking their own lives in despair of being able to bear such grief, and of these some were flinging themselves from high rocks. Others were strangling themselves with their own hands, while yet others seized their own children and in an instant dashed them to their death . . . Already hunger, the minister of death, had taken the lives of a great many of the animals by the time corpses, now fermented, rose from the bottom of the deep and broke the surface of the water. Beating one against the other among the contending waves, like inflated balls bouncing back from the spot where they have struck, they came to rest upon the aforementioned bodies of the dead animals. And above these accursed horrors the air was seen covered with dark clouds ripped apart by the jagged course of the raging bolts from heaven that flashed their light now here, now there, amid the obscurity of the darkness.

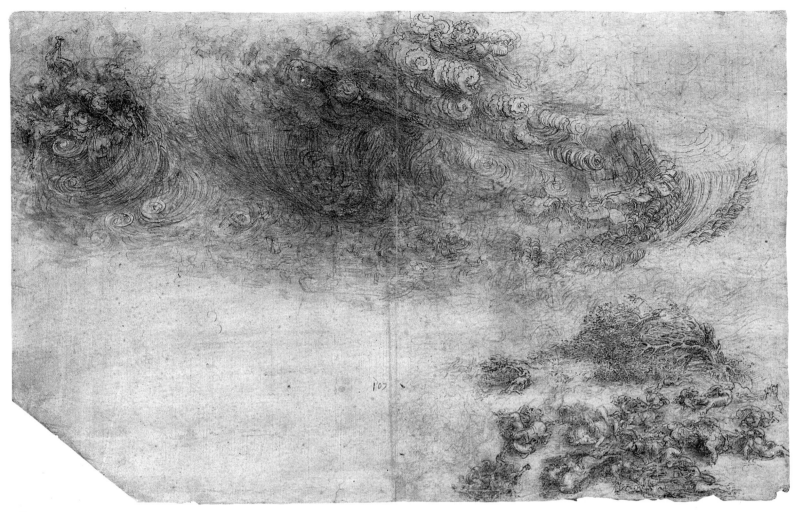

64

HURRICANE OVER HORSEMEN AND TREES,
 *c.*1518
Pen and ink over black chalk with
 touches of wash and traces of white,
 on grey washed paper.
 270 × 410 mm (irregular)
Prov.: Windsor Leoni volume (12376)
Ref.: Popham 290; C&P; Pedretti I 68r

This image is perhaps the most
extraordinary of the remarkable 'Deluge
Drawings', introducing elements of
fantasy which lie outside even the
'visionary naturalism' of such examples
as nos. 63 and 66. Although echoes of
the *Battle of Anghiari* have generally led
to a dating somewhat earlier than the
series as a whole, Pedretti has produced
effective arguments for its origin in the
French period, that is to say 1516 or
later.

 Even the cloaked but otherwise naked
horsemen and their companions – if

indeed they are 'men' at all rather than
humanoid creatures – belong to a time
other than Leonardo's or ours, while the
wind-gods in the clouds confirm the
mythical flavour of this primitive
devastation. Yet the mechanisms of
destruction, involving gyrating masses of
cloud and water, remain as informed by
his hydrodynamic researches as the other
drawings on this theme. The floods of
water, bursting from the rocky basin on
the right, seem virtually to fuse with the
airborne vortices. The tone of this
drawing finds close parallels in his
written descriptions, which warrant
further quotation:

O what fearful noises were heard
throughout the dark air as it was
pounded by the discharged bolts of
thunder and lightning that violently
shot through it to strike whatever
opposed their course. O how many
you might have seen covering their

ears with their hands in abhorrence at
the uproar caused throughout the
gloomy air by the raging, rain-soaked
winds, the thunder of the heavens and
the fury of the fiery bolts. For others,
the mere closing of their eyes was not
enough. By placing their hands one
over the other they more effectively
covered them in order not to see the
pitiless slaughter of the human race by
the wrath of God. O how much
weeping and wailing! O how many
terrified beings hurled themselves
from the rocks! Let there be shown
huge branches of great oaks weighed
down with men and borne through
the air by the impetuous winds . . .
O how many mothers wept for the
drowned children they held upon
their knees, their arms raised towards
heaven as they voiced their shrieking
curses and remonstrated with the
wrath of the gods! Others, crouched
forward with their breasts touching

their knees in their hugely unbearable grief gnawed bloodily at their clasped hands and devoured the fingers they had locked together. You might see herds of animals such as horses, oxen, goats and sheep, already encircled by the waters and left marooned on the high peaks of the mountains. Now they would be huddled together with those in the middle clambering on top of the others, and all scuffling fiercely amongst themselves . . . The air was darkened by the heavy rain that, driven aslant by the crosswinds and wafted up and down through the air, resembled nothing other than dust, differing only in that this inundation was streaked through by the lines that drops of water make as they fall. But its colour was tinged with the fire that rent and tore the clouds asunder, and whose flashes struck and split open the vast seas of the flooded valleys, where the bowed tops of the trees could be seen in the bowels of the fissures. Neptune might be seen amidst the waters with the trident, and Aeolus, as he envelops in his winds the uprooted vegetation that bobs up and down on immense waves.

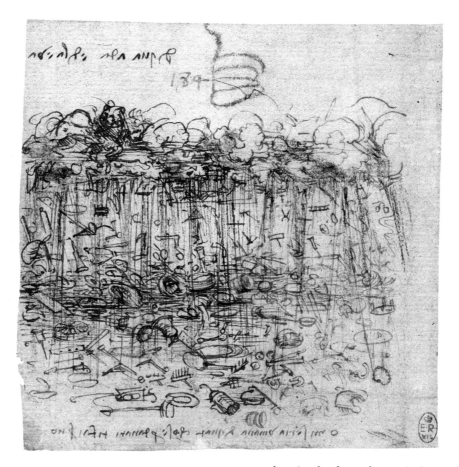

65

A CLOUDBURST OF MATERIAL POSSESSIONS,
c.1510
Pen and ink with traces of black chalk.
117 × 111 mm
Prov.: Windsor Leoni volume (12698)
Ref.: Popham 116C; C&P; Pedretti IV 396

It is not easy to tell what is happening in this extraordinary drawing, nor to assign to it a date, though it is likely to be later than 1508. A torrent of human artefacts and tools – including rakes, barrels, bagpipes, clocks, set-squares, spectacles, ladders and pincers – rain down on the earth from a turbulent layer of clouds. A lion appears to be prowling across the clouds at the upper left. The upper note reads: 'on this side Adam, on that Eve'. The note below, which is placed as if it is a caption, is one of Leonardo's moral aphorisms: 'O human misery – how many things you must serve for money'.

Leonardo's allegories are notoriously difficult to decipher. When he does explain one of them, the meaning is so complex (and often obscure) that it is little wonder we have problems with the unexplained drawings. The notes suggest that the meaning of this design lies in the labours to which man was condemned by the Fall of Adam and Eve. He had once loosely paraphrased Horace in a more optimistic if perhaps ironical vein: 'God sells all goods at the price of labour'. The tools here appear less as a rain of benefits from heaven than as a cascade of vanities, symbolic of man's puny and futile labours. The presence of a lion might suggest a political dimension to the allegory, but it could be explained with greater internal consistency as representing the nobility of the beasts, who, as Leonardo stressed, were not cursed with the desire to invent tools in order to live fittingly in their environment.

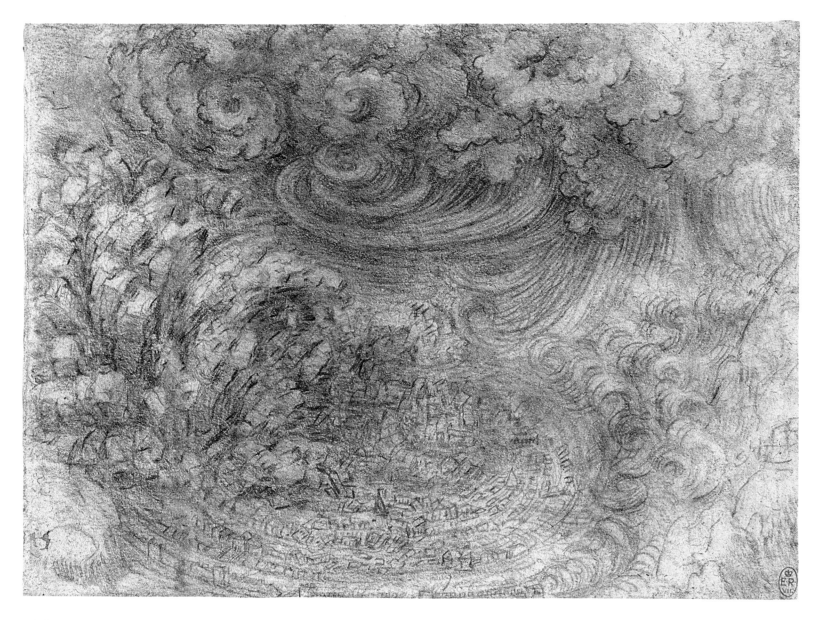

66

A TOWN AT THE CENTRE OF A DELUGE,
 *c.*1515
Black chalk. 163 × 210 mm
Prov.: Windsor Leoni volume (12378)
Ref.: Popham 293; C&P; Pedretti I 62r

This drawing is one of the nine studies of the 'deluge' in black chalk at Windsor, so close in style and dimensions as to suggest that they were intended to form a coherent set. Once more, there are striking similarities to elements in Leonardo's instructions to the painter:

> Let there be first represented the summit of a rugged mountain with a number of valleys surrounding the base, and on its sides show the surface of the soil heave up and dislodge the fine roots of low shrubs and free itself of a great many of the surrounding rocks. Wreaking havoc in its downwards course, let such a landslide go turbulently on, striking and laying bare the twisted and gnarled roots of great trees as it overturns and destroys them. And let the mountains as they lay themselves bare reveal the deep fissures made in them by ancient earthquakes . . . And let some mountains collapse headlong into the depths of a valley. . .

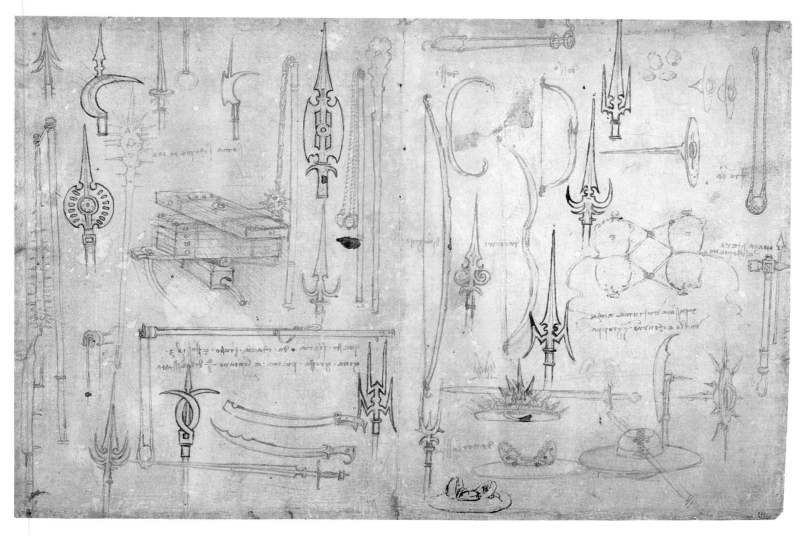

67

WEAPONS AND SHIELDS ETC., c.1487–8
Metalpoint with pen and ink on paper
 coated with a blue preparation.
 210 × 309 mm
 Musée du Louvre, Département des
 Arts Graphiques, Paris
Prov.: G. Vallardi; Musée du Louvre,
 1856 (2260)
Ref.: Reale Commissione Vinciana, III,
 pp. 17 & 21 & pl LXXI; Popham 307

This sheet belongs with a series of folios
in Ms.B which catalogue and describe a
wide variety of weapons, in large part
drawn from ancient sources. Using the
writings of Vitruvius and Pliny from
ancient Rome, and the more recent
compilation of Valturio, Leonardo lists
the weapons as if compiling a humanist
thesaurus. The following examples are
typical:

Fonda [sling] is made of a double
chord, somewhat wider where it is
bent . . . Flavius says it is found
amongst the inhabitants of the
Balearic Isles . . . However, Pliny says
that this same thing was invented by
the Syrio-Phoenician peoples.
Auctori according to what Celidonius
says are sickle-shaped weapons with a
cutting edge on one side only and the
length of a *braccio*, with a handle
forked in the manner of the tail of a
swallow.
Arpa according to what Lucan says in
the ninth [book] is a sickled-shaped
sword with which Perseus slew the
Gorgon.

The sling is represented at the top
right of this sheet, and at the centre left
is a lash-like variant with a handle three
braccia long, which 'throws large stones
two-thirds the distance of a crossbow
shot'. In addition to some characteristic

variations on pike heads, swords, axes,
bows and maces, this page contains some
notably vicious designs for shields,
including a trap-like device of jaws
intended to shut crunchingly on an
adversary's sword. The arrangement of
chords and bladders to the centre right
above the shields is one of his many
flotation devices for crossing turbulent
rivers. The neatly-drawn diagram above
the lash-like sling shows a 'total of 100
scoppietti [light guns]' in five pivoted
stacks.

 The rich amalgam of humanist
scholarship, knowledge of current
weaponry and busy inventiveness – of
which this sheet is so characteristic –
must be seen in the context of
Leonardo's employment at this time in
the Renaissance court of Ludovico il
Moro, for whom military might was
both a matter of survival and style.

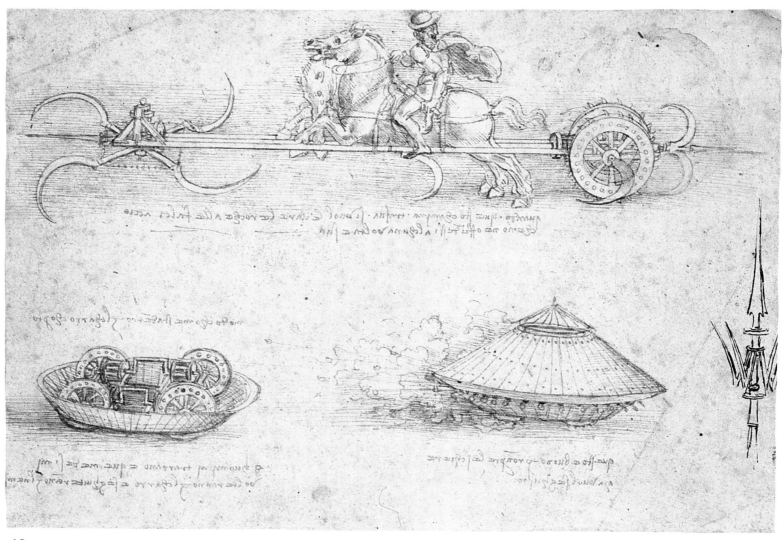

68

A SCYTHED CHARIOT, 'ARMOURED CAR'
AND PIKE, *c*.1487
Pen and ink and wash. 173 × 246 mm
Trustees of the British Museum, London
Prov.: P. J. Mariette; Thomas Lawrence;
Samuel Woodburn; British Museum
(1860-6-16-99)
Ref.: Popham 308; Popham and Pouncey
107

The scythed contraption, inspired by antique examples, resembles other military chariots in drawings at Windsor (12653), in the Biblioteca Reale, Turin, in the École des Beaux Arts, Paris, in the Codex Atlanticus (f.40va/113v) and in Ms.B (f.10r). They are dated by reference to Ms.B to the late 1480s.

Below the chariot Leonardo has written, 'when this travels through your men, you will wish to raise the shafts of the scythes, so that you will not injure anyone on your side'. In a longer account of such a device in Ms.B he writes, 'these scythed chariots were of various kinds, and often did no less injury to friends than they did to enemies, and the captains of the armies, thinking by the use of these to throw confusion into the ranks of the enemy, created fear and destruction amongst their own men'.

The upside-down view of the 'armoured car', without its roof and lying on its back like a stranded beetle, shows 'the way the car is arranged within – eight men operate it, and the same men turn the car and pursue the enemy'. Where it scuttles along on the right, raising a cloud of dust, he notes that 'this is good for breaking the ranks, but you will want to follow it up'. This contraption fulfils the sixth of the claims Leonardo made in his letter to Ludovico Sforza: 'I will make covered vehicles, safe and unassailable, which will penetrate the enemy and their artillery, and there is no host of armed men so great that they would not be broken by them. And behind these the infantry will be able to follow, quite uninjured and unimpeded.' In Ms.B he states that such vehicles 'take the place of elephants' – thinking more of ancient battles than of current Italian practice.

In spite of the obvious fertility of Leonardo's imagination in the invention of such military devices, and his unrivalled brilliance in depicting them, his conceptions are not essentially different in type from those of a certain type of Renaissance virtuoso – including his colleague Francesco di Giorgio – who continually promised their patrons the decisive weapon or weapons. Such

designs seem to have exercised little impact on the conduct of actual battles in the open field, and even the advent of portable guns such as muskets, which were slow-firing and inaccurate, affected infantry and cavalry tactics relatively little until well into the sixteenth century.

69

MARINE AND OTHER WEAPONRY, c.1483–4
Pen and ink and wash. 282 × 205 mm
Prov.: Windsor Leoni volume (12652)
Ref.: Popham 306; C&P; Pedretti IV 429

This sheet belongs with a series of extravagant designs from the early and mid-1480s. It is particularly close to Codex Atlanticus f.395rb/1098r, to which it may have originally been joined. Like the project for an 'armoured car' (no. 68), it reflects the confident and even boastful tone of his letter to Ludovico Sforza.

One would not doubt that the mortar-like device at the top of the sheet would potentially make quite an impression on the enemy: 'I have also types of cannon . . . with which to hurl small stones with the effect almost of a hail-storm; and the smoke from the cannon will instil a great fear in the enemy on account of the damage and confusion it causes.' But it is open to question whether the device mounted on a small boat as at the bottom of the page would shoot its missiles forward or propel the boat backwards.

The other studies show an upright mortar, comparable to that in *An Artillery Park* (no. 113) and varieties of cannon. Similar guns are illustrated in the Codex Atlanticus (e.g. ff.23va/71v and 28va/79v). It appears that the barrels in the third sequence from the top are to be screwed back-to-back onto a central mounting which pivots – presumably to

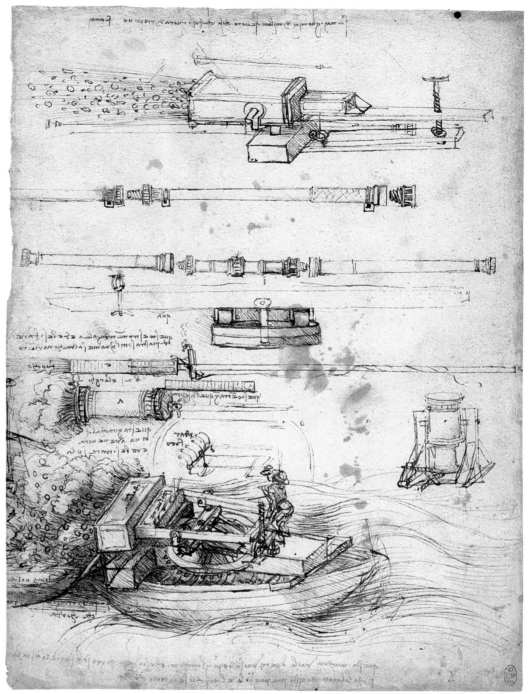

permit the loading of one while the other is being fired. At the centre left Leonardo notes that 'this instrument for a galley must be made from thin plates of copper soldered with silver'. Below this note he illustrates a gun – '2 *braccia* [long] and one-third [*braccio*] in width' – mounted on a long pole with a string for remote firing. The threaded cylinder 'goes inside that above'. Below and to the right of the broad cannon – like a mortar on its side – he sketches an

ignition mechanism for a six-barrelled gun, perhaps that on the boat below.

The writing at the very top of the sheet is one of his characteristically gnomic musings: 'If ever the men of Milan did anything which was beyond the requirements [*fuora di propositto*] or never?' May we detect a tone of resigned impatience with the caution of the Milanese in the face of his military wonders?

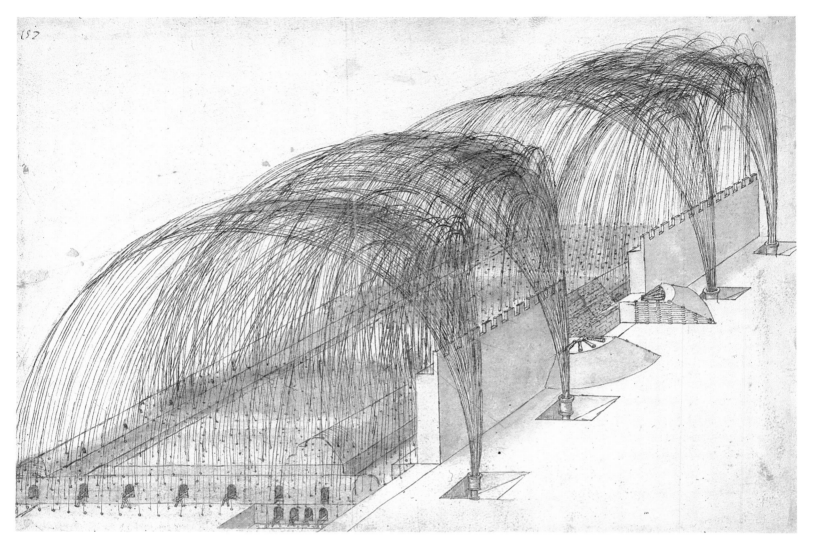

70

A ROW OF FOUR MORTARS FIRING STONES
INTO THE COURTYARD OF A FORT,
c.1503–4
Pen and ink. 329 × 480 mm
Prov.: Windsor Leoni volume (12275)
Ref.: C&P; Pedretti IV 423

A less finished drawing, in which the mortars are arranged in two groups of three, is also at Windsor (12337v). Other comparable designs are in the Codex Atlanticus (ff.24ra/72r and 360va/1002v). Although such highly finished drawings are hard to date, the series of related studies can be dated reasonably securely to the period of Leonardo's work on the *Battle of Anghiari*. The note on Windsor 12337v gives some idea of the scale. He explains that 'the walls are 16 [*braccia*] high. I wish to take over a width of 200 *braccia* and cast down 10 *braccia* of the height of this wall.' The graceful arcs described by his projectiles reflect his ballistic researches during the 1490s, in which he had developed a sophisticated if not definitive understanding of the path of balls fired from cannons and mortars.

The cool objectivity and ornamental grace of this demonstration of awesome fire-power give it a strangely abstract quality, quite different from the more obviously man-made violence of the Milanese designs (e.g. nos. 67 and 69). The extreme neatness suggests it was made for presentation to a patron.

Although the extraordinary level of saturation and orderly efficiency of this bombardment is clearly removed from the actual performance of such weapons at this time, we do know that Ludovico il Moro used a barrage of this kind when he attempted to reconquer Novara in 1500, following his ousting from Milan by the French troops of Louis XII.

7
ART AND IMAGINATION: 'THE FICTION THAT SIGNIFIES GREAT THINGS'

He who scorns painting loves neither philosophy nor nature. If you scorn painting, which is the sole imitator of all the manifest works of nature, you will certainly be scorning a subtle invention, which with philosophical and subtle speculation considers all manner of forms: sea, land, trees, animals, plants, flowers, all of which are enveloped in light and shade. Truly this is science, the legitimate daughter of nature, because painting is born of nature; but to be more correct, we should say the granddaughter of nature, because all visible things have been brought forth by nature and it is among these that painting is born. Therefore we may justly speak of it as the granddaughter of nature and as the kin of God.

No one ever set a more demanding visual agenda for painting. Leonardo's aim was the most perfect and all-embracing imitation of nature – an imitation which was not like that achieved by the photographic camera, but an imitation which remakes nature in any required form on the basis of a total understanding of the relationship between the effects of natural appearance and the causes of natural law. To accomplish this highest form of imitation, the painter needed to forge a new kind of union between *intelletto* and *fantasia* – between rational understanding and imaginative recomposition.

Perhaps the closest precedent for his ambition lies not within the realm of painting and its theory – though Alberti's *De pictura* and Ghiberti's *Commentarii* had advocated high intellectual aspirations for practitioners of the visual arts – but with the poetry of Dante, whose work Leonardo certainly studied with real profit and, we may intuit, with considerable enthusiasm. Of all the High Renaissance masters, Michelangelo is the one who is most commonly associated with Dante, but I think it is fair to argue that Dante's profound exercise of science in the service of imagination, and of imagination in the service of rational understanding, found its true successor in the art and theory of Leonardo. The way in which Dante's poetic visions are structured by his understanding of such aspects of natural philosophy as optics and dynamics can be compared to the manner in which Leonardo's 'Deluge Drawings' (nos. 22, 63, 64 and 66) deliver their expressive power in a scientifically designed vehicle, or the extent to which the elusive ambiguities of a late drawing such as the *Pointing Lady* (no. 79) are founded upon a sophisticated understanding of the vagaries of sight itself.

It may seem strange to be adducing a poetic precedent for a painter who went to such lengths to decry the poet's art, harshly criticising its ineptitude in visual matters. However, the very vehemence of his attack on poetry in his *paragone* – the comparison of the arts which Melzi used as the basis for the opening part of the *Trattato della pittura* – and the range of the different kinds of poetry he felt bound

to challenge, reflect the seriousness with which he regarded its rivalry. This rivalry was felt most keenly in matters of imaginative invention – in the devising of the 'fiction that signifies great things'. In true humanist fashion, when he wished to illustrate the painter's ability to convey a great moral he cited the elaborate allegory of *Calumny* by Apelles, the renowned painter of ancient Greece, whose masterpiece is known through literary descriptions. Leonardo's own allegories, and in particular the magnificent image of the nautical wolf and imperial eagle (no. 82), show his own ambitions in the invention of significant fictions. In a comparable way his images of hellish fires and monstrous creatures (nos. 84 and 85) show him rivalling the poet's ability to conjure up terrifying visions of the inferno. His *Five Characters* (no. 90) show him emulating the vivid humour of Boccaccio's *Decameron* and the rough-house satire of burlesque poetry. His landscapes and the Dantesque vision of the *Pointing Lady* show his ability to evoke the same moods of romance and pastoral delight as the poets of the *dolce stil nuovo*. And his turbulent scenes of gods, warriors and horses (nos. 64, 71 and 72) show his willingness to take on the masters of the chivalric epic on their own ground.

Leonardo himself directly compared his innovatory inventive process – his 'brainstorm' technique of drawing with a welter of scribbles (nos. 5 and 77) – with that of poets:

> Have you never considered how the poets in composing their verses are not bothered to form beautiful letters nor do they worry whether they cross out any of their verses in remaking them better? Hence, painter, compose roughly the parts of your figures and attend first to the movements appropriate to the mental states of the creatures composing your narrative.

It was through the depiction of the bodily effects of such 'mental states' that the painter could give his figures the semblance of life and give them their communicative power. Without a deep understanding of the causes and effects of emotion and motion, any figure made by the artist would be 'twice dead, since it is dead because it is fictive, and it is dead another time when it displays the motion neither of the mind nor of the body'.

He went to the greatest trouble to observe the outer effects of the inner mechanisms he studied as an anatomist. He recommended that the artist should always be on the lookout for examples of telling actions:

> Take these down in abbreviated notations [*brevi segni*] . . . in your little notebook which you must always carry with you, and it should be of tinted sheets, so that it cannot be erased . . . but will preserve with the greatest care the forms and actions of things, which are so infinite that the memory does not have the capacity to retain them. Hence preserve them as your guides and masters.

Precisely the kind of *piccolo libretto* and *brevi segni* he had in mind can be seen in Codex Forster I on the folio which Leonardo had previously used for one of his discussions of perpetual water screws (no. 59). The reasoning which accompanies the thumb-nail sketch is so characteristic of his observations and analyses that it is worth quoting in full:

> Someone who wishes to draw back his bow a considerable way must set himself entirely on one foot, lifting the other so much higher than the first that

it makes the necessary counterpoise to the weight which is thrown over the first foot. He must not hold his arm completely extended, and in order that he should be able better to bear the strain, he places a piece of wood against the bow, as is used in the stock of a crossbow, going from his hand to his breast, and when he wishes to let go, he suddenly and simultaneously leaps forward and extends his arm and releases the bowstring; and if he dexterously does everything simultaneously, the arrow will go a considerable distance. [The note continues below the hydrodynamic text.] You should know that the reason for the above is that since the leap forward is swift it gives one increment of fury to the arrow, and the extending of the arm, because it is swifter, gives two increments; the thrusting of the bowstring, being yet faster than the arm, gives three increments. Accordingly, if other arrows are driven by three increments of fury, and if, by dexterity, this arrow is driven by six increments it ought to go double the distance.

The aspiration is clearly to achieve a communicative dynamism of human action which is founded on the greatest rigour of empirical analysis. A bowman in one of Leonardo's paintings would not have exhibited the statuesque symmetries of the archers in Antonio Pollaiuolo's *'Martyrdom' of St Sebastian* (National Gallery, London), any more than the horsemen and mounts in the *Battle of Anghiari* resembled the rocking-horse combatants in Uccello's three panels of the *Rout of San Romano*. The revolution in the art of narrative, which Vasari correctly recognised Leonardo as initiating, was not a mere question of style but rather a top-to-bottom reform of the creative procedures of the artist and the founding of these procedures upon the most profound understanding of nature. The artist who achieved these goals could indeed claim to have become the 'lord of every kind of person and of all things'.

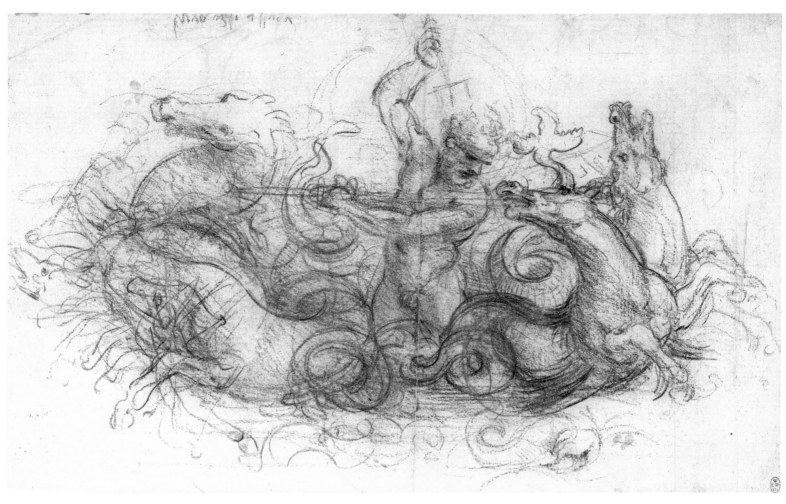

71

NEPTUNE WITH FOUR SEAHORSES, *c.*1503–4
Black chalk. 251 × 391 mm
Prov.: Windsor Leoni volume (12570)
Ref.: Popham 205; C&P; Pedretti III 339

First strive in drawing to give to the eye in indicative form the notion and the invention made first in your imagination, subsequently taking away and adding on until you satisfy yourself.

In the inscription at the upper edge of the sheet Leonardo instructs himself to 'lower the horses'. He is known to have presented a drawing of *Neptune* to Antonio Segni, a learned Florentine who, as a patron of Botticelli, appears to have favoured classical subjects portrayed in the 'antique' manner. The present study may reasonably be regarded as a preliminary study for the lost presentation drawing, which would presumably have been worked up to a high finish, comparable to that of the

Allegory with a Wolf and Eagle (no. 82). In terms of style and composition it may be dated to the period of Leonardo's work on the *Battle of Anghiari*.

This drawing is an excellent example of the fluidity of his creative process. The relationship between Neptune's bold movements and the leaping rhythms of the seahorses has grown organically out of the design process for the *Battle*, in which he was seeking an ever closer integration between the motions of horses and riders. The rapidly worked black chalk lines, some emphasising key elements in the orchestration of the serpentine curves and others giving the barest suggestions of alternative motifs, play a creative role in their own right in the emergence of the most effective composition. In one respect, however, its growth out of the *Battle* designs has caused a problem. Neptune's relatively low position reflects his origin in a warrior seated on a horse, and fails to convey the degree of

command and majesty appropriate to a god who drives his marine chariot across the waves. Hence Leonardo's instruction to 'lower the horses'. It is likely that the rearrangement was carried out, and that the final version for Segni exercised a considerable influence on Raphael's *Galatea* in the Villa Farnesina, Rome.

72

STUDIES OF HORSES, A CAT, AND
 ST GEORGE AND THE DRAGON, *c.*1517
Pen and ink with touches of wash over
 faint traces of black chalk.
 298 × 210 mm (irregular)
Prov.: Windsor Leoni volume (12331)
Ref.: Popham 86; C&P; Pedretti II 158

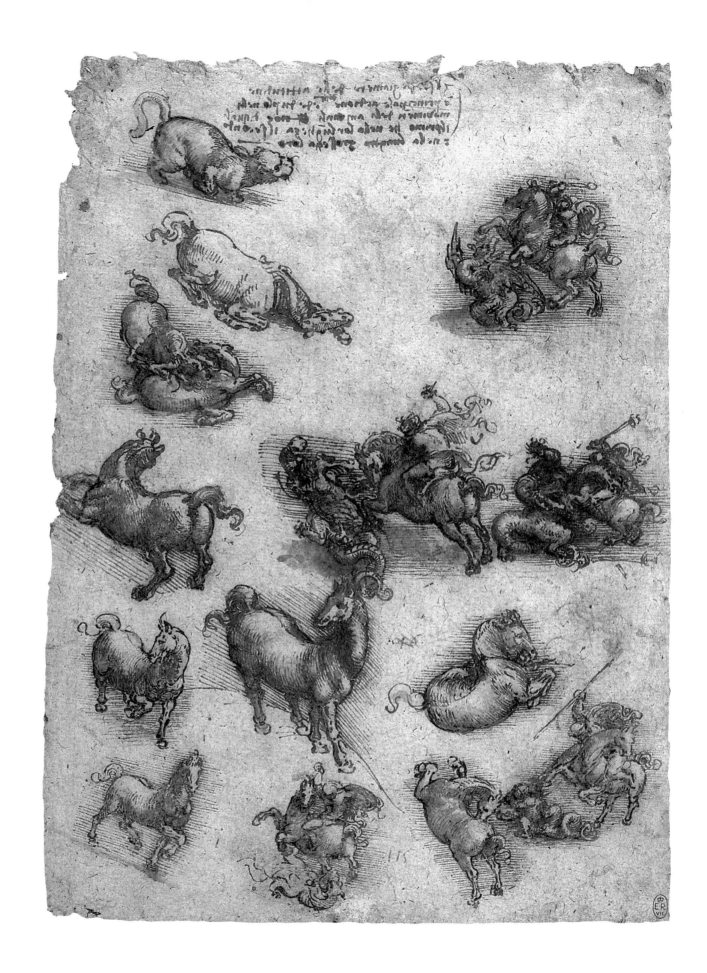

Motions are of three kinds, that is to say motion of place, simple action [of limbs etc.] and motion compounded of motion of place and of action . . . The compound motions are infinite.

The same pose may display infinite variety because of the infinite places from which it can be seen.

At the top of the sheet Leonardo has written: 'serpentine postures comprise the principle action in the movements of animals, and this action is double; the first is along the length and the second across the breadth'.

This brilliantly energetic and suggestively arranged set of drawings may be compared to the page of cats from a similarly late date (no. 38), and, like the cat studies, may be directly associated with his continuing project to write a treatise on the motion of animals.

Whereas the *Neptune* drawing (no. 71) displays alternative dispositions of the parts of a composition overlaid in the same design, this page shows Leonardo's matching ability to envisage infinitely varied components in separate studies, rather as if each is a separate wax model of great plastic complexity. Indeed we know that he planned to make such models in the preparations for his *Battle of Anghiari* (see the note on Windsor 12328). This series of studies is a perfect embodiment of his sense of the infinite possibilities in the 'compound' poses of mobile animals, and of the infinite possibilities presented by viewing them from different angles. The fluency with which he moves between studies of individual horses and imaginative narrative subjects is also deeply characteristic of his creative methods.

Although the figure of St George enjoyed some popularity in Milan, there is no indication that Leonardo was actually planning a picture on this theme. Rather, the subject seems to have been adopted as the ideal didactic vehicle in the illustration of the 'serpentine' quality of compound motion – particularly in the case of the serpent-like dragon.

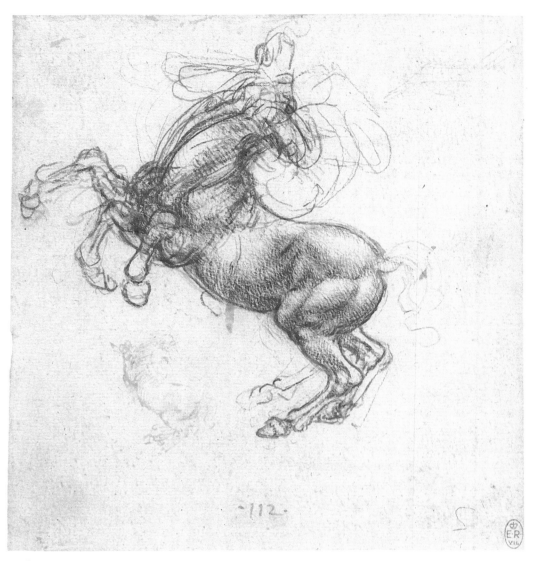

73

A REARING HORSE, *c.*1505
Red chalk with traces of pen and ink.
153 × 142 mm
Prov.: Windsor Leoni volume (12336)
Ref.: Popham 84B; C&P; Pedretti II 113

Compose roughly the parts of your figures and attend first to the movements appropriate to the mental states of the creatures composing your narrative.

The subject of rearing and fighting horses had fascinated Leonardo from the time of his *Adoration of the Magi* in 1481. This particular drawing is a study for one of the rearing horses in the *Battle of Anghiari*, and can be dated with reference to a compositional study in Venice (Accademia 215) to the earlier stages of his work on the theme, that is to say to 1503–4. Studies for horses in comparable poses are at Windsor (12334), in the Codex Atlanticus and in nos. 74 and 87.

Having determined the need for a rearing horse at a particular place in his composition, and understanding the basic dynamics of the rearing pose, Leonardo has isolated the horse and worked rapid variations on those components – the head and forelegs in particular – that remained freely disposable. He is searching impulsively for the action that would be most expressive of the horse's terrified recoil from the percussive forces of the battle.

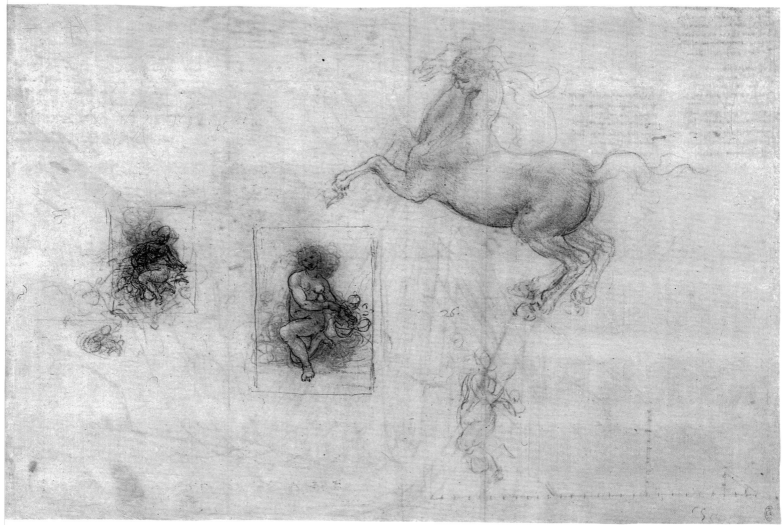

74

A REARING HORSE AND STUDIES FOR THE
 KNEELING LEDA, c.1505

Black chalk partly drawn over with pen
 and ink. 293 × 413 mm
Prov.: Windsor Leoni volume (12337)
Ref.: Popham 212; C&P; Pedretti II 118r

*You should know that an unpolished piece
of composing which turns out to be in
keeping with your invention will give the
greatest satisfaction when it is ornamented
with a perfection appropriate to all its
components.*

The most remarkable features of this
sheet are the two small framed sketches
– probably Leonardo's very first
thoughts – for *Leda with her Children*,
apparently at this stage without the swan
as an essential component. In this first
phase, he was experimenting with Leda
in a kneeling and twisting pose of great
complexity, which was to be further
developed in drawings at Chatsworth
and Rotterdam (nos. 14 and 75). The
inspiration for this pose appears to have
come from antique Roman sculpture,
such as a single figure of the kneeling
Venus (known in a number of variants)
or the Venus Anadyomene on a Nereid
sarcophagus.

Over a soft blur of black chalk
curves, he has superimposed lines drawn
in pen and ink to pick out the favoured
alternatives. The practice of 'framing'
rapid compositional sketches seems to
have been relatively common in
Leonardo's preparation of a particular
composition, once the shape and scale of
the work was reasonably clear in his
mind. He particularly favoured this
technique when dealing with a
composition of interwoven elements in
which relatively large figures were to be
compressed within a picture field of
limited size. Here he is particularly keen
to understand how the complex,
dynamic plasticity of the figure group
can be set off to greatest advantage
against the compressed voids between it
and the frame.

The rearing horse is obviously
comparable to those in no. 73 and can
similarly be associated with the *Battle of
Anghiari*. However, it is notably less
violent in pose, and probably was not
intended to play the same role in the
composition. It may have been destined
for the 'calvalcade' of troops, which was
apparently to be located at the right-
hand side of the composition and is
known from a drawing at Windsor
(12339). Although the rider is barely
indicated, Leonardo's deft shading gives
a clear indication that the heads of the
rider and horse were to be expressively
juxtaposed.

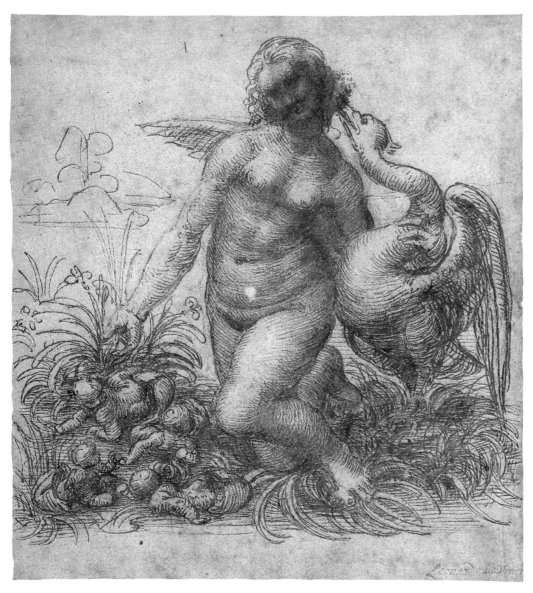

Consider with the greatest diligence the boundaries of any body and the manner of their serpentine turning. This serpentine turning must be inspected to see whether its sides partake of rounded curvature or of angular concavity.

The composition of the kneeling *Leda* appears to have reached a highly resolved stage in Leonardo's mind, before he replaced it with the standing version which appeared in the lost painting. The developed drawings at Chatsworth and Rotterdam (no. 14) coincide with the final phases of his thoughts about the *Battle of Anghiari*, probably after he had ceased actually to paint on the wall, and can be dated to *c.*1506. A variant of the kneeling *Leda*, in which she cradles one of her children in her right arm, was painted by one of his followers, normally identified as Giampetrino. The existence of a painted version might suggest that Leonardo had taken his kneeling *Leda* as far as a cartoon. However, we should entertain the possibility that the kneeling version was planned as a finished presentation drawing, comparable to the *Neptune* for Antonio Segni (see no. 71). The composition seems to benefit from compressed expression on a small scale, but produces an uneasy effect in a larger-scale painting.

The extraordinary pen-work, in which the lines excavate the forms in the manner of the tooth-marks of a claw chisel, is an extreme development of the graphic convention he adopted after *c.*1500 to describe plasticity without loss of motion. It both succeeds in evoking the procreative energies of nature – the central theme of the subject – and in achieving a compelling degree of relief, which he repeatedly emphasised as one of the painter's most important goals.

75

STUDY FOR THE KNEELING LEDA, *c.*1505–7
Black chalk, pen and ink and wash.
160 × 139 mm
The Duke of Devonshire and the
Trustees of the Chatsworth Settlement
Prov.: Chatsworth, Devonshire
Collection (717)
Ref.: A. E. Popham, *Old Master
Drawings from Chatsworth*, 1962–3,
no. 32

76

A KNEELING ANGEL, c.1480–3
Pen and ink over black lead.
 123 × 61 mm
Trustees of the British Museum, London
Prov.: H. Stone Wilcocks; British
 Museum (1913-6-17-1)
Ref.: Popham 29B; Popham and
 Pouncey 102

*The sketching of narratives should be rapid
and the disposition of the parts should not be
too determined. Be satisfied only to establish
the positions of the limbs, which can in due
course be finished as you please.*

There is a natural tendency to associate
this spirited drawing of an angel
kneeling amongst long grasses or reeds
with Leonardo's participation in the
painting of the Verrocchio altarpiece of
the *Baptism* for S. Salvi in Florence,
which cannot have occurred much if
any later than 1476. However, the
complex *contrapposto* and dense pen-
work cannot be documented in his work
before his studies for the *Adoration* and
the *Madonna, Child and Cat* in the early
1480s. The turning pose and positive
gesture of the right arm – in either of its
positions – would have been extremely
disruptive in Verrocchio's balanced
composition. The slight sketch of a
figure below the angel, apparently
swinging both arms across and upwards
in a praying gesture, has no obvious
connection with the subject of Baptism.
It seems likely that this is one of
Leonardo's typical 'spin-off' variations,
made as a reprise of an earlier motif. It
may even have been triggered by his
work on the *Virgin of the Rocks*,
commissioned in 1483, which was to
include a kneeling angel. However, the
cutting-down of this sheet, particularly
on the left, severely hinders any
judgement of its function.

77

STUDIES FOR THE VIRGIN AND CHILD WITH
ST ANNE AND THE INFANT ST JOHN THE
BAPTIST, *c.*1508

Pen and ink and grey wash with some
white heightening in the principal
study, over black chalk. The main
outlines of the principal study have
been gone over with a stylus.
267 × 201 mm
Trustees of the British Museum, London
Prov.: E. Galichon; British Museum
(1875-6-12-17)
Ref.: Popham 175; Popham and Pouncey
108

*I have seen clouds and patchy walls which
have given rise to beautiful inventions of
varied things. Although these patches were
in themselves wholly devoid of perfection in
every detail, they did not lack perfection in
their movements and other actions.*

The role of this drawing and its date
within the sequence of his *Virgin,
Child and St Anne* compositions have
been hotly debated. The hydraulic
studies, including an overshot water-
wheel and constructional techniques for
dams, may help to clarify the question
of date. The drawings at the lower left
and right show clearly that this sheet has
been cut down. One fragment of the
missing portion from the lower left has
been recognised by Pedretti as a sheet of
water studies at Windsor (12666). The
drawings on the parent and detached
sheet belong reasonably securely with a
set of hydraulic studies of 1506–8. This
evidence, though not conclusive, does
support the revised stylistic dating of
*c.*1507 given by Popham and Pouncey in
their catalogue of the British Museum
drawings, following Popham's initial
advocacy of 1498–9.

The main study is recognisable in its
general disposition if not in its details as
preparatory for the cartoon of the
Virgin, Child, St Anne and St John in the
National Gallery, London (fig. 28). Not
only has Leonardo added rough
indications of the frame (as in no. 74),
but he has provided a series of equally
spaced dots as an indication of the scale.
His studies of Vitruvian proportions in
man use a size for a *palmo* of one eighth
of a *braccio* (about 7.25 cm), and the
fifteen or sixteen units along the base
would indicate an intended size in the
region of 108 to 116 cm. The width of
the London cartoon is 101 cm, but it has
been folded over at the edges and would
almost certainly have been wider in its
original state. The other studies, ranging
from ghostly, black chalk traces of
figures to the relatively defined baby in
pen and wash, deal with variations on
the whole composition and alternative
components in a characteristically free-
wheeling manner.

The main study is an extreme
example of alternative solutions overlaid
in a single drawing, until it becomes
overworked to the point of illegibility.
This technique first emerges fully in the
Virgin, Child and Cat studies of the late
1470s or early 1480s (no. 6). In the
present study black chalk has been
overworked with pen and ink, followed
by a grey wash and white heightening
applied with a brush. This already dense
structure has then been subjected to a
series of incisions with the sharp point of
a stylus to transfer the composition to
the reverse of the sheet. The effect is
more like the process of modelling a
clay relief than an orthodox drawing.
The relative illegibility, which permits
new 'inventions' to rise by chance, as
when he looked at patches on walls, is
clearly an important aspect of the
creative process for Leonardo. In this
extreme form it is not only
unprecedented in drawings by his
predecessors but also finds no real
equivalent in the drawings of his
contemporaries, although both
Michelangelo and Raphael adopted
certain aspects of the 'brainstorm'
technique.

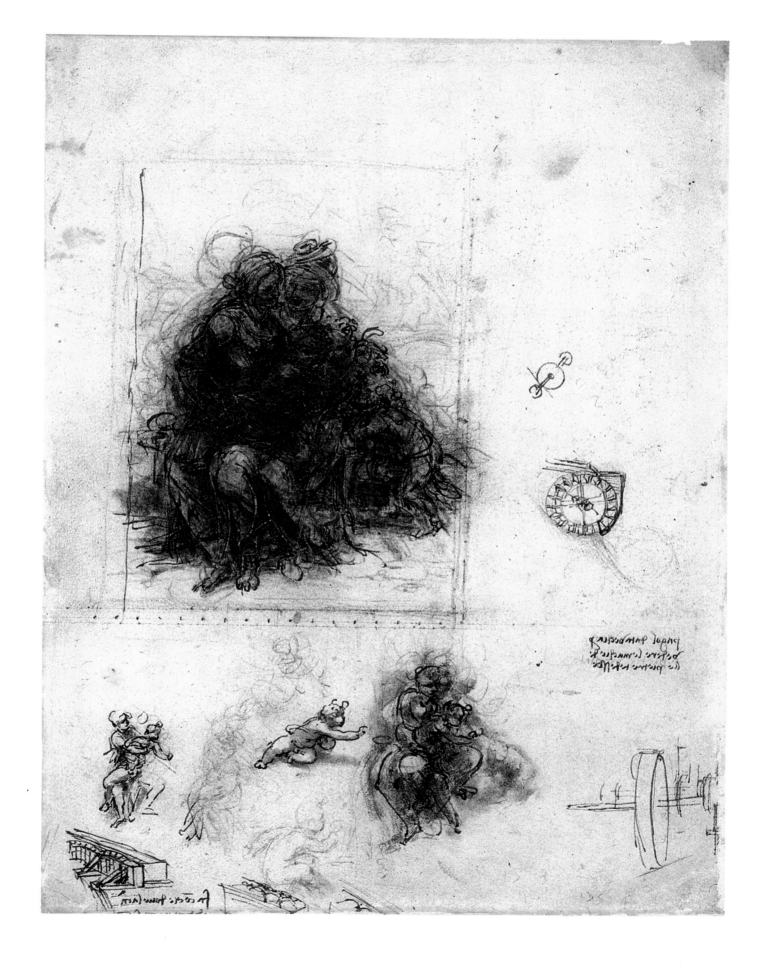

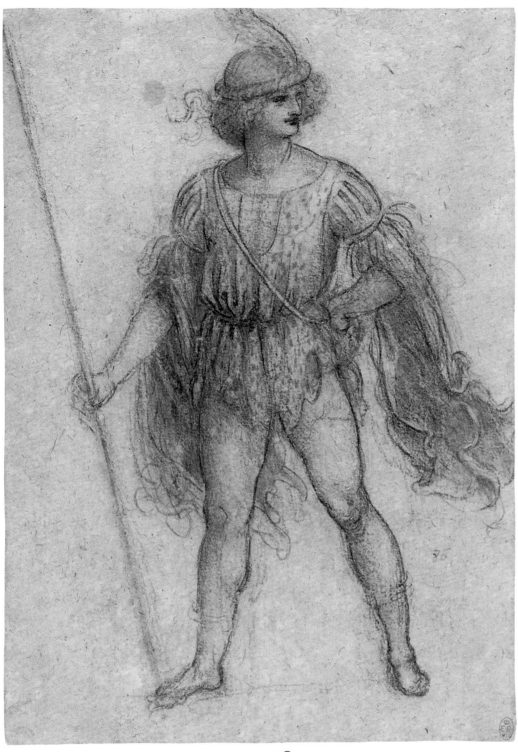

The limbs of the body must be accommodated with grace to convey the effect which you wish the figure to make, and if you wish to make a figure which embodies attractiveness make the limbs sweet and attenuated, without displaying too many muscles, and those few you do make apparent should be soft, that is to say little evident, and the limbs, above all the arms, should be bent at their joints.

This graceful, curly-haired youth, of a type that appealed to Leonardo throughout his career, is here used to display a costume design to best effect. His well-documented and much admired production of designs for theatrical events and pageants at various stages of his career has left a disproportionately meagre visual record. The only substantial record of his design of costumes is a group of five 'masqueraders' at Windsor from the later stages of his career. Two of these studies, the present drawing and Windsor 12574, have been associated by Pedretti with the great festivities for the triumphal visit of the Medici Pope Leo X to Florence in 1515 – an occasion for the exercising of the talents of many of the major resident and non-resident Florentine artists from the older and younger generations. The chronicler, Luca Landucci, conveys an impression of the richness of the entry and subsequent festivities: 'all the chief citizens went in procession to meet him, and amongst others about fifty youths, only the richest and foremost, dressed in a livery of clothing of purple cloth with fur collars, going on foot and each with a type of small, silvered lance in his hands – a most beautiful thing; and next came a great parade of horsemen. . .'. When the pope left Florence a few days later, he was accompanied by the youths wearing the same costumes.

Whether or not this design was made specifically for this occasion, it was obviously produced for an occasion of such lavish pageantry, and testifies to Leonardo's gracious skills as a costume designer. The compound technique of chalk, pen and ink and wash is exploited for soft, understated, romantic effects, in a manner typical of his later drawings.

78

FIGURE IN MASQUERADE COSTUME,
*c.*1513–15
Black chalk, pen with black and brown
ink and wash. 270 × 181 mm
Prov.: Windsor Leoni volume (12575)
Ref.: Popham 120; C&P; Pedretti III
357r

79

POINTING LADY IN A LANDSCAPE, c.1515
Black chalk. 210 × 135 mm
Prov.: Windsor Leoni volume (12581)
Ref.: Popham 123; C&P; Pedretti I 55r

If a painter in the cold and frozen times of winter set before you the same or similar landscape as that in which you once took your pleasures beside a spring, you will be able to picture yourself again as a lover with your beloved in flowery meadows, beneath the sweet shade of verdant trees.

This drawing, identifiably late in style, is the most romantically poetic of all his inventions. The lady is suffused with the air of the 'beloved lady' in Italian poetry of the *dolce stil nuovo* – evanescently graceful, full of sweet promise yet ultimately unobtainable. Meller has suggested the specific identification of this lady with Matelda, who appears at the end of canto XXVIII of Dante's *Purgatorio*. Her role is to act as Dante's guide until the final appearance of Beatrice:

As a dancing lady turns with her feet together,
Foot by foot set close and to the ground,
And scarcely putting one before the other,
So she to me . . . turned round . . .
So when she'd come to where the crystalline
Clear water bathes the grasses, she at once
Did the grace to lift her eyes to mine . . .
So upright on the other bank she smiled.

Matelda then begins the process of spiritual enlightenment through which Dante is initiated into the ineffable secrets of the *Paradiso*, promising to 'make the offending mists to fly'.

Whether it is right to read this drawing as a precise illustration of a literary text – something Leonardo does not otherwise appear to have done – it is clear that Leonardo's lady and Dante's Matelda inhabit the same territory in the Renaissance literary imagination.

The draperies, in the classical wind-blown style commended by Leonardo

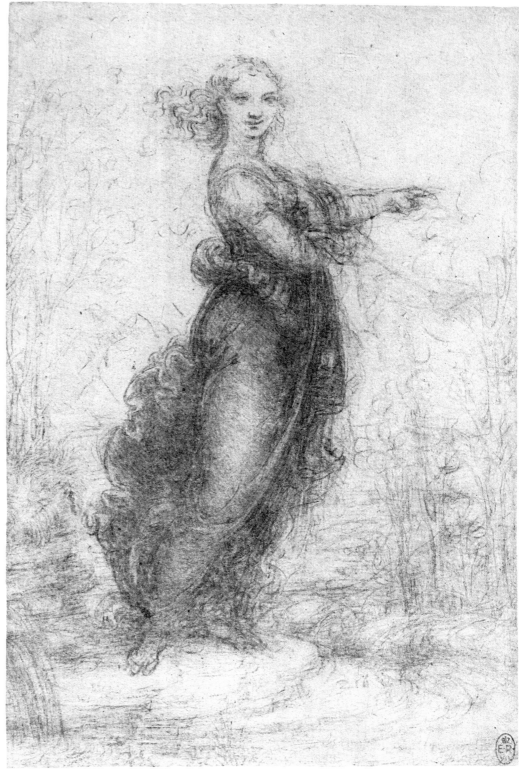

and Alberti, recall in his customary manner the flow of water, but the fluttering dress here exhibits more of the erratic turbulence of the black chalk 'Deluge Drawings' (nos. 22 and 66) than the ornamental curves of his earlier water and hair studies. Indeed, the

Pointing Lady may be regarded as an emotional pendant to the 'Deluge Drawings', promising the spectator transition into a world of an ineffable tranquility rather than immersion in a world of physical destruction.

80

MAIDEN WITH A UNICORN, c.1481
Pen and ink with traces of preliminary
 indentations with a stylus.
 95 × 75 mm
The Visitors of the Ashmolean Museum,
 Oxford
Prov.: Thomas Lawrence; Samuel
 Woodburn; Chambers Hall;
 Ashmolean Museum (P.15)
Ref.: Popham 28B; Parker 15

*Painting is mute poetry and poetry is blind
painting, both imitating nature as far as
possible within their capacities, and in each
of them many moral customs can be
displayed.*

There are three surviving drawings of
unicorn subjects from the early stage of
Leonardo's career. In addition to the
two exhibited from the Ashmolean,
there is a small 'framed' sketch of a
Maiden with a Unicorn on the verso of
one of the studies for the *Virgin, Child
and Cat* in the British Museum (1860-6-
16-98). Although the three drawings are
not wholly consistent in style, it is likely
that they all originate from the period
of his work on the Madonna
composition, that is to say c.1481.
 Leonardo's notebooks contain
extensive accounts of what we would
now regard as legendary animals, drawn
from a number of sources, including
Pliny and the *Physiologus* (the Mediaeval

bestiary). There is nothing to suggest
that he doubted the existence of some of
these apparently well-documented
creatures, and there is, after all, nothing
more obviously implausible in a unicorn
than in a giraffe. In the tradition of the
bestiary, he interpreted the supposed
behaviour of real and fabulous animals
as exemplifying 'moral customs'.
 The unicorn was a particularly
popular beast in heraldic and allegorical
contexts throughout Europe. One of its
legends, recorded by Leonardo himself,
was that it could only be captured and
tamed by a virgin, and the maiden in
the present study points conspicuously to
her docile unicorn in case we should
miss the point about her chaste
condition. The composition should
therefore be interpreted as an allegory of
chastity, and as such would have been
regarded as appropriate when a
particular lady was to be praised for her
virtue – real or, as may often have been
the case in a court context, a matter of
literary convention. The delightfully
romantic and delicate air of this small
study emphasises that at the same time
as inventing 'fictions that signify great
things', like the *Adoration*, Leonardo
could serve up lighter morsels of poetic
fantasy.

81

A UNICORN DIPPING ITS HORN INTO A
 POOL OF WATER, c.1481
Pen and ink and metalpoint.
 94 × 81 mm
The Visitors of the Ashmolean Museum,
 Oxford
Prov.: Thomas Lawrence; Samuel
 Woodburn; Chambers Hall;
 Ashmolean Museum (P.16)
Ref.: Popham 60A; Parker 16

*Whatever exists in the universe through
essence, presence or imagination, the painter
has it first in his mind and then in his
hands, and these are of such excellence that
at the same time and in a single glance they
generate a proportional harmony.*

The complex pose and energetic pen-
work of this small study might suggest a
later date than the other two unicorn
subjects (see no. 80), but the
characterisation does share much in
common with the studies for the animals
in the background of the *Adoration*, and
should probably also be assigned a date
c.1481.
 The subject is another of the famous
legends of the unicorn. When the
unicorn comes upon a pool which has
been polluted by poison from serpents,
it is able to purify it by dipping its horn
in the water and making the sign of a
cross. It is indulging in a similar activity
in Bosch's *Paradise*. As an allegorical
subject it would convey a message of
purity and virtue, much in keeping with
the legend of the Virgin and the
Unicorn in the previous drawing.

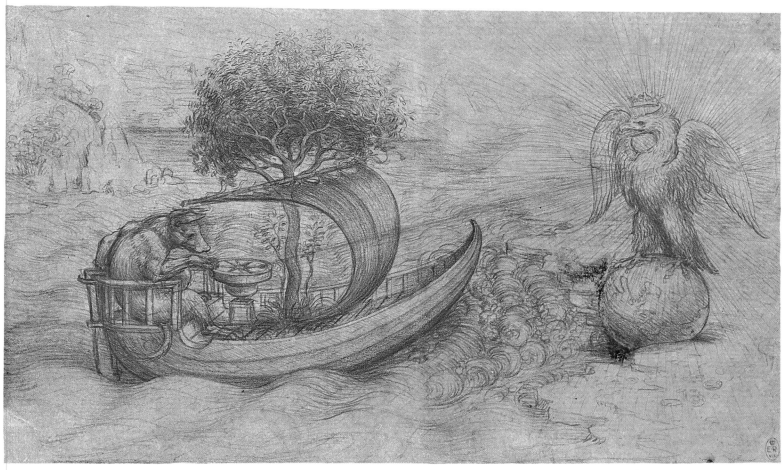

82

ALLEGORY WITH A WOLF AND EAGLE,
 *c.*1515–16
Red chalk on brown/grey paper.
 170 × 280 mm
Prov.: Windsor Leoni volume (12496)
Ref.: Popham 125; C&P; Pedretti I 54r

The poet may say 'I will make a fiction that signifies great things'. The painter can do the same, as when Apelles painted the Calumny.

This virtuoso red chalk allegory is unique in Leonardo's *œuvre* as the only surviving example which has been worked up to the high finish of a 'presentation' drawing. The *Neptune* presented to Antonio Segni (see no. 71) would probably have been similarly finished. There is a tendency to date such works earlier than rougher studies, but a close examination of details such as the turbulent waves and landscape suggest that this drawing originates from the period of the 'Deluge Drawings', in

the last years of his life.

There is little difficulty in recognising the kind of 'fiction' depicted here, since it clearly falls into the category of a political allegory in which the animals and objects are used symbolically as allusions to contemporary events or political concepts. However, the specific meaning of the components and the overall significance of the allegory are harder to define, and have been the subject of much dispute.

One plausible interpretation, developed by Pedretti, starts from the convention of the billowing sail as an emblem of *fortuna*, symbolising the way in which man's course through life is dependent on the whims of fortune just as the helmsman is reliant upon favourable breezes. The transformation of the mast into a tree is not only a pun on the word *albero* (tree and mast in Italian), but can be read as a reference to *fortuna verde* (evergreen fortune) in Machiavelli's sense. On the question of its specific political application Pedretti

has suggested that it might refer to the French patronage of schemes to canalise the Adda in Lombardy in 1516.

This author prefers to start with the most recognisable of the political symbols – the eagle on the globe – as a reference to the Holy Roman Emperor. However, the crown appears to be that of a French monarch, with *fleur-de-lys*, rather than that of Maximilian, the German incumbent at this time. This suggests that the drawing may allude to Francis I's well-known interest in becoming the next Holy Roman Emperor. Reference is made to this ambition in Raphael's *Coronation of Charlemagne* in the Vatican, in which the first such emperor has been given the features of Francis, while the pope is recognisable as Leo X. The shared aspirations of the French king and the pope comprised part of the understanding behind their famous 'Concordat' of 1515. In this light, we may read the wolf (the symbol of Rome) as standing for the Roman pope

and the boat as the *navis ecclesiae* – the ship of the Church, as represented in manuscript illuminations, papal medals etc. In this reading, the papacy in the guise of the wolf is steering the ship of the Church across the turbulent waters of the times, using the compass to set course determinedly by the radiance emanating from the imperial eagle. The olive tree in the boat would in this context stand as a symbol of peace. This French-centred interpretation would imply that the drawing was made by Leonardo for Francis I either shortly before or shortly after entering his service in 1516. It should be stressed, however, that any such specific reading must remain as a working hypothesis rather than established fact.

83

ALLEGORY ALLUDING TO THE POLITICAL
STATE OF MILAN, *c*.1485–7
Pen and ink. 206 × 283 mm
The Governing Body, Christ Church, Oxford
Prov.: General J. Guise; Christ Church (0037)
Ref.: Popham 105; Byam Shaw 18

Painting surpasses nature because natural products are finite in number, and the works which the eye commands of the hands are infinite.

A group of allegorical drawings in pen may be dated to Leonardo's years at the Sforza court in Milan. They fall into two categories: one type deals with general concepts, such as 'pleasure and pain' and 'virtue and envy', which may or may not allude to particular events, circumstances or people; the other kind makes overt reference to political concerns, such as the drawing in the Musée Bonnat at Bayonne which shows Ludovico il Moro being protected by Justice from 'lying slander'. On the verso of the present sheet is a composition in which 'fame or rather virtue' with spear and shield is repulsing 'envy' who attempts to fire a tongue-tipped arrow, signifying evil report. A caption at the top states that 'immediately virtue is born she gives rise to envy opposite herself, and a body will more readily exist without a shadow than virtue without envy'. (A trace of the figures on the verso can be seen on this side of the sheet.)

Unfortunately, the more complex allegory on the recto, shown here, has been provided with no such helpful labels. The broad drift of what is happening is tolerably clear. The seated figures may be identified as Justice, with a sword, and Prudence, who has two faces and whose customary mirror is being held by Justice. They are undergoing attack from the evil forces of an aged devil or satyr (apparently female), foxes and a bird of prey. The 'weapons' in the hand of Prudence indicate that the allegory contains a direct political meaning, since two of them are Sforza emblems – the Milanese serpent and a *scopetta* (a besom brush). The branch may be olive and signify peace, as may the dove on a string, though the branch may come from the *moro* (mulberry) which was emblematic of Ludovico il Moro, while *columba* (dove) was also the heraldic device of his sister-in-law, Bona di Savoia. Prudence appears to be defending a bird (a cockerel?) and another serpent, which may or may not be within the circular

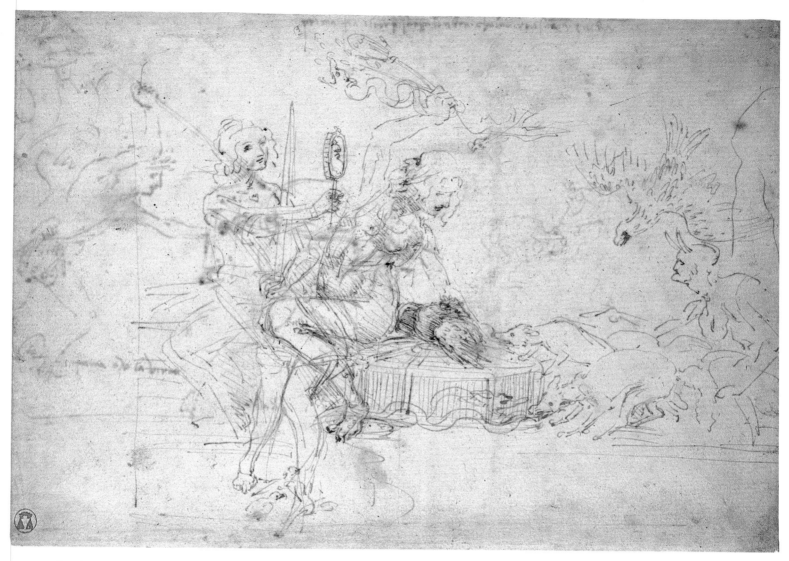

cage – if indeed it is a cage – and perhaps also a small bird in the pool(?) at her feet. It is possible that the cockerel stands for Gian Galeazzo, Ludovico's young nephew, on the basis of a typical emblematic word-play on Galeazzo and *galletto* (young cockerel).

Gian Galeazzo was the legitimate Duke of Milan, but Ludovico had effectively usurped power, even before his nephew's mysterious death in 1494. He was sensitive to the inevitable criticism of his actions – the kind of 'evil report' represented on the verso – and this composition may have been designed to signal the virtues he was exercising as 'guardian-protector' of the young duke or, if the drawing postdates the duke's death, of his infant son (Francesco). Whether the forces of evil are generalised or make reference to specific enemies is unclear.

Allegories of this kind could have been utilised in a variety of circumstances and in a variety of media, but would have been particularly appropriate as decorations for the sumptuous temporary structures erected on days of dynastic celebration.

Leonardo's sheer fertility of invention is not necessarily an unqualified advantage in devising such allegories – certainly not as far as conveying lucid meaning is concerned. The way in which meaning emerges and changes during his development of a composition is not well suited for working within a stable language of recognisable symbols. Although one of the points of such imagery in the Renaissance was that it relied upon arcane secrets available to the initiated, the prolixity of Leonardo's most complex allegories appears likely to have compromised their legibility and coherence even for their courtly audience.

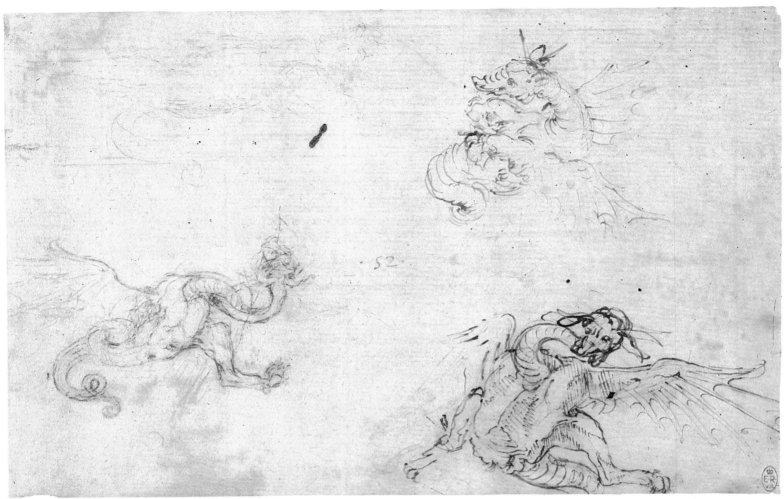

84

DRAGONS, c.1480

Metalpoint(?) partly retouched in ink.
 159 × 243 mm

Prov.: Windsor Leoni volume (12370)
Ref.: Popham 62; C&P; Pedretti II 78

If the painter wishes to depict animals or devils in hell, with what an abundance of inventions he teems.

The late sheets of cats and horses with dragons (nos. 38 and 72) show the way in which Leonardo's study of the motion of observed animals merged with the invention of fantastic beasts. This particular drawing originates from much earlier and appears to be one of the 'spin–off' variations from his work on the turbulent scene of horsemen and animals in the background of the *Adoration of the Magi*. These variations included a horseman fighting a griffin (Ashmolean, Oxford) and a dragon fight (ex-Rothschild Collection, Louvre, Paris).

For the invention of such fantastic creatures Leonardo recommended the procedure of combinatory imagination, which was one of the attributes of *fantasia* in the tradition of Mediaeval faculty psychology: 'you should know that you cannot fabricate any animal that does not have parts such that each is similar to that of one of the other animals. If therefore you wish to make an animal devised by you appear natural – let us say a dragon – take for its head that of a mastiff or setter, for its eyes those of a cat. . .' The dragons on this sheet conform to the spirit of this instruction, particularly the most developed study at the lower right, which has the snarling head of a dog, the serpentine neck of a swan or snake, the body and wings of a fighting cock, the splayed hindlegs of a cat and the tail of a lizard. The conviction with which Leonardo can not only invent an animal from an assemblage of parts but also render it in convincing action reflects his insight into the principles of animal motion. In this case, he seems to have learnt much from his studies of cats for the *Virgin, Child and Cat* composition (no. 6), on which he was working at this time.

85

APOCALYPTIC SCENES OF DESTRUCTION,
*c.*1517

Pen and ink over traces of black chalk.
300 × 203 mm
Prov.: Windsor Leoni volume (12388)
Ref.: Popham 288; C&P; Pedretti I 70r

*If poetry terrifies people with infernal
fictions, the painter uses the same things for
like effect.*

This cluster of studies is clearly related
in a general sense to the 'Deluge
Drawings' (nos. 22, 63, 64 and 66), and
originates from a similarly late date.
However, the content is somewhat
different. The agents and the victims of
the destruction are characterised in a
way that calls to mind written sources,
such as Dante's *Inferno* or some of the
prophecies of the Old Testament. The
open pit within the mountain at the
bottom is particularly Dantesque, while
the chaotic group of little figures at the
left, some of whom are obviously
skeletons, recalls Ezekiel's 'valley of the
dry bones'. Even in the more apparently
naturalistic upper scene, which is closer
to the 'Deluge Drawings', the
destruction appears to take the form of a
rain of flames from heaven, while the
lower right-hand group, which includes
a gigantic central figure, is clearly
subject to some kind of conflagration
from above. The rain of fire from
heaven, as a punishment for the
sinfulness of man – and of the
Florentines in particular – was a
prominent motif in the sermons of Fra
Girolamo Savonarola, the Dominican
friar who was a central figure in the fall
of the Medici in Florence in 1494.

It does not appear likely that
Leonardo was directly illustrating these
or other specific texts, but rather freely
exercising his imagination across a range
of subjects that would permit him to
challenge the writers and preachers on
their own traditional ground, where
painters had previously seemed least
well-equipped to follow.

The notes are obviously very different
in tone from the drawings, but they
may well provide an example of
Leonardo's process of free association,
which permitted him to pass effortlessly

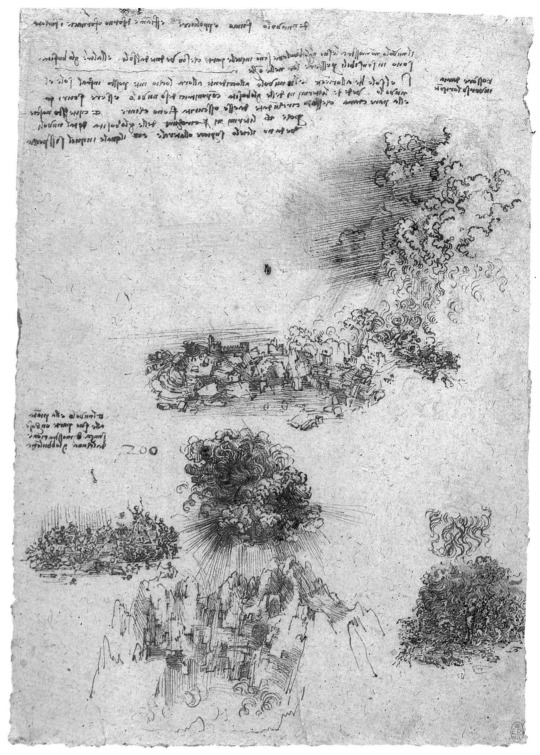

between cool observation and expressive
fantasy, and back again:

On clouds, smoke and dust and flames
of a furnace or fired kiln. The clouds
do not show their convexities except
on those parts exposed to the sun, and
the other convexities are
imperceptible through being in the
shadows. If the sun is in the east and
the clouds in the west, then the eye
interposed between the sun and the
cloud sees that the boundaries of the
convexities composing these clouds
will be dark, and the parts which are
surrounded by this darkness will be
light. . .

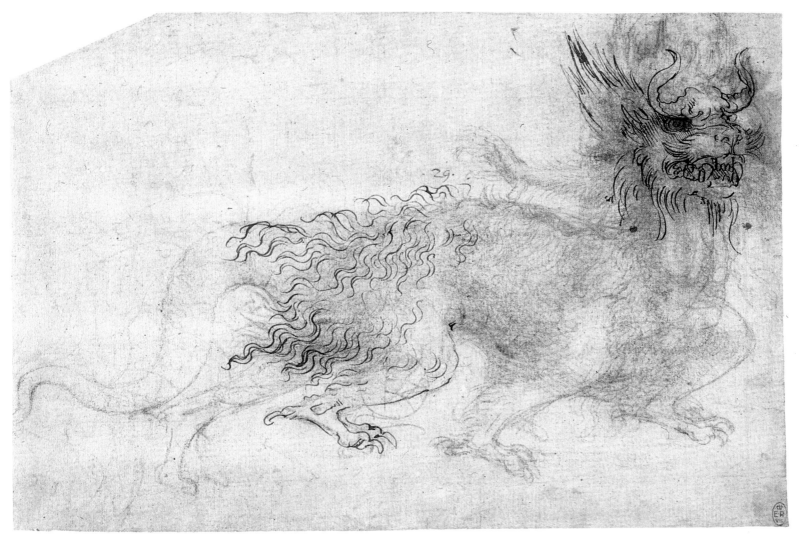

86

A DRAGON, c.1515–17
Black chalk partly gone over with pen
and ink. 188 × 271 mm
Prov.: Windsor Leoni volume (12369)
Ref.: Popham 88; C&P; Pedretti II 156

*If the painter would see beauties that
enrapture him, he is lord of creation for
them, and if he would see monstrous things
which terrify or will be buffoonish and
laughable or truly pitiable, he is their lord
and god.*

The way in which the fiery 'fur' of this
dragon is characterised, and the style of
the black chalk under-drawing point to
a late date, contemporary with the
'Deluge Drawings'. This decorative
monster differs sharply in type from
Leonardo's more serpentine dragons,
even those on the late horse and cat
sheets (nos. 38 and 72), and shares
something of the character of Chinese
dragons, which are similarly wingless.
The way in which the legs, body and
head are set up suggests that this may be
a costume design for a pageant, masque
or other courtly diversion. The two men

inside would walk with a bent-legged
gait to give the proper effect – tiring
though this would be for any sustained
distance. We know that in 1515
Leonardo surprised Francis I, the King
of France, with a mechanical lion that
advanced a few threatening paces before
opening its breast to reveal an
abundance of *fleur-de-lys*. The present
design appears to be conceived in the
same mock-frightening spirit.

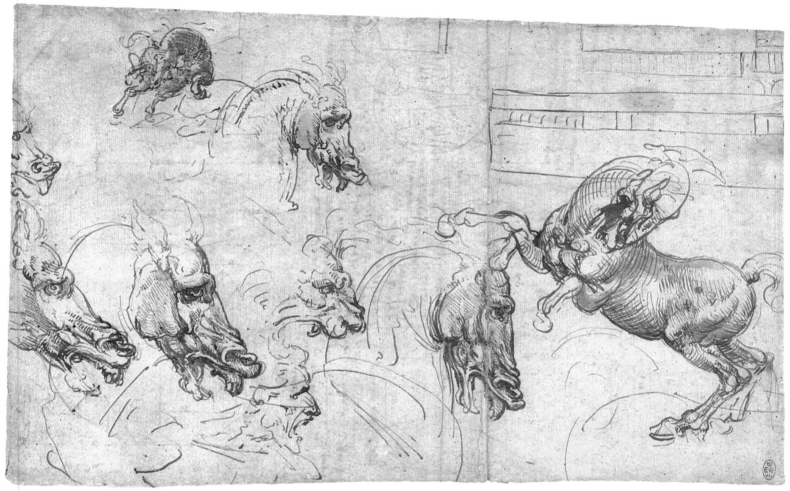

87

STUDIES OF HORSES WITH THE HEADS OF
 HORSES, A LION AND A MAN, *c*.1503–4
Pen and ink and wash with traces of
 black and red chalks. 196 × 308 mm
Prov.: Windsor Leoni volume (12326)
Ref.: Popham 85; C&P; Pedretti II 117r

*Let the sides of the noses be wrinkled in an
arch from the nostrils and finishing where
the eyes begin. Show the flared nostrils
which cause these crease lines, and the lips
arched to reveal the upper teeth, and the
teeth parted, as if to wail in lamentation.*

This sheet has been cut down
considerably, as is apparent from the
mark of a vertical fold, which
presumably ran down the original centre
line. The rearing horse identifies it as
one of the series concerned with the
planning of the *Battle of Anghiari*, and is
close in conception to the red chalk
study of no. 73, though the position of
the head is more resolved in this pen

version. The little study at the top left
of a horse in a pose of extreme
dynamism is typical of a group of
remarkable sketches in the *Anghiari* series
depicting individual animals moving at
ferocious speed.

The dominant concern of this page, at
least in its cut-down state, is the
characterisation of horse expression for
the *Battle*. In Leonardo's earliest scenes
of equestrian warriors, drawn for the
Adoration, the horses are fully engaged in
the fighting, reacting with both
aggression and terror. Even in his
demonstrations of weaponry (e.g. no.
68) the horses are portrayed as
committed participants. The central
horses in the section of the *Battle* that he
did paint on the wall were attacking
each other with bared teeth, while
others were to be shown throwing back
their heads and whinnying in panic –
much in keeping with his assessment of
war as '*pazzia bestialissima*' (most beastly
madness).

Leonardo saw a fundamental
commonality in the mechanisms and
language of such expressions in man and
animals. The passage quoted at the start
of this entry from his description of
'How to represent a battle' applies with
equal validity to the horses and the men,
though he is actually describing human
expression. Analogous heads of shouting
men and snarling animals appear on the
recto and verso of one of his early
Virgin studies (no. 5), and direct
parallels between leonine and human
physiognomies appear in both the early
drawing of a warrior in profile (no. 2)
and the mature drawing of the 'choleric
warrior' (no. 33). By the time of his
work on the *Battle* his early intuition of
shared expressions has been informed
and confirmed by his anatomical
investigations of the facial mechanisms
in man and animals.

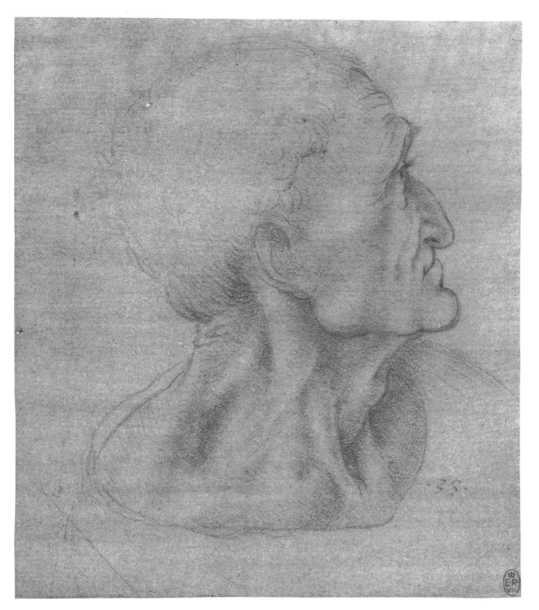

88

STUDY FOR JUDAS, *c*.1495–7
Red chalk on paper coated with a red
 preparation. 181 × 151 mm
Prov.: Windsor Leoni volume (12547)
Ref.: Popham 166; C&P; Pedretti III
 201; Pedretti *L.S.* 13

*I say that in narratives it is necessary to mix
closely together direct contraries, because they
provide a great contrast with each other, and
so much more if they are adjacent, that is to
say the ugly close to the beautiful.*

This study, probably made from life
with a sitter of semitic appearance, was
used for the head of Judas in the *Last
Supper*, though the painted version is
somewhat more overt in its expression
of villainy. Compared to the shocked
innocence of St James's spontaneous
action (no. 89), Judas reacts with tense
restraint, in effect giving himself away
by trying not to give himself away. In
exploiting the muscles and tendons of
the neck as major vehicles for the
expression of this tension, Leonardo has
given a rather misleading impression of
anatomical features that he had earlier
portrayed with exemplary accuracy.
 The current conservation work on the
wall-painting in the refectory of Sta
Maria delle Grazie confirms – in those
areas where there is anything of
substance left at all – that the faces of
the painted figures originally retained
much of the subtlety of the drawings,
with expressions of greater formal and
human complexity than the crude
stereotypes of the overpainted versions
and copies in various media.

89

STUDY FOR ST JAMES THE GREATER AND A
 CORNER PAVILION FOR A CASTLE,
 *c.*1495–7

Red chalk, pen and ink. 250 × 170 mm
Prov.: Windsor Leoni volume (12552)
Ref.: Popham 167; C&P; Pedretti III 199;
 Pedretti *L.S.* 10

*A picture or rather the painted figures must
be made in such a way that the spectator is
readily able through their gestures to
recognise the thoughts within their minds;
and if you have to make a good man speak
ensure that his actions are appropriate for
good words. And similarly, if you have to
represent a bestial man make him with fierce
movements.*

This red chalk head is perhaps the most
compellingly vivacious of the surviving
studies for heads of the disciples of the
Last Supper (see also nos. 31 and 88).
The main lineaments of the facial
expression in this study are retained in
the painted figure of St James, who is
seated to the immediate right of Christ.
The relaxed gesture of the faintly
sketched hand in the drawing has,
however, been transformed in the
painting into a more vivid action in
which the arms are thrown wide –
reminiscent of one of the mourning
figures in a *Meleager* sarcophagus. The
subtle motion of recoil, with down-
turned head and open mouth, is oddly
analogous to the motion of the dragon's
head and neck on no. 84.

Leonardo's repeated insistence on the
need for the artist to express the inner
workings of each figure's mind through
facial expression and bodily actions drew
direct support from his anatomical
studies. In the physiology which he
adopted from the classical and Mediaeval
authorities, the ebb and flow of the
'animal spirits' from the brain to the
peripheral regions of the body, through
the 'medulla' of the nerves (no. 111),
resulted in every part of man's body –
and most conspicuously his hands and
face – moving spontaneously to express
the 'motions of his mind'. The intensity
with which he achieved this goal set
new standards for narrative painting,
firing the imaginations of artists as
diverse as Raphael and (as we have seen)

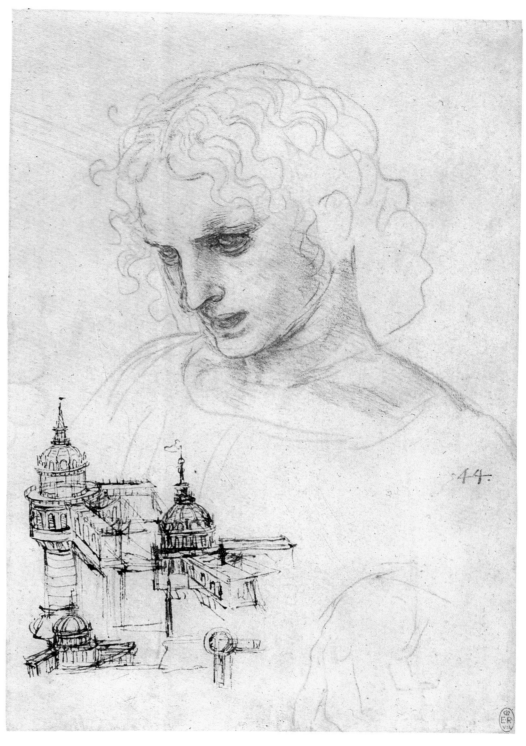

Rembrandt. It was this aspect of the *Last
Supper* that so moved Goethe: 'James the
Elder draws back, from terror, spreads
his arms, gazes, his head bent down, like
one who imagines that he already sees
with his eyes those dreadful things
which he hears with his ears'.

(The architectural studies of schemes
for domed corner pavilions were
presumably made with one of the Sforza
castles in mind.)

90

FIVE CHARACTERS IN A COMIC SCENE,
 c.1490
Pen and ink. 261 × 206 mm
Prov.: Windsor Leoni volume (12495)
Ref.: Popham 133; C&P; Pedretti III 279

Make the motions of your figures appropriate to the mental conditions of these figures; that is to say if you have to depict he who is enraged his face should not display anything opposing this emotion; rather, nothing other than rage should be judged to be present there – and similarly for joy, melancholy, mirth, tears and such like.

This drawing is one of the rare instances in which Leonardo has brought together a group of his grotesque and semi-grotesque characters in such a way as to imply a narrative. Another example is the drawing at Windsor (12449) in which an old crone appears to be receiving a wedding ring from a man whose expression exudes anything but love. Although it is tempting to bring these two drawings into close relationship, as halves of the same composition, the symmetrically curved distribution of the heads in the present drawing implies that it is self-contained as it stands.

The central head in profile is a characteristic variation on his 'Roman emperor' type, displayed most splendidly in the British Museum metalpoint drawing (no. 2). The figures surrounding him do not appear to represent the four temperaments, but rather correspond to Leonardo's repeated instructions about mingling the 'conditions of man' in close proximity for the greatest effect.

The interpretation of the grotesque heads as a series, and of this drawing in particular, is deeply problematical, and there are personal aspects in the motivation behind the individual heads scattered erratically across so many pages of his manuscripts that remain resistant to historical analysis. However, one aspect of their meaning appears to lie within the popular Renaissance genres of the ribald and grotesque as expressed in literature and, less frequently, in the visual arts. The Italian *novella* in the tradition of Boccaccio relied heavily upon the proud being humbled through mockery, the miserly being inveigled into parting with money, the pious being exposed as hypocrites, and so on. The related genre of burlesque poetry, as practised amongst others by Bellincioni at the Milanese court, made ironic

mockery of the ugly and the idiotic through a knowing distortion of the suave conventions of Petrarchian love poetry. Just as the burlesque poets inverted the *dolce stil nuovo*, Leonardo appears in this drawing to be inverting his own rules about decorum: 'in a narrative the dignity and decorum of a prince or sage should be respected. This can be established in a narrative by his separation and complete isolation from the tumult of the common herd.'

If we read the present drawing in this light, we may sense that the central character, crowned with a wreath of oak leaves in an 'imperial' manner, is being encouraged cruelly by the accomplices in the foreground to parade himself as something he is not – much in the manner of the 'king of fools'. Three of the accomplices gain malicious if relatively restrained pleasure from the spectacle, while the fourth laughs with a manic savagery at their success in inducing the 'emperor's' delusions of grandeur. Whether or not this account is a correct reading of the drawing in its details, it does at least relate generally to a known environment in which this kind of image would have possessed articulate meaning for a contemporary audience.

The technique of 'character juxtaposition', used here for ribald effect, was no less applicable to subjects of the greatest moment. Its implications were certainly not lost on Albrecht Dürer, whose painting of *Christ and the Doctors in the Temple* shows the sweet face of the young Christ surrounded by grotesque and grizzled physiognomies in a manner which is strongly reminiscent of Leonardo's drawing in composition and characterisation. Like Rembrandt a century later, Dürer possessed the supreme level of insight to penetrate to the heart of Leonardo's creative techniques for the portrayal of human emotion.

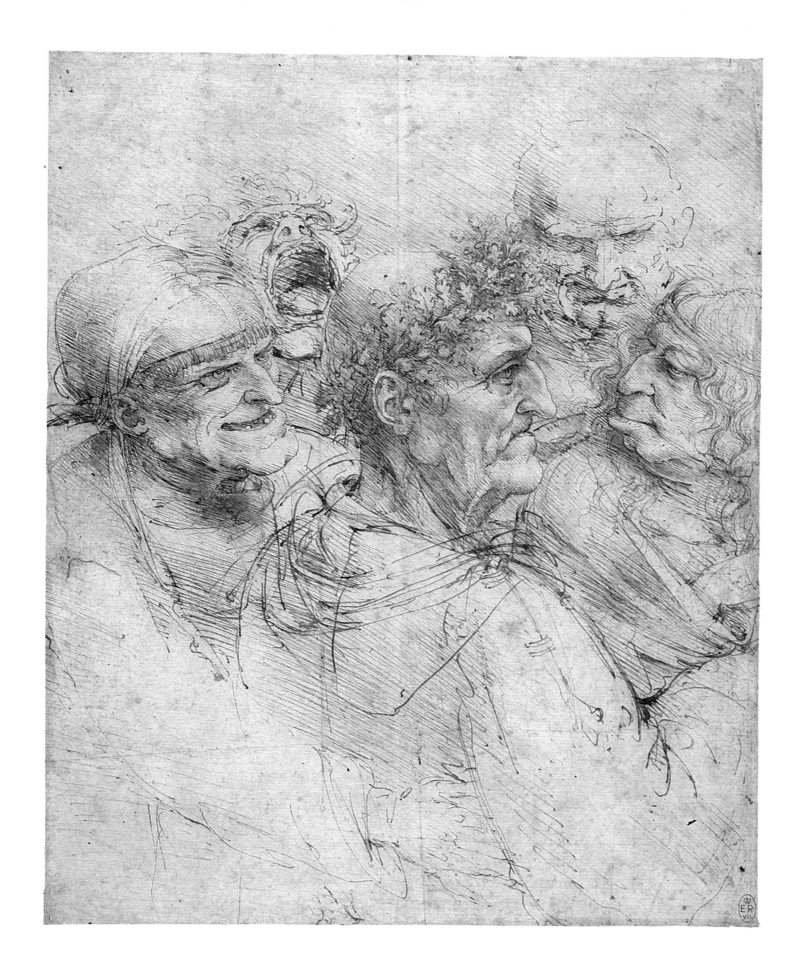

8
THE MEASURING EYE

The eye, which is said to be the window of the soul, is the primary means by which the sensus communis *of the brain may most fully and magnificently contemplate the infinite works of nature . . . Now, do you not see that the eye embraces the beauty of all the world? The eye is the commander of astronomy; it makes cosmography; it guides and rectifies all the human arts; it conducts man to the various regions of this world; it is the prince of mathematics; its sciences are most certain; it has measured the height and size of the stars; it has generated architecture, perspective and divine painting. Its excellence places it above all other things created by God.*

Throughout his notebooks, and in the texts recorded by the compiler of the Codex Urbinas (the *Trattato della pittura*), Leonardo sings repeated hymns in praise of the wonders of vision. The eye, an optical instrument designed in its own right in accordance with the supreme perfection of geometrical law, 'reconciles the soul to stay in its bodily prison'. It not only delights the soul with the sight of the multitudinous wonders of nature but it also provides the means through which man may perceive the effects of nature in such a way as to understand the mathematical rationale of all created things.

The dominant principle in Leonardo's theory of art and science is 'experience' – above all visual experience, which is more certain and comprehensive than any other form of sensory experience. His commitment as a scientist and artist was to a totally comprehensive rational scrutiny and representation of natural forms. Thus he applies an optical principle to the sequential surveying of the human body (nos. 95 and 96), aspiring to leave no visual corner unilluminated by the light of reason. He takes a series of detailed measurements of the bodies of men and horses to codify the systems of proportions on which they have been designed (nos. 91, 92 and 93). He uses a systematic series of geometrical and arithmetical measures to map the surface of the body of the earth (no. 98).

The understanding of appearance, and its subsequent recreation in works of art or scientific demonstrations, relies upon a rigorous analysis of the performance of light as it plays across bodies, casting shadows of various densities and rebounding in complex patterns between surface and surface (nos. 100 and 102). The basic laws, relying upon the proportional grading of effects according to the size, intensity, relative angle and distance of the source, could be formulated with reasonable brevity, but the exploration of the apparently endless variety of effects in particular circumstances led Leonardo into one of his unrealisable sequences of demonstrations – unrealisable, that is, until the advent of computer techniques of ray tracing.

The way in which the brain perceives the geometry of light in nature is through the science of perspective, which he defines as:

A rational demonstration by which experience confirms that all things send

their images to the eye by pyramidal lines. Bodies of equal size will make greater or lesser angles with their pyramids according to the distances between one and another. By pyramidal lines I mean those which depart from the outside surfaces of bodies and travelling over a distance are drawn together towards a single point.

Linear perspective in painting was perhaps the most seminal invention of Renaissance art, but Leonardo is here defining it in terms of Mediaeval optics, emphasising the role of the 'radiant pyramids' diffused throughout the air. The geometrically-structured eye was designed to register these perspectival phenomena in such a way that they might be truly comprehended by the intellect within the ventricles of the brain (no. 94).

The increasingly close attention that Leonardo paid to Mediaeval authors on optics, such as Witelo and Pecham, led him to undertake detailed studies of reflection from curved mirrors, the geometry of which represented a considerable challenge, both in the abstract and in the practical terms of perfecting burning mirrors as sources of heat (no. 101). The Mediaeval texts also served to emphasise the complexities of the visual process, and unsettled the rather simple view of the functioning of the eye which he at first adopted from the theory of art, above all from that of Alberti. His later conception of the eye, sketched on no. 97 and explored in more detail in Ms.D (*c*.1507–8), was of a complex refractory apparatus, in which the incoming image underwent a double inversion – with attendant deceptions and illusions.

Additional complexity in the world of visible forms – indeed, infinite multiplicity – arose from the nature of geometrical processes in themselves. He repeatedly emphasised that geometry was concerned with 'continuous quantity', compared to the discrete, 'discontinuous quantities' of arithmetical units. He came to apply this principle to the motion and representation of all forms in space (nos. 95, 96 and 97), and to the transformation of one geometrical body into another in a systematic manner. Even the regular 'Platonic' solids gave rise to infinite permutations (no. 104 and fig. 43):

> The regular bodies are five and the number participating between the regular and the irregular are infinite, seeing that each angle when cut uncovers the bases of a pyramid with as many sides as there are sides of this pyramid, and there remain as many bodily angles as there are sides. The angles may be bisected anew and so you may proceed an infinite number of times because a continuous quantity may be infinitely divided.

This sense of the infinity of geometrical transformation is powerfully present in Leonardo's almost obsessive exploration of equivalences of area in straight-sided and curvilinear figures (no. 99). The ancient conundrum of squaring the circle was an ever-present concern, though each of his apparent 'solutions' proved to be less than conclusive on further reflection. At first sight, the hours he spent in his later years nagging away at unproductive geometrical puzzles seem rather dispiriting. However, it was the inexhaustible variety of simple geometrical permutations that provided the rationale for his vision of geometry as the basis for the functional design of all organic forms (e.g. no. 55). Abstract geometry and the physical properties of organic nature were totally integrated in Leonardo's vision of the world – perceived via the medium of sight, the noblest sense.

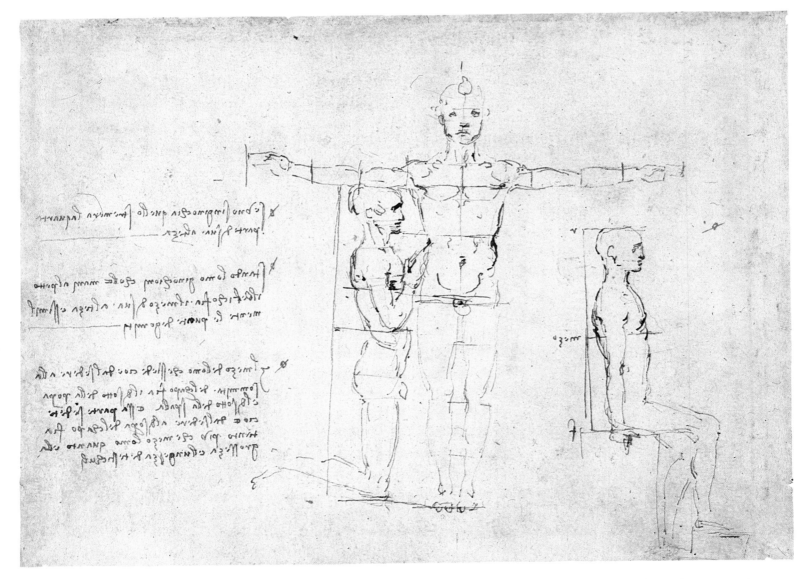

91

STUDIES IN HUMAN PROPORTION, c.1490
Pen and ink. 159 × 216 mm
Prov.: Windsor Leoni volume (19132)
Ref.: C IV 8r; Popham 224; K/P 27r

A mathematical system of proportions for the human figure was a long-standing interest in the Renaissance, inspired particularly by the writings of the ancient Roman architect, Vitruvius, whose theories Leonardo illustrated in a drawing in the Accademia, Venice. The standing man with his arms spread is in the 'Vitruvian' position, as later adopted by Dürer. The present drawing belongs to a group datable to the years around 1490, perhaps from a single notebook, in which Leonardo attempted to establish an extremely detailed system of correspondences between all the parts of the body, large and small. He intended his system not only to take into account figures of different ages and types, but also to embrace the changes in the relative proportions of the parts when the limbs and body are in various positions. On the present sheet he explains that:

When a man kneels down he will diminish by a quarter of his height. When a man kneels with his hands to his breast, the navel will be the midpoint of his height and similarly the points of his elbows. The midpoint of the seated man, that is to say from the crown of his head, will be just below the breasts and just below the shoulders. The seated part, that is to say from the seat to the top part of the head, will be as much more than half the man as is the breadth and length of the testicles.

92

PROPORTIONAL ANALYSIS OF A HORSE,
 c.1479–81
Pen and ink over black lead.
 298 × 290 mm (irregular)
Prov.: Windsor Leoni volume (12318)
Ref.: Popham 61; C&P; Pedretti II 88

This is the earliest of all Leonardo's surviving studies of proportion. The horse relates in type to those in the earlier phase of his studies for the *Adoration of the Magi* (commissioned in 1481). Compared to the elaborate series

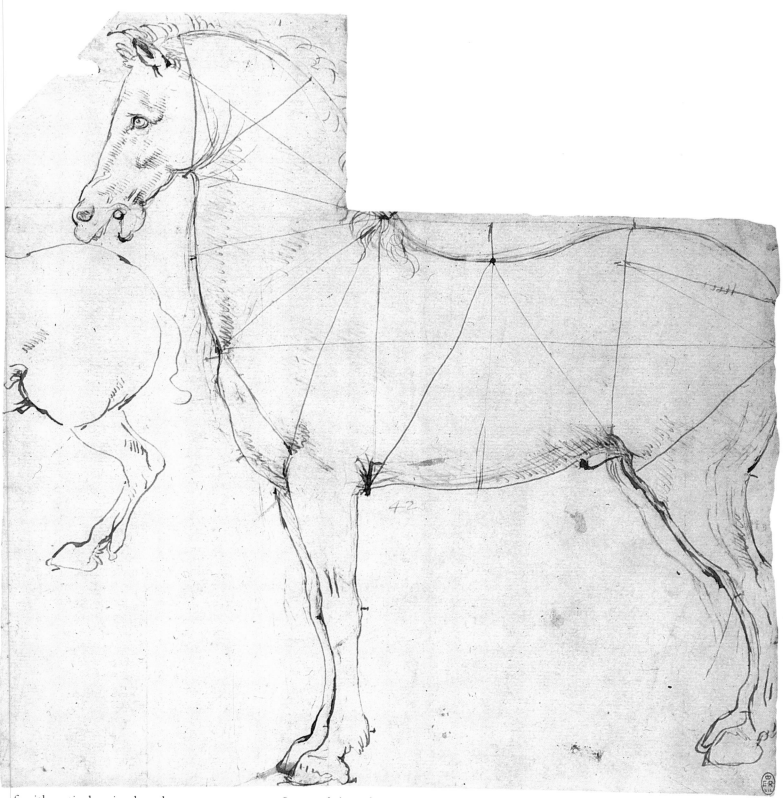

of arithmetical ratios based upon very detailed measurements, which were to become characteristic of his proportional studies around 1490, he is here using relatively large geometrical divisions, searching for equal and similar triangles.

Leonardo's early interest in horse proportion almost certainly reflects similar investigations made by Verrocchio in connection with his project for the Venetian equestrian monument to Bartolomeo Colleoni

from 1479 onwards. The technique of proportional division in this drawing is similar in type to a study of horse proportions in the Metropolitan Museum of Art, New York, convincingly attributed to Verrocchio.

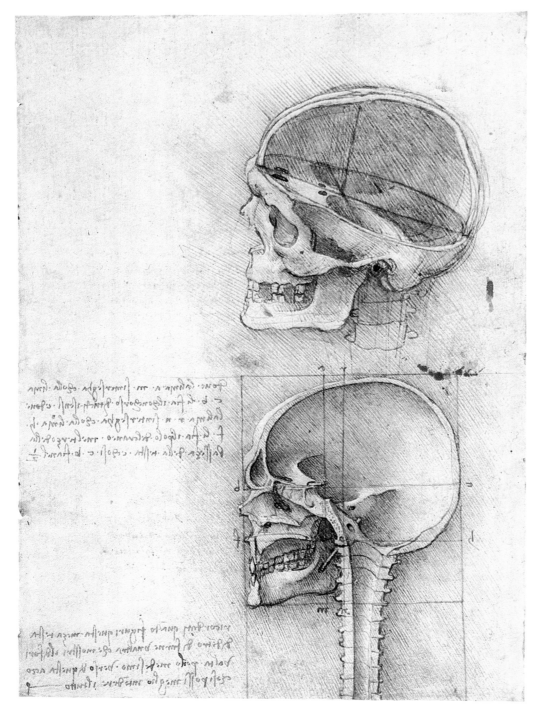

TWO VIEWS OF THE SKULL, *c.*1489
Pen and ink over black chalk.
188 × 134 mm
Prov.: Windsor Leoni volume (19057)
Ref.: B 40r; Popham 217; C&P; K/P 43r

Leonardo's earliest surviving anatomical
studies which definitely record first-hand
human material are the skull drawings at
Windsor. Another of the series (Windsor
19059) is inscribed with the date 2 April
1489. In these drawings and those on the
verso Leonardo represented several
features not previously described, such as
the maxillary outrun and the frontal
sinus.

However, the purpose of these
demonstrations went beyond descriptive
anatomy in the modern sense. The note
indicates that he was concerned to
correlate the mathematical proportions
of the skull with the location of key
components in the intellectual apparatus
of the brain: 'Where the line *am* is
intersected by the line *cb*, there will be
the confluence of all the senses, and
where the line *rn* is intersected by the
line *hf*, there the fulcrum of the cranium
is located at one third up from the base
line of the head.'

The 'confluence of all the senses'
corresponds to the *sensus communis* in the
Aristotelian theories of faculty
psychology in the Middle Ages. The
various mental functions were each
located in different parts of the three
cavities (ventricles) of the brain, and the
sensus communis was the place at which
the sensory impressions from different
organs came together to be co-
ordinated. He considered it appropriate
that such a crucial function should be
performed at a proportionally significant
place within the skull.

94

VERTICAL AND HORIZONTAL SECTIONS OF
THE HUMAN HEAD, WITH THE LAYERS OF
THE HEAD COMPARED WITH AN ONION,
c.1489–92

Pen and ink and red chalk.
206 × 148 mm
Prov.: Windsor Leoni volume (12603)
Ref.: C V 6v; Popham 227; C&P; K/P
32r

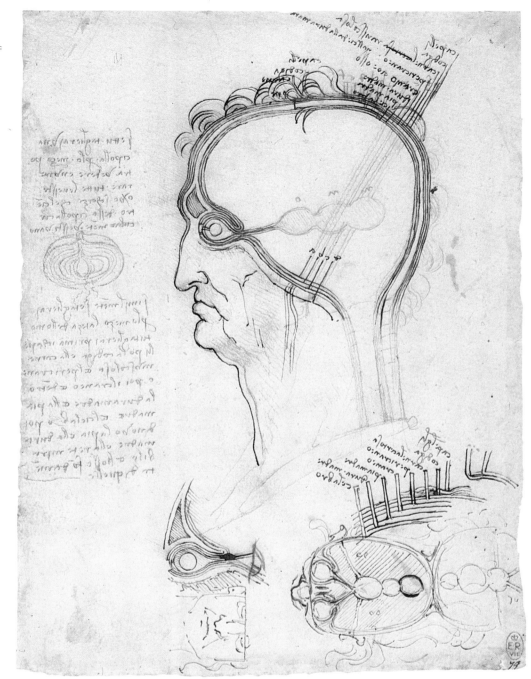

These sections of the human head
continue the investigations initiated in
the 1489 skull studies (nos. 9 and 93),
and should not be dated much if any
later. The larger drawing shows the
coats of the skull and brain, with a
somewhat exaggerated frontal sinus
(previously undescribed) and the
ventricles of the brain as three
continuous flasks connected by a short
stalk to the eye, which is envisaged as an
extrusion of the surface of the brain.
The diagram at the lower right shows
the head sectioned horizontally and
hinged back to show the nerves from
the eyes and ears.

At this date Leonardo's understanding
of the brain and its functions is entirely
traditional in kind, though he works his
own variations of the localisation of the
various cerebral functions. The eye,
characterised with a spherical 'lens', is
also dependent upon traditional notions.
The conception of the eye as a
geometrically designed organ
communicating directly with the
imprensiva (receptor of impressions),
sensus communis (confluence of the
senses), intellect and memory is entirely
consistent with this emphasis upon the
priority of sensory knowledge and his
assertion of the superiority of the eye
over the other senses.

The note and marginal diagram
compare the successive layers of the
coats of the skull and brain with the
concentric skins which are apparent
when an onion is sectioned. Leonardo
records the layers of the skull below the
main drawing as 'hair, scalp, lacterous
flesh, pericranium, cranium, pia mater,
dura mater, brain'. In the upper diagram
he had given the dura mater and the pia
mater in their correct order, but here
they are inadvertently reversed.

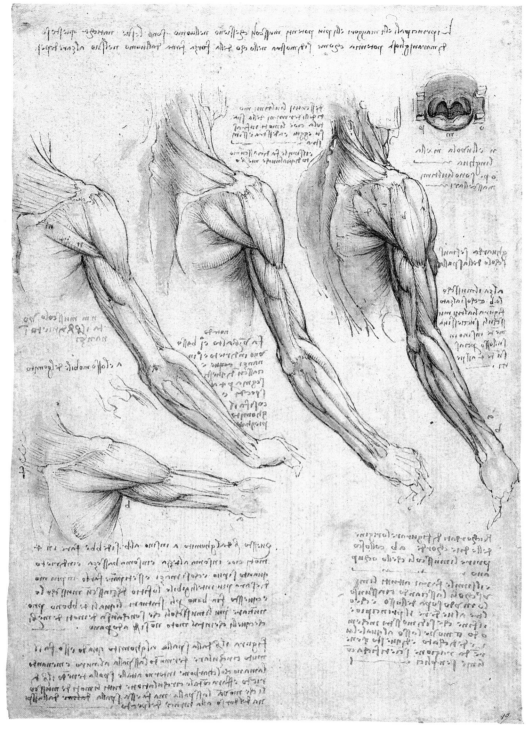

95

MUSCLES OF THE ARM AND SHOULDER IN
ROTATED VIEWS, c.1510
Pen and ink with wash modelling over
black chalk. 289 × 199 mm
Prov.: Windsor Leoni volume (19005v)
Ref.: A 6v; C&P; K/P 141v

This and the following drawing (no. 96) should be read together as a continuous series of views, starting at the right of the next sheet and proceeding through 180° to the leftmost view on this page. They are part of his campaign around 1510 to bring the studies of human anatomy to completion. The studies of the muscles and skeleton at this time represent one of Leonardo's finest anatomical achievements (e.g. nos. 105, 106, 108 and 109).

He explains the system behind his sequential views in the note and stellated diagram (fig. 41) on the next drawing: 'I turn the arm into eight aspects, of which three are from the outside, three from the inside, and one from behind and one from in front. And then I turn it into eight others when the arm has its two follicles crossed [i.e. when the wrist is rotated to cross the radius and ulna].' Elsewhere he explains that the effect is the same whether it is the object that turns or the eye that moves around the object.

The diagram of the sequence of viewpoints, each of which is the apex of a visual pyramid surveying the form, is based upon the optical precepts of the thirteenth-century Franciscan, John Pecham, who wrote that every part of the air is filled with radiant pyramids of light originating from a lit object.

Leonardo's desire for a totally comprehensive visual survey of the human body from all sides, in a variety of poses and at different stages of dissection, remained impossible to accomplish within any feasible time-scale, given the limitations of the graphic techniques available to him. Yet his sense of the infinite subtleties of the interrelationships of mobile forms from different aspects continued to demand such comprehensiveness.

The note at the top of the sheet deals with the 'marvellous power' of the muscles in man's buttocks, while the small diagram at the upper left displays the tongue, epiglottis and start of the throat.

96

MUSCLES OF THE RIGHT ARM, SHOULDER
 AND CHEST, c.1510
Pen and ink with wash modelling over
 traces of black chalk, and small red
 chalk strokes between the main
 figures. 289 × 200 mm
Prov.: Windsor Leoni volume (19008v)
Ref.: A 9v; C&P; K/P 140v

This sheet initiates the sequence of
'cinematographic' views completed in
no. 95, the entry for which explains the
illustrative technique. At the top of the
page the three demonstrations of the
muscular 'stays' of the upper spine and
neck are labelled: 'first, second and third
demonstrations of the muscles of the
cervical spine'. This series is developed
in another drawing at Windsor (19015).

 Although the deltoid muscle of the
shoulder is incorrectly divided into
separate fascicles or slips – marked *a* to *d*
on the upper right-hand drawing – each
of which he considered to exercise a
distinct function, these demonstrations of
myology clearly reflect intense scrutiny
of an actual subject. The verso of this
drawing shows the bones of the leg
from various aspects with notable
accuracy, confirming his commitment at
this time to the direct representation of
first-hand material whenever possible.

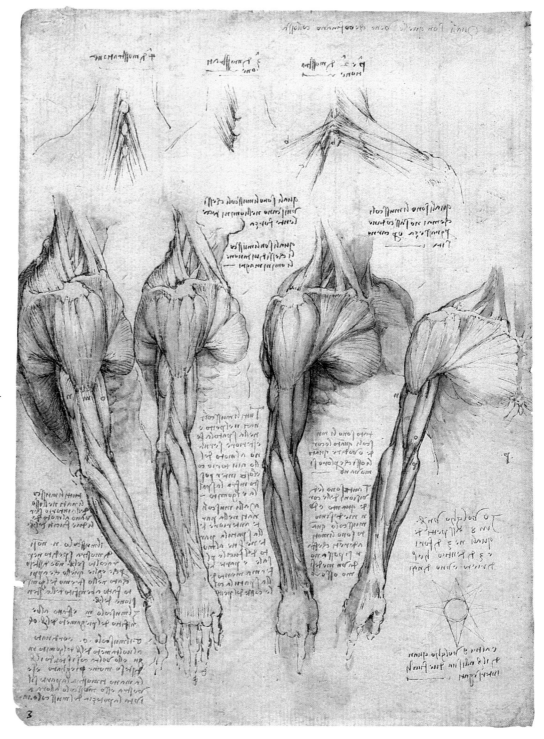

Fig. 41 Leonardo's system for surveying a form
from eight viewpoints (based on no. 96)

STUDIES OF IMAGES PASSING THROUGH
APERTURES, COLOURED LIGHTS, THE
HUMAN FIGURE IN MOTION, AND LIGHT
AND SHADE, *c*.1508
Pen and ink. 437 × 314 mm
Prov.: Windsor Leoni volume (19149-
52v)
Ref.: C&P; K/P 118v

This sheet was originally folded twice, making eight 'sides', but it is now opened up in such a way that the writing on Windsor 19149v-50v is orientated the opposite way to that on Windsor 19151v-52v. It provides an excellent insight into the variety of visual concerns upon which Leonardo was working at any one time. The ghostly drawing of a crouching figure underneath the writing on Windsor 19150v (bottom right) is not by Leonardo. He has apparently taken up a large sheet on which a pupil had made an inconclusive beginning. The studies of the eye at the lower right are closely related to Ms.D in the Institut de France, which can be dated with some confidence to 1507–8.

Not the least remarkable aspect of this important and complex sheet is the 'cinematographic' series on Windsor 19149v (bottom left) of thumb-nail sketches of a man dealing a vigorous blow with a hammer, labelled *a* to *d*. The related note is headed 'On Painting'. The sequence of sketches illustrates the principle of 'continuous quantity' outlined in one of the notes transcribed in the *Trattato*:

> In the case of a man delivering a blow on some object, I say that such a blow occurs in two directions; that is to say either he is raising the thing which is to descend to give rise to the blow, or he is making the descending motion. In either of the two modes, it cannot be denied that the motion occurs across space and that the space will be a continuous quantity, and every continuous quantity is infinitely divisible.

It appears likely that the comparable technique of 'cinematographic' continuity of motion in space used later in the century by Carlo Urbino in the compilation of the Codex Huygens (The Pierpont Morgan Library, New York) drew inspiration from Leonardo's application of the principle of 'continuous quantity' to the illustration of the human body in motion.

The main drawing on 19151v (upper left), shows red and blue light sources illuminating a round object and casting coloured shadows on a flat surface. He explains that the shadow cast on the surface by the red light will be blue, because it is illuminated by the blue light alone, and *vice versa*. The area illuminated by both lights display a 'reddish' colour, mixed from red and blue. Elsewhere he records that yellow and blue lights will combine to make green, incorrectly assuming that mixtures of coloured light behave in the same way as mixtures of coloured pigments.

The diagrams on 19152v (upper right) deal with the transmission of images through apertures of different sizes, and those on 19150v (in the margin of the lower right portion) deal specifically with the phenomenon of the camera obscura. The multiple light sources, casting images through two apertures into a darkened chamber, prove that 'the images [*spetie*] of bodies are all infused throughout the air'. The passage of images through small apertures had been of considerable interest to natural philosophers in the Middle Ages, and Leonardo follows such students of optics as Roger Bacon in arguing that since the linear rays have no physical breadth they can cross without mingling: 'all the lines can pass through one point without interfering with each other because they are incorporeal'. This discussion leads naturally on to the formation of images in the eye at the bottom right of the sheet. He recognises that images will be inverted after entering the eye, but believes that a second intersection is necessary if the objects are to be seen correctly: 'no image, of however small a body, penetrates into the eye without being turned upside down, and in penetrating the crystalline sphere [the 'lens'] it will be turned the right way up again.'

The diagram on 19149v (bottom left), below the hammering man, demonstrates the five grades of shadow – with intermediate grades – that arise when a ball is illuminated by two light sources. He notes that 'the greatest depth of shadow is the simple, derived shadow' immediately behind the object, because it receives light from neither source. This demonstration probably relates closely to the contents of the lost *Libro W* which was used in the compilation of the sections on light and shade in the *Trattato*.

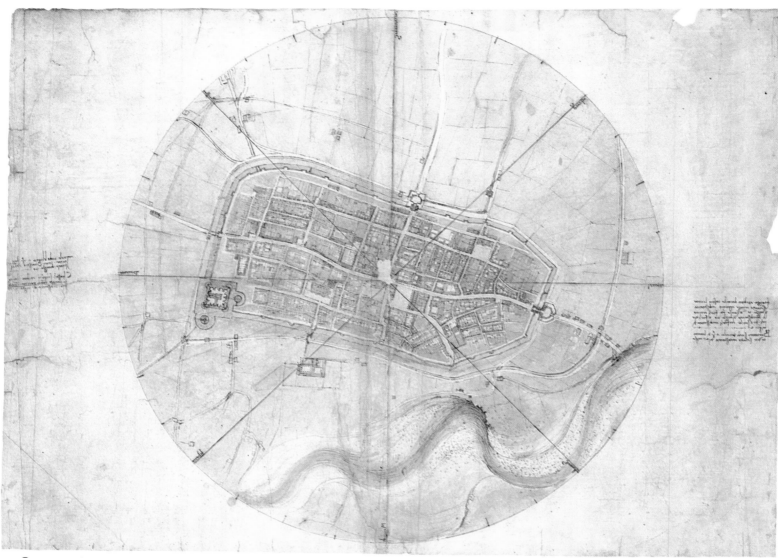

98

THE MAP OF IMOLA, c.1502–3
Pen and ink and watercolour.
440 × 602 mm
Prov.: Windsor Leoni volume (12284)
Ref.: Popham 263: C&P; Pedretti IV 437

This map is normally dated to 1502–3, when Leonardo was employed by Cesare Borgia, to whom Imola was of considerable strategic importance. Taking the necessary measurements would have required considerable effort and resources, and we know that Cesare authorised Leonardo to requisition such services as he required. Although the association of this map with his duties for Cesare has been questioned, it is difficult otherwise to explain its origins.

Leonardo's procedure was to use a horizontally mounted and graduated surveying disk – an astrolabe, circumferentor or related instrument – to record the radial angles of significant features from a high central vantage point. Sixty-four equally spaced lines radiate from the centre of the circular plan. Eight of these are drawn in more heavily and labelled in the wind-rose tradition: *septantrione* (north), *grecho* (north-east), *levante* (east), *sirocho* (south-east), *mezzodi* (south), *libecco* (south-west), *ponente* (west), and *maesto* (north-west). The linear distances on the ground between significant features, along the streets etc., were then measured either by pacing out or by a hodometer (such as that illustrated on Codex Atlanticus f.1ra/1r). Records of the linear measurements are found in sketch plans at Windsor (12686).

The angular and linear measurements were then correlated to produce the developed version of the map, using conventions of line and colour to denote different kinds of features. The result is the most impressive town map of the period. The notes, written from left to right and obviously intended for reading by someone else, record the distances of other towns at various bearings.

In addition to its undoubted merits as a functional map, the drawing exudes a remarkable quality of life. This is apparent not only in the impetuous parabolas of the meandering river Santerno but also in the town itself which, in keeping with the sense of the earth's body, conveys an impression of life more like that of an organism under a microscope than a static map.

99
GEOMETRICAL INVESTIGATIONS OF AREAS
AND CALCULATIONS, *c.*1508–9
Pen and ink. 494 × 330 mm
Prov.: Windsor Leoni volume (12280)
Ref.: C&P; K/P 121r

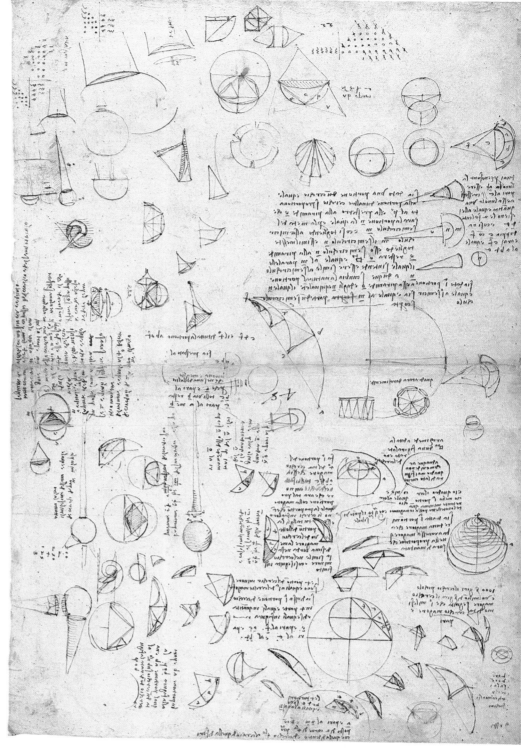

A basic competence in simple geometry
would have been a standard requirement
for a major master in Renaissance
Florence, though this knowledge need
not have extended beyond practical
mathematics in the abacus-book
tradition and the procedures of
perspective construction. Already in his
first Florentine period Leonardo had
shown an interest in pure geometry, and
the study of geometrical areas became
one of the recurrent themes in his
mathematical investigations. It is not
surprising that he was attracted by the
old and difficult problem of squaring the
circle; that is to say the finding of a
formula or procedure for the
construction of a square of precisely the
same area as a given circle. The booklist
on Codex Madrid II (ff. 2v–3r) shows
that he owned a volume on 'squaring
the circle' – probably the compendium
of various authors (including
Archimedes) published as *Tetragonismus
id est quadrata* by L. Gaurico in Venice in
1503. He claims in the note below the
small wheel-like drawing at the centre
right that: 'Archimedes gave the
quadrature of a straight-sided figure but
not of the circle. Hence Archimedes
never squared any figure with curved
sides; and I have squared the circle
minus the smallest portion that the
intellect can imagine, that is to say a
visible point.' The diagram shows the
'Archimedean' solution in terms of the
transformation of a circle into a polygon
by the removal of small segments
around the circumference. The more
sides possessed by the polygon, the
closer would be the approximation of its
area to that of a circle. For his part,
Leonardo was hoping that the study of
lunulae and falcated triangles (the bodies
with both straight and curved sides
elsewhere on the sheet) would solve the
problem, though his note indicates that
his 'solution' involved an approximation
– however slight – in the traditional
manner.

A note in Madrid Codex I (f.112r)
records the end of one of Leonardo's
prolonged bouts of wrestling with the
problem: 'the night of St Andrews day,
I came to the end of the squaring of the
circle and it was the end of the light and
of the night and of the paper on which I
was writing. It was concluded at the end
of the hour.' It is not clear whether he
thought he had reached a solution or
simply taken the problem as far as he
could. In any event, his later notes show
an awareness that a definitive solution
continued to remain elusive, as indeed it
must if the problem is formulated in its
traditional way in terms of construction

with straight-edge and compass.

Such geometrical conundrums, although they fascinated Leonardo as intellectual challenges in their own right, were intimately related to the design of those organic structures in which forms change shape in a systematic manner, such as the valves of the heart (nos. 19 and 55) and the muscles of the anal sphincter (no. 23).

100

STUDIES OF GRADES OF LIGHT AND SHADE
WITH THEIR REBOUNDS, *c*.1490–2
Pen and ink. Folio measurements:
 328 × 460 mm
Bibliothèque de l'Institut de France, Paris
Prov.: Biblioteca Ambrosiana, 1609; to Paris, 1795–6; Institut de France (Ms. 2174; Ms.C, ff.4v–5r)
Ref.: Richter 215–16; Corbeau and Nando de Toni, 1972

Ms.C, which bears the dates 1490 and 1493, comprises twenty-eight relatively large folios and appears to have survived in incomplete form. Folio 15v records the start of the second phase of Leonardo's work on the equestrian monument to Francesco Sforza: 'on 23 April 1490 I began this book and recommenced the horse.' Ms.C is particularly concerned with detailed explorations of light and shade. As *Libro G*, it was one of the manuscripts consulted by the compiler of the Codex Urbinas (the *Trattato*), together with a lost manuscript (*Libro W*), which probably contained later versions of similar investigations, like that of the two light sources on no. 97.

Around 1490 Leonardo made a major effort to formulate comprehensive rules for the behaviour of light and shade under all varieties of circumstance in such a way that the painter would need to leave nothing to guesswork. His system was intended not only to embrace the varied intensities of illumination across the surface of an object and the varied densities of its cast shadows, with respect to bodies of different sizes and light sources of different kinds, but also to take account of the mutual influence of adjacent surfaces as the light rebounds from one to the other according to precise geometrical laws. In addition he recorded the subjective effects of contrast which make light objects seem brighter against dark backgrounds, and *vice versa*. Thus he notes on f.4v the way in which 'that part of something illuminated which surrounds the impact of a shadow will seem more luminous the closer it is to this impact'.

The drawings and notes on these two folios are part of an attempt to formulate a systematic series of propositions. The complex diagram at the top of the left-hand page illustrates how 'that part of the surface of a body which receives the impact from a wider angle of the images of the bodies placed opposite it will be more tinged by the colour of these bodies'. In other words, the degree of influence of one body at a particular point on a surface is directly proportional to the angle subtended by that body on the surface at that point. The central diagram illustrates the reinforcement of 'derived shadows' by reflection from the surface on the left. The lower diagram illustrates the proposition that there is 'such proportion between the impact of the luminous circles and shadows as there is between the distances of these luminous bodies'.

The upper diagram on the right-hand page illustrates the effect of oblique impacts of light and shade – with delicately depicted reflections of light on the undersides of the three spheres. The second study indicates how a surface on the right which is dark above and light below, will influence the surface opposite when an obstruction intervenes up to half the height of that surface.

Leonardo's measured control of parallel hatching in pen and ink achieves subtle gradations of density comparable to those in his drawings for works of art from this period, such as the Sforza horse studies (no. 40). Indeed, it is likely that his depiction of nuances of light and shade on objects in nature gained conviction and refinement from his work in Ms.C and Ms.BN2038 (no. 102).

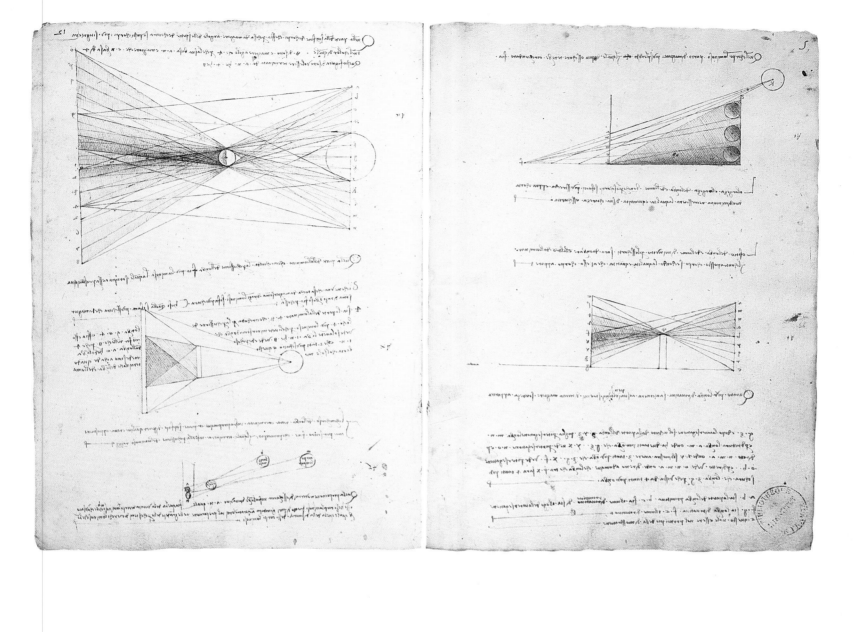

101

STUDIES OF CONCAVE MIRRORS OF
CONSTANT AND PARABOLIC
CURVATURES, *c.*1492
Pen and ink. Folio measurements:
235 × 412.5 mm
The British Library Board, London
Prov.: Thomas Howard, Earl of
Arundel; British Library (Codex
Arundel, Ms.263, ff.87v–88r)
Ref.: Reale Commissione Vinciana,
1923–36, I, pp. 137–8

The Codex Arundel is a compilation of 283 folios of various dates, spanning much of Leonardo's career, including sequences of pages from separate notebooks and miscellaneous sheets. The diagrams on this sheet relate to a series of pages on optics and can be linked to the investigations of mirrors which he undertook from *c.*1507 onwards. In these demonstrations he is tracing the courses of the rays from parallel beams of light after they have been reflected from concave mirrors.

The study of reflections from plane and curved mirrors had been a major focus of attention in the tradition of Mediaeval optics inspired by the Islamic philosopher Alhazen, and one of the most popular bones of contention – the determination of where an object at a given location is seen in a curved mirror – came to be known as 'Alhazen's problem'. Leonardo probably learnt of it from the treatise on optics by Witelo, the Polish philosopher, and in the last years of his life provided an effective solution with an instrument of hinged rods.

In the main diagram on the left-hand page Leonardo plots the rays from a shallow concave mirror of constant curvature, showing that they focus on an axis rather than a single point and that 'the convergence of reflected rays does not go beyond a quarter of the diameter of the sphere'. On an adjoining page in the Codex (f.86) he argues that a shallow curve of the kind illustrated will focus the rays on to a shorter focal axis than is possible with a deeper mirror, such as a complete hemisphere. 'As a consequence, it will kindle a fire with greater rapidity and force.'

Having demonstrated the pattern of reflections in an abstract manner using pure geometry, Leonardo characteristically feels that it should be confirmed by his beloved 'experience', and in the lower diagram he proposes coating a mirror in the form of a half ring with a layer of opaque tempera paint which is then removed in thin lines 'so we will see the separated rays on the plan *abc*'.

In addition to his natural fascination with the geometrical intricacies of the patterns of intersecting rays, he was interested in the potential utility of concave mirrors. He would have been aware of the famous exploits of Archimedes, who reportedly used a huge burning mirror to destroy enemy ships in the defence of Syracuse. While working in the Vatican after 1513 in the service of Giuliano de' Medici, who was commander of the papal forces, Leonardo experimented with the making of moulds for burning mirrors. He noted that 'with this any dyer's cauldron can be made to boil; and by it a pool will be heated, because there will always be boiling water'.

The half-mirror illustrated on f.88r is specifically designed to focus all the rays to a single point for such purposes: 'this is the mirror of fire . . . and the point of convergence of the reflected rays arises from angles equal to the angles of incidence, that is to say every pair of contingent angles are equal to each other'. Leonardo also explains that the designer of such a mirror should ideally know the distance of the mirror from the sun and the size of the sun – though in practice the distance is so vast as to make no significant difference. The curvature of such a mirror would be parabolic rather than spherical. The note at the bottom of the page indicates that Leonardo intended to plot the required curvature by calculating the angles of the mirror separately at each of the numbered points.

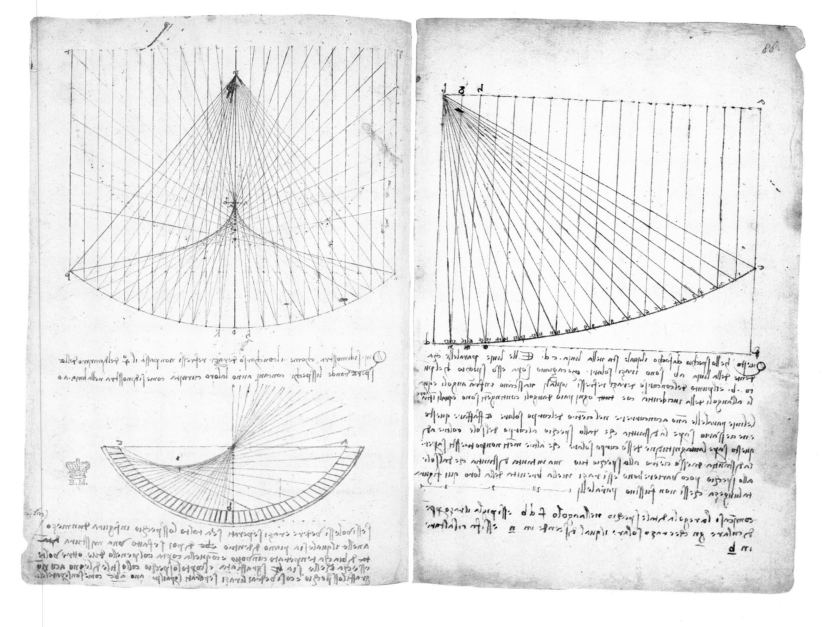

88

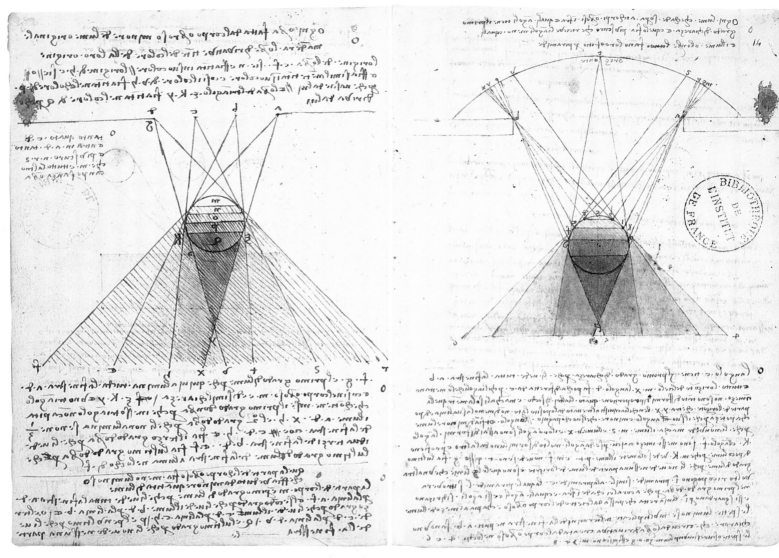

102

STUDIES OF THE GRADATIONS OF SHADOWS
ON AND BEHIND SPHERES, c.1492
Pen and ink and wash with traces of
stylus. Folio measurements:
240 × 380 mm
Bibliothèque de l'Institut de France,
Paris
Prov.: Biblioteca Ambrosiana, 1637; to
Paris, 1795–6; Institut de France;
extracted from Ms.A by Count
Guglielmo Libri, 1830s; Ashburnham
Place; Bibliothèque Nationale; Institut
de France (Ms.2185; BN 2038,
ff.13v–14r)
Ref.: Ravaisson-Mollien, 1891; Richter
148, 149

This manuscript originally comprised
folios 81–114 of Ms.A in the Institut de
France, and can be dated with some
confidence to 1492. These
demonstrations with accompanying texts
were transcribed in the Codex Urbinas
on folios 213 and 214.

The meticulous investigations of
grades of light and shade on and behind
bodies in this manuscript are part of the
same campaign as represented in Ms.C
(no. 100). On these folios Leonardo is
defining the gradations produced when a
sphere is illuminated by the light of the
sky through a window.

The diagram on the left-hand page is
headed: 'every shadow made by an
opaque body smaller than the source of
light casts derivative shadows tinged by
the colour of their original shadows'.
The 'original shadows' are those on the
actual object, while the 'derivative
shadows' are those cast by the 'original
shadows' in a pyramidal fashion behind
the object. The diagram on f.14r shows
that 'every light which falls on opaque
bodies between equal angles [i.e.
perpendicularly to the surface] produces
the first degree of brightness and that
will be darker which receives it by less
equal angles, and the light and shade
both function by means of pyramids'.

The grading of light and shade
according to the quantity of illumination
and angle of exposure was one of the
rigorously proportional effects which
manifested for Leonardo the universal
rules underlying the behaviour of all the
powers of nature.

103

DECORATIVE DESIGN OF HOLLOW BOXES,
c.1492
Pen and ink and wash over black chalk.
120 × 147 mm
The Governing Body, Christ Church,
Oxford
Prov.: C. Ridolfi; General J. Guise;
Christ Church (0042)
Ref.: Byam Shaw 21

A second, rather more formalised
drawing showing similar 'boxes' – two
units high and five units long within a
straight border – is also in the Christ
Church collection, and related studies
appear in the Codex Atlanticus
(ff.109ra/303r and 342vb/940v). Formal
drawings for such decorative motifs are
difficult to date, but it is likely that these
were made during Leonardo's time at
the Sforza court. They could have been
intended for a variety of purposes, but
this design of ambiguously illusionistic
'boxes' was probably conceived as a
pattern for floor tiles in the Roman
manner. Leonardo's delight in such
optical puzzles is the visual counterpart
to the enjoyment of word-play which is
evident in his riddles and to the visual
'puns' in his picture-writing and knot
designs.

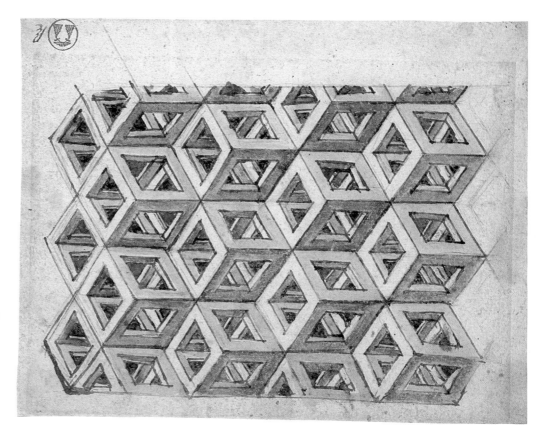

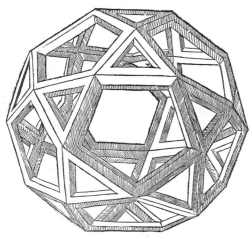

a. Skeletal version of the truncated dodecahedron

c. Skeletal version of the truncated and stelleted dodecahedron

b. Solid version of the truncated and stellated dodecahedron

104

LUCA PACIOLI, WITH ILLUSTRATIONS BY LEONARDO, *De divina proportione*, FLORENCE, PAGANIUS PAGANIUS, 1509, PLATE XXXIIII

Woodcut of the skeletal version of the truncated and stellated dodecahedron (icosidodecahedron) (*upper right*).

Page measurement: 290 × 450 mm

University of St Andrews Library, St Andrews

Prov.: J. D. Forbes; University of St Andrews

Leonardo's drawings of geometrical bodies were originally made for the manuscript versions of the treatise by the mathematician Luca Pacioli. The superior of the two surviving manuscripts, in the Biblioteca Ambrosiana, Milan, is dated 1498 and dedicated to Galeazzo Sanseverino, commander of Ludovico il Moro's army. The other manuscript (Bibliothèque Publique et Universitaire, Geneva), dedicated to the duke himself, is a disorderly compilation with illustrations of lesser quality, and was probably assembled in its present format after the duke's fall and the departure of Leonardo and Luca from Milan. The printed version was published in Florence and dedicated to the Gonfaloniere, Piero Soderini.

Each of the regular solids is depicted in solid and skeletal form, and a number of truncated and stellated variants are illustrated. In these derivatives the corners of the polyhedra are sliced away and pyramidal additions built on to the faces. The body illustrated here is a dodecahedron (a regular body of twelve pentagonal faces), which has been truncated to produce alternate triangular and pentagonal faces, and then stellated with three- and five-sided pyramids.

Pacioli followed Plato in believing that the regular solids corresponded to the elements from which the universe was composed, and that they were therefore of fundamental importance to 'all perspicacious and curious minds, essential for anyone who studies philosophy, perspective, painting, sculpture, architecture, music and other mathematical disciplines'. Leonardo did not accept that the world could be physically built from the Platonic solids, but he did share Pacioli's belief that all natural design aspired to the condition of pure geometry. The depiction of the solids provided a major intellectual and visual challenge for Leonardo, and he responded by inventing a system which was regularly repeated in subsequent books on perspective, geometry and astronomy.

Pacioli for his part made laudatory references to Leonardo's ability in carving, casting and painting, also praising his friend's work 'on local motion, on percussion and weight, on all forces, that is to say accidental weights (having already with all diligence brought to completion a noble book on painting and human movements)'.

9
STRUCTURE AND MECHANISM

Although human ingenuity makes various inventions, corresponding by various machines to the same end, it will never discover any inventions more beautiful, more appropriate or more direct than nature, because in her inventions nothing is lacking and nothing is superfluous.

Nature constrains all created things to obey its laws. No structures or mechanisms in nature fail to act in conformity with natural law, and the design of these structures and mechanisms is perfectly in keeping with their designated functions within the framework of this law – nothing is missing and nothing is in excess. The form of every natural object is therefore governed by an inexorable 'necessity'. In Codex Forster III, from which we are illustrating a lifting mechanism (no. 112), Leonardo laid down alternative drafts of an aphorism, which read almost like a religious chant (f.43v):

> Necessity is mistress
> and guardian of nature.
> Necessity is theme and inventor of nature
> and bridle and rule and theme.

The human inventor is no less constrained by the 'bridle' of necessity, and cannot do better than strive to follow nature's principles, inventing forms of perfect utility in which every effect is achieved in the shortest way, with no redundancies and no insufficiencies. This principle applies equally to the static structures of architecture and the dynamic operation of machines.

The parallel between the design of a great building such as a cathedral and the fabric of the human body was an old one, and had become something of a commonplace, but for Leonardo it was no loose analogy or stock theological metaphor. The structure of the human frame and the statics of architectural design were to be researched at the deepest levels, each body of knowledge informing the other and revealing the underlying rules of 'necessity'. When he was involved in the early stages of the project for the crossing-dome (*tiburio*) for Milan Cathedral in 1487–90, the letter he wrote to the authorities to establish his own credentials centred upon an extended medical analogy:

> Doctors, teachers and those who nurse the sick should be aware what sort of thing man is, what is life, what is health and in what manner a parity and concordance of the elements maintains it; while a discordance of these elements ruins and destroys it; and one with a good knowledge of the nature of the things mentioned above will be better also to repair it than one who lacks knowledge of them . . . The same is also necessary for the ailing cathedral, in that a doctor-architect understands what kind of thing is a building and from what rules a correct building derives . . . and what are the causes which hold the building

together and make it permanent, and what is the nature of weight and what is the potential of force, and in what manner they may be conjoined and interrelated. . .

In this light it is altogether unsurprising that there should be such strong visual, structural and proportional analogies between his plans for centralised temples (no. 118) and the dome of the cranium (nos. 9 and 93); between the vaults of the ventricles of the heart (no. 119) and the interior of a colonnaded building; and between the system of supports and stays required to stabilise the human neck, which bears the weight of the head (no. 110), and the armature required by a lifting device (no. 112) or the mast of a ship. The parallel he explicitly draws between the muscles of the neck, passing diagonally to the ribs, and the stays which support a mast is particularly effective, since he argues that the whole system is under tension, one part lending mutual support to another and providing the framework within which the forces of motion can be exercised.

If statics provide the necessary structures for nature's body, it is dynamic design that provides the mechanisms through which the life of that body can find expression. This expression occurs in the context of universal force: 'Force . . . is an immaterial power, an invisible potency which is created and infused by animated bodies in inanimate ones through acquired violence, giving these bodies the appearance of life. This life is of marvellous efficiency, compelling and transmuting all created things from their places.'

The dynamics of the powers of nature, as we saw in the vortex, obey a remorseless 'necessity' no less than the statics of structure. Thus the bones and muscles of the human body are conceived as mechanical designs of the utmost compactness and economy, achieving movements of infinite complexity in space with designs of 'chords' and levers in which nature demonstrates the perfect efficiency of her inventions. This vision is most compellingly expressed in a series of anatomical designs from around 1510, in which such members as the foot (no. 105), arm (no. 106) and above all the hand (no. 108) are shown as instruments of wonderfully subtle complexity. With good reason Leonardo tells us to 'praise the first builder of such a machine'.

The dominant method of detailed description in this later phase of his anatomical work was founded on his conviction that the true task of the investigator was to explain every tiny detail of the morphology of created form on the basis of function in the context of natural law. This conviction, implicit in his anatomical work from the first, seems to have gained explicit expression as a result of his increased acquaintance with the ideas of the great Alexandrian anatomist Galen, who had argued that 'nature does nothing in vain . . . the artifice of nature is worked out in every part'.

When Leonardo as an engineer came to portray the 'elements of machines' in Codex Madrid I – showing what may be called the anatomy of the members of mechanical 'bodies' – he was aiming to demonstrate a 'second world of nature' (to use his own phrase). The design of the volute gear (no. 116) is founded on the principle that the powers of nature diminish according to a pyramidal law, progressively losing their force, as in a coiled spring, or expending their impetus, as in a thrown ball. Thus, to counteract the diminution in power of a spring as it unwinds, he designed a gear whose pyramidal principle runs proportionately counter to the pyramid of diminution.

It is from this secure base of understanding the static and dynamic principles of design that the imagination of Leonardo as an inventor leaps into realms between feasibility and fantasy. His architectural imagination could ascend to peaks as high as those of nature herself, as in his scheme for a mountainous mausoleum (no. 117). The boundary between vision and viability is particularly blurred in his military designs, which often seem to evoke the spirit of warfare, sometimes in a self-consciously 'antique' manner, rather than describing practical mechanisms. This is certainly true of his most extraordinary illustration of the theme of military engineering, the great *Artillery Park* (no. 113), in which his studies of the motion of the human body – often carried out in thumb-nail sketches (nos. 59 and 97) – and his engineering knowledge have been placed in the service of an imaginative portrayal of a huge monster which man is about to unleash on the unfortunate world of nature.

105

THE SUPERFICIAL ANATOMY OF THE FOOT
AND LOWER LEG, *c.*1510
Pen and ink. 388 × 280 mm
Prov.: Windsor Leoni volume (19017)
Ref.: A 18v; C&P; K/P 151r

This is one of the most impressive of the fine series of skeletal and myological demonstrations during his second Milanese period. The companion drawing of the foot and lower leg from the side (Windsor 19016) is accompanied by the note: 'and this winter of 1510 I hope to complete all this anatomy'. He also reminds himself to 'draw here the foot of a bear, of a monkey, and of other animals and how they differ from the foot of man'.

Although this should be regarded as a composite, synthetic drawing – based on rougher sketches of actual forms such as 19006 and 19010 at Windsor – rather than a direct representation of a dissection, it retains a powerful sense of the structures actually encountered during the removal of the overlying layers. In his clear description of the relationship between the 'chords' and the swelling muscles he is seeking to convey the compact complexity of the mechanism of the foot and ankle. His notes record his approach and the confident way he debates with established authority:

> Remember that to be certain of the point of origin of any muscle you must pull the sinew from which the muscle springs in such a way as to see that muscle move, and where it is attached to the ligaments of the bones . . . Mundinus says that the muscles which raise the toes are in the outward side of the thigh [an error for 'leg' or 'lower leg'], and he adds that there are no muscles in the back of the feet because nature desired to make them light so as to move with ease.

Leonardo then introduces his own analysis with the words, 'in this regard experience shows that. . .'.

Mundinus's *Anathomia* (1316) was the standard point of reference for anyone wishing to follow the established format of a formal dissection, and Leonardo consulted it throughout his career as an anatomist, approaching his predecessor with increasing authority as his own knowledge developed.

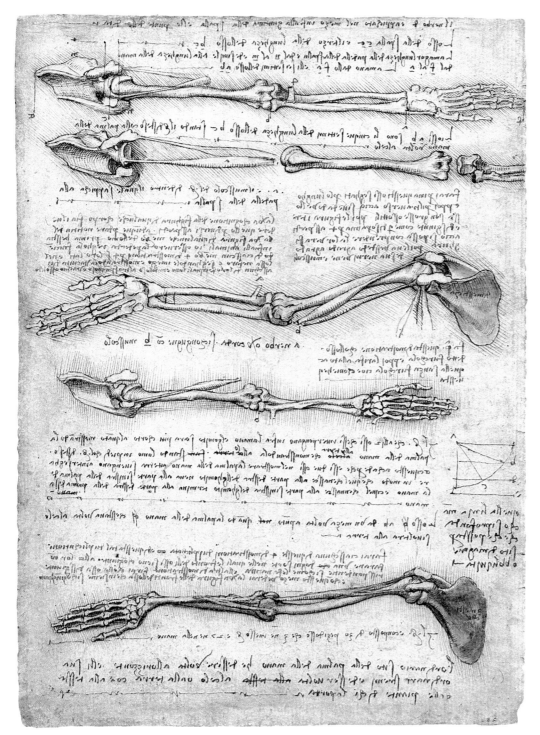

106

STUDIES OF THE ARM SHOWING THE
MOVEMENTS MADE BY THE BICEPS,
*c.*1510

Pen and ink with wash over traces of
black chalk. 291 × 200 mm
Prov.: Windsor Leoni volume (19000v)
Ref.: A iv; C&P; K/P 135v

This drawing, belonging to the
campaign around 1510 to bring his
anatomical studies to a point of
publishable completion, is one of the
most refined examples of Leonardo's
understanding of bodily mechanics and
of his lucid illustrative techniques. His
investigation centres on the role of the
biceps, not only as the muscle which
bends the arm at the elbow but also as
the one responsible for the supination of
the hand – its rotation on the axis of the
forearm by the crossing of the radius
and ulna. This latter function,
emphasised by his careful illustration of
its insertion in the radius of the arm,
was not otherwise described until the
eighteenth century. The geometrical
diagram in the right-hand margin
explains that the crossing of the radius
and ulna will slightly shorten the
forearm according to the principle that
'that line which is lower down becomes
shorter because it is placed in a position
of greater obliquity'. Such a variation in
length has obvious implications for the
system of proportions illustrated in the
upper diagrams.

The transmission of a linear force into
a circular motion in a different plane
was of continuing fascination to
Leonardo as an engineer. His methods of
anatomical demonstration were
conceived to lay bare the anatomical
engineering with the greatest clarity, and
also, by emphasising the system of levers
and using the exploded view in the
second illustration, to show how the
articulations are designed to facilitate the
range of motions required of each joint.
He also reasserts his view that 'the true
knowledge of the shape of any body
consists of seeing it from different
aspects'.

107

STUDIES OF THE ANATOMY OF A BIRD'S
WING AND BIRD FLIGHT, *c*.1510–14
Pen and ink over black chalk.
224 × 204 mm
Prov.: Windsor Leoni volume (12656)
Ref.: C&P; K/P 187v

Leonardo's most sustained analysis of the
dynamics of bird flight is conducted in
his manuscript *Sul Volo degli Uccelli*
(Biblioteca Reale, Turin) which is dated
1505. The small sketch of the flying bird
on this sheet has much in common with
the Turin studies, but the presentation of
the anatomical structures seems to
belong with his anatomical work of the
1510–13 period. The note on
aerodynamics may also be aligned with
his discussion of bird flight in Ms.E
(1513–14).

The understanding of the mechanisms
and dynamics of bird flight remained of
crucial importance in his continuing
attempts to invent a flying machine, but
by this stage of his career he had come
to realise that direct imitation of a bird
or bat was impossible. His closer
knowledge of both bird and human
anatomy confirmed the essential
analogies between the mechanisms of
bones, tendons and muscles but also
convinced him that the differences were
such that man could not hope to
emulate the specialised strength of the
bird. In particular, manned flight could
not exploit the favourable power-to-
weight ratio in flying creatures. He
noted that 'the muscles which move the
bird's wings . . . possess in themselves a
greater weight than all the rest of the
bird'. And, 'the simple power of man
will never work the wing of the crow
with such speed as did the crow'.

The deleted note and flying birds at
the upper right explain the importance
of the 'thumb' *ab* at the leading edge of
the wing, by which 'the bird remains
stationary in the air against the motion
of the wind'. It was such mechanisms,
devoted to gliding and banking against
air currents rather than active flapping,
that now seemed to promise the best
hope of human flight.

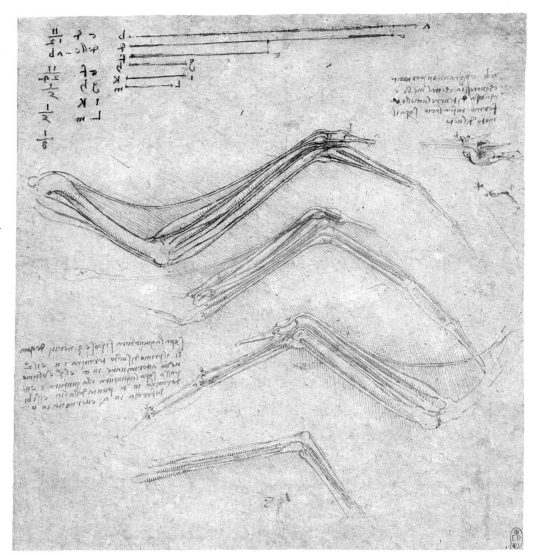

108

THE MECHANISMS OF THE HAND, c.1510
Pen and ink with wash over traces of
 black chalk. 288 × 202 mm
Prov.: Windsor Leoni volume (19009)
Ref.: A 10r; C&P; K/P 143r

The main subject of these drawings, which clearly belong with the c.1510 series in style and function (nos. 105–6), is the operation of the flexor tendons. These demonstrations are part of a sequence entitled 'depiction of the hand' which begins on the verso of this sheet. He planned to display the hand systematically from various aspects at successive stages of the clothing of the bones with ligaments, muscles, tendons, nerves, blood vessels and skin. This already extensive series, which would have involved eight or ten demonstrations, was to be further amplified: 'these separate operations should be carried out on an old man, a young man, and a child, noting the length, thickness and breadth in each case'.

In order to render the mechanical system in all its three-dimensional complexity, Leonardo recommends his own special kind of illustrative technique: 'when you have drawn the bones of the hand and wish to draw on this the muscles which are joined to these bones, make threads instead of muscles. I say threads not lines in order that one should know what muscles go below or above another muscle, which cannot be done with simple lines.'

Around the small mechanical diagram between the upper studies of the whole hand, which shows the *flexor digitum profundus* passing through the *flexor digitum sublimis*, he has written: 'make the book on the elements of machines and its practical applications precede the demonstration of the movement and force of man and other animals, by means of which you will be able to prove all your propositions'.

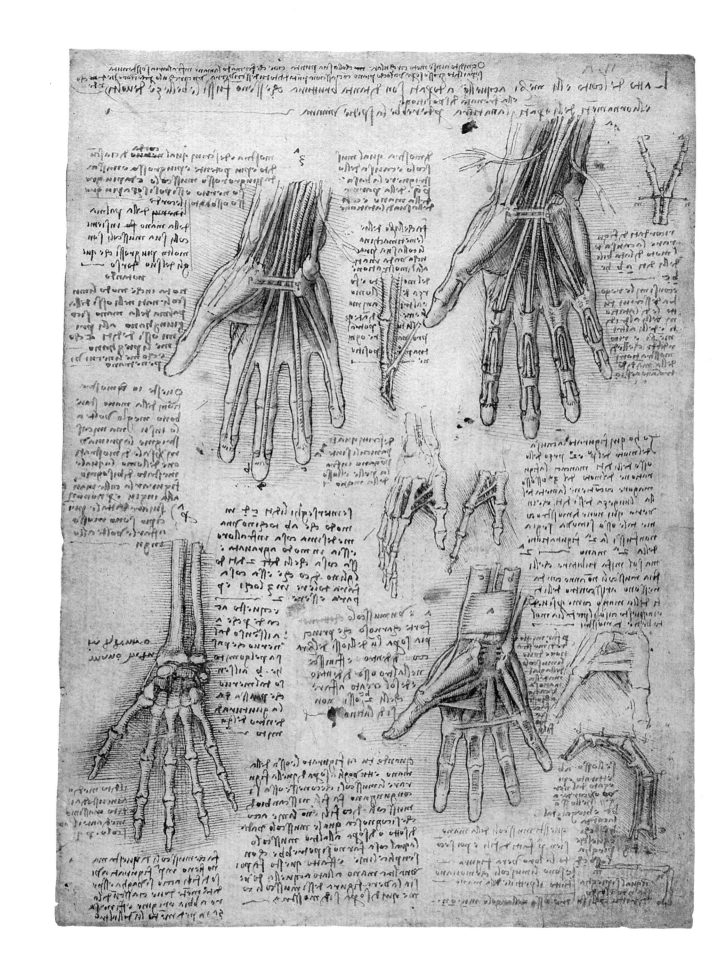

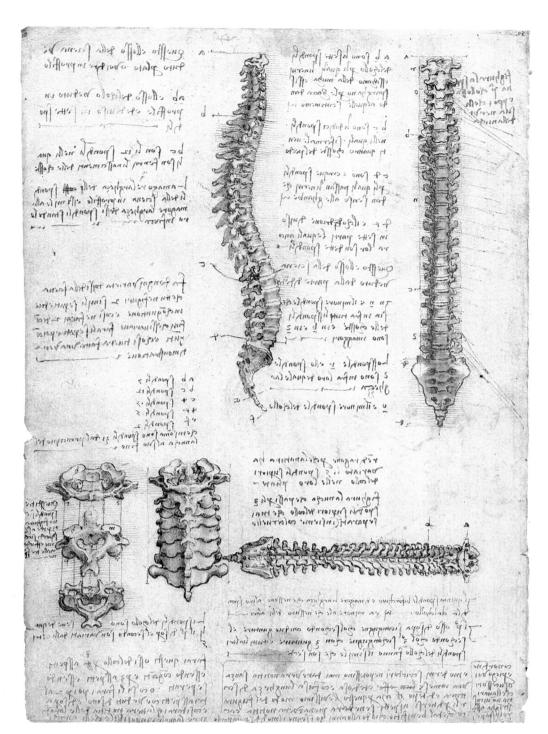

109

THE VERTEBRAL COLUMN, *c*.1510
Pen and ink with wash over traces of
 black chalk. 299 × 199 mm
Prov.: Windsor Leoni volume (19007v)
Ref.: A 8v; C&P; K/P 139v

This magnificent depiction of the
vertebral column, from the campaign
around 1510, illustrates the flexible
articulation of the spine, in particular the
complex engineering of the neck. The
seven cervical vertebrae are studied more
closely at the lower left, and the first
three are shown in an exploded view to
clarify the intricacies of their abutment.
He reminds himself to 'indicate for what
reason nature has varied the processes of
the five superior vertebrae of the neck'.
However, even while he is concentrating
on this overtly structural investigation,
his interest in the nervous system has
intruded, and he notes the destinations
of the nerves originating from the spinal
column.

With evident satisfaction he writes at
the bottom of the sheet that his system
of demonstration will give a 'true
knowledge' of the configuration of the
vertebrae:

> which is impossible for either ancient
> or modern writers . . . without an
> immense, tedious and confused length
> of writing and time. But through this
> very short way of drawing them from
> different aspects one gives a full and
> true knowledge of them. And in
> order to give this benefit to men I
> teach ways of reproducing and
> arranging it, and I pray you, O
> successors, not to be parsimonious by
> getting them printed in . . . [woodcut?].

There is evidence in Codex Madrid II
(f.119r) that Leonardo was
experimenting with his own system of
relief printing with copper plates as a
superior alternative to cruder
woodblocks.

His ability to visualise the shape of the
spine within the spatial configuration of
the whole body has resulted in a
depiction of spinal curvature which is
unmatched in Renaissance anatomy –
using not only his control of contour
but also his mastery of light and shade.

110

MUSCLES OF THE RIBS AND UPPER SPINE,
*c.*1510

Pen and ink. 285 × 195 mm
Prov.: Windsor Leoni volume (19015v)
Ref.: A 16v; C&P; K/P 150v

This page of extended notes with
marginal illustrations, analysing the
functioning of the parts of the body, is a
common type in Leonardo's later
anatomical work. The drawings are not
so much intended as accurate
descriptions of the actual appearance of
the features in dissection as
demonstrations of the relevant
mechanical principles.

He explains that the muscles which
run diagonally from the upper spine to
the ribs maintain the bones in a system
of supportive tension, just as 'a chord
acts through the ends of a bow'. The
diagram at the lower left exploits the
analogy of the mast of a ship: 'such a
convergence of the muscles of the spine
holds it erect just as the ropes of a ship
support its mast, and the same ropes,
tied to the mast, also support in part the
framework of the ships to which they
are attached'. He also argues that the
stays will produce greater stability the
greater the angle they make with the
mast, just as the muscles will be most
effective when they are attached to the
ribs further from the axis of the spine.

The use of purely mechanical
diagrams to clarify anatomical functions
is characteristic of his later researches. In
another drawing at Windsor (19061v) he
uses a diagram of a lever operated by a
rope over a pulley to explain the
mechanical principles at work when the
muscles raise the ribs in breathing.

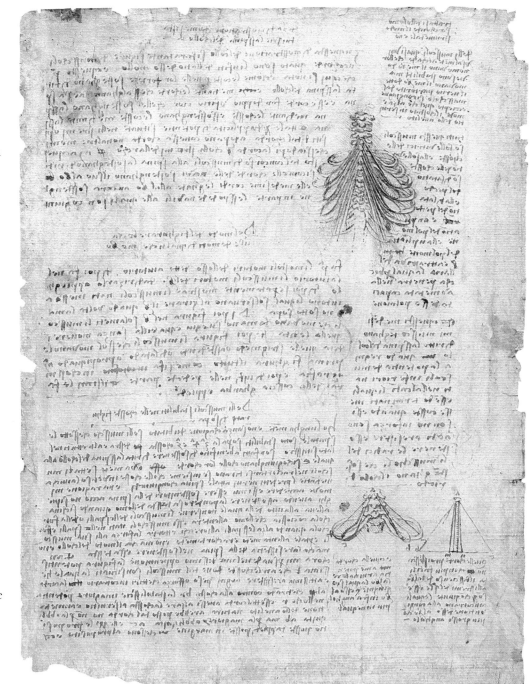

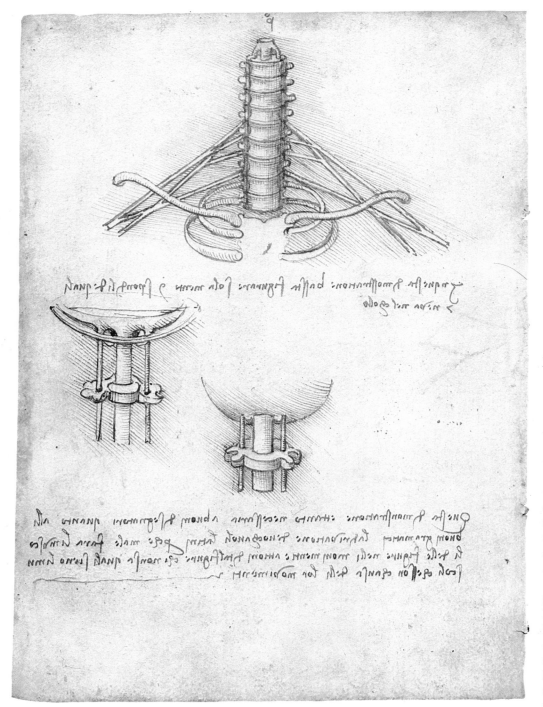

SCHEMATIC DRAWINGS OF THE BRACHIAL
PLEXUS, AND THE JUNCTION OF THE
SKULL AND SPINAL COLUMN, c.1506–7
Pen and ink. 190 × 133 mm
Prov.: Windsor Leoni volume (19021v)
Ref.: B 4v; C&P; K/P 62v

The depiction of the 'spondyls'
(vertebrae) and nervous system is
deliberately schematised to clarify the
basic configuration of the neural tubes
running through the structural blocks of
the spine. The spurious lateral channels,
as in his earliest demonstrations of the
spinal chord, are intended for the
transmission of the 'animal spirits'. Only
four of the five roots of the brachial
plexus are shown, though he was later
to recognise the fifth. The schematic
quality tends to give the drawing
affinities with his work of the 1490s, but
evidence of content suggests a date little
if anything earlier than the 'centenarian'
series (nos. 51 and 53).

The structure and function of the
nerves are conceived in the traditional
manner in terms of 'pipes' containing a
medulla, through which the 'animal
spirits' ebb and flow to carry sensations
to the brain and to convey commands
to the limbs. This system of
communication held considerable
interest for Leonardo, since it was the
means by which the mind controlled the
expressive dynamics of the human body.
As he wrote below the central diagram,
'this demonstration is as necessary to
good draughtsmen as is the declension of
latin vocabulary to good grammarians,
because he will poorly make the muscles
of the figures in the movements and
actions of these figures if he does not
know what are the muscles which are
the cause of the movements'. The direct
relevance of this note to this particular
drawing becomes clearer when we
realise that the chord-like substance of
the nerves and the fibres of the muscles
were regarded as continuous.

The similarity of this demonstration
to a piece of ship's rigging is not
intended in this instance to convey
precise structural analogies of the kind
seen in the preceding drawing (no. 110),
but it does reflect his desire to represent
the body as a composition of mechanical
units.

112

A LIFTING DEVICE, *c.*1493

Red chalk. Folio measurement:
93 × 68 mm

The Board of Trustees of the Victoria
and Albert Museum, London

Prov.: J. Forster; Victoria and Albert
Museum, London (Codex Forster III,
f.56v)

Ref.: Reale Commissione Vinciana 1934,
IV, p. 83

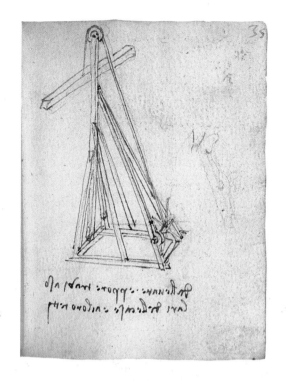

Forster III, containing 88 folios, is a
well-preserved example of one of
Leonardo's small 'pocket-books' (*piccoli
libretti*) in its original binding. This
particular notebook deals with various
subjects – and may have been used both
in and outside the studio.

This right-hand page shows one of his
typical demonstrations of a pyramidal
armature of a relatively conventional
kind. Such armatures would have been
of wide use on varying scales when a
stable structure was needed for the
purpose of supporting heavy weights,
and one such system is illustrated on a
huge scale as the base for a crane to lift
buckets of soil from the excavations of a
canal.

In this particular example a relatively
simple arrangement of a pulley, rope
and winch is used to lift a weight, while
the armature both provides a rigid
support and a counterweight for the
raised object. Its purpose, defined in the
note, is 'to lift and put in place beams in
the attics of houses and on their roofs'.

The framework of diagonal stays –
supporting a central, vertical member
and providing a stable base for motion –
exploits engineering principles similar to
those used in the human body to sustain
the weight of the head (no. 110).

113

AN ARTILLERY PARK, *c*.1487
Pen and ink. 250 × 183 mm
Prov.: Windsor Leoni volume (12647)
Ref.: Popham 305; C&P; Pedretti IV 433

This drawing portrays a yard with a store of cannons, balls and at least one mortar. An armature with ropes, pulley and winches (similar in general type to that on no. 112) is being used to heave an enormous cannon barrel on to a gun carriage. Teams of naked men strain at the long levers of the winches, while others push and haul the axles and wheels into place. In the foreground is a cradle with rollers that has been used to transport the cannon (from the foundry?).

Although not precisely comparable to any other drawing by Leonardo, this drawing has clear affinities with a series of military designs executed during his early years in Milan in which practical invention, antique precedent and imaginative implausibility are seamlessly mingled.

The characterisations of the structures, mechanisms and dynamics of human force are founded upon the kind of researches described by Luca Pacioli (no. 104), but they are here placed in the service of an imaginative vision, in which primitive squads of workers appear to have become slaves to their monstrous creation. The frantic tenor of the drawing is comparable to the fable he composed about the extraction of metal from mined ores for military purposes:

> It will emerge from dark and gloomy caverns, casting all human races into great anxiety, peril and death . . . It will take away the lives of many, with this men will torment each other with many artifices, traductions and treasons. O monstrous creature, how much better it would be if you were to return to hell.

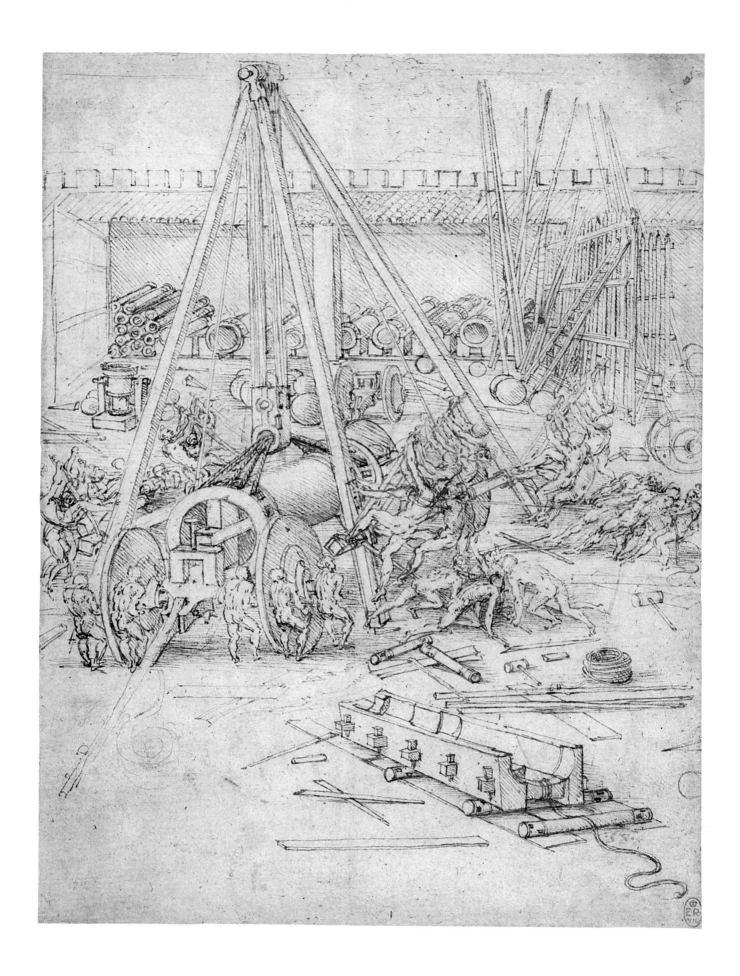

114

This interesting sheet of studies is relatively little known and has not been fully analysed in the standard literature. The upper drawing is a device for assaulting maritime defences, and is closely related to a design in the Codex Trivulzianus (f.2r) for attacking a tower at sea. In Ms.B (f. 48r) he discusses the defence of such a tower. In his letter of self-commendation to Ludovico Sforza, Leonardo claimed that 'should a sea battle be occasioned, I have examples of many instruments which are highly suitable either in attack or defence'.

This device is to be mounted in the bows of a boat. Leonardo's notes explain that its function is 'to scale the top of a tower from the sea, and if there are two towers put them in line so that one makes a shield for the other, but make sure you ascertain that the sea is calm'. The large, curved counterweight to the left is to be filled with 'wet hay', and will, at an appropriate moment, be used to swing the sides of the scaling-tower into an upright position. The lower of the two sides passes over a roller to permit it to remain at the same level as the fixed central arm. The attackers then climb to the top of the scaling-tower to assault the maritime defences.

The lower mechanism is designed to 'turn a beam to make frameworks [*chavaletti*]'. As the beam is levered into an arched position over the central wedge, so the pegs are moved successively lower in the holes in the right-hand uprights. The uprights are firmly anchored 'below ground'. Such curved beams could be used in various structural roles (e.g. Codex Madrid I, f.139r), and most particularly in bridges, vaults, roofs and centering for stone constructions. This design may be connected with his work on the project for the crossing-dome of Milan Cathedral in 1487–8.

The combinations of supports and levers which on the one hand provide the mechanisms for motion and on the other a system under tension are precisely analogous to the forms and functions in Leonardo's anatomical investigations of the bones, tendons and muscles of the human body (see especially no. 110).

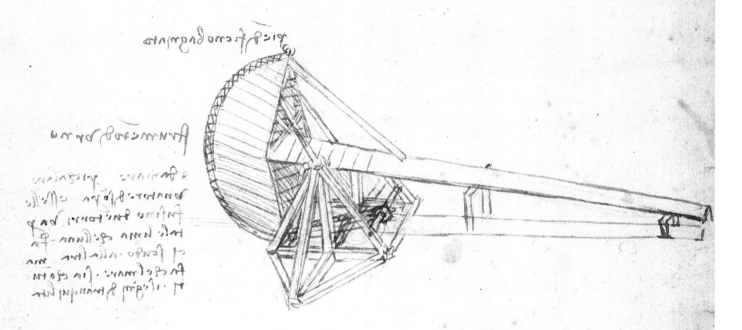

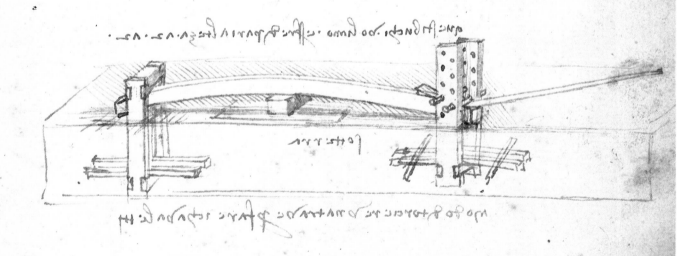

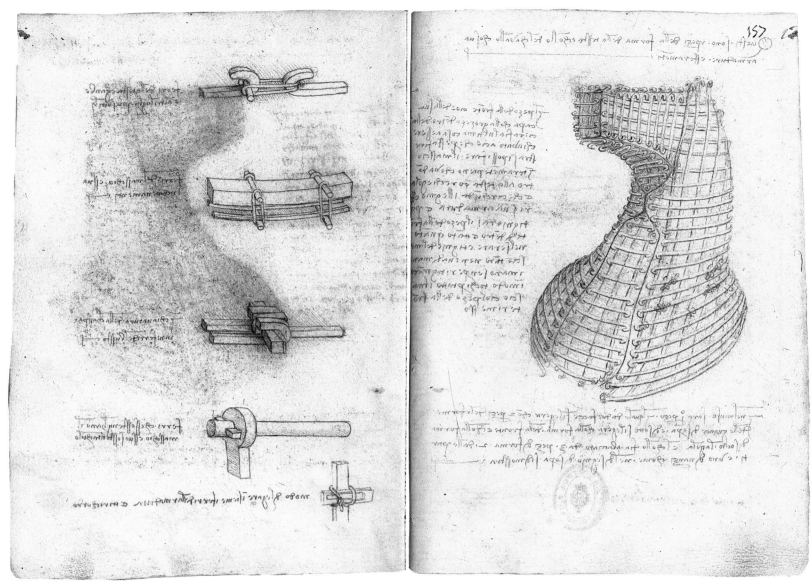

115

DEVICE FOR SECURING THE PIECE-MOULD
OF A HORSE'S HEAD FOR CASTING,
*c.*1491–3

Red chalk. Folio measurements:
220 × 300 mm
Biblioteca Nacional, Madrid
Prov.: Pompeo Leoni; Biblioteca
Nacional, Madrid (Madrid Codex II;
MS.8936, ff.156v–157r)
Ref.: L. Reti, 1974

Seventeen folios devoted to the casting
of the bronze equestrian monument to
Francesco Sforza are bound at the end of
Codex Madrid II, which otherwise
contains material of a later date. Folios
157v and 151v carry the dates 1491 and
1493 respectively. On the earlier of these

Leonardo writes that 'here a record shall
be kept of everything related to the
bronze horse presently under
construction'. The later note records a
decision: 'I have decided to cast the
horse without its tail and lying on its
side.' The years 1491–3 marked the
second phase of his work on the horse,
culminating in a colossal clay model,
three times life-size. Not surprisingly, he
was much occupied with the enormous
technical problems of casting such an
equestrian giant.

The elaborate and beautiful drawing
on the right-hand page shows the pieces
of the outer mould for the head and
neck held in place by an ingenious
corset of iron hooks and stays. Leonardo
explains that:

These are the pieces of the mould of
the head and neck of the horse with
its armatures and ironwork. The piece
of the forehead, that is to say of its
outer layer with thickness of the wax
within, will be the last thing to be
locked, so that it is possible to fill
completely through this aperture the
core [the 'male' of the mould], which
goes inside the head, ears and neck,
and is surrounded by the wood and
iron. Afterwards you shall stain the
piece of the forehead on the inside
shutting it in place so that it stains the
core, successively taking it off and
restaining it in such a way that the
core is wholly in contact with the
piece of the forehead when put
back.

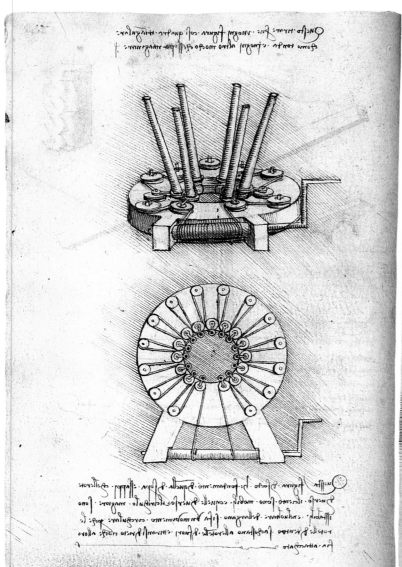

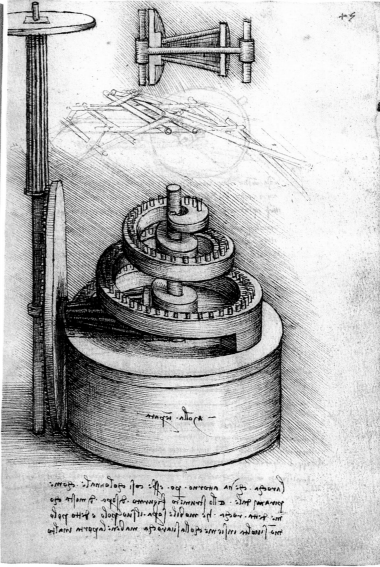

The lower note discusses the number of pieces involved in the mould of the head and neck, and the way they are to be interlocked.

The drawings of the left-hand page show close-ups of the locking mechanisms for the outer stays and for the transverse rods to hold the piece-mould and inner core rigidly in place during the arduous and infernal process of casting. They are labelled respectively: 'irons of the side, legs and other more slender parts'; 'irons of the core and their linkage'; 'locking of the head with the irons of the chest'; 'irons that sustain the core and its support'; 'manner of binding together the irons of the armature, and I draw it to your attention'.

116

STRETCHING DEVICE AND VOLUTE GEAR
 FOR A BARREL SPRING, *c*.1498–1500
Pen and ink. Folio measurements:
 220 × 300 mm
Biblioteca Nacional, Madrid
Prov.: Pompeo Leoni; Biblioteca
 Nacional, Madrid (Madrid Codex I;
 Ms.8937; ff.44v–45r)
Ref.: L. Reti, 1974

The verso of the first page of this manuscript of 192 folios is dated 1493, and the inside of the flyleaf carries a memorandum from 1497. Most of the highly-worked engineering drawings of the kind shown here appear to date from the late 1490s at the earliest. The somewhat different quality of line on these two folios indicates that they were drawn at different times with different pens, but not necessarily that they are significantly different in date.

Leonardo's meticulous demonstrations of the anatomical 'elements of machines' – of the kind mentioned on the later drawing of the hand (no. 108) – are as close to a publishable state as any of his drawings that have come down to us. His concern in this set of illustrations is

less to illustrate complete machines – though he does that on occasion – than to show components capable of performing difficult functions in a compact and economical manner.

The instrument on the left-hand page is designed to produce a powerful, all-round stretching motion as the upright arms are dragged progressively further apart. Its practical application is unclear, though it may have been of use in the textile industry. 'This traductor works with any shape, whether square, triangular or round, and in any other way that can be imagined.' In the lower note, accompanying the plan of the machine, he explains that 'the wheels towards the centre are movable and those towards the outside are fixed. And in turning the crank a circular movement is made, because the inner rollers approach the outer rollers and pull towards them whatever is attached to the inner ones.'

The drawing on the right-hand page shows how a 'tempered spring' within a barrel can be linked to a volute gear to equalise its power as it unwinds. The regulation of a spring in such a way that it would not deliver a greatly differing amount of power at the start and near the end of its unwinding was a major problem in the Renaissance, particularly with respect to clockwork mechanisms. Leonardo considered various forms of conical and spiral gearing, of which the present example is the most beguiling if not the most practical. He indicates that the 'pinion which turns may be either columnar or pyramidal [as here]. And the device depicted above shows how the pinion is mobile on its shaft. And this shaft does not turn with its pinion, but carries it smoothly upwards.' The cut-away drawing at the top shows this shaft and its two sleeves on the upright axles.

These two inventions are superbly representative of Leonardo's brilliance in envisaging and representing the transmission of motion. The 'traductor' transmits circular motion – a subject of major fascination for Leonardo – from one plane into another, while the volute gear is knowingly designed to neutralise the 'pyramidal law' of diminution which he saw as inherent in all the powers of nature.

To meet the challenge of representing such devices in a compellingly three-dimensional manner Leonardo exploits a system of curving hatching lines of a kind that he later develops in his studies for works of art (e.g. nos. 14 and 75).

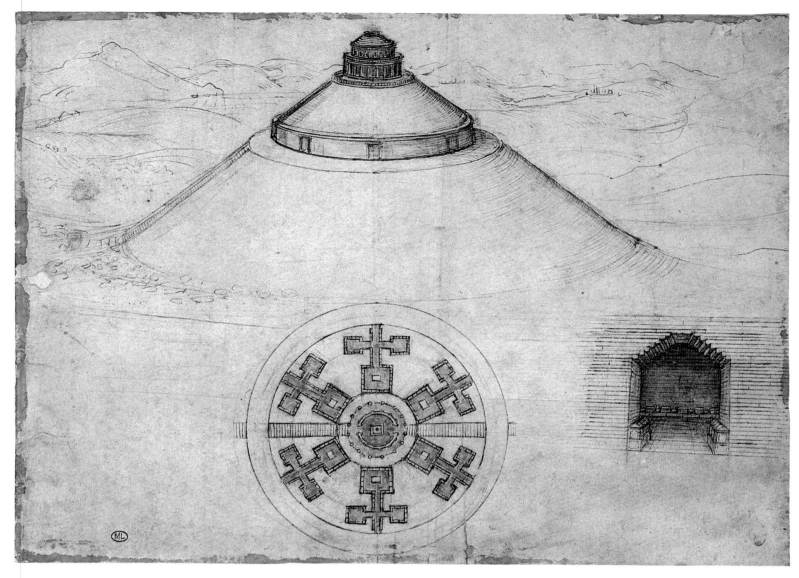

117

A MONUMENTAL MAUSOLEUM IN THE
ANTIQUE MANNER, *c.*1507
Pen and ink and wash over black chalk
and stylus. 266 × 197 mm
Musée du Louvre, Département des Arts
Graphiques, Paris
Prov.: G. Vallardi; Musée du Louvre,
1856 (2386)
Ref.: Pedretti, *Leonardo Architect*, p. 122

This surprisingly little-known drawing
(occasionally attributed to Francesco di
Giorgio) shows one of Leonardo's most
extraordinary architectural conceptions.
He has envisaged a conical mountain –
not at all dwarfed by the real mountains
– capped by a circular temple with a
peristyle and stepped dome. At two-
thirds of the height of the cone a terrace

is cut, providing access to six galleries,
leading to a series of burial chambers,
the largest of which appears to contain
square altars. Each burial chamber is
lined with funerary urns, making about
500 in total.

In general terms Leonardo is setting
himself up to surpass the builders of the
seven wonders of the world, such as the
architect of the Mausoleum of
Halicarnassus, and even to rival the
engineering feats of nature herself. He
was probably also thinking of the great
Roman mausoleums such as that of
Hadrian (now the Castel S Angelo) and
more particularly that of Augustus of
28 BC, which has a comparably tiered
structure and radial chambers. His
immediate source of inspiration appears
to have come from archaeological

discoveries in Tuscany. The form of the
burial chambers, particularly the
corbelled arch construction illustrated in
the smaller study of one of the inner
chambers, is based upon Etruscan tombs.
The specific stimulus for Leonardo's
imagination may have been the
discovery in 1507 of an Etruscan tomb
on the tumulus of Montecalvario at
Castellina in the Chianti region. None
of the likely antique precedents,
however, quite prepare us for the
elemental grandeur of Leonardo's
conception.

118

CENTRALISED TEMPLE, AND MARITIME
ENGINEERING, *c*.1488
Pen and ink and wash over black chalk.
 Folio measurement: 240 × 190 mm
Bibliothèque de l'Institut de France,
 Paris
Prov.: Biblioteca Ambrosiana, 1637; to
 Paris, 1795–6, Institut de France;
 extracted from Ms.B by Count
 Guglielmo Libri, 1830s; Ashburnham
 Place; Bibliothèque Nationale, Institut
 de France (Ms.2184; BN 2037, f.5v)
Ref.: Ravaisson-Mollien, 1891

Ms. BN 2037, comprising thirty-two folios, and Ms.B (of which it was originally part) contain a series of designs for churches or 'temples', the majority of which work ingenious variations on centralised plans – square, polygonal, round or in combination. They appear to have been made around the year 1488, when Leonardo was involved with the project for a domed crossing for Milan Cathedral.

Centralised church designs were beloved of Renaissance theorists, such as Alberti, who was inspired not least by the Roman treatise of Vitruvius, but they were rarely commissioned on a large scale for reasons of liturgy and function. Leonardo's own variations on the theme are notable for their sustained variety, the intricate geometry of their plans, the elaborate accretion of primary and secondary spaces, and the organic clustering of varied shapes on the exteriors. His system of presentation, using solid exterior views in perspective, plans and various kinds of sections is closely related to the system of demonstration used in his skull studies at this time (nos. 9 and 93). He was fully conscious of the proportional and structural similarities between the 'dome' of the skull and his domed temples, and his letter to the authorities at Milan Cathedral about their project centred upon an elaborate analogy between a sound building and a healthy body.

This particular design is one of his most unified and resolved schemes, and provides the basis for the exhibited model. At the upper left he revises the structure of the eight secondary domes, introducing drums with round windows to admit more light into the circumferential chapels. The lower note discusses the problem of how to accommodate a bell-tower in this type of design:

> Here a campanile neither can nor should be made. Rather they should stand separately, as happens at the Cathedral and S. Giovanni in Florence and similarly the Cathedral at Pisa, and each shows its perfection on its own. And if you nevertheless wish it to be with the church, make the lantern serve as the campanile, as at the church of Chiaravalle.

It is unclear if Leonardo's temple designs were made for a specific project, and they seem to vary considerably in scale (to judge from windows, doors, statuary etc.). Some, including this example, may represent thoughts for a Sforza mausoleum, such as Bramante was to build in his semi-centralised east end of Sta Maria delle Grazie. It is likely that Bramante was profoundly influenced by Leonardo's vision, though his mastery of volume and interval avoids the rather cluttered effects of Leonardo's unrelievedly dense designs.

The sketches on the left-hand page are concerned with maritime engineering, showing a device of chains to stabilise a rudder, and a lifting mechanism. The double pulley is a relatively early example of the kind of systems he was to investigate intensively in the 1490s, particularly in Codex Madrid I. (The left-to-right note is not by Leonardo.)

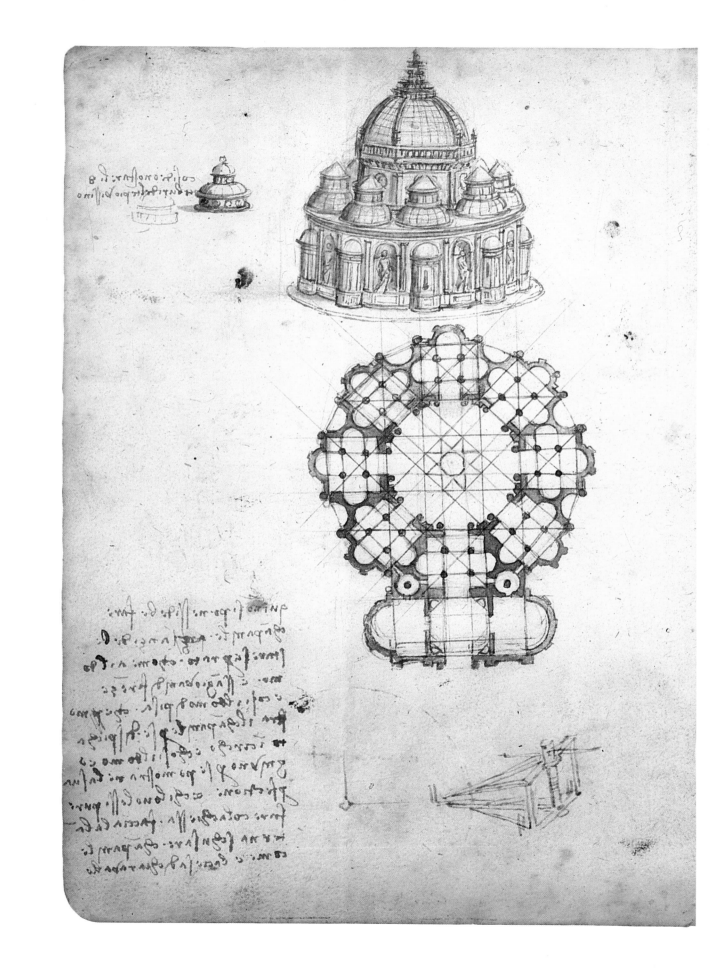

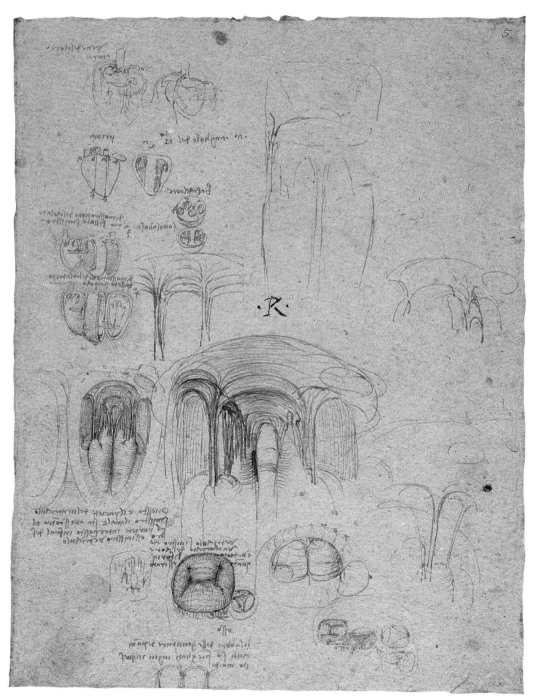

THE VENTRICLES OF THE HEART, *c*.1513
Pen and ink on blue paper.
 284 × 209 mm
Prov.: Windsor Leoni volume (19080)
Ref.: C II 10r; C&P; K/P 107r

Leonardo's most detailed investigations
of the heart and lungs were conducted
during the last years of his life, and one
of the sheets at Windsor (19070v) is
dated 1513 (see also no. 109). He appears
to have been using readily available ox
hearts for his studies.

His central aim in the series was to
define how the intricate structures of the
heart and its delicate valves operated in
conjunction with the hydrodynamic
turbulence of the pumped blood. It was
through the perfect economy of design
of the components that the flexible
structures were able to transform their
shapes in such a way as to orchestrate
the potentially destructive power of the
vortices (no. 55).

In the central drawing he is looking
within the left ventricle at its vaulted
'roof'. He shows the columnar *chordae
tendineae* of the papillary muscle fanning
out to form the curved flaps of the
mitral valve, which is depicted in
isolation from above and below in the
drawings under the main study. Even in
such fleshy and mobile features the sense
of divine architecture is always apparent.

The other drawings show Leonardo
experimenting with various sectional
methods for demonstrating the heart,
and the configuration of valves from
above.

10
MODELLING LEONARDO'S IDEAS BY COMPUTER

The painter, Leonardo believes, must study nature ceaselessly, minutely and intensely, in order to learn how to reproduce its appearances. At the same time this habit of observation and analysis, as practised by Leonardo himself, leads on to a deeper consideration of the ordering principles behind natural appearances. Painting *is* natural philosophy. 'Painting encompasses the surfaces, colours, and forms of anything created by nature, and philosophy penetrates those same bodies, considering their essences, but is not satisfied with its truth as is the painter with his, which comprises the primary truth of the bodies.'

It is striking how many sections of Leonardo's anthology known as the *Trattato della pittura* – on human anatomy, the analysis of optical principles, plant physiology – go well beyond the limits of what is strictly relevant to the painter's needs; and how often a section ends with a remark by Leonardo that he will pursue the subject elsewhere in one of his other projected scientific works. As Heydenreich says, Leonardo's book breaks the traditional pattern of such treatises on art. It has grown beyond these into 'an encyclopaedia of visually transmissible science'.

It is this continuity between Leonardo's visual preoccupations as a painter, and his deeper concerns with geometrical and structural order in nature, his 'visual science', that comprises the main theme of the computer graphics sequences on show in this exhibition. The new medium is especially well suited for this task. Unlike photography which records surface patterns of light and colour directly, computer graphics techniques build realistic images of the world starting, as Leonardo wished, from geometrical and physical first principles. (I am referring here to three-dimensional modelling and rendering by computer; not computer draughting or 'paint systems', which are essentially analogous to traditional two-dimensional graphical media.)

The first step in making such images is to construct numerical 'three-dimensional' models of the objects which make up the scene to be depicted, by specifying the co-ordinates in space of points on these objects. The points fix the positions of lines marking the edges of the objects, and the edge-lines in turn define their bounding surfaces. These surfaces are then assigned numerical values to denote colours and textures.

The next step is to decide the position of the viewer and picture plane relative to the scene, and to have the computer construct a perspective view, by calculating the diminution of size with distance and determining which parts are visible and which hidden.

The last step is to decide the positions of lights in the scene – either sun and skylight, or artificial light sources. The computer then calculates the effects of this

illumination on the appearances of objects in the scene. When the colour and intensity of illumination of every point in the image have been calculated, the picture may be displayed.

Once a three-dimensional mathematical model of a scene is built, it is possible to compute perspective views from different viewpoints by reference to the same model. If successive views are computed with slightly changed viewpoints – or if the positions of models in the scene are gradually altered – and these perspective images are then recorded and replayed in sequence, the result is an animated film. All the computer images included in the exhibition have been produced in this way.

We can compare this process of computer modelling and rendering with the very first sections of the *paragone* which prefaces Leonardo's *Trattato della Pittura*.

> The first principle of the science of painting is the point, then comes the line, then the surface, and then the body bounded by a given surface . . . The second principle of painting is the shadow of the body which it represents . . . The science of painting includes all the colours of the surfaces, and the forms of the bodies bounded by them, as well as their nearness and distance, including the proper degrees of diminution, according to degrees of distance. This science is the mother of perspective, or visual lines . . . [From perspective] there arises another science, which includes shadow and light, or brightness and darkness, a science capable of great development.

It is hardly exaggerating to say that Leonardo covers the same subjects, and in much the same order, as one would expect to find in a modern manual of computer graphics. What Leonardo misses, of course, is the last stage in which single images are combined to make moving pictures. One can almost feel his frustration at the limitations of static graphical forms of representation, in those sequences of anatomical drawings of the arm and shoulder in which the viewpoints are moved slowly round the body (nos. 95 and 96), or in his sketches of birds in flight (eg. no. 107), water in movement (nos. 21 and 61) and men at work (no. 97).

Three of the sequences in the exhibition explore topics within these three areas: the geometry of solid bodies, the geometry of linear perspective, and the optics of light and shadow. Of necessity we have had to be highly selective from amongst Leonardo's multifarious interests.

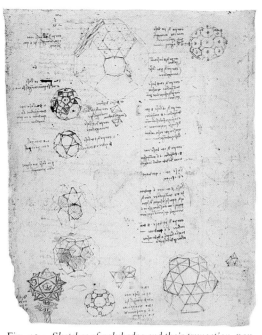

Fig. 42 *Sketches of polyhedra and their truncation*, pen and ink (C.A. 272vb/735v). The pair of bodies at top left are both originally dodecahedra (bodies with twelve pentagonal faces). The upper of the two solids (with the black shaded triangles) has been transformed by truncation into the 'truncated dodecahedron'; and the lower into the 'icosi-dodecahedron'.

Geometrical bodies

Out of Leonardo's wide-ranging studies in plane and solid geometry, we have chosen to illustrate his work on polyhedra. He was familiar with and made sketches of the five Platonic or regular polyhedra, and most of the thirteen Archimedean or semi-regular polyhedra. He prepared finished perspective drawings of some of these for the geometrical treatise *De divina proportione* written by his mathematician friend Luca Pacioli, produced in manuscript in 1498, and printed in 1509 (no. 104).

The Platonic solids are bodies whose faces are all regular polygons of the same type. They comprise the tetrahedron (whose four faces are triangles), the cube (six squares), the octahedron (eight triangles), the dodecahedron (twelve pentagons)

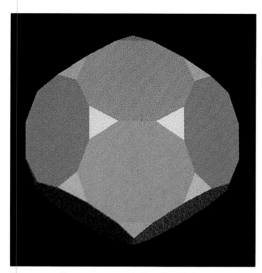

Fig. 43 Computer models of polyhedra in the process of truncation. *Top*: the light-coloured triangles show where a dodecahedron has been truncated (compare Fig. 42). *Bottom*: the dark-coloured pentagons show where an icosahedron has been truncated. When the process of truncation is taken further, the result in both cases is the icosidodecahedron.

and the icosahedron (twenty triangles). The Archimedean solids also have faces which are all regular polygons, but now faces of two or more types are found in the same body. However, there are always faces of the same types arranged in the same order around every corner of the solid.

As their names indicate, these bodies were known to the Greeks. Where Leonardo's special interest lies is in their relationships, and how they may be *transformed* one into another. He appreciates that one way this can be done is through a process of truncation, that is by cutting pyramids off their corners. This is clear from a very remarkable page of sketches in the Codex Atlanticus (f.272vb/735v; fig. 42).

Consider for example the two bodies at the head of the left-hand column of diagrams. These are both originally regular dodecahedra (with twelve pentagonal faces). The upper of the two bodies has been truncated – the black shaded triangles show where triangular pyramids have been removed – to produce the 'truncated dodecahedron', which is an Archimedean solid. (The drawing is somewhat complicated by the fact that Leonardo has further subdivided some of the resulting ten-sided faces.) The lower dodecahedron has also been truncated, but now the triangular pyramids which are being removed touch at their corners. The result is the Archimedean solid known as the icosidodecahedron.

Equivalent relationships exist between many other pairs of bodies. These are depicted in the filmed sequence (fig. 43). In some cases the same body may be produced by truncating two different other bodies. For example the cuboctahedron can be produced by truncating either the octahedron or the cube.

The perspective of paintings

Leonardo devoted much time and thought to the study of perspective – both the geometry of how images of three-dimensional objects may be projected onto two-dimensional surfaces, and the physics of how light can be changed in colour and intensity by its passage through the atmosphere ('linear perspective' and 'atmospheric perspective'). Cellini even speaks of seeing a manuscript by Leonardo containing 'the most beautiful discourse on perspective ever composed' – but this seems to have been lost.

What is odd is that very few of Leonardo's surviving paintings contain any architectural element in their settings, in which his skill and knowledge of perspective geometry could be deployed (although many of his landscape backgrounds display the effects of atmospheric perspective). The exceptions are the *Adoration of the Magi* – for whose architectural structures there exists a well-known perspective study – the *Annunciation*, and the *Last Supper*. We have chosen to explore the third of these in the computer graphics sequence, since the *Last Supper* presents the most interesting, albeit the most controversial, problems to perspective analysis. These problems occur in part because of the poor physical state of the picture, especially in those peripheral areas, at the sides and in the painted floor, which would give clues to its perspective structure.

A fundamental difficulty is created for Leonardo at the outset by the fact that his fresco is painted on the upper part of the end wall of the Refectory of Sta Maria delle Grazie, with its lower edge somewhat above the height of the viewer's head (figs. 25, 44 and 45). Had Leonardo painted the 'upper room' in which Christ and

the disciples are seated from the theoretical perspective viewpoint of a person standing in the Refectory, then the floor of the room would have not been visible and, more serious, the dining table would have been seen from its *under side*, concealing the bodies of the disciples beyond it. Leonardo solves the difficulty by choosing a viewpoint at a much greater height – opposite Christ's head in the picture. It is not possible (without a step-ladder) to view the painting from this 'correct' position.

However the solution of one problem only creates another. The floor of the painted room, now visible but seen from the 'wrong' height, is in danger of appearing to slope upwards towards the back. It is no doubt in part to conceal this that Leonardo's figures and table are brought right to the front and fill the whole lower half of the painting, so hiding all of the floor surface except its nearest edge.

Leonardo's second difficulty in perspective geometry is connected with the fact that he clearly intends the painted room to appear to continue the real Refectory, so that the monks take their supper in the same space with Christ and the disciples. The painted room is lit as if by the real windows in the west wall of the Refectory. (The windows in the east wall were removed when the building was restored after the bombing during the Second World War.) And the top edges of the tapestries on the walls of the painted room appear to continue precisely the line of the painted cornice in the Refectory.

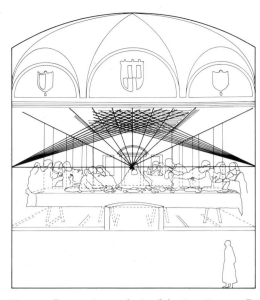

Fig. 44 Perspective analysis of the *Last Supper*, © 1988 Philip Steadman. Above the painting are the vaults of the roof. The central vanishing point falls in Christ's head. The theoretical viewpoint of the picture is opposite this vanishing point, about 4½ metres above the present floor level. The actual viewpoint of any person standing in the Refectory must be below the bottom edge of the painting.

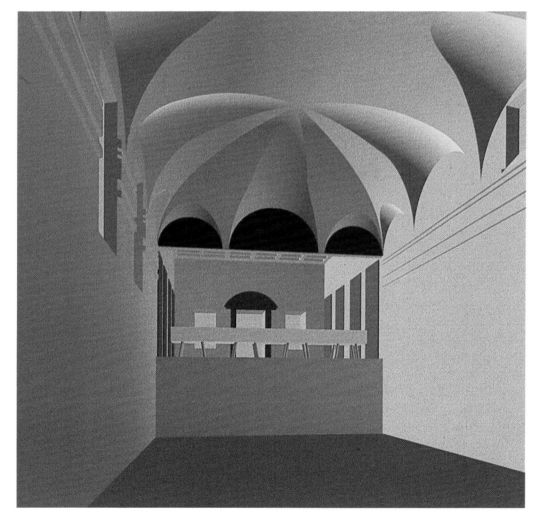

Fig. 45 Computer model of the Refectory of Sta Maria delle Grazie. The fictive room depicted in the *Last Supper* appears as a three-dimensional model beyond the position on the wall which the painting occupies.

A perfect illusion of continuity can, however, be created only for one single point – the theoretical viewpoint. From all other viewing positions the perspective lines of the side walls in the picture are bound to break at angles from the lines of the real side walls of the Refectory. There is nothing Leonardo can do to prevent this. He has to rely upon the spectator colluding with his perspective scheme in such a way that the contradictions are effectively ignored.

Several alternative hypotheses have been offered as to what shape in plan the painted room might be – that is to say, what shape Leonardo conceived it to be. Some authors have argued for a double-square plan, which makes the coffers in the gridded ceiling square in shape. But a room of this plan is perhaps excessively deep and empty; and the tapestries on the side walls towards the back of the room would have to be wider than those nearer the front – which seems odd. Some have even argued, with dubious logic, that the room is not rectangular at all, but tapering. We have assumed for the computer graphics sequence that the room is square in plan, which makes the ceiling coffers double-square.

This seems to reconcile several of the puzzling features of the picture's perspective construction. One consequence is that the 'distance points', to which the diagonals of the grid of ceiling coffers converge, lie exactly on the edges of the painting. Leonardo would have been able to set out this geometry with strings stretched from the two points in question.

Shadow and light

One of the longest sections in the *Trattato della pittura*, Part Five, is devoted to the subject 'On Shadow and Light'. This offers direct practical advice to the painter on how to render light and shadow in landscapes, mountains, on drapery and on the human face. But the major part of the chapter is taken up with a much more abstract, analytical account of the underlying optics of natural and artificial illumination. Much of this material comes in turn from the lost *Libro W*, which developed ideas explored in Ms.C (no. 100).

Leonardo describes a systematic series of experiments – some of which he undoubtedly carried out for himself, others of which are perhaps imaginary 'thought experiments' – with lamps shining on simple geometrical solids. He varies the size and shape of the lamp, the size of the illuminated body (usually a sphere), and the distance between the two; and studies the resulting shadows formed on the body itself ('primary' shadows), cast by the body through the air and imprinted onto other surfaces ('derivative' shadows). He introduces more lamps, and looks at the resulting gradation of the depths of shadows at their penumbral edges. He examines how the shadows move as lamps and object move. He studies the way light is interreflected between opposing surfaces, and how as a consequence one surface can take on something of the colour of the surface opposite.

In this context, again, Leonardo emphasises how complementary are the manual activities of the painter and the mental activities of analysing and comprehending visual phenomena.

The scientific and true principles of painting, first determining what a shadowed body is, and what primary and derivative shadows are, and what is illumination, i.e. darkness, light, colour, body, form, location, distance,

nearness, motion and rest, are principles which are comprehended by the mind alone without manual participation. This is the pure science of painting which is in the mind of those who reflect upon it. From it is born creative action, which is of much more value than the reflection or science just mentioned.

In this sequence we use computer graphics to recreate some of these optical experiments of Leonardo's. As part of his investigations, and to explain their results, Leonardo traces the paths of individual light rays in straight lines from lamp to illuminated surface. The technique which is now widely used for calculating just such complex optical phenomena by computer is, precisely, that of 'ray tracing'. Ray tracing in effect follows the paths of many separate rays of light from their origins in light sources, to their final common destination in the notional eye-point of the observer. In the film, ray tracing is used to automate the process which Leonardo carries out so laboriously by hand.

Leonardo is aware of how the intensity of illumination falls off with distance from a light source; and of the way in which the intensity of illumination of a surface also varies with the angle at which the light strikes it (formalised as 'Lambert's cosine law' in the eighteenth century). He studies the formation of highlights on shiny surfaces: how these take their colour from the light source, not the body on which they appear; how they look on dark surfaces by comparison with light surfaces; and how they move as the observer moves. He considers extended or 'area' light sources, such as windows, as well as effective 'point' sources such as candle flames or the sun. And he investigates the combined effects of direct solar illumination with ambient light, or as he calls it 'the universal light of the sky'. The simulation of all these kinds of effects has been a very active branch of computer graphics research over the last few years.

The first principles of Leonardo's 'science of painting' find echoes then in modern techniques of computer modelling and image syntheis. But the parallels between Leonardo's visual science and computer graphics go further.

Until only a few years ago, computer modelling was limited to objects with smooth, plane or simply curved surfaces, suitable for showing the products of mechanical engineering, hence the universal computer graphics clichés of grids in perspective and tumbling letter forms, but it was incapable of anything beyond the crudest representation of complex organic form. Today that has all changed, and every computer graphics conference brings new developments in realistic modelling of the appearances of mountains, trees, breaking waves, even clouds, mist and rainbows. This is not the place to go into detail about the techniques involved, but in essence most of this work depends on two things. First, the models incorporate something of the basic physics of the phenomena depicted: the fluid dynamics of wave formation, the optics of the scattering and refraction of light, and so on. Second, the models build on the mathematical discovery that complex forms and patterns may be represented in economical ways by applying simple rules repeatedly – that is by methods of 'recursion'.

Thus, if a triangle is divided into four triangles whose corner points are subjected to small random disturbances in their positions, and each of the four triangles is then similarly subdivided into four more triangles, and so on, the end-result is a complex, randomly corrugated surface of whatever fineness of texture is desired. It is by essentially this or equivalent techniques, for example, that 'fractal' computer images of rocky terrain are produced.

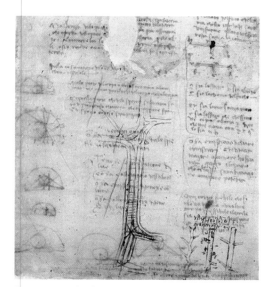

Fig. 46 *Study of a canal system (left) set against diagrams of growth forms in plants (right)*, c.1504, pen and ink (C.A. f.207va/551v, detail). This drawing shows three basic forms of plant growth: *Right*: 'monopodial' growth, as in the elder tree. *Left*: 'sympodial' growth, as in the elm. *Centre*: spiral arrangement of branches around the trunk, as in the walnut.

Fig. 47 Computer models of trees: *Right*: 'monopodial' growth; *left*: 'sympodial' growth

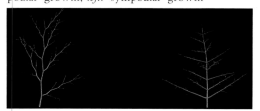

It would be wrong to try to press the analogies with Leonardo's thought and methods too far. But it is perhaps not too fanciful to see some affinities with Leonardo's approach to both the description and the creation of formal complexity – as explored in the fourth and fifth films. Gombrich has described how 'throughout his life . . . Leonardo followed a method that might be called a method of permutation and combination'. We have seen this already in Leonardo's studies of the transformation of geometrical bodies. It is further exemplified in his analysis of the geometry of trees and plants, and in his techniques of architectural composition.

Morphology of branching structures

The sixth part of the *Trattato della pittura* carries the title 'Of Trees and Verdure'. Much of this section is devoted to the visual effects of light and shadow on plants. But the chapter starts by collecting together Leonardo's observations of the geometrical growth habits of plants. He shows how different species are characterised by the angles at which branches are set to each other, and by the patterns in which branches are arranged round the main stem or trunk. Other variables are the diameters and lengths of branches, and the numbers of branches at each junction. Leonardo here foreshadows that field of theoretical botany, devoted to the symmetries of plant forms, which was to be taken up in earnest again only at the beginning of the nineteenth century, under the name of phyllotaxis.

A sketch from the Codex Atlanticus f.207va/551v (fig. 46) captures Leonardo's basic three-way classification of forms of growth, into those which are today termed 'monopodial' (characteristic of a tree like the elder) and 'sympodial' (characteristic of the elm), together with an instance of 'spiral phyllotaxis' (found in the walnut). In spiral phyllotaxis the branches depart from the main stem at regular intervals, but rotate through equal angles around the stem between successive branchings. After a certain number of branchings, an exact number of turns around the stem is completed, and at this interval the respective branches are aligned one above the other.

Leonardo refers to a particular and very common case of spiral phyllotaxis, found for example in the blackberry, in which 'nature has arranged the leaves of the last branches of many trees so that the sixth leaf is always above the first, and this follows successively unless the rule is impeded'. He points out the advantage this kind of arrangement has in exposing leaves to the sky without one leaf overshadowing the next: 'where there are five branches turned in five directions, the sixth grows far enough away above the first to avoid this'. (Although he believes that the functional purpose is to maximise the area which receives dew falling at night, rather than to maximise exposure to sunlight in the day.)

It is possible to construct computer models of trees by assembling cylindrical elements for the trunk and branches, and by adjusting those parameters of diameter, length and angle with which Leonardo is concerned (fig. 47). Different parameter values can generate basic tree skeletons whose forms are characteristic of different species. Smaller branches may be grown from larger branches and so on, recursively, so that the end-product is a branching structure of potentially great complexity. This is how the models in our film are produced. (Our purpose

is to show underlying geometrical structure, and so the skeletons are left bare. In other work on computer models of trees, aiming for greater realism the effects of wind and gravity have been accounted for, and realistic bark and leaves added, to produce rendered images of startling verisimilitude.)

Besides his classification of growth habits, Leonardo also reasons that the total cross-sectional area of the limbs of a tree at each level of branching must remain constant (fig. 48). This fact acts as an important constraint on the tree's form overall. His explanation is that the tree carries a constant flow of sap, dividing between the branches on its journey upwards; and the quantity of sap carried by any one branch is in proportion to its cross-section. (The rule is not strictly true, for a number of reasons; but the spirit of Leonardo's attempt to relate organic form to physiological function is still astonishingly percipient.)

Nor are plants the only kinds of branching structure to which such a principle might apply. It would be true of systems in the animal and human body: for example, the flow of air from the windpipe into the branching airways of the lungs (no. 54). And it would be as true of the 'macrocosm' of the geological realm, as of the 'microcosm' of the body: in the way in which the constant flow of water in streams and rivulets collects together into the tributaries and finally reaches the mainstream of a great river like the Arno.

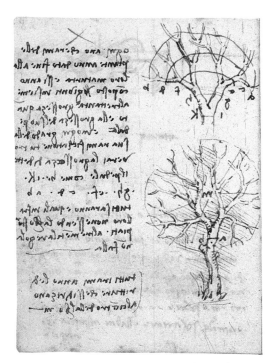

Fig. 48 *Sketch to demonstrate that the total cross-sectional area of branches remains constant at each level of branching*, pen and ink, Bibliothèque de l'Institut de France, Paris, (Ms.M 78v)

Centralised churches

The subject of our final sequence differs from the others, in that it concerns the design of artefacts, rather than the forms and appearances of nature. Here Leonardo applies his 'method of permutation and combination' not to scientific analysis, but to the composition and construction of works of architecture.

Between 1487 and 1490 Leonardo worked in Milan on designs for churches with centralised symmetry. Some thirty schemes, shown in tiny plans and bird's-

Fig. 49 *Three sheets with plans and perspective views of centralised churches*, c.1488, pen and ink, Bibliothèque de l'Institut de France, Paris, (Ms.B 2173. ff.21r, 17v, 18v respectively)

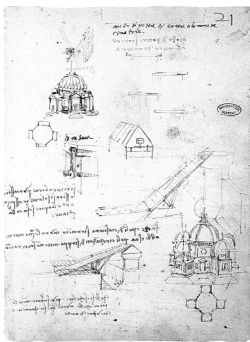

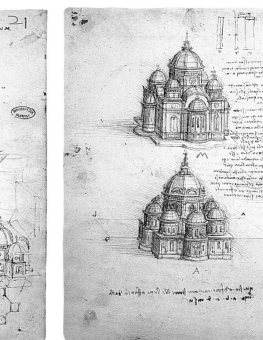

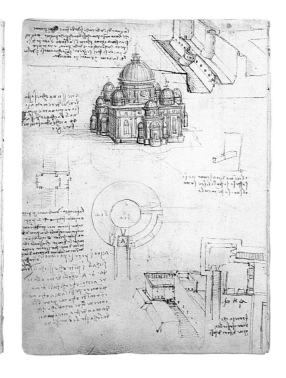

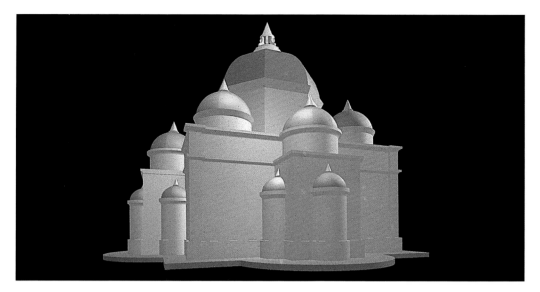

eye view perspectives, appear in Ms.B and in some contemporary manuscripts (no. 118). Together they represent Leonardo's most sustained and systematic exploration of a consistent architectural theme.

The plans are all derived through a process of setting together a number of simple geometrical shapes in symmetrical patterns. Every design consists of a large central space, surrounded by smaller chapels disposed symmetrically about the centre. The central space is carried up into a drum and dome, and the chapels into subsidiary domes or vaults, to produce a generally pyramidal composition in three dimensions.

The plan of the central space may be either square, octagonal, twelve-sided or circular. The side-chapels have similar plan-shapes, and in the more complex designs the principal chapels may themselves have sub-chapels or apses. (In computer terminology, there is a second level of recursion in the rule-based procedure by which the designs are generated.) A further complication is that in some schemes, central space and chapels are all embedded within a larger square 'body', from which they partly protrude. All these features in plan have implications for the resulting patterns of vaults and domes at roof level.

Leonardo's compositional procedure is so systematised, and so close in spirit to some present-day ideas in computer-aided architectural design about 'shape grammars' and rule-based generative methods for plan layout, that these church designs of his actually feature in one of the leading modern textbooks on the subject (W. J. Mitchell, 1977).

We have chosen to illustrate in our film a selection of six churches in which the central spaces are all octagonal (fig. 50). The sequence starts with a very simple plan, with four rectangular chapels, and proceeds via a series of elaborations to two plans with alternating circular and square chapels, the square chapels each having three or four semi-circular apses. These plans are then simplified again, back to the original basic octagon. In one scheme Leonardo offers 'two churches for the price of one'. Either the whole composition as he shows it could be built; or else the square base might be omitted, and the 'upper storey' of eight circular chapels brought down to ground level.

II
THE MODELS

Weight and force, together with material motion and percussion, are the four accidental powers by which the human species in its marvellous and varied works appears in this world to be manifested as a second world of nature.

The pages of Leonardo's manuscripts, particularly the bound folios of the Codex Atlanticus and Codex Madrid I (see no. 116), seethe with designs for machines and their components. Although earlier Renaissance engineers, such as Mariano Taccola and Buonaccorso Ghiberti, have left vivid records of Renaissance technology, the sheer volume and variety of Leonardo's designs are unrivalled in this period. Some of his drawings give the barest indications of form and function, serving him either as *aides-mémoire* of devices he had seen or as rough sketch-plans when he was thinking about new contrivances. Other studies are highly finished, even ornamental in appearance, and convey the impression that they are resolved and definitive designs. Indeed, many of the individual illustrations in the Madrid volume are worked to a degree of finish and arranged so carefully on the page that they may be regarded as having reached a publishable state, even if the whole treatise 'On the Elements of Machines' was never to reach completion. Such highly developed designs present us with an obvious and fascinating challenge. Can we make Leonardo's creations live again by constructing the devices precisely according to his designs? Will they really work as he intended?

The project looks straightforward enough, particularly when his innovatory brilliance as a technical illustrator seems to promise precise information about the whole machine and its parts. However, it should immediately be stressed that his illustrations are not what a modern machine-maker would regard as working drawings, displaying measured components in plan, elevation and perspective in such a way that their forms and functions are wholly explicit. Even the most precise drawings, apart from the simplest schemes for individual components, leave the builder of models with crucial decisions to be taken about such questions as the articulation of a vital joint or the setting of an axle. To some extent our knowledge (incomplete though it is) of how such problems were handled by Renaissance engineers can help resolve the difficulties – much as Leonardo would have expected a maker of weaponry to have the basic constructional tricks up his sleeve when he proposed a variation upon an existing weapons system. However, this is to assume that Leonardo's designs were ever intended as working drawings. It is more likely that the highly-finished illustrations were in the nature of exemplary demonstrations, ready for presentation to a patron as a way of establishing Leonardo's credentials for a particular task, or suitable for inclusion in a formalised treatise which was intended to illustrate concepts and principles of engineering rather than to serve literally as a constructional manual for the workshop.

It is not surprising, therefore, that the modern builder of Leonardo's designs encounters problems, discovering that some vital feature is not clarified, or that an apparently clear detail, such as the pitch of the teeth in a gear, produces an effect which is inoperative in practice. If this kind of difficulty is apparent with most of the Madrid designs, how much more it becomes a problem when reconstructing Leonardo's flying machine on the basis of designs which, even at their most elaborate, represent a process of 'thinking aloud' rather than a set of developed solutions. To varying degrees, therefore, the models must be regarded as creative reconstructions of Leonardo's designs in a manner consistent with his intentions – demonstrating the ideas and techniques with which he was working when he required to achieve a particular end – rather than as straightforward reproductions of inventions which could be pressed into immediate service, with no need for further translation into practical form.

This is not to say that all of Leonardo's designs were wildly impractical – though some were overtly fantastical and visionary in conception – or that they were unrelated to contemporary technologies. Indeed, a group of his earliest drawings, two of which are represented by models (nos. 120 and 121), record the famous machines invented by Filippo Brunelleschi when he undertook the enormous technical and architectural project for the erection of the dome of Florence Cathedral. Brunelleschi's remarkable hoists and cranes, upon which much of his contemporary reputation rested, had become exemplary works for Renaissance engineers, and were recorded in the notebooks of Buonaccorso Ghiberti, Francesco di Giorgio and Giuliano da Sangallo. These machines were exemplary not just because they had been successfully used in the greatest engineering feat of the era but because they showed the way to solve some of the central problems of Renaissance engineering, such as the transmission of motion from one plane into another, the use of gearing to achieve great power for lifting weights etc., and the development of bearings that would minimise friction and wear. This last problem was particularly taxing, given the materials available in the Renaissance, and Leonardo's close attention to the design of bearings (nos. 122, 123 and 124) is entirely understandable in a contemporary context.

It is virtually certain that other of Leonardo's studies represent known machines rather than his own inventions, but it is rare to be able to document the existing devices as well as we can those of Brunelleschi. However, the notes and drawings show that even when he appears to be working with established designs, his own questioning and inventive faculties were never at rest. The texts often have the air of a running debate with himself as to the best way to achieve a particular effect, often with direct reference to the underlying 'causes' – the physical laws of the universe – with which the engineer necessarily has to co-operate. If the engineer has a true understanding of the 'causes', the potential for their exploration should be unlimited: 'Force is infinite, since by it infinite worlds might be moved if instruments could be made by which the force could be propagated . . . The quality and quantity of the force of a man can give birth to another force that will be proportionately so much greater as the movement of one is longer than the other.'

It was this kind of ratio for the amplifying of human or animal power that Brunelleschi had exploited in his hoist, and that Leonardo intended to utilise in his design for a screw-jack (no. 122), in which the rapid turning of the worm-gear is translated into a slow, powerful lifting motion. The limits, as we know, are

strictly finite in the world of physical machines, given the dissipation of power by friction and other sources of inefficiency, but the abstract principle did at least provide a systematic base on which he was able to work towards the achieving of a particular end.

Although the models chosen for illustration in the present context are amongst the most obviously functional of his designs, they share what may fairly be called a common aesthetic with all his studies of mechanical and natural engineering. It is an aesthetic based upon a delight in the compact and economical interplay of mobile forms, one abutting on another with the same perfection of design as characterises the human spine (no. 109) or any other item in nature's repertoire of inventions. Leonardo seems to have been particularly satisfied when a backwards and forwards movement in a straight line was converted into a continuously circular motion, or *vice versa* (nos. 126 and 127). The most pleasing of the designs exude an air of compact inevitability, which is entirely intended, in as much as each device must take its cue from nature and achieve its ends in the shortest way possible according to the principle of 'necessity'. In this light, the presentation of models based on his drawings as objects for delight, much like constructivist sculptures, plays to a quality which is intrinsic to the nature of Leonardo's designs.

In at least one respect, however, the presentation is misleading, namely with regard to scale. For obvious reasons of practicality and legibility, the models tend to depart from their intended size. The '*Armoured Car*' (no. 131) is obviously a small-scale model, while the bearings (nos. 123 and 124) may have been envisaged for operation on a small scale, without excluding their use in large machines. The screw-jack (no. 122) could presumably work on various scales, as could the two-wheel hoist (no 127), though he suggests elsewhere that the system of gearing in the latter could be used to translate a pumping action with the feet into rotary motion to drive a pedal-boat.

The exception is the model of the flying machine (no. 135), which does not quite achieve the grandest of the dimensions conceived by Leonardo but does work within the correct range of sizes for his mechanical bird. It is in this design, above all others, that his ambition as an artist-inventor to create a 'second world of nature' is most strikingly expressed. And nowhere would his failure to realise his dream have been more keenly felt. However, for us it may fittingly epitomise the grandeur of his vision and give concrete form to his conviction that the products of the human creator are governed by the sublime 'necessity' of nature herself.

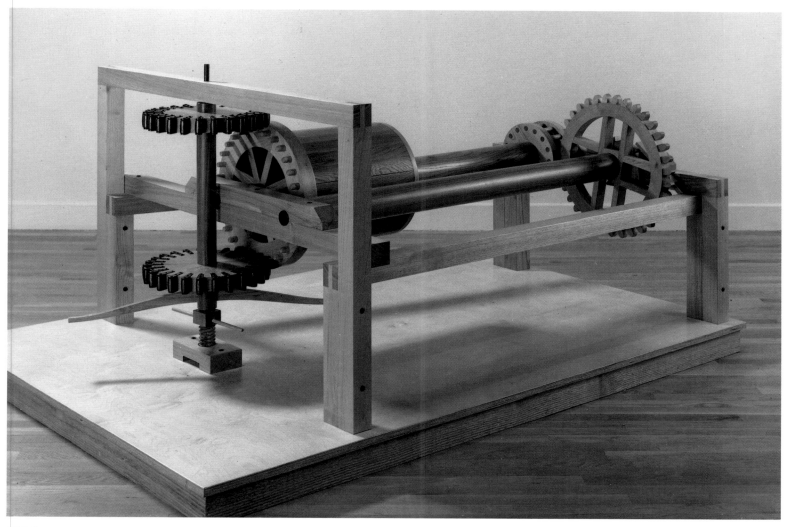

120

FILIPPO BRUNELLESCHI'S REVERSIBLE HOIST
Based on Codex Atlanticus,
 f.391vb/1083v (fig. 51)
101 × 220 × 150 cm
Constructed by S. A. R. I. and Mariani,
 Florence, 1986
The Montreal Museum of Fine Arts
(Not in the exhibition.)

The workshop of Verrocchio, Leonardo's master, was responsible for the erection of the great gilded sphere on top of the lantern of Brunelleschi's dome for Florence Cathedral in 1468–72. This activity would have provided the young Leonardo with direct access to the cathedral workshop and to Brunelleschi's famed designs for hoists, cranes etc. A series of very early drawings, which can be dated to no later than 1478 on the basis of a dated sheet in the Uffizi, record the overall forms and some of the details of Brunelleschi's devices. Although the same machines appear in the notebooks of other Renaissance engineers, the way in which Leonardo extracts particular components for detailed study indicates that he was working directly from the original machines rather than from other drawings.

This particular machine is identifiable as the *colla grande* built in 1421 by Brunelleschi as the main hoist for lifting worked stone and other heavy materials to the top of the cathedral. The most remarkable aspect of its functioning was that the gearing enabled the device to be switched into either a lifting or lowering mode by engaging the upper or lower wheel on the vertical axle, without needing to reverse the direction of the animals turning the windlass at its base. Another notable feature, on which Leonardo concentrated in one of his detailed sketches, was the use of pivoted gear teeth which consisted of rollers on individual axles. Compared to the normal gear teeth, which tended to grind over each other, the rollers permitted smoother movement, thus reducing friction and minimising wear.

Fig. 51 *Design for a reversible hoist*, pen and ink (C.A. f.391v/1083v)

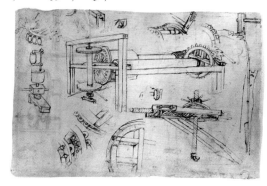

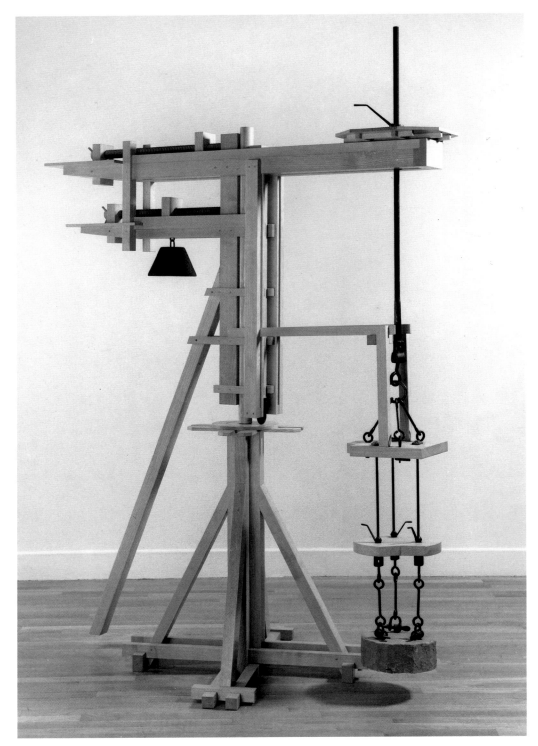

121

FILIPPO BRUNELLESCHI'S REVOLVING CRANE
Based on Codex Atlanticus, f.349ra/965r
(fig. 52) 206 × 167 × 90.5 cm
Constructed by S. A. R. I. and Mariani,
Florence, 1986
The Montreal Museum of Fine Arts

This elaborate crane was designed to
provide a stable and precise manner of
locating worked stones in their assigned
positions in the dome of Florence
Cathedral. The weight is raised by the
thin, vertical screw, while the system of
suspension, including two horizontal
arms from the main shaft, ensures that
the stone does not begin to swing
dangerously. The upper horizontal screw
moves the platform towards or away
from the axis, while the lower screw
moves the counterweight in such a way
as to balance the platform. The upper
part of the crane pivots when the
diagonal tiller is turned. The principles
of balance embodied in Brunelleschi's
device were to be the subject of
intensive investigations in Leonardo's
manuscripts during the 1490s.

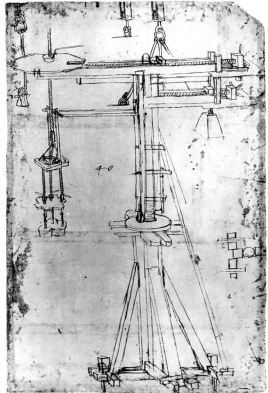

Fig. 52 *Design for a revolving crane*, pen and ink
(C.A. f.349ra/965r)

122

SCREW-JACK
Based on Codex Madrid I, f.26r (fig. 53)
145 × 110 × 110 cm
Constructed by S. A. R. I. and Frullini,
 Florence, 1987
The Montreal Museum of Fine Arts

The major purpose of this design is to
overcome the severe problem of friction
which arises when a load-bearing surface
revolves on another. There is no
indication as to how Brunelleschi tackled
this problem on the platform of his
crane (no. 121), but various systems of
wheels, rollers and balls might have been
used. Leonardo's splendidly compact
design shows that 'if a weight as a plane
surface moves on another similar plane
of dense surface, their movement will be
as much facilitated by interposing balls
between them as rollers'. However, he
subsequently explains that care needs to
be taken to see that the freely-moving
balls do not come into contact with each
other, 'since on touching they rub
together with contrary motions, as is
demonstrated in the 5th [chapter] of the
6th [book]'.

The other notes on the folio
containing this design discuss the
bending of the legs of the device under
the strain of lifting.

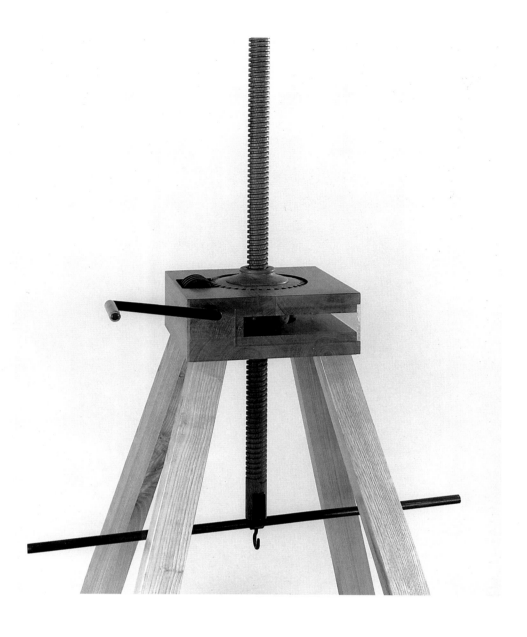

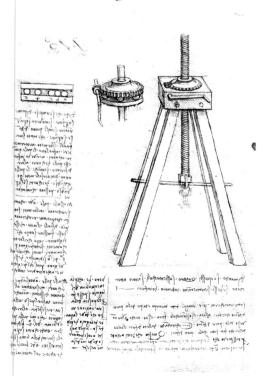

Fig. 53 *Design for a screw-jack*, pen and ink,
Biblioteca Nacional, Madrid (Madrid I, f.26r)

123

ROTARY BEARING OF BALLS AND ROLLERS
Based on Codex Madrid I, f.20v
 (fig. 54)
31 × 58 (diam.) cm
Constructed by Muséo Techni,
 Montreal, 1987; technical drawing by
 A. Regoli
The Montreal Museum of Fine Arts

This beautiful bearing solves the same
kind of problems as the ball-bearing in
the screw-jack, but now automatically
ensures the separation of the balls.
Leonardo indicates that he is using
'wooden balls in place of rollers to
move a weight'. Between them are
placed 'axled wheels which keep the said
wheels in order, so that they perform
their rotating function and cannot
escape'.

Fig. 54 *Design for a rotary bearing of balls and rollers*,
pen and ink, Biblioteca Nacional, Madrid (Madrid I,
f.20v)

124

BALL–BEARING FOR AN AXLE WITH A
CONICAL PIVOT
Based on Codex Madrid I, f.101v
 (fig.55)
77 × 47 × 47 cm
Constructed by Muséo Techni,
 Montreal, 1987; technical drawing by
 L. Marchini
The Montreal Museum of Fine Arts

The design of efficient axles for load-
bearing mechanisms was a matter of
some importance in Renaissance
technology. This kind of bearing for a
vertical axle could have been used in a
variety of circumstances, as for instance
at the base of the shaft of a heavy mill-
stone, or even at the foot of the upright
axle in Brunelleschi's crane (no. 120).
 Leonardo explains that the three-ball
design obeys the key law of 'necessity':

> the three balls under the axle are
> better than four bearings, because
> three with certainty and by necessity
> always touch and are equally moved
> by the axle. With four there would
> be a danger that one of them would
> not touch. Hence it would not be
> moved and would wait for its
> companion, with which it would
> cause rubbing together.

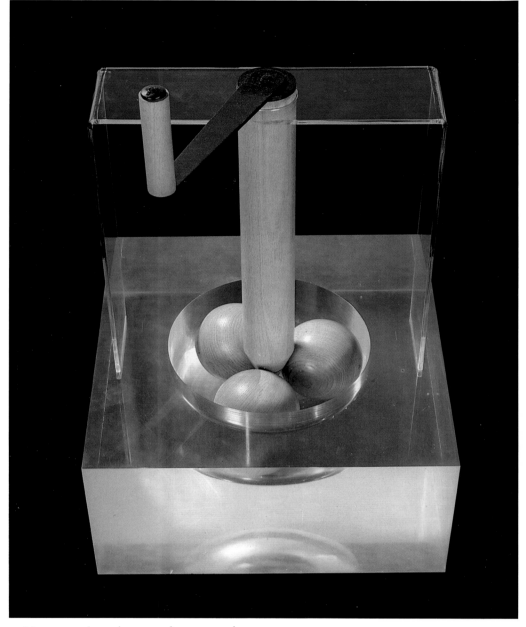

However, he subsequently argues that
a design with three conical bearings –
each presenting a continuous surface
with the conical pivot – would be even
better, 'because where there is less
contact there will be less wear, and since
the balls touch at a point it is necessary
that they will be rapidly worn away'.

Fig. 55 *Design for a ball-bearing for an axle with a
conical pivot*, pen and ink, Biblioteca Nacional,
Madrid (Madrid I, f.101v)

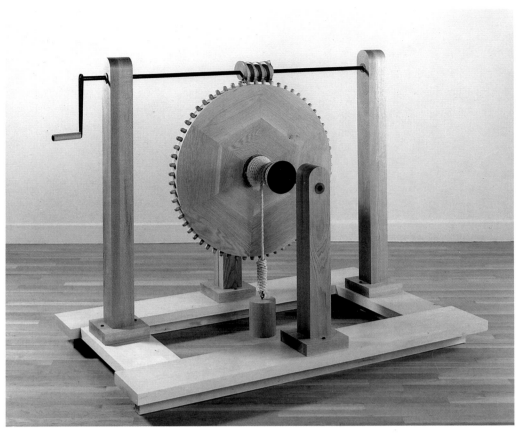

125

HELICOIDAL OR WORM-GEAR
Based on Codex Madrid I, f.17v
 (fig. 56)
125 × 157 × 99 cm
Constructed by Muséo Techni,
 Montreal, 1987; technical drawing by
 L. Marchini
The Montreal Museum of Fine Arts
(Not in the exhibition.)

One of the major problems with gears in Leonardo's era was that insufficiently strong materials were available to prevent the snapping of teeth when subjected to strain. The helicoidal gear, with its concave profile, is designed to reduce this difficulty: 'This device for traction has a screw without end, which has sufficient turns to engage a number of teeth on the wheel. Hence such a device is very reliable, whereas when this screw engages a single tooth of the wheel, which is affected by fatigue, this tooth will be broken and cause great damage and ruin on another turn of the screw.'

This particular 'screw without end' is what came to be called a worm-gear. Leonardo's drawing appears to be the first illustration of it, though this does not in itself provide sufficient grounds for crediting him with its invention. Its succinct integration of parts is, however, entirely characteristic of the qualities he strove to realise in his designs.

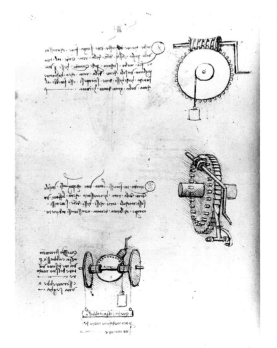

Fig. 56 *Design for a helicoidal or worm-gear*, pen and ink, Biblioteca Nacional, Madrid (Madrid I, f.17v)

126

DEVICE FOR THE TRANSMISSION OF ROTARY
 MOTION INTO ALTERNATE RECTILINEAR
 MOTION
Based on Codex Madrid I, f.28r (fig. 57)
98 × 201 × 171 cm
Constructed by Muséo Techni,
 Montreal, 1987; technical drawing by
 A. Regoli
The Montreal Museum of Fine Arts

This model reconstructs one of two
related designs on the same folio, which
is headed, 'movements made with a
slowed down time'. In other words, the
generated motion is slower than that of
the original mover.
 Leonardo explains that:

> if you turn the crank *op* in one
> direction, the rack *mn* will first go in
> one direction and then in the other.
> And this occurs because the circle in
> the middle of the toothed wheel only
> has teeth over half of it. And the
> pinion turned by this wheel which is
> half-toothed should have six spindles.
> But you should know that such a
> pinion works better if it is shorter and
> not divided in half.

A number of designs on succeeding
folios in the Codex provide alternative

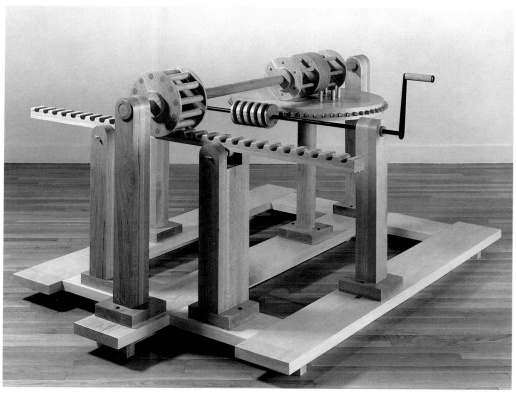

solutions for the generation of back-and-
forth motion. Such mechanisms would
have been useful when reciprocating
lateral motions if fixed amplitude were
needed in an automated process of
manufacture. He did not however
envisage their use when rapid motion
was required: 'Beware, contriver of
instruments, that you do not use such
components in situations where they
have to move at too great a speed,
because in acquiring flight, or rather
impetus in one direction, and when the
pinion has suddenly to return back in
the other, it will become in danger of
breaking its teeth.' (f.30v)

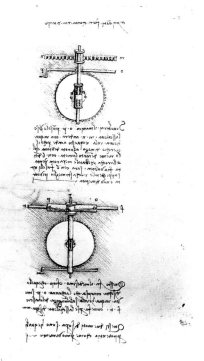

Fig. 57 *Design for the transmission of rotary motion
into alternate rectilinear motion*, pen and ink, Biblioteca
Nacional, Madrid (Madrid I, f.28r)

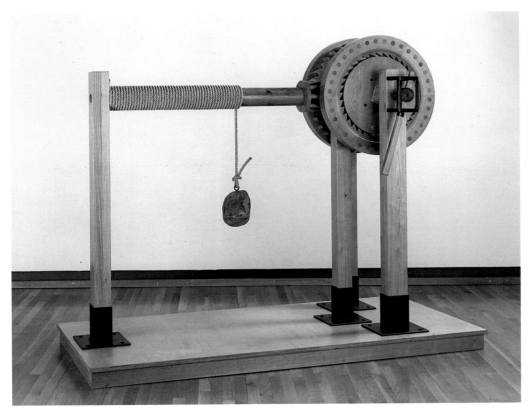

127

TWO-WHEELED HOIST WITH A CAGED GEAR
Based on Codex Atlanticus, f.8vb/30v
 (fig. 58)
180 × 220 × 102 cm
Constructed by S. A. R. I. and Frullini,
 Florence, 1987
The Montreal Museum of Fine Arts

This model is based upon one of Leonardo's most notable engineering drawings, which displays the mechanism in assembled and exploded form. The style of the drawing, with its diagonal hatching, and the handwriting of the inscription over the exploded view indicate conclusively that this folio of the Codex Atlanticus is significantly earlier than Madrid Codex I. Pedretti has dated the drawing as early as 1478–80, but it is difficult to reconcile such a mature system of demonstration with his other mechanical drawings of this period, and a date in the early 1480s is more probable. Even at this date, the exploded view precedes the introduction of this method of demonstration into his anatomical work by many years. The use of wash shading in this and other early mechanical illustrations, probably inspired by the drawing technique of earlier engineers, also seems to predate its regular use in other areas of his draughtsmanship, although the study of a Lily (no. 42) is an unusually early example of its use in an artistic context.

The exploded view shows how the ratchets set within each wheel force one wheel to turn when the arm is pulled in one direction whilst permitting the other wheel to idle – and *vice versa* when the arm is pushed back again. Since the teeth on each wheel will successively move in opposite directions on either side of the lantern gear, the shaft around which the chord is wound will revolve more or less continuously in the same direction with the back-and-forth motion of the arm. There is no way of knowing whether this was Leonardo's own invention – there must remain a possibility at this early date that it was one of Brunelleschi's devices – but the exploded view suggests strongly that it was drawn from an actual mechanism.

Fig. 58 *Design for a two-wheeled hoist with a caged gear*, pen and ink (C.A. f.8vb/30v)

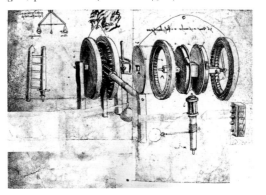

128

Based on Codex Madrid I, f.14r (fig. 59)
125 × 174 × 71 cm
Constructed by S. A. R. I. and Frullini,
 Florence, 1987
The Montreal Museum of Fine Arts

Leonardo experimented with a number
of devices to equalise the progressively
diminishing power of a barrel spring as
it unwinds, including the volute gear on
folio 45r (no. 116). This model
represents one of the more sober and
practical of the designs, and may record
an existing mechanism. As the spring
unwinds, the toothed wheel at the top
of the spring engages progressively
wider turns in the conical gear and
therefore acts with a greater leverage on
the vertical shaft in order to compensate
in due proportion for its diminishing
power. To accommodate the changing
location of the shaft, a worm-gear on its
lower portion causes a vertical wheel to
take three 'steps' along the grooves in
the lower frame. The wheel at the top
of the conical gear drives the other shaft
on which the wheel s is located.
Leonardo explains how the winding
mechanism works, and in the smaller
diagram illustrates a ratchet for this

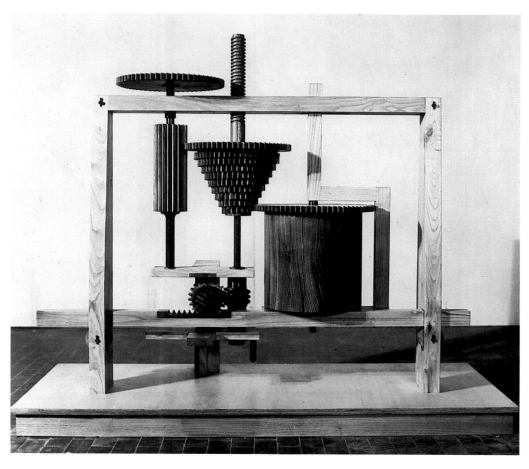

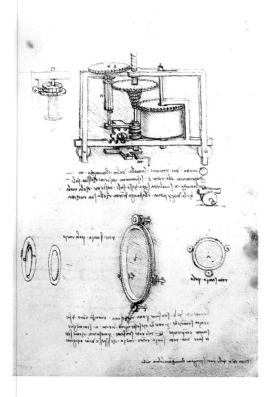

purpose: 'When you wish to wind up
the spring, turn the crank m
contrariwise, and the wheel s will stop
with its axle, and the pinion n will be
turned freely around this axle, together
with the spring, the continuous screw
and the toothed rack with its pinion.'

 Elsewhere in the Codex he is
specifically concerned with clockwork
mechanisms, and the present device is
probably intended for this purpose. The
challenge of utilising a spring to drive a
clockwork mechanism at a constant
speed had been taken up by a number of
Renaissance inventors including the great
Brunelleschi, if his earliest biographer is
to be believed, but no fully satisfactory
solution was to be found until the
seventeenth century.

Fig. 59 *Design for the gearing for a barrel spring,* pen
and ink, Biblioteca Nacional, Madrid (Madrid I,
f.14r)

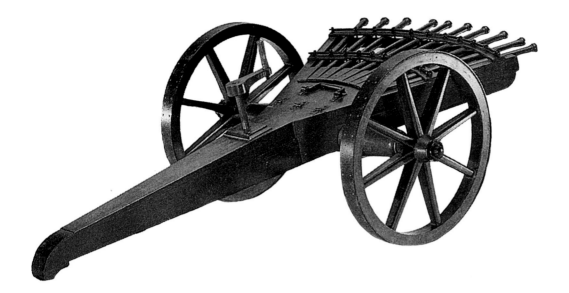

129

GUN WITH ARRAY OF HORIZONTAL BARRELS
Based on Codex Atlanticus, f.56va/157r
 (fig. 60)
60 × 180 × 90 cm
Museo Nazionale della Scienza e della
 Tecnica 'Leonardo da Vinci', Milan

Renaissance firearms suffered from many limitations, two of the most severe of which were their inaccuracy and their slow rate of fire. One solution to the former problem was to organise an indiscriminate saturation of the enemy ranks with fire, while the latter could be obviated if ranks or volleys of guns were organised in such a way that some were going through the lengthy process of reloading while others were being fired. The present gun is designed for the former purpose. A series of light cannon or *scoppietti* – little more than muskets in size – are arranged in a splay pattern to cover a sweep of ground. Their elevation can be changed by means of the screw-jack, and the hinged section with a handle, labelled *a* in the drawing, lifts 'when you wish to clear out the tails of the guns from outside'. The most likely use of this system would have been to repel advancing ranks of infantrymen or cavalry.

The folio containing this design can be dated to *c*.1481 on grounds of style, and is therefore close in date to Leonardo's letter to Ludovico Sforza in which he claims to be able to 'make cannon, mortar, and light ordnance of very beautiful and functional design that are quite out of the ordinary'.

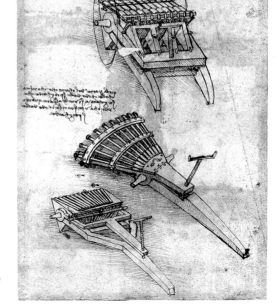

Fig. 60 *Design for a gun with array of horizontal barrels*, pen and ink (C.A. f.56va/157r)

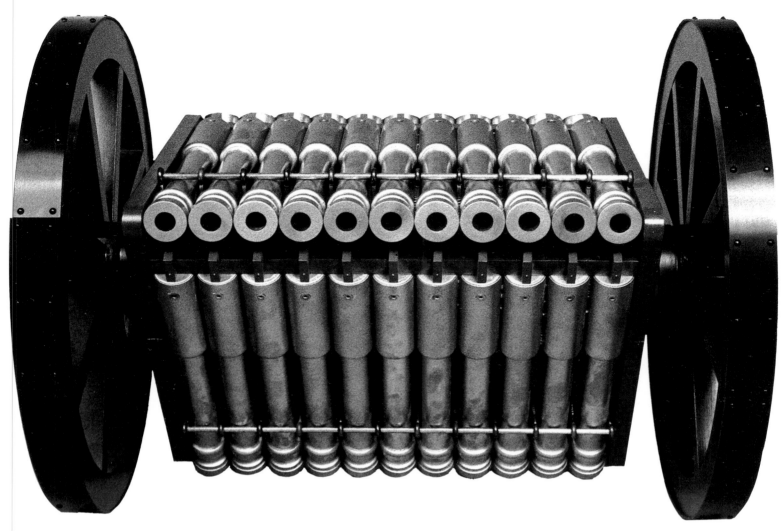

130

GUN WITH THREE RACKS OF BARRELS
Based on Codex Atlanticus, f.56va/157r
 (fig. 60) 57 × 100 × 74 cm
Constructed by Dr Roberto A. Guatelli
Dr Roberto A. Guatelli Associates, Inc.,
 New York

This model is taken from the same sheet of designs as the other multi-barrelled gun, and also dates from about the time when he was entering the service of Ludovico Sforza. Like the former design, it is intended to saturate an area with fire, but in this case has the added advantage that the arrangement of thirty-three barrels in three ranks of eleven would permit the loading of one volley down the muzzles of the guns while another is being discharged. As in the previous design, a screw-jack is provided to alter the elevation, while a horizontal bar, which the drawing shows to be retained in position by pegs, could be removed to provide access to the rear of the guns when clearing the barrels. In the third design on the same folio Leonardo considers arranging this system in a splay pattern like that of the single volley weapon. He refers to this

design as arranged *a organi* – in the manner of organs.

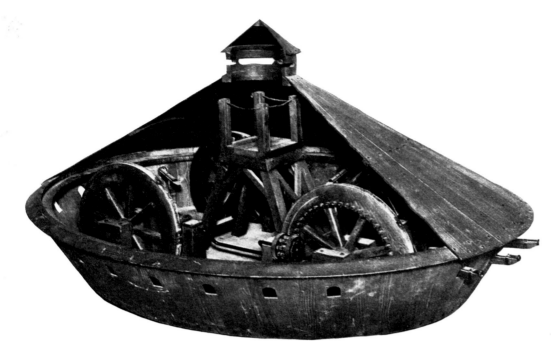

131

'ARMOURED CAR'
Based on BM 1860-6-16-99 (no. 68 in
 the exhibition)
110 × 200 × 160 cm
Museo Nazionale della Scienza e della
 Tecnica 'Leonardo da Vinci', Milan

The note on the drawing (no. 68)
explains that this conical chariot was to
be operated by eight men. Presumably
some of them would have been
occupied in turning the cranks to move
the wheels, while others would have
been responsible for firing the volleys of
scoppietti arranged radially around the
rim. It is not clear in the drawing how
the soldiers were to see where they were
going, but the drum beneath the smaller
conical 'hat' at the top may have
permitted all-round vision through slits
or portholes. On Ms.B, f.59r two horses
are shown blindly galloping towards the
enemy inside a comparable, covered
chariot; his note argues that 'this is also
of great utility'. The present design, like
that in Ms.B, dates from the second half
of the 1480s.

The purpose of such 'armoured cars'
was to breach the ranks of the enemy's
infantry, and, not least, to sow confusion
amongst them. However, the operating
problems would have been formidable
in almost every respect. Co-ordinating
the motion of the wheels would have
been difficult, and the moving of such a
heavy contraption across uneven or
muddy terrain would have presented
grave problems. One also fears for the
hearing of the incarcerated soldiers when
the guns are fired.

132

Based on Leonardo's illustration for
 Luca Pacioli's *De divina proportione*
 (no. 104 in the exhibition)
35 × 35 × 35 cm
Museo Nazionale della Scienza e della
 Tecnica 'Leonardo da Vinci', Milan

Leonardo's collaboration with the
mathematician Luca Pacioli in Milan
during the late 1490s resulted not only
in Leonardo gaining fresh insight into
Euclidian geometry in the tradition of
Piero della Francesca but also in the only
set of Leonardo's designs that appeared
in a published treatise in his own
lifetime. Following the production of
the primary manuscript version in 1498,
Pacioli arranged the printing of *De
divina proportione* with woodcut
illustrations in Florence in 1509 (no.
104).

Pacioli himself had initiated the
making of models of the five regular
geometrical bodies and their derivatives.
One set of models had been offered to
the Duke of Urbino in 1494, and the
government of Florence paid for a set in
1504. In the famous portrait of Pacioli
with a young patron or noble pupil
(Museo Nazionale di Capodimonte,
Naples), the mathematician is
accompanied by models in wood and
glass. The perspective of Leonardo's
illustrations suggest that he draughted
them from actual models using a
drawing frame or 'perspective window'
such as that illustrated in the Codex
Atlanticus (f.1ra/1r) for the depiction of
an armillary sphere.

The present model shows the *vacuus*
(skeletal) form of the icosahedron
(twenty equilateral triangles) in its
stellated derivative – that is to say with
equilateral pyramids erected on each of
its triangular faces. Leonardo was
fascinated by the plastic transformation
of regular bodies by processes of
geometrical manipulation, and it is this
fascination which is taken up in the
computer modelling sequences.

I33

CENTRALLY PLANNED TEMPLE WITH EIGHT
RADIATING CHAPELS

Based on Ms.2184, BN 2037, f.5v (no.
118 in the exhibition)
268 × 272 (diam.) cm
Constructed by S. A. R. I., Florence,
1987; technical drawing by
K. De Jonge
The Montreal Museum of Fine Arts

The measured plans necessary for the
making of this model were skilfully
reconstructed from Leonardo's drawings
by J. Guillaume and K. De Jonge.
Although Leonardo's perspective view
and plan of his temple (no. 118) are
amongst the most precise of his
architectural studies, they are not
working drawings for a builder any
more than the mechanical designs in
Codex Madrid I are measured designs

for the machine-maker. There are, for
instance, discrepancies between the
perspective and plan. The perspective
suggests that the apses of the radiating
chapels were virtually to fill the spaces
between the columns framing the niches,
whereas the plan shows that there must
be a considerable area of blank wall
visible between the columns and the
apses. The model follows Leonardo's
instructions to replace the domes over
the radial chapels in the main drawing
with the variant design in the smaller
study, but the tiered structure of the
replacement domes makes the
relationship between them and the
oculus windows in the octagonal drum
even more awkward. There are also
many details, most notably the design of
the lantern, that need to be judiciously
introduced to the model on the basis of
Renaissance practice in general and
Leonardo's architectural vocabulary in
particular. Accepting these necessary
qualifications, the model nevertheless
provides a vivid testimony to the
complex beauty of Leonardo's
conception – in its exterior interplay of
convex, flat and concave shapes, and in
its intricate interweaving of interior
spaces.

When realised as a large model, this
temple's line of descent from
Brunelleschi's Florentine work becomes
even clearer than in the drawings. The
dome is one of a series of Leonardo's
designs that pay homage to the dome
of Florence Cathedral, while the plan is
a variation on Brunelleschi's centralised
design for Sta Maria degli Angeli, which
Leonardo sketched in a form which
modified his predecessor's plan in the
direction of the present scheme.

The drawing in Ms. BN 2037 is one
of a series of intricate variations on
centralised themes which seem to have
been stimulated by his work in 1487–8
on the project for the *tiburio* (domed
crossing-tower) for Milan Cathedral, for
which he submitted a model, probably
not dissimilar in scale to the present one.
This series seems, like his machine
studies in Codex Madrid I, to present
exemplary designs rather than plans for
specific projects, though the possibility
of a Sforza mausoleum may have been
generally in his mind. It is difficult to

gain a clear idea about the intended size of the present design. The statues in the niches tend to imply a relatively small scale, but if these statues were to be life-size the interior chapels would be impossibly cramped. His note about a bell-tower standing separately (see no. 118) implies that this is intended to be a full-scale church, but the statuary would then become grotesquely gigantic. These problems of relative scale tend to confirm that these designs are illustrative of concepts rather than designs to be put directly into practice.

134

DOOR WITH A DOUBLE PEDIMENT
Based on Codex Atlanticus, f.279va/757v
 (fig. 61)
387 × 310 × 90 cm
Constructed by S.A.R.I., Florence, 1987;
 technical drawings by K. De Jonge
The Montreal Museum of Fine Arts

The drawing on which this model is based occupies a small part of one of his characteristic sheets of late geometrical designs, datable to the last years of his life, perhaps even to his time in France. As in the scheme for the temple (no. 133), the drawing leaves a number of details unexplained, though the

Fig. 61 *Door with a double pediment* (C.A. f.279va/757v)

supporting of the triangular pediment on corbels and of the curved pediment on columns indicates that they project to different degrees. The visual relationship between the corbels and the capitals of the adjacent columns has clearly given him some trouble, and he has sought clarification of this detail in a tiny lateral sketch.

Leonardo's studies of architectural features show that he handled the classical vocabulary in a free and inventive manner. In general he seems to have preferred a *quattrocento* elaboration of detailed elements rather than the monumental massing of Bramante's High Renaissance structures, but the Louvre drawing of the antique-style

Mausoleum (no. 117) shows that Bramantesque grandeur did not lie outside his range. In this particular instance the plastic interplay of contrasting pediments on different planes has something of the sculptural and licentious quality of Michelangelo's later designs for the Laurentian Library at S. Lorenzo in Florence. However, the final effect retains a Brunelleschian sprightliness which is in marked contrast to Michelangelo's self-conscious manipulation of implied weight. In Leonardo's own terms, we may say that the intended effect is akin to the vitality of nature's own structures.

12
THE FLYING MACHINE

A bird is an instrument working according to a mathematical law. It lies within the power of man to make this instrument with all its motions, but without the full scope of its powers; but this limitation only applies with respect to balancing itself. Accordingly we may say that such an instrument fabricated by man lacks nothing but the soul of man.

None of Leonardo's ambitions lay closer to the heart of his vision of man's ability to create 'a second world of nature' than his desire to achieve man-powered flight. His ambition was to create a mechanical organism which would work in perfect concord with the physical laws of the universe to overcome the very elements themselves. He was also keenly aware of the challenge of the legendary inventors from the ancient world, including of course Daedalus for flight, and had no doubt that legendary status would be accorded to the first modern inventor who was successful in teaching man to fly: 'the great bird will take its first flight on the back of the great Swan [i.e. from Monte Cecceri, near Fiesole] filling the universe with stupor, filling all writings with its fame and bringing eternal glory to the place of its birth'.

He also had no doubt as to where the solution lay. If he could arrive at a full understanding of how birds sustain themselves in the air, particularly mighty birds such as the eagle, he would be able to apply the acquired principles to the exigences of manned flight. He sought this understanding not only in detailed analysis of bird flight, recording with great subtlety the refined skill with which birds achieve balanced dynamism, but also through the science of the motions of air – 'which will be confirmed by means of the motion of water within itself, and by means of this visible science you will arrive at understanding'.

His first sustained assault on the problem of manned flight occurred in Ms.B in the late 1480s, although there are signs of his interest in this question as early as *c*.1478–80. He considered a number of systems, including a spiral 'air-screw' and a device in which a standing man operates four giant wings, somewhat like a monstrous dragonfly. The most coherent of his designs occur on folios 73–75r, and provide the basis for the present model. They show an overtly bird-like system, in which a man in a prone position operates two palmate wings, primarily through foot-pedals. None of the designs are wholly resolved, complete and unambiguous. Like so many of his sheets of mechanical studies, the notes and drawings constitute an unfinished debate about ways and means. This debate was to continue into the second major phase of his investigation of flight some fifteen years later.

A small Codex in Turin, composed in 1505, is largely devoted to perceptive analyses of bird flight in its own right, but his notes show that the idea of a flying machine was still very much in his mind. His more sophisticated grasp of the dynamics of bird flight and of the highly specialised anatomy of birds (no. 107)

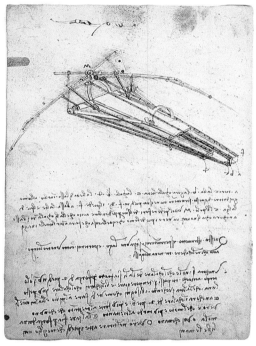

Fig. 62 *Design for a flying machine*, *c*.1488, pen and ink, Bibliothèque de l'Institut de France, Paris (Ms.B, f.74v)

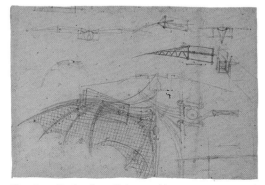

Fig. 63 *Design for a flying machine*, *c*.1505, pen and ink (C.A. f.22vb/70r)
Fig. 64 *Model of a flying machine*, constructed by James Wink, Tetra Associates, London, 1988

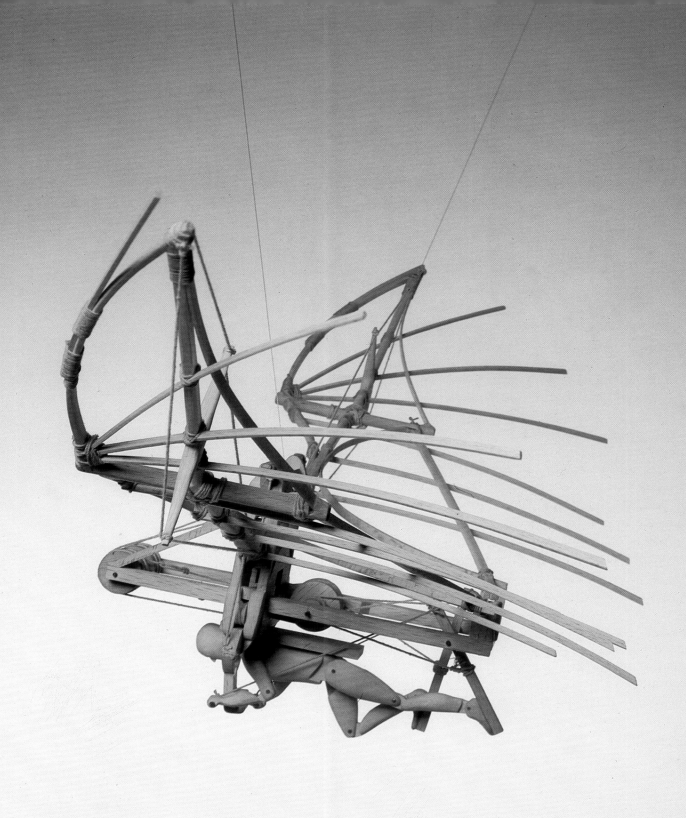

– with so much of the bird's body-weight being assigned to the breast muscles – convinced him that a simple and direct emulation of flying creatures was not possible. Rather, man would have to re-apply the principle in keeping with his own limitations. Thus he looked increasingly to systems of gliding in which the articulation of the wings was designed to orchestrate flight through subtle adjustments of angle and balance, rather than to provide the primary power. Again a series of designs can be seen to be evolving with none apparently achieving definitive status.

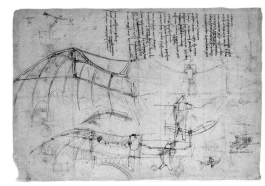

Fig. 65 *Design for a flying machine*, c.1488, pen and ink (C.A. f.309va/846v)

Any attempt to construct 'Leonardo's flying machine' therefore necessarily involves the designer and builder in an act of creative reconstruction rather than careful reproduction. To some extent the process is one of collage, pulling together compatible solutions from various pages of designs. But even this will not suffice, since there are decisions to be taken by the designer who wishes to produce a fully working system, and unequivocal guidance for these decisions is not available in Leonardo's surviving manuscripts, nor, probably, was it provided by his lost ones. The best the designer can do in these circumstances is to ensure that the decisions are compatible with Leonardo's own technology and consistent with the style of his own inventive process.

In designing and building the present machine, for which a preliminary and a scale model were made, James Wink has worked from a large range of Leonardo's drawings for bird-like and bat-like mechanisms, including detailed studies of components such as joints. Ms.B, 74v (fig. 62) provided the starting point, with the power amplified by the hand-turned windlass on f.75r, which also provided a general indication of the pulleys on vertical posts. The automatic flexing motion of the wing-tip was based on Ms.B, f.73v, which is also one of the folios on which the flap system is represented, while the system of upright rods in the wings required to provide sufficient angle for leverage was clarified through various drawings, including Codex Atlanticus f.22vb/7or; (fig. 63) and Turin Codex, f.11v. At the time of Ms.B Leonardo was considering various hand-like wings, but the most satisfactory and workable wing-shape and articulated armature was found in later designs which used the wing motions for aerobatics rather than power (particularly Codex Atlanticus ff.309va/846v; fig. 65 and 308ra/844r; fig. 66).

Fig. 66 *Designs for the wings of a flying machine*, c.1490–3, pen and ink (C.A. f.308ra/844r)

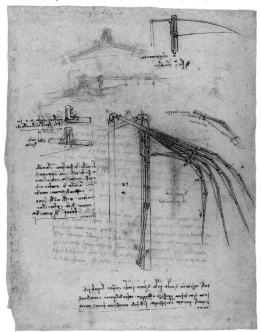

To achieve a functioning machine, a further series of choices were made of what seemed intuitively to be the best ways of achieving the desired results. As an example, we may look at one of the key problems which is unresolved in Leonardo's surviving notes and diagrams. Leonardo was uncertain as to whether each pushing motion of one leg should correspond to a single downbeat of the wings, or whether the pushing of both feet in succession should correspond to one downbeat, and whether the upbeat should be accomplished by a hand-driven windlass or by the motion of the feet – and so on. James Wink's solution has been to use a form of crank integrated with a pulley – of a type consistent with Leonardo's technology – to permit each pushing action to create both a downbeat and an upbeat, and to use the windlass to amplify the power.

The building of the model has vividly illustrated the most intractable of all the problems faced by Leonardo or any aspiring aviator of his period, namely the lack of ultra-light materials of high strength. Merely to support its own structure, the beech skeleton of the machine necessarily uses struts of quite considerable thickness. If we add Leonardo's other 'anatomical' components, such as leather

joints and thongs, springs of steel or cow-horn, and skin of starched taffeta, the weight becomes formidable. The present model, made with the kind of materials he planned to use, weighs in at a massive 650 lbs. This compares with just 72 lbs for *Daedalus 88*, the man-powered aircraft with a 112 ft wingspan (about three times that of the present model) which flew 74 miles over the Aegean Sea in April 1988. If, as seems likely, Leonardo did at least proceed as far as making test wings, he cannot but have become aware that he was far from any answer to the problem of achieving the necessary power-to-weight ratio for successful flight.

If the making of the model has underlined such difficulties, it has also confirmed the extraordinary potency of Leonardo's vision. Using mechanical systems, the wings flap with much of the sinuous and menacing grace of a gigantic bird of prey. Though his 'great bird' was never destined to fill 'the universe with stupor' through taking flight, his designs retain their conceptual power as archetypal expressions of man's desire to emulate the birds, and remain capable of inspiring a sense of wonder even in a modern audience, for whom the sight of tons of metal flying through the air has become a matter of routine.

135

THE FLYING MACHINE
Based on Ms.B, f.74v amongst others
Beech wood, iron, brass, hemp and coir
 rope, tarred marline, leather and
 tallow
Wing span: 1100 cm; length: 320 cm;
 depth (wing flat): 167 cm; depth of
 wing stroke: 490 cm
Designed and constructed by James
 Wink of Tetra Associates, 1988
Commissioned by the South Bank
 Centre, London

Fig. 67 *Model of a flying machine*, constructed by James Wink, Tetra Associates, London, 1988

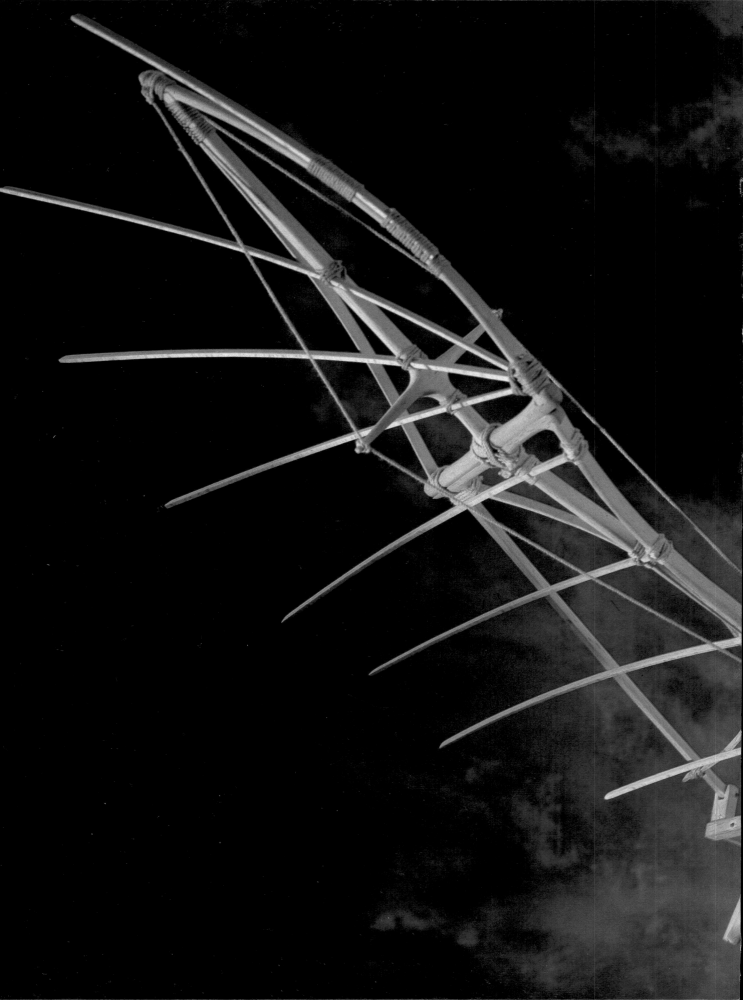

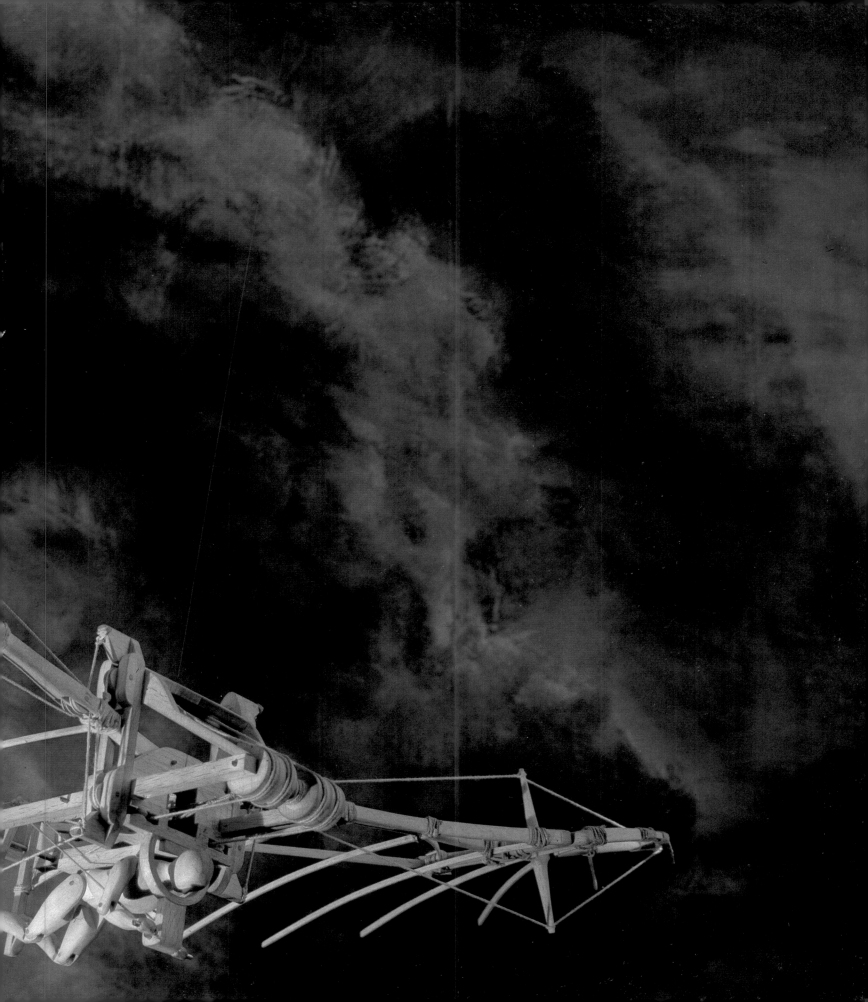

Concordances

Concordance of Royal Library, Windsor Castle, inventory numbers, section numbers and catalogue numbers

ROYAL LIBRARY	SECTION NUMBER	CATALOGUE NUMBER	ROYAL LIBRARY	SECTION	CATALOGUE
12275	VI	70	12547	VII	88
12276	I	5	12551	II	31
12279	IV	49	12552	VII	89
12280	VIII	99	12558	I	4
12281	IV	52	12562	II	29
12284	VIII	98	12570	VII	71
12303	III	41	12575	VII	78
12318	VIII	92	12579	I	21
12321	III	40	12581	VII	79
12326	VII	87	12596	II	32
12331	VII	72	12597	IV	50
12336	VII	73	12603	VIII	94
12337	VII	74	12625	I	15
12356	I	16	12647	IX	113
12358	I	8	12652	VI	69
12363	III	38	12656	IX	107
12369	VII	86	12660v	V	61
12370	VII	84	12678	IV	48
12376	VI	64	12680	V	62
12377	I	22	12698	VI	66
12378	VI	66	12726	I	1
12380	V	63	19000v	IX	106
12388	VII	85	19005v	VIII	95
12394	IV	46	19007v	IX	109
12395	IV	45	19008v	VIII	96
12400	I	20	19009	IX	108
12409	IV	47	19015v	IX	110
12418	III	42	19017	IX	105
12421	III	44	19021v	IX	111
12422	II	28	19027	IV	51
12424	V	57	19028	IV	53
12427	III	43	19054v	IV	54
12429	II	27	19055	II	25
12431	I	12	19057	VIII	93
12495	VII	90	19058v	I	9
12496	VII	82	19073–74v	I	19
12500	II	36	19080	IX	119
12502	II	33	19083v	V	55
12516	V	58	19095	II	23
12519	II	30	19097v	II	24
12521	I	11	19101	I	18
12532	V	56	19102	II	26
12533	I	17	19132	VIII	91
12542	I	10	19149–52v	VIII	97

Concordance of A. E. Popham *The Drawings of Leonardo da Vinci*, London, 1946 reference numbers, section numbers and catalogue numbers

POPHAM	SECTION	CATALOGUE	POPHAM	SECTION	CATALOGUE
3	I	3	208	I	14
9B	I	6	210	V	58
18	I	4	212	VII	74
23	I	5	217	VIII	93
28B	VII	80	219	I	9
29B	VII	76	224	VIII	91
47	I	7	227	VIII	94
60A	VII	81	230	I	15
61	VIII	92	232	IV	50
62	VII	84	233	II	32
68	I	8	247	IV	52
77	III	40	248	II	26
78A	III	37	249	I	19
79B	III	39	254	III	42
84B	VII	73	255	IV	45
85	VII	87	261	IV	47
86	VII	72	262A	I	12
87	III	38	263	VIII	98
88	VII	86	267	V	62
93	I	16	268B	I	20
95	III	41	270	II	27
105–6	VII	83	272	III	43
116C	VI	65	273	V	57
120	VII	78	276	III	44
123	VII	79	277	II	28
125	VII	82	281	V	61
129	I	2	282	I	21
133	VII	90	288	VII	85
141	II	35	289	IV	46
142	II	33	290	VI	64
146	II	34	292	I	22
155	II	36	293	VI	66
158	I	11	296	V	63
161	I	10	305	IX	113
165	II	31	306	VI	69
166	VII	89	307	VI	67
167	VII	88	308	VI	68
171A	II	30			
175	VII	76			
181	II	29			
182	I	17			
184B	V	56			
193A	I	13			
205	VII	71			

Bibliography

FACSIMILES, TRANSCRIPTIONS, TRANSLATIONS AND
CATALOGUES

Mss A–M
 *Les Manuscrits de Léonard de Vinci, Manuscrit A.
 (etc) de l'Institut de France*, ed. C. Ravaisson-
 Mollien, 6 vols., Paris, 1881–91; and
 A. Corbeau and Nando de Toni, France, 1972
 *The Manuscripts in the Bibliothèque de l'Institut de
 France, Paris*, Giunti Barbera Editore, Florence
 (forthcoming).
Ash I, II (Ms.2037, 2038)
 *Les Manuscrits de Léonard de Vinci, Manuscrit A.
 (etc) de l'Institut de France*, ed. C. Ravaisson-
 Mollien, 6 vols., Paris, 1881–91; and
 A. Corbeau and Nando de Toni, France, 1972
Arundel (B.L.)
 *I Manoscritti e i Disegni de Leonardo da Vinci, Il
 Codice Arundel 263*, Reale Commissione
 Vinciana, 3 vols., Rome, 1923–36
Byam Shaw
 J. Byam Shaw, *Drawings by Old Masters at
 Christ Church, Oxford*, 2 vols., Oxford, 1976
C.A.
 *Il Codice Atlantico di Leonardo da Vinci nella
 Biblioteca Ambrosiana di Milano*, 12 vols.,
 Florence, 1973–5, with transcripts and
 concordance by A. Marinoni
C.A. *Catalogue*
 *The Codex Atlanticus of Leonardo da Vinci, a
 Catalogue of its Newly Restored Sheets*,
 C. Pedretti, New York, 1978–9
C&P
 K. Clark and C. Pedretti, *A Catalogue of the
 Drawings of Leonardo da Vinci at Windsor Castle*,
 3 vols., London, 1968–9
Forster I, II, III, IV
 *I Manoscritti e i Disegni di Leonardo da Vinci, Il
 Codice Forster I (etc)*, Reale Commissione
 Vinciana, 5 vols., Rome, 1930–6
K/P
 K. D. Keele and C. Pedretti. *Leonardo da Vinci,
 Corpus of Anatomical Studies at Windsor Castle*, 3
 vols., London and New York, 1979–80; see
 also G. Piumati and T. Sabachnikoff, *I
 Manoscritti di Leonardo da Vinci della Reale
 Biblioteca di Windsor, Dell'Anatomia, Fogli A, B*,
 2 vols., Paris, 1898 and Turin, 1901; O. C. L.
 Vangensten, A. Fonahn and H. Hopstock,
 Leonardo da Vinci. Quaderni d'Anatomia, 6 vols.,
 Christiania, 1911–16
Madrid I, II
 *The Manuscripts of Leonardo da Vinci at the
 Biblioteca Nacional of Madrid*, ed. L. Reti, 5
 vols., New York, 1974
Parker
 K. T. Parker, *The Catalogue of the Collection of
 Drawings in the Ashmolean Museum. II The
 Italian Schools*, Oxford, 1956
Pedretti I
 *Landscapes, Plants and Water Studies in the
 Collection of Her Majesty The Queen at Windsor
 Castle*, ed. C. Pedretti, London, New York,
 1982
Pedretti II
 *Horses and other Animals, Drawings by Leonardo
 da Vinci in the Collection of Her Majesty The
 Queen at Windsor Castle*, ed. C. Pedretti,
 London, New York, 1987
Pedretti III, IV, V
 (Subsequent volumes of the above series,
 forthcoming.)
Pedretti L.S.
 C. Pedretti, *Leonardo – Studies for the Last
 Supper*, Milan, 1983
Pedretti, *Windsor Fragments*
 C. Pedretti, *Leonardo da Vinci: Fragments at
 Windsor Castle from the Codex Atlanticus*,
 London, 1957
Popham
 A. E. Popham, *The Drawings of Leonardo da
 Vinci*, London, 1946 (and later editions)
P&P
 A. E. Popham and P. Pouncey, *Italian
 Drawings of the 14th and 15th Centuries . . . in the
 British Museum*, 2 vols., London, 1950
Tofani
 Annamaria Petrioli Tofani, *Gabinetto disegni e
 stampe degli Uffizi. Inventario I. Disegni e esposti*,
 Florence, 1986
Turin
 *I Manoscritti di Leonardo da Vinci. Codice sul volo
 degli uccelli e varie altre materie, Biblioteca Reale,
 Turin*, ed. T. Sabachnikoff, G. Piumati and C.
 Ravaisson-Mollien, Paris, 1893
Uffizi
 *I Disegni di Leonardo da Vinci e della sua cerchia
 nel Gabinetto disegni e stampe della galleria degli
 Uffizi a Firenze*, ed. C. Pedretti, Florence, 1985
Urb
 *Treatise on Painting (Codex Urbinas Latinus 1270)
 by Leonardo da Vinci*, ed. A. P. McMahon, 2
 vols., Princeton, 1956

ANTHOLOGIES OF LEONARDO'S WRITINGS IN
TRANSLATION

Richter, J. P., *The Literary Works of Leonardo da
 Vinci*, ed. J. P. Richter, 3rd edition, 2 vols.,
 London and New York, 1970
Richter Commentary: Pedretti, C., *The Literary
 Works of Leonardo da Vinci, edited by
 J. P. Richter. Commentary*, 2 vols, Oxford, 1977

MacCurdy, E., *The Notebooks of Leonardo da Vinci*, ed. E. MacCurdy, London, 1938

Leonardo on Painting. An Anthology of Writings by Leonardo da Vinci with a Selection of Documents Relating to his Career as an Artist, ed. M. Kemp and M. Walker, London, 1989

EARLY SOURCES AND WORKS CONTAINING DOCUMENTS

Beltrami, L., *Documenti e memorie riguardanti la vita e le opere di Leonardo da Vinci in ordine cronologico*, Milan, 1919

Goldscheider, L., *Leonardo da Vinci*, London, 1943 (for translations of some early sources)

Giovio, P., *Imagines Clarorum Vivorum Graecial & Italiae*, 1580

Lomazzo, G. P., *Idea del tempio della pittura*, Bologna, 1785

Lomazzo, G. P., *Trattato dell'arte della pittura, scultura ed architectura*, 3 vols., Rome, 1844

Lomazzo, G. P., *Scritti sulle arti*, ed. Roberto Paolo Ciardi, 2 vols., Florence, 1973–4

Pacioli, L., *De divina proportione*, Venice, 1509

Sironi, G., *Documenti inediti per la storia della 'Vergine delle Roccie' di Leonardo da Vinci*, Milan, 1918

Vasari, G., *'Le vite'*, trans. from second edition of 'The Lives' with commentary by Herbert P. Horne, London, 1903

Vasari, G., *Lives of the Artists*, selected and translated by G. Bull, London, 1971

SELECTED LATER LITERATURE

Clark, K., *Leonardo da Vinci*, London, 1939; new edition with an introduction by M. Kemp, London, 1988

Emboden, W. A., *Leonardo da Vinci on Plants and Gardens*, London, 1987

Gombrich, E., *New Light on Old Masters: Studies in the Art of the Renaissance*, IV, Oxford, 1986

Gould, C., *Leonardo, the Artist and the Non-Artist*, London, Boston, 1975

Heydenreich, L., *Leonardo da Vinci*, 2 vols., New York and Basel, 1974

Keele, K., *Leonardo da Vinci's Elements of the Science of Man*, London and New York, 1983

Kemp, M., *Leonardo da Vinci: The Marvellous Works of Nature and Man*, London and Cambridge (Mass.), 1981

MacCurdy, E., *The Mind of Leonardo da Vinci*, London, 1928

Marani, P. C., *L'Architettura fortificata negli studi di Leonardo da Vinci con il catalogo completo dei disgeni*, Florence, 1984

Marinoni, A., *La Matematica di Leonardo da Vinci*, Milan, 1982

Mitchell, W. J., *Computer-Aided Architectural Design*, Petrocelli/Charter, New York, 1977

Pedretti, C., *Leonardo Architect*, London, 1986

Pedretti, C., *Leonardo da Vinci on Painting: A Lost Book (Libro A)*, California, 1964

Veltman, K. H., *Linear Perspective and the Visual Dimensions of Science and Art*, Munich, 1986

Zubov, V. P., *Leonardo da Vinci*, Cambridge (Mass.), 1968

Leonardo dopo Milano, ed. A. Vezzosi, Florence, 1982

Leonardo's Legacy, An International Symposium, ed. C. D. O'Malley, Berkeley, Los Angeles, 1969

Leonardo e le vie d'acqua, Florence, 1982

Leonardo e l'eta della Ragione, ed. Bellone e Rossi, Milan, 1982

Leonardo da Vinci, Engineer and Architect, Montreal Museum of Fine Arts, ed. P. Galluzzi, Montreal, 1987

The Unknown Leonardo, ed. L. Reti, London, 1974

Photographic
Acknowledgements

Alte Pinakothek, Munich fig. 19; *Ashmolean Museum, Oxford* cat. 80, 81; *Biblioteca e del Museo Leonardiano Vinci* cat. 129; *Biblioteca Nacional, Madrid* cat. 115, 116, figs. 53, 54, 55, 56, 57, 59; *Museum Boymans-van Beuningen, Rotterdam* cat. 14; *The British Library, London* cat. 101; *The Trustees of the British Museum, London* cat. 2, 6, 13, 68, 76, 77, fig. 36; *The Governing Body, Christ Church, Oxford* cat. 34, 83, 103; © 1988, *Giancarlo Costa* cat. 132; *Giunti Barbera Editore, Florence*, publisher of the facsimile edition of 'The Manuscripts in the Institut de France' by Leonardo da Vinci. Reproduced by courtesy of the *Bibliothèque de l'Institut de France, Paris* cat. 100, 102, 118, figs. 48, 49, 62; © 1988, *Ian Hessenberg* cat. 135; © *IBM UK Scientific Centre Winchester* figs. 43, 45, 47, 50; © *Joseph Lawton Dot* cat. 130; © 1982, *Lucilla Malara* fig. 40; *The Metropolitan Museum of Art, New York*: Reproduced by courtesy of the *Lehman Collection* fig. 5; Musée Bonnat, Bayonne fig. 14; *The Montreal Museum of Fine Arts* cat. 120, 121, 122, 123, 124, 125, 126, 127, 128, 133, 134; Musée du Louvre (Service photographique de la Réunion des musées nationaux), Paris cat. 3, 67, 117, figs. 4, 6, 24, 27, 29, 32, 33; Museo Nazionale della Scienza e della Tecnica 'Leonardo da Vinci', Milan cat. 131; Reproduced by courtesy of the *Trustees, The National Gallery, London* figs. 23, 28; *National Gallery of Art, Washington DC* fig. 22; © 1987, *New Yorker Magazine, Inc.* fig. 1; Reproduced by courtesy of the *Earl of Pembroke, Wilton House, Salisbury* fig. 31; © *The Pierpont Morgan Library, New York*, 1986, cat.114; *Pinacoteca Ambrosiana, Milan* figs. 11, 12, 42, 46, 51, 52, 58, 60, 61, 63, 65, 66; *Royal Library, Windsor Castle*: Reproduced by Gracious Permission of *Her Majesty The Queen* cat. 1, 4, 5, 8, 9, 10, 11, 12, 15, 16, 17, 18, 19, 20, 21, 22, 23, 24, 25, 26, 27, 28, 29, 30, 31, 32, 33, 36, 38, 40, 41, 42, 43, 44, 45, 46, 47, 48, 49, 50, 51, 52, 53, 54, 55, 56, 57, 58, 61, 62, 63, 64, 65, 66, 69, 70, 71, 72, 73, 74, 78, 79, 82, 84, 85, 86, 87, 88, 89, 90, 91, 92, 93, 94, 95, 96, 97, 98, 99, 105, 106, 107, 108, 109, 110, 111, 113, 119, figs, 7, 8, 9, 10, 12, 37, 38, 39; © *SCALA Istituto Fotografico Edtoriale SpA*, Florence: Reproduced by courtesy of Biblioteca Reale, Turin fig. 34, *Czartoryski Museum, Cracow* fig. 20, *Gabinetto Disegni e Stampe degli Uffizi, Florence* cat. 35, figs; 13, 15, 16, 20, 21, *The Hermitage, Leningrad* fig. 18, *Pinacoteca Vaticana, Rome* fig. 17; *Sopritendenza ai Beni Artisticie Storici della Lombardia*: Reproduced by courtesy of *Ing. C. Olivetti & C, SpA, Milan* fig. 25; Reproduced by courtesy of *Nicholas Treadwell Gallery, Bradford* fig. 2; *University of St Andrews Library, Scotland* cat,. 104; *Victoria and Albert Museum, London* cat. 59, 60, 112; *Wallraf-Richartz-Museum, Cologne* cat. 7; *Wayland (Publsihers) Limited* fig. 3; *The Witt Library, Courtauld Institute, London*: Reproduced by courtesy of *His Grace The Duke of Devonshire and Trustees of the Chatsworth Steelement* cat. 75; Reproduced by courtesy of *Richard Waite/The Observer Magazine* fig. 64

Extracts taken from Leonardo da Vinci © 1939 by Kenneth Clark reissued 1987 by Viking Penguin inc, London and New York and *Leonardo at Windsor Castle* © 1968–9 by Kenneth Clark and Carlo Pedretti by Phaidon, Oxford and London, reproduced by permission of his estate, c/o Margaret Hanbury, 27 Walcot Square, London SE11 4UB.